W9-BRL-761

Family Business

Also by Janet LaPierre

Unquiet Grave
Children's Games
The Cruel Mother
Grandmother's House
Old Enemies
Baby Mine
Keepers
Death Duties

JANET LAPIERRE

Family Business

A Port Silva Mystery

DISCARDED FROM THE
PORTVILLE FREE LIBRARY

PORTVILLE FREE LIBRARY
Portville, New York 14770

2006
PALO ALTO/McKINLEYVILLE
PERSEVERANCE PRESS/JOHN DANIEL & COMPANY

This is a work of fiction. Characters, places, and events
are the product of the author's imagination or are
used fictitiously. Any resemblance to real people,
companies, institutions, organizations,
or incidents is entirely coincidental.
.

Copyright © 2006 by Janet LaPierre
All rights reserved
Printed in the United States of America

A PERSEVERANCE PRESS BOOK
Published by John Daniel & Company
A division of Daniel & Daniel, Publishers, Inc.
Post Office Box 2790
McKinleyville, California 95519
www.danielpublishing.com/perseverance

Distributed by SCB Distributors (800) 729-6423

Book design by Eric Larson, Studio E Books, Santa Barbara
www.studio-e-books.com

Cover photo by Morgan Daniel

2 4 6 8 10 9 7 5 3 1

LIBRARY OF CONGRESS CATALOGING-IN-PUBLICATION DATA
LaPierre, Janet.
Family business / by Janet LaPierre.
p. cm. — (A Port Silva mystery)
ISBN 1-880284-85-5 (pbk. : alk. paper)
1. Pacifists—Fiction. 2. Port Silva (Calif. : Imaginary place)—Fiction. I. Title.
PS3562.A624F36 2006
813'.54—dc22
2006003856

This book is dedicated to
two wonderful yellow Labrador retrievers.
∽
After twelve years of faithful companionship,
bold, sturdy Emmitt has left us for that
Great Swimming Hole in the Sky,
bequeathing his duties to pretty Dulcie,
who fulfills them with grace and enthusiasm
and always, always lives up to her name.

AUTHOR'S NOTE

Port Silva, California is a fictitious town. Stretch the Mendocino coast some twenty miles longer, scoop up Mendocino village and Fort Bragg, toss in a bit of Santa Cruz. Set this concoction on a dramatic headland over a small harbor and add a university. Established 1885. Elevation 100 feet. Population 24,020, a mix of old families, urban escapers, students, academics, and tourists in season.

Family Business

1

"I WISH VERITY WAS COMING WITH US," Sylvie Medina said as she clicked her seat belt into place.

"She's busy, dear, so you and I will be representing the family." Patience Mackellar, in spite of an unorthodox business life as proprietor of Patience Smith, Investigations, was a fairly regular attendee at Port Silva's First Baptist Church. Nine-year-old Sylvie accompanied her there for the comfort of familiarity and because she knew her dead mother would have wished it. Verity, however, Patience's daughter and Sylvie's "found mom," was respectful but secular, and the event they were setting off for would be largely a gathering of the faithful.

"Wow! Look at the traffic!" said Sylvie moments later, staring in wonder through the windshield.

"There's certainly a lot of it," said Patience with a good deal less enthusiasm. Cars, vans, pickups, and the occasional motorcycle were streaming past the intersection where Raccoon Lake Road joined California Highway One, which was also known further south in Port Silva as Main Street.

"How are we going to...? Oh, very good," Sylvie said as Patience stepped on the gas and inserted her little RAV4 neatly into the opening she'd glimpsed. "Patience, where do you think they're all going?"

The small American flags fluttering from many antennas made that an easy call. "I'd say they're headed for the same place we are," Patience told her. Port Silva's one-year memorial for the victims of September 11th deserved to draw a crowd, and she hoped that the park on the bluffs south of the river was big enough to accommodate what promised to be one. "It appears that many people besides you and me want to pay their respects today."

"How come so many cars have those teensy American flags?"

Surprise; she'd noticed. "Because the people we'll be honor-

ing were Americans, killed in an American city."

"Could we get a flag?"

Patience admitted silently that her inner response to this request was almost pure reflex from her lefty-Berkeley-student days in the sixties, and not something that should be passed on. "Of course we can."

Sylvie settled back in her seat, apparently satisfied with her victory, and Patience turned her attention to her mental map of the town ahead, and possible parking places.

"Patience, weren't some of the people in the buildings and the airplanes from other countries? Besides the bad guys who took over the planes, I mean."

She foresaw the next request, and headed it off. "I'm sure some were, Sylvie, but we're honoring them, too, just by going to the memorial today. Now, keep an eye out and help me look for a parking place."

Sylvie obediently sat up straighter and turned her gaze on the passing streets.

"SYLVIE!"

Sylvie stopped and turned, causing the slow-moving tide of humanity to slow still further before splitting to flow around them. "Patience, there's Jess."

"I see, dear. And her mother, too. Let's step to the side and wait for them."

Ronnie Kjelland—mother, restaurant owner, and Verity's now-and-then employer—waved to Patience and followed her daughter through the crowd. "Incredible turnout," she said as she reached out to take the older woman's arm. The little girls greeting each other with hugs made a picture of contrasts: tall Sylvie with a narrow, olive-skinned face, shoulder-length black hair, and air of controlled intensity; and Jessica, a diminutive red-haired dynamo of ten.

Patience and Ronnie stood where they were to survey the scene. People of all ages, in numbers too large to estimate, nearly filled the grassy expanse of the park. Latecomers were still trickling in, trying to find a spot with at least a partial sight line to the flag-draped stage set at bluff's edge above the Pacific. Patience noted a couple of rows of folding chairs at the front and a few people

sitting on the grass, but most who'd come to this memorial service were standing, shading their eyes or squinting into the last rays of a sunset muted by wisps of fog and talking, if at all, in low voices.

"Parking was a bitch," said Ronnie. "My Jeep is sitting partly on somebody's lawn about six blocks away."

"I got lucky," said Patience. "There was a space just this side of the bridge too small for the van trying to get into it, so I waited and then whipped right in. I saw a couple of big videocams on my way in," she added, "I think from the local station. Nothing from the networks, at least not so far."

"I'd bet there's an event like this in most major cities and a good many small ones today," said Ronnie. "So if Mayor Riley was expecting national notice, he'll be disappointed, but I'd say his little town is doing itself proud." She glanced past Patience. "Verity's not with you?"

"Verity's busy with her new love."

Ronnie's eyes widened. "New? What's happened to Johnny Hebert?"

Patience's grin made her round, middle-aged face look years younger. "Nothing, or so I devoutly hope. Her new love is a house she's just bought and is remodeling."

"Well, that'll keep her busy for a while," said Ronnie with a sigh. "I was hoping I could get her to come in on the lunch shift at Veronica's. My best daytime cook is eight months pregnant."

"I don't think... Yes, Sylvie?"

"Excuse me, Patience? Jess and I aren't going to be able to see from back here." Sylvie's tone was polite, but her feet were fidgeting, eager to move.

"We'll just go down in front and sit on the grass," said Jess. "We'll be able to hear better from there, too."

"Hank Svoboda told me the event will be very well patrolled," said Patience, and Ronnie nodded.

"Yeah, I saw several cops on my way in. Okay, girls. Just stay together and out of trouble, and meet us back here by the main path when it's over. And remember the purpose of this event."

Sylvie stopped just short of rolling her eyes, substituting a nod instead. "Yes, ma'am. We'll be just like in church."

Ronnie sighed as the pair ran off. "Hey, I'm really glad we ran into you two. Jess finds Sylvie much better company than her

tired old mom."

A brief *click-click* of sound, probably from someone tapping a live microphone, stilled chatter and brought most eyes to the stage, where the row of seated dignitaries, in dark suits or black robes, got to their feet as a local man with a not-bad tenor voice stepped center-front to sing "The Star-Spangled Banner."

The singer finished, and after a moment of respectful silence, Mayor Ed Riley moved forward with somber greetings to this group gathered to honor the victims of the tragic events of a year earlier. He ended with a slow, precise recitation of the names of nine locally connected people who were among those thousands of victims. Each name brought a reaction from some part of the crowd, and Patience stood a little straighter as the name of her insurance agent's adult son was spoken. Then came the Assemblywoman from District One, who spoke briefly and introduced two large, blue-suited men, Port Silva firemen who had joined New York firefighters in dealing with the disaster.

That brought the whole crowd to vocal life, and the pair of heroes stood even straighter and looked abashed at the roar of approval and applause.

Mayor Riley again: "Following a few hymns from one of our fine choirs, we'll listen to hopeful words from men of faith well known to Port Silva. Please hear Pastor Schultz, Father Eccles, Rabbi Hirsch, Father Lucchesi, and Reverend Noble." As he moved back to his seat, some twenty-five or so black-robed figures began to line up in front of the stage.

"Let's see," said Ronnie, who was not a Port Silva native but was married to one. "That takes in Lutheran, Episcopalian, Jewish, R.C., and Baptist. Pretty old-line ecumenical."

"I'd heard there was to be a Muslim, from that storefront mosque downtown," said Patience.

"Yeah, my mother-in-law was really pissed about that. Maybe he got cold feet."

Patience frowned, and took another look around. The choir members were still arranging themselves, the crowd mainly quiet. "So far, it looks peaceful enough. Did you notice many political buttons as you came in?" Port Silva was a northern California coastal town and thus home to many political points of view. Earth First!ers and people opposed to coastal oil drilling had

marched here; lumbermen and fishermen from both ends of the political spectrum were vigorous in defense of their waning industries. While local support for the military action in Afghanistan was nearly total, rumblings were beginning to be heard over the possibility of another war in Iraq.

Ronnie shook her head. "Beyond a lot of SUPPORT OUR TROOPS, the only buttons I saw were those PEACE IS PATRIOTIC numbers, and I wouldn't think that's a statement to pull anybody's chain."

Patience, with Vietnam-era protests part of her personal history, knew very well that political buttons and banners could have nuances not always obvious to the uninitiated. "You're probably right."

"However," Ronnie went on, "I do believe that's our Lutheran choir. They must have beaten out the Baptists, and now we'll get 'A Mighty Fortress' instead of—what would Baptists go for, 'Onward Christian Soldiers'?"

"Possibly," said Patience, and turned to watch, and listen. A note sounded very softly—a pitch pipe, she thought—and the choir straightened, took breath, and the old hymn burst forth: *"Oh God, our help in ages past, our hope for years to come..."*

"A fitting choice," said Patience softly, and Ronnie nodded.

SYLVIE and Jess had threaded their way politely to the edge of the crowd and now moved more freely among others, mostly teenagers, who were hanging about in pairs or groups. Jess said, "Hi, Sara," to a plump girl with spiky purple hair whose low-slung jeans and cropped top exposed a broad strip of less-than-flat belly. Sara said, "Oh, hi, Jess," with a nod, and turned to rejoin two other girls about her age, the three of them giggling as they looked around in search of more interesting passersby.

"She used to baby-sit me," Jess told Sylvie. "She's kinda dumb, but nice enough. Except my mom didn't like it that she brought her boyfriend over."

"She must be cold," Sylvie said, pulling her own light jacket closer against the early-evening chill as they moved on.

"Sara likes to be right out there," said Jess. "She's got this big tattoo on her butt. Oh, look out." Three big guys Sylvie thought looked older and hairier than high school boys blocked their path

in a face-off with two others. Before the confrontation got any further than snarled comments, a uniformed policeman appeared out of nowhere, it seemed to Sylvie, and snapped, "Cool it!"

The boys froze and then the trio stepped back from the other two with exaggerated care. "Hey, man, no problemo," said the tallest with a shrug.

"That really relieves my mind, Dickerson. Now. If you guys want to pay your respects to the people who died, maybe you better do it separately. Or you can all just clear out so other folks can hear what the preachers have to say." He watched as the boys set off with various degrees of swagger, then noticed the little girls as he himself turned to go. "Well hi there, Sylvie, you're looking real pretty today. Verity here with you?"

"Hi. No, I came with Patience."

"Well, tell Verity 'hey' from me when you see her. You two be careful now, and keep out of the way of the big boys." He gave a half salute and strolled away.

"Who's he?" asked Jess.

"Dave Figueiredo. He likes Verity."

"He's really good-looking," said Jess, following the departing figure with her glance.

"I guess. Listen!" Sylvie breathed, and cocked her head. "The choir is starting. Oh, they're very good."

"That's our choir from Shepherd of the Sea," said Jess, but Sylvie waved her to silence and stood stock-still through that hymn and those that followed.

"Come thou almighty King, help us thy name to sing…"

"Be still my soul, the Lord is on thy side; bear patiently the cross of grief or pain…"

As the last words died away and the choir members began to separate and move into the crowd, Jessica said, "I'm tired of standing here. Let's go find a place to sit." She tugged Sylvie's hand, and Sylvie sighed and followed. "That was just lovely, Jess. I wonder if I could maybe come to your church?"

"Sylvie, I don't think you become a Lutheran just for the music."

"I don't see why not."

By the time they'd found a patch of summer-dry grass to sit on, a tall, black-robed man with a neat beard had been speaking

for a few moments. His deep voice was sad, Sylvie thought; and he talked about being sorrowful but staying hopeful and strong with God's help. " …the Lord lift up His countenance upon thee, and give thee peace."

The next speaker, in a suit and beanie, was speaking of sorrow and bravery, a fight against evil, God on our side, when a small crowd of teenagers, Jess's former baby-sitter among them, drifted past and stopped to talk, bumping against each other and laughing. By the time two women moved out from the crowd to hush them and shoo them away, the third speaker was up and talking. "Pastor Schultz," said Jess.

Sylvie, attention wavering, turned to see whether she could spot Patience and saw another familiar cop, Verity's friend Alma Linhares, pause in her patrolling of the crowd's edge to speak into what Sylvie knew was the radio mike near the collar of her jacket.

When she turned her eyes to the stage again, another black-robed man—Father Lucchesi, Sylvie had seen him at Our Lady of Mercy church and school a few blocks from Muir Elementary— was at the lectern, speaking of what he called a "just war," to be conducted according to moral principles. What had happened on this date, he said, was neither just nor moral. Scenes of smoke and falling buildings and running people filled Sylvie's mind again, and she clenched herself against those images and concentrated on Father Lucchesi as he told the audience to pray and seek counsel in this time of sorrow.

And next—last?—was a smallish, bouncy man in a suit whose big voice made the sound system seem unnecessary. "Reverend Noble, I promised Patience I'd listen," Sylvie said, but it seemed to her that the words these men were speaking differed only in tone, from sad to angry. Maybe there'd be more music soon.

"…and to this memorial of a tragic event I'll add Our Lord's words from Matthew 10:34. 'Think not that I am come to send peace on earth: I came not to send peace, but a sword.' Amen, and God bless America."

That brought movement and scattered cries of "Amen" from the crowd, but it was the action in front of the stage that captured Sylvie's full attention. Moving into the place the choir had occupied earlier were four young women wearing tunics of various colors over white trousers. "Jess, look, that's 'Old Music, New

Voices'! Gracie's quartet!"

"Gracie? That teaches the chorus?" Unmusical Jess was not one of the participants in the select chorus at their school.

"She's the little one, with all the brown, curly hair. Wait till you hear them, they're awesome!"

"Who's that big guy helping them get set up? He's the one I'd call awesome."

Now and then Sylvie was reminded that Jess was a year older than herself. "That's Gracie's boyfriend, Danny. He's one of the guys working on our new house. Shh, now."

Jess grimaced but sat back down as one of the woman sounded a note on a pitch pipe and then the four voices soared into "Amazing Grace." Sylvie listened so hard she nearly forgot to breathe.

"THAT was interesting," said Patience, as Father Lucchesi blessed the crowd and stepped back. "Did you notice a bit of un-ease around us?"

"Probably just in people who were listening very carefully," said Ronnie, and looked at her watch as Reverend Noble approached the lectern. "Last guy now, I believe. This should be pretty straightforward."

And it was. "So who won, the Catholics and 'moral war,' or the Baptists with the sword?" Ronnie asked softly as the "Amen"s rang out. "And do you suppose it matters?"

"I hope not. I prefer to think the music won. Ah," Patience went on, peering around the people in front of her to see what was happening, "this will be good. And Sylvie will be in heaven. Let's see what 'Old Music, New Voices' gives us."

Some minutes later she sighed and grinned at Ronnie, who grinned back. "I'd bet," Patience said, "that's the best white folks' version of 'Amazing Grace' we'll ever hear. And I personally bless them for ending with 'America the Beautiful.'"

"Yup. Fine choice. *Fine* voices."

Patience pulled her jacket closer and glanced out at the horizon where only the faintest line of light still shone, and then around the park, where high banks of lights to either side of the grassy expanse had not yet been turned on, but low lamps along the paths were now glowing. "Let's move out smartly and find the

girls. It's getting cold, it's getting dark...."

"And this park is a night-time hang-out for teenagers looking for action or trouble."

"Hank's information was clearly correct," noted Patience. "I've seen six— no, seven. Eight. Eight cops just out here on the grass. There's Alma," she added, and waved to a uniformed woman who waved back but didn't stop her half trot along the edge of the moving mass of people. Patience craned her neck, and after a moment thought she spotted Sylvie, or more accurately her hooded red jacket. She gave a shrill, two-fingered whistle and the red-clad figure turned to whistle in return. "There they are. Here they come."

Not too far away a siren blared, then rose and fell, another joining in moments later. Patience and Ronnie exchanged glances, and Ronnie took the lead in forging a path for the pair of them.

"Patience! Did you hear the music? Did you see Gracie?" said Sylvie moments later, reaching to take Patience's hand.

"It's cold, and I'm hungry," announced Jess." Can we all go get something to eat before we go home?"

Ronnie's "Not tonight" followed fast on Patience's "I don't think so."

"It's late, and my feet hurt," Ronnie went on. "We'll do it another time. Now grab hands and let's get out of here before we get trampled in the rush."

2

VERITY MACKELLAR LEFT THE sun-filtering corridor of redwoods on Highway 128, kept company with the Navarro River for a few miles, and picked up the Coast Highway north as the river met the Pacific. Here she found the sky still clear but the air noticeably cooler. Northern California's fabled Indian summer still persisted in mid-October, but she thought she could taste the coming November in the air. People who thought this part of the country had no distinct seasons simply didn't appreciate subtlety.

Nearing the end of a two-hundred-mile round trip that had allowed no time for lunch, she paid scant attention to the expanse of ocean on her left but was aware that the many B&Bs and resorts along the route still showed NO VACANCY signs. As a result, she was now caught in a steady stream of traffic that held the two-lane highway down to city-streets speed. This was the price locals paid for Indian summer.

As the big bridge across the Pomo River came into view, Verity slowed from saunter to crawl. Clusters of pedestrians were gathered at the north end of the old structure, a few peering out at the water or possibly at the Coast Guard motor lifeboat that had patrolled the harbor entrance with increased frequency since the attacks of September 11th over a year earlier. But most pedestrians, no surprise, were also placard-carriers, those on one side of the roadway glaring at those on the other. Today the signs on her left said variously NO WAR or U.S. STAY OUT OF IRAQ or PEACE IS PATRIOTIC, with one FUCK SADDAM! GET OSAMA! Those on the right called for DEATH TO SADDAM! or NUKE THE BASTARDS! or, oddly, PACIFISTS GO TO HELL. She noted with a too-brief moment of humor that for people driving south, the peaceniks would be on the right.

And those were, or should be, her people, a twinge of guilt reminded her. "Never mind," she said aloud, and narrowed her vision to the road ahead, and the possibility of suddenly flaring

taillights. For months Port Silva had been seeing small demonstrations in opposition to any U.S. invasion of Iraq, the usual participants mostly students from the nearby university and a number of gray-haired locals who were longtime activists.

Then last month on the September 11th anniversary, a city-sponsored memorial event at the headlands park south of the bridge drew a crowd so large that CBS picked up clips from the local television station for inclusion in a later program on such memorials in America's small towns. Subsequently, the peace vigils had grown in size and frequency over ensuing weeks, to be met by smaller but noisier groups of "war-lovers" or "patriots," depending on your point of view.

On the night of the memorial, a group of teenagers had been arrested for vandalizing the storefront mosque downtown. Beyond that, so far as Verity knew, no protestor on either side of the ongoing disagreement had yet taken more damage than flung epithets or a hard push. But you've been so busy with your own project, she reminded herself, that you wouldn't have noticed anything less than full-blown riots. Now, as she drove very slowly off the bridge, she spotted two blue uniforms keeping watchful eyes on the scene, surely not the norm for an ordinary afternoon. Standing back a bit, no doubt for a fuller, wider view, was another uniform with a camcorder.

"Is that even legal?" she asked aloud of no one as she drove on. "What gives them the right to do that?"

Ten minutes later, on Raccoon Lake Road, Verity turned in at the mailbox marked p. MACKELLAR/V. MACKELLAR to find the gate open and Patience's RAV4 parked in its usual place, but the cottage closed and silent under its sheltering Monterey pines. Where was Patience? And Sylvie?

As she got out of her Subaru, a black-and-white shape uncurled from beneath the deck and trotted forward, head and pointed ears up and tail curled high. "Hello, Zak," she said to Sylvie's half-Akita, and rubbed his hard head as she remembered that this was Thursday, and Sylvie would catch the late bus home after a guitar lesson. "Not to worry, she'll be here in another hour or so.

"But there's action next door," she added, mostly to herself. Voices and sounds of movement came from beyond the fence and

hedge marking the east edge of the lot; some of the crew working on the former Cimeno house must be still on the job. She tossed her shoulder bag back into the car and trotted off to see how things were going. "Zak, stay," she ordered as she opened the new gate in the fence and slipped through.

Two pickup trucks and a light blue van were parked haphazardly before the two-story house in which Liz Cimeno had raised three children and tended numerous grandchildren. Presently Liz, with a new, comfortably retired husband, lived alternately in Hawaii and Denver and had been happy to sell her old home to her neighbor's daughter for what Verity, a former San Francisco homeowner, knew was a near-steal of a price.

One of the trucks belonged to friend and police officer Val Kuisma, who'd clearly come by to work for an hour or so after his shift ended. And another, even more familiar, belonged to Port Silva police captain Hank Svoboda, Patience's very good friend. Patience and Hank were standing a dozen feet back from the house in quiet contemplation of its transformation. "Hi, Mother," said Verity, giving the much smaller woman a quick hug. "Hi, Hank. You approve, so far?"

"Absolutely," he said with a nod. "You've got yourself a good, solid house there, better than any of those I've been looking at lately. And with the exterior work all done, a change in the weather isn't going to slow things down much."

Verity gazed at her prize, and grinned. "Isn't it wonderful?" The house was squarish and plain, with a side-gabled roof and a flat front, the entry centered above a small roofed stoop. It had a full basement, a foundation that had been completely replaced twelve years earlier following the earthquake, fireplaces and chimney judged sound by professionals. Now the roof wore new dark gray composition shingles and the clapboard siding gleamed with fresh light gray paint trimmed with a Wedgwoody blue.

"Have you been inside yet?" Verity asked, leading the way toward the open front door.

"Not for about a week," said Hank, following her.

"Well, come have a look."

"The floor people did a very good job," said Patience, bringing up the rear. The three of them paused in the entryway to ad-

mire the mellow dark amber glow of quarter-sawn oak floorboards, their new surface protected by strips of heavy plastic leading up the staircase ahead, right into the living room, left into the dining room and kitchen. Those two rooms were now one, divided at the level of the former wall only by a low cabinet that would be a peninsula counter as soon as its butcher-block top arrived. "Okay if we come through?" called Verity.

"Come ahead. Watch your step." Val Kuisma, who kept his craftsman's hand in by moonlighting in construction and woodworking, was helping a taller, larger man maneuver a lower cupboard into its predestined spot against the far wall. As the unit settled into place, Val brushed sawdust from his black hair and turned to give Verity a grin. "I wouldn't promise you can count on carving Halloween pumpkins here, but it'll be close."

"For that I thank you, and so does my mother. Hi, Val. Hello, Daniel."

The other man—more of a boy, really, with dark brown hair and long gray eyes—ducked his head in a sort of bow.

"Good-looking cabinetry," said Hank, moving forward to inspect the wall-mounted units. "Cherry, I'd guess. From Al Frank's shop?"

"Yup. With a bit of help from yours truly and Danny," said Val. "These old houses, it's hard to fit ready-made stuff in."

"Val, I just picked up the decorative tiles for the backsplash from that place in Healdsburg. They're wonderful, just what I had in mind," Verity told him.

"Good. Gary Peters and his sons will be here Monday to go to work on the tile. And Danny figures he needs—tomorrow morning?" he asked his helper, and received a quick nod in reply. "To finish mending and prepping the walls upstairs," Val went on. "Then you can get to work on the painting, if you're still determined to do it yourself."

"If you want," said Danny in tentative tones, "I could maybe do the ceilings for you."

"Better take him up on that, Verity," said Hank. "I've painted more ceilings than I care to remember, and it's a real workout for the shoulder muscles."

"Good advice," said Val. "Oh, by the way, Charlie Garcia stopped by a few minutes ago."

"My toilet!" she said in delight, and then rolled her eyes. "Sorry."

"He'll be thrilled that you're thrilled," Val assured her. "He says that the units for the little WC you want, in that former closet upstairs, just came in and he'll bring 'em over Saturday. He says they're cute."

"On that note, I think I'll go home and have a glass of wine," said Verity. "Thanks, guys. You do fantastic work, and I appreciate it. Daniel, I guess I'll see you tomorrow? I want to get in a few hours' work on the windows."

"Yes, ma'am, I'll be here. And probably Apodaca, too."

"Sounds good," she said, and headed for the door, Patience and Hank on her heels. Outside, she sighed happily and shook her shoulders loose. "Long drive. Maybe I should settle for a cup of tea. What would you guys prefer?"

Hank shook his head. "I started the day at four A.M. Now that I've seen you're still in good hands with this project, I'm going home to catch a nap before the city council meeting."

"Good thinking. Oh, Hank, a quick question. I just came over the bridge, and there was a cop with a videocam filming the protesters. And I wondered, is that legal?"

Hank sighed and wiped a hand wearily over his face. "Yeah. Yeah, it is. The mayor and four of the seven council members insisted on it, for security reasons. Vince wasn't happy about it, but he agreed, so long as the cop with the camera was in uniform."

Even Vince Gutierrez, the town's often irascible police chief, sometimes had to take orders. "Hard times, hard choices, I guess," said Verity.

"I guess." Hank touched Patience's shoulder briefly. "I'll see you ladies maybe tomorrow."

BACK on their own side of the fence—at least, it was "her own" for a few more weeks yet, Verity reminded herself—Patience went on to unlock the cottage and open a window or two while Verity stopped briefly at the studio, the small outbuilding that had served for more than a year as her one-room apartment, to do the same.

"So, wine or tea?" she asked Patience, who had carried Zak's evening meal out to the deck and now returned to sit down at the kitchen table.

"Wine. Oh, I have some good news," she went on as Verity surveyed the contents of the refrigerator to see what was open. "Patience Smith, Investigations received a nice check today from the Ridgewood Resort people, and most of it's yours, for your undercover work."

"Oh ho! Did they turn that so-called wine steward over to the authorities?"

"Actually, they simply fired him. I think they didn't want the kind of attention an arrest would have attracted. But they were very glad the person fiddling the orders was the wine steward rather than their head chef."

"Well, they bought the place only a year ago and need to maintain the *luxe* image and clientele," Verity said, pouring sauvignon blanc into two glasses and setting one before her mother. "But I have to tell you, I'd cook in a greasy spoon any day over waitressing in a rich-folks' playground. One more day there, and I'd have given a champagne-bottle launch to the next guy who put his hand on my butt." Verity, who'd fled a bad marriage and a suit-and-briefcase job in a San Francisco bank more than two years earlier, worked for Patience's agency as an assistant investigator when business was good, usually cooking in this or that restaurant otherwise.

"And I should be looking for some of that secondary employment before long, but I'll probably wait until I finish with the house." Verity propped her backside against the sink counter and sipped from her glass. "Ah, lovely. By the way, is Hank thinking of getting into real estate?"

"Not that I know of. We, however, may have a new job," said Patience. "I had a call this morning from a local family, a missing-persons case."

"Your favorite kind," Verity said, and then, "Local? Anybody I'd know?"

"Probably not. The Flynn family has had a ranch up by the Little Blue River for something like eighty years. It's the current rancher, Pete, a man with two grown children, who has disappeared." Patience paused for a sip of wine. "I did some work for his wife, Allie Flynn, several years ago, when their daughter, Norah, was being pursued by a man who looked dubious to Allie."

"And was he?"

"Oh my, yes." She made a face at the memory. "He had two ex-wives and several children in, as I recall, Oklahoma and Texas. A prison record for assault, nonpayment of child support, and other crimes I don't recall at the moment."

"Poor Norah," said Verity. "Or lucky Norah. Eventually. So, the father. Haven't they reported him missing, to, oh, the sheriff's people, I guess it would be?"

"They're holding off on doing anything that official," Patience said. "For one thing, he's a healthy sixty-something. And there's a local bit of doggerel about the family: 'Footloose Flynns, run, walk, or crawl, come home when they like or not at all.'"

"Ah. So the cops would figure he left because he wanted to, and why use up police resources."

"Probably. So Allie asked her son, Tim, to call me. I don't know whether it's anything I can help with," she added with a shrug, "but I agreed to go out to the ranch tomorrow to talk to them."

Zak, who'd finished his supper in quick-time and now dozed beside the table, suddenly lifted his head for a sharp bark, and seconds later the women heard the sound of a vehicle on the gravel outside and then a brief horn-toot.

"That will be Silveira's delivery van, with the grocery order I phoned in this morning," said Patience, getting to her feet. "I'll tell you more about the Flynns later."

"LOOK away, look away over Yandro." After singing the last line of "He's Gone Away," Sylvie made a small, triumphant *arpeggio* of the F-chord before setting the guitar down in her lap.

"Very good," said Grace Beaubien.

"I like that song. Lily used to sing it," Sylvie told her.

"You were lucky to have a mother who sang folk songs. And I think she must have passed her fine voice on to you," Grace added.

"I…guess. I can't remember anymore how she sounded."

"Next time we'll make a tape, and you can listen to yourself. Here, let's swap for a minute," she said; she reached out for Sylvie's guitar, laid it on a table to one side, and handed her own over.

Sylvie took the larger instrument, cradled it close, wrapped

the fingers of her left hand around the neck and fingered the F-chord easily.

"Right, that's what I thought. Your fingers are skinny, but they're long and strong."

"Like me," said Sylvie. "My father gave me that guitar, but he doesn't see me very often. And he doesn't know anything about music, he can't even sing."

"It's a nice enough little instrument, Sylvie, but you could certainly handle a full-sized version. If Verity would like me to look around for a good one, I'd be happy to," she added, and got to her feet at the sound of footsteps. "Oh, I bet that's Danny."

The front door of this small house opened directly into the living room, and Daniel Soto's big frame filled the doorway briefly as he surveyed the room before breaking into a broad grin. "Hi there, Gracie love. And good afternoon to you, Miss Sylvie. How's the music?" he added as he stepped inside and closed the door.

"Just lovely. Grace says I might need a big guitar."

"Well, you're a pretty big girl, I bet Gracie's right. Probably you'll be ready to wrestle with a big old Martin any day now."

"Probably," she echoed with a grin. Sylvie, who'd spent several of her nine years as buffer or bone of contention between an emotionally frail mother and an explosive stepfather, had reason to be habitually wary of men. At first, she'd kept her distance from Daniel Soto, part of the crew remodeling what was to be Verity and Sylvie's new house. In addition to height and muscle, he had a squared-off, high-headed stance and a face that seemed to be mostly bone, with gray eyes so light that they sometimes looked like cartoon blanks against his tanned skin. And he hardly ever talked.

Then Sylvie found that Grace Beaubien, her chorus teacher and now her guitar teacher as well, was Daniel's lady. Not a lot taller than Sylvie herself, with a mop of curly light brown hair, huge brown eyes, and a wide mouth with corners always quirked up, Grace was just lovely, Sylvie's favorite word. The fact that Daniel clearly thought so, too, had earned him many points on Sylvie's personal scorecard.

Now he looked down at his dusty boots, made a face, and sat in a straight chair to unlace them. "Need a ride home, Sylvie?"

"No, thanks. There's a late bus at the school at five o'clock, and I'll walk over and catch it. Thank you for the lesson, Grace," she added, and picked up her guitar to put it in its case.

"Sylvie, it's a pleasure every time. I'll see you next week."

Grace watched Sylvie out to the sidewalk, waved, and closed the door. "I won't feel right about taking money for Sylvie's lessons for long; she could probably pick up folk guitar all by herself."

"She's kind of a pushy little kid," Danny said. "Comes over to the house almost every day to check on progress and try out paint samples for her bedroom. Your old boyfriend says she's very smart."

"Sylvie is smart, talented, and a person of character," said Grace. She put her own guitar in its case and folded up the music stand. "What boyfriend?"

"Apodaca."

"Harley was never my boyfriend, he's just a nice boy I've known all my life. What *is* the matter with you?"

"Hey, I know he's a nice guy, you could've done a lot worse. You're probably doing a lot worse right now."

"Oh, for heaven's sake!" she snapped, and caught the tight look on his face. "Danny? What's wrong? Did you get hurt today?"

"Hurt? Oh. No," he said, as if he'd just registered the question. "Everybody on this job is experienced, and careful. No, I made a run downtown to the hardware store to pick up something for Val, and I thought for a second that I saw somebody from— another time. But it couldn't have been." He got to his feet and stretched. "Not possible."

"Who?"

"Nobody you'd know," he said, unbuttoning the first two buttons on his work shirt before pulling it off over his head. "I need to go back downtown, but first I need a shower."

"And some supper. I got home from class early and made a chicken stew."

"Uh, okay," he said, with a glance at his watch. "Great. I'll be ready in five."

"What's happening downtown?"

"There's a protest underway by the bridge, and they're talking about another, really big one, maybe next week. I told Sean I'd pick him up."

Grace stiffened and shoved her hands into the pockets of her jeans. "I don't like these 'protests,' I think they're asking for trouble. People like that nasty Sean Flynn are getting too mad. I don't want you to go."

"Gracie…" He took a step toward her, but she moved back, and he let his reaching hands drop.

"Look, it's important. Those chicken-hawks in Washington haven't finished the war in Afghanistan and they're hot to take on another one. Do you want Ethan to wind up slogging across the Iraqi desert with an AK-47?"

Grace hunched her shoulders. Her brother, nineteen years old to her own twenty-three, had joined the Marines the year before in a burst of post–September 11 patriotism helped along by general restlessness. "No, I don't. I don't. But I can't believe that fighting in the street here is going to change anything."

"We'll be protesting, not fighting."

Grace just looked at him, and after a moment he sighed and reached out to pull her close. "I will be good," he said, resting a cheek on the top of her head. "I won't look for trouble. I'll be a fuckin' pacifist—a pacifist," he corrected himself. "Promise."

"Oh, well. Go have your shower, and I'll get supper on the table like a good little pacifist housewife."

"Wife. Now that has a nice ring," he said, his voice light but his expression, she looked up to observe, somber.

"In your dreams, buster. I'm a musician, with miles to go."

AT not quite ten P.M. Chief of Police Vincent Gutierrez surged through his own front door, slammed it behind him, and snarled, "Gin!"

"Good evening, dear. And how was the monthly city council meeting?" Meg Halloran set aside the lapful of papers she'd been grading and got to her feet in time to take the uniform jacket he was about to toss at the couch. "Never mind," she added. "Just sit down, or pace if that's what you prefer, and I'll hang this up before playing barmaid."

Gutierrez was slumped on the couch, head back and legs outstretched, when she returned with two small, frosty glasses full of ice and colorless liquid. "I suspect you've earned this," she said as she handed him one. "It's a bit late for me, but I can be flexible."

"Thank you, my love. Cheers," he said, and took a good mouthful and groaned with pleasure. "Truly your price is above rubies."

"That's a virtuous woman, as I recall, not a description I'd lay claim to. Cheers." She settled onto the other end of the couch, feet tucked under her. "What was Hizzoner the mayor up to today?"

Gutierrez took another sip. "I gotta say, Ed Riley stayed pretty cool under trying circumstances."

"Mmm. And the circumstances this time involve the anti-war protests?"

"What else? Incidentally…" He turned only his head and narrowed his black eyes to give her the gaze that caused even innocent people to think back carefully over past deeds. Son of a Mexican father and a New England mother, Vince Gutierrez had a stern, brown face that might have been carved from wood. "Why didn't you tell me about the discussion groups at the high school?"

"Knock it off, Gutierrez, or I'll cut off your gin supply. At the very least."

He grinned. "God, it does me good to come home. Okay, I should tell you that council member Bergman had heard that some 'liberal' teachers at Port Silva High School were encouraging innocent teenagers to involve themselves in illegal and antisocial activities. He asked for an explanation of this."

Meg merely raised her eyebrows and sipped her gin.

"So I assured him that teenagers were very good at finding antisocial activities all on their own. And that if he had specific examples of anything illegal, he should let us know down at the shop."

"Who got the most applause?"

"I did." He took a little mock-bow from his seat, and then shook his head. "But there was a good sprinkling of people on the other side in the audience."

"I'm sure. And I know that people have reason to be upset," Meg said. "A girl in my first-period class, a quiet, smart girl, was out with an anti-war group carrying one of the milder signs—she assured me—and got pushed around painfully by a pair of boys who objected to the protest. They broke her glasses."

Gutierrez hunched his shoulders and made a face. "I know. That kind of shit has happened half a dozen times. So far, no one has been seriously hurt, although there have been incidents of vandalism—making some merchants very edgy. We've geared up to increase foot patrols downtown."

"Well, for your information, Jim Jeffries and I were approached by some interested kids to monitor a few informal after-school sessions where they could talk openly about the current political situation." Gutierrez nodded: *And?*

"Jim teaches American history, knows a lot about the history of civil protest, and is an army vet who fought in the Gulf War. I am, or was, an experienced debater with some personal protest history. We both have good standing with the kids and we keep our personal opinions to ourselves. *And* we got Principal White's approval of the whole thing."

"Uh-huh," said Gutierrez. "Anyway, a woman in the audience tonight had heard it differently. She stood up to say that the high school was teaching kids nonviolent resistance, like lying down in the street or hooking arms together to form a human chain."

Meg snorted and stood up. "And she objected to that?"

"Well…"

"Not at the school, Vince. And not me, I should probably be ashamed to say, because some of our kids have already been to rallies in San Francisco. But I have heard that a couple of local citizens I won't name are providing instructions of that kind, as well as how to understand one's legal rights in such situations. Give me your glass."

He handed the empty glass over without a word, and she brought it back moments later, with her own, both refreshed.

"Thanks. Not cut off?"

"Not yet." She sat down beside him, leaning her shoulder against his. "Were any actions taken tonight by the council?"

"Oh, yeah. There was a request for a permit for an anti-war demonstration at the park next weekend. I don't like it, but I think it's legal and so does the city attorney. Freedom of speech in a publicly owned park. The mayor, however, says legal isn't the point, public safety is. The votes were five against including the mayor, two in favor, one abstention. So we've turned down the request—although minds may change."

"They wanted South Bluffs Park? Isn't that a tricky place for a, shall we say, potentially volatile event?"

"Yes, ma'am. We offered them the big baseball park out on Monterey Street. The response from the organizers—I bet you could have guessed this. Since we'd let all those religious people hold an event at South Bluffs last month, they were entitled to equal secular, or whatever, access."

"Good argument."

"You bet. We're going to work on crowd control reviews, just in case. Hey!" He straightened and cocked an ear. "I don't hear any music. And I didn't look in the garage or stop to say hi to Katy when I came in. Is she home?" Katy, Meg's almost-seventeen-year-old daughter, had a separate room, which she called her suite, beneath the main house.

"Yes, Daddy, she is. Katy's very good about her week-night curfew. So far," she added.

"Uh, Meg? Can I ask, do you know if Katy's taking part in the protests?"

"She is. It won't surprise you to hear that she's firmly opposed to our invading Iraq."

"Nope, no surprise. But I hope she's—careful. Maybe I should have a talk with her about that."

"Katy loves you, Vince. She's always willing to listen to you."

"That's probably another 'so far.' Okay, tomorrow will probably be a lot like today, only more so. Let's drink up." He turned to look at her. In her late forties, Meg was long and lean, her narrow, tight-skinned face lit by bright hazel eyes and framed by a mop of hard-to-control dark hair streaked liberally with gray. "I really like your hair," he said, reaching out to stroke it. "Don't do anything about the gray, okay?"

"*Moi?* Gutierrez, don't be silly. Come on, let's go to bed."

3

THE UPSTAIRS WINDOWS IN THE old/new house were all double-hung, and following the replacement of a few worn sash cords, in surprisingly good condition. Midmorning Friday, Verity finished a light sanding of the fourth window in the big bedroom on the west side of the house—definitely the master bedroom— and stepped back to view her work before wiping down window and frame with a tack cloth. Unless she picked up her pace, she wouldn't get around to any actual painting until tomorrow. Windows were time-consuming, fiddly work.

And the casement windows downstairs, with their six panes each, had been even more so. "But just think what it would have cost to pay someone else to do this." Proclaiming aloud this mantra of the frugal new homeowner, she collected herself and her gear and moved out and on to her next job-site, the first of the two smaller bedrooms.

"Oh, Daniel. I didn't realize you were ready to paint." Daniel Soto, barely recognizable in a painter's cap and a pair of goggles, set his trowel carefully in the paint tray on the ladder's shelf and pulled down the goggles before descending to the floor and turning to face her.

"I got an early start and the mending didn't take as long as I'd figured," he said, and then stood there in silence, waiting for her reply or more probably for her departure.

Verity refused to admit defeat here in her own house. "Well, what you're doing here looks very good. Is it a special technique, to get that kind of surface?" The ceiling here, as in most of the house, was lath and plaster, with many mended cracks. The section Daniel had already worked on had a slightly rough appearance.

"It's texturing, with joint compound, to cover the mended spots better. You paint over it." When she made no reply beyond an encouraging glance, he reddened slightly and went on. "I

learned about it on some other jobs, from talking to the painters, and I thought, nice rooms like these…"

He trailed into silence, as if expressing an opinion had drained his vocabulary. And Verity had other things to do. "Well, I'll let you get on with it, then. And I'll work in the other bedroom." She turned to head for the door.

"Uh, Ms. Mackellar?"

She turned, eyebrows raised.

"Tomorrow I can be here only for a few hours in the morning."

She very nearly asked why. "Thank you for telling me. I hope you're keeping track of your hours?"

"Yes, ma'am. I fill out a time sheet and give it to Val."

"Fine." She sailed out the door, caught the sound of movement downstairs, and looked down the staircase to see Harley Apodaca's familiar, cheerful face turned up in her direction.

"Harley. Good morning."

"Afternoon, almost," he said as she reached the entry hall. "I had a lab this morning, and it went on longer than I expected. Sorry."

"No problem. But I think I'm going to knock off for lunch." She set her bucket of gear down by the door and moved out onto the stoop, to stretch and breathe sun-warmed air unsullied by fine particles of wood or paint. Harley followed, and they spent a few minutes discussing his punch list.

"Daniel is in there preparing ceilings for painting," she told him when they'd finished. "So tell me, does he dislike women? Tall women with red hair? People of any sex who watch him work?"

"He's, um, I guess, shy?" Harley, handsome, bright, and kind but endearingly unimpressed with his own virtues, shrugged. "I don't know. Val says he's really good at whatever he does, and I know he works hard, but he doesn't talk much about anything but the job. Just a natural loner, I guess."

"Do you know where he comes from? Where his family is? I'd guess he can't be more than, oh, twenty-three, twenty-four."

Harley sighed. "Verity, I always figure if somebody wants you to know stuff like that, he'll tell you. And Danny doesn't. He'll make a remark about baseball now and then; from the CDs he plays, I know he likes country music and bluegrass. That's about

it. Except," he added as an afterthought, "I heard he's Gracie Beaubien's boyfriend, so he must be a really good guy. Probably we're back to shy."

"Grace Beaubien, the music teacher?"

"That's Gracie." Harley looked at his watch. "Hey, I better get to work."

"Right. I'll see you later this afternoon, Harley. I'm going with Patience to see a client." On her way back to the Mackellar cottage, Verity gave a moment's thought to one of life's enduring puzzles: what on earth did someone like talented, sweet-faced, cheerful little Grace Beaubien find to love in that silent, even sullen, man?

AFTER a quick lunch, Patience and Verity set off for an initial interview with Allie Flynn. With Verity at the wheel of the Subaru, Patience settled back in her seat and pulled a notebook from her bag. "I'm going to give you just a brief rundown on the Flynns; I have a feeling most of them will be there today. Once we're there, I'll do the talking and ask you to hang back and listen for nuances and undertones."

"Silent observer, my most difficult role. I'll try, Ma."

The Flynns' home, set well back from the high banks of the river with ranch outbuildings to the rear, was a tall old farmhouse to which pieces had been tacked on over the years; the outbuildings and corrals were not visible from the road. The thirty-something man who opened the front door as soon as their feet sounded on the wooden porch was tall, dark, and worried-looking; Tim Flynn, Verity figured, the son.

He smiled down at Patience, small and round with soft gray curls and an amiable, middle-aged face; he widened his eyes at Verity behind her, six feet tall in boots and jeans, her strawberry-blond hair in a single long braid.

"Good morning, Mr. Flynn," said Patience. "This is Verity Mackellar, my assistant."

"Come in, the family's here. You should know that nobody's really happy about hiring help, but we've decided to do it for Mother. She had a triple bypass four months ago."

In the high-ceilinged living room, he gestured Patience to a chair near a pillow-strewn couch, and Verity moved to stand

beside the fireplace, in a pool of shadow. "Everybody, this is Patience Smith, the investigator we hope to hire, and her assistant. Ms. Smith, I believe you know my mother, Allie Flynn." Probably sixty, Verity thought, gray-faced and propped in the corner of the couch as if not trusting her bones to support her.

"Hello, Allie," Patience said, moving to grasp the other woman's hand briefly before sitting down in the designated chair. "I'm sorry you've been ill. And Norah; how are you?" Norah Flynn, a second-grade teacher some years younger than her brother, had small bones, dark hair, and a gamine face unsuited to the troubled look it wore.

"I'm fine, thank you, and I'm *so* glad to see you. I hope you can help us."

Tim, who'd waited with ill-concealed impatience through these exchanges, now went on. "And my uncle, Dennis, and his son, Sean." Verity noted pale blue eyes in a leathery face, hunched bony shoulders, a cane hooked on the chair arm. The gangling, white-blond youth with the same blue eyes was, Patience had said, an off-and-on environmental studies major at Humboldt State University in Arcata.

"As some of you know," Patience said, "I've been a licensed investigator for more than twenty-five years, seven years here in Port Silva. I understand that Pete Flynn has been missing for two weeks...."

"Two and a half weeks," said Norah.

Patience pulled a notebook and pen from her bag and looked at Allie, who said, "Since October first."

"And you have heard nothing, and you believe he may be in trouble somewhere?"

Allie Flynn sighed tiredly. "It's a Flynn thing. They all do it. Pete was exhausted from taking care of me, and tired of the— pressure here. So he went off into the woods for a while."

"Pressure?"

Dennis snorted. "The son of a bitch is selling the family place here to developers who'll turn this ranch into a goddamn resort, with bridle trails and a fuckin' golf course. Probably ran off because he figured somebody was going to shoot him."

"Who?" asked Patience.

"Hell, maybe me."

"Uncle Dennis, don't." Norah, who'd been standing apart, now went to kneel next to her uncle's chair. "Besides, I bet Dad's just gone away to think. I bet he's going to change his mind."

"I don't think so." Allie Flynn's voice was soft. "The beef market is improving a bit, but we're just too old and tired to wait. The timber we have left is nearly inaccessible. If Pete and I want to keep eating, if there's to be anything left for you younger ones…"

"Patricularly that younger one," drawled Dennis, his eyes on Tim.

Tim grimaced. "I love this place as much anyone. I figured to make enough money in the City to keep it going—but you know where the economy went. So I helped Dad opt out of the agricultural land trust, and dealt with the Coastal Commission and the county, and I'm not ashamed of it."

"The potential buyers want this site, with the river and ocean views, and I don't remember exactly how many additional acres for stables and trails and such," said Allie. "We'll retain most of the land and Pete says they might even pay to move the house."

"Bullshit!" This from Sean, eyes narrowed and jaw hard.

"Don't you curse at my mother!" snapped Tim. "Besides, when've you ever put any work or money into the place?"

Dennis Flynn's cane slashed the air, Tim leaping clear as Sean and Norah pressed the older man back into his chair.

"Oh, stop it," said Allie wearily. "None of you would be acting like this if Pete were here."

"Meanwhile, if local eco-freaks get wind of his absence, they'll turn up with a whole new flood of petitions and lawyers and scare the commissioners into backing down," Tim advised.

"Where do you think Mr. Flynn has gone?" Patience's clear voice brought everyone to attention.

"The Trinities."

"Shelter Cove."

"The woods," said Allie. "Pete knows every backwoods inch of Mendocino and Humboldt counties."

Tim nodded. "Mom can give you names of some of the other woods-and-trails rats he's been buddies with, people he might have checked in with, or at least seen. Wherever he is, he might have let time get away from him, or maybe gotten hurt some-

where. If you could hire some assistants, people with off-road vehicles…"

Dennis caught Patience's look and shook his head. "We're not bustin' an axle or a leg looking for that bastard. Suits me fine if he never turns up." He struggled to his feet and picked up his cane. "Come on, Sean. Allie…" He gave her a long look. "Sorry. But I don't think you really want to move from here."

As the door closed on the pair, Patience looked up from her notebook. "I understand the problem, but I'm not sure why you need me to deal with it."

Tim straightened as if to speak, but Allie held up a thin hand to stop him. "Tim and Norah both have full-time jobs elsewhere and can't reasonably spare the time for this. And me…" She sighed, and gave a weary shrug. "I just don't have the physical or emotional energy. I really need my husband to come home."

Patience turned the page of her notebook. "In addition to his favorite retreats, I'll need that list of Mr. Flynn's close friends, as well as any business associates. I'll ask you to call your bank and credit card companies, to see whether there's been any action. Tim could give my assistant a look at Mr. Flynn's office, for some hint of his intentions you might have missed. And it's probably not necesssary in this case," she added, "but I like to have a recent photo of the person I'm searching for."

"I HAD a feeling this might be a family-feud thing," Patience said almost two hours later as Verity released the brake and sent the Subaru carefully down the rutted driveway. "And I ignored it, silly me."

"Right, pot-shots and undertones," said Verity. "What's the ownership breakdown?"

"Pete, Allie, and Dennis share equally in the land and buildings."

"So probably two of the three would have to agree to disposal of any of it."

"Very likely. So, the office?"

Verity pulled down the visor against the afternoon sun. "All the correspondence I found involved the cattle business, the timber business, or the Coastal Commission and the county planning people. Hard copy in folders, originals on his hard drive along

with a ton of other stuff. If he had a backup disk, I didn't find it.

"The stuff in the correspondence files got very sparse about four months ago," she added. "I asked Tim about it; he said his dad was totally wrapped up in taking care of his mother after her surgery and stopped doing much of anything else."

"Mmm. Maybe we can manage to have Harley take a look at the hard drive," said Patience. "Pete Flynn hasn't used any plastic since he disappeared, but he drew a thousand in cash from the bank two days before that. So he could be in some small place, spending lightly. In his dark green GMC pickup with matching shell."

"That'll be a bitch to spot out in the piney woods," muttered Verity. "Anyway, his bookshelves had lots of local history, and more books and brochures than you'd think existed on care and feeding of cattle, range control, timber practices. None of it looked new. Oh, there were some devotional pamphlets and newletters from Our Lady of Mercy. Apparently the Flynns are Catholic?"

"Allie isn't, nor the kids, I think. But Pete is. For that reason Allie is sure he wouldn't purposely do harm to himself. He does take blood pressure medication, something for high cholesterol, prescription pain relievers for arthritis, and she's not sure how much of those he might have with him."

"Ma, I'm not sure what we can do about this. He could be anywhere on that ranch."

"All eight thousand acres," said Patience.

"Right. Or anywhere in several very large, sparsely populated counties."

"Well, I know quite a few people out there. I'll make some calls. For the moment, any quick opinions about that crew?"

"I think Allie, the mom, wants to find Pete for personal reasons more than for action on the sale. She just wants him home. Tim is eager for the sale, I wouldn't venture an opinion about why. Brother Dennis is clearly an arrogant s.o.b, but he's got a soft spot for his sister-in-law, I think. The son is in training for s.o.b.-hood with no soft spot. Oh—not important, but I've seen him, Sean, a time or two among the protestors at the bridge. That shock of almost-white hair is easy to spot. And before you ask, he's on the anti-war side, aggressively so."

"Mmm. I'll need to find out more about Pete." Patience looked at her watch. "It's about time for Sylvie's bus. Or does she have a lesson this afternoon?"

"Uh, Friday. Yeah, she has chorus right after school, but she'll catch the late bus. There's aikido tomorrow morning, but she's staying overnight with Jess, and Ronnie will take both of them. I'll just have to pick her up."

"One of the nice things about raising a child in Berkeley was the availability of public transportation," Patience said.

4

"SYLVIE, JESSICA'S MOM WILL BE HERE any minute. Are you all packed?"

The tight expression around Sylvie's mouth was so brief that only an alert watcher would have caught it. Verity was indeed alert, but kept her own mouth shut to hold the words inside: Are you sure you want to go?

Sylvie ran a dishtowel carefully over the non-dishwasher-safe pottery bowl before putting it in the cupboard. "Yes. In my backpack. I'll go get it."

When a car horn sounded a polite tap-tap soon after that exchange, Sylvie pulled on her windbreaker, shouldered the pack, and bent to drop a kiss on Zak's head. "You all take care of Zak, please."

"We will. And I'll be there tomorrow to see your aikido class."

Sylvie departed after hugs all round. Verity waved at Ronnie Kjelland, and stood in the doorway until her Jeep had driven away.

"Well," she said as she shut the door. "I think she's coming along. But god*damn*, I wish we could get her to tell us what her asshole father said or did on that pre–Labor Day visit to make her so wary. We should never have let him take her home to Susanville."

Sylvie's father had without apparent complaint yielded both his wife and his daughter to another man before Sylvie turned five. Now that mother and stepfather were both dead, David Simonov chose to surface occasionally in his daughter's life, motivated by vague twinges of fatherliness, or more likely the hope that Sylvie's small inheritance from her mother might fall into his grasp. Sylvie's present home with the Mackellars was the result of lucky happenstance, and all three of them knew it was vulnerable to David Simonov's interference.

Patience resisted pointing this out anew. "I believe she was telling the truth when she said he hadn't hit her or touched her in

any sexual way. And the latter is not something she'd have misinterpreted; the sexual abuse awareness program the police present at her school is very straightforward."

"So were her mother's instructions, and ours. And Sylvie doesn't lie. But she will evade, or clam up." Verity grimaced as she began to slide scraped dinner plates into the dishwasher. "One of these days we're going to have to…" The telephone rang, and she closed the door of the machine and went to pick up the handset. She said, "Hello?", cocked her head to listen, and promptly disappeared into the hallway, and then, from the *snick* of a closing door, into one of the bedrooms.

Patience, still sitting at the kitchen table with a half-full wineglass, considered getting up and filling it. After many months as Verity's regular—and, so far as Patience knew, only—male companion in bed and out, Detective Johnny Hebert had been called to Chicago to deal with his ailing seventy-year-old father. That was in mid-July, and while Verity had clearly missed him at first, she'd appeared to recover quickly as time went on. So far as Patience could tell, which wasn't really very far. She decided to have more wine after all.

Some minutes later Verity returned, and replaced the phone. "That was Johnny. He just got back to town, and as soon as he's unloaded his car and had a shower, he's coming over."

"There's plenty of pork stew left," Patience told her.

"No, he's had supper. But we probably won't go anywhere, just sit out on the deck for a glass of wine."

"That sounds…pleasant."

Verity turned to inspect her mother's face, and laughed. "Mom, you don't get points as a non-meddling mother when it's obvious to anyone watching that you're biting your tongue."

"Half credit, maybe?"

"Fair enough. When Johnny realized that his father's condition meant he'd have to ask for a leave, I decided it might be a good thing. I thought it was possible that we'd been too much involved with each other too soon, and would benefit from some breathing space."

"And how did Johnny feel about that?"

"He, um, didn't see the situation quite the way I did. But he agreed that we'd keep contact to a minimum until he got back."

Patience, who had known Johnny Hebert longer than Verity had, was sure his nearly inexhausible good humor had been sorely challenged by this arrangement. She had a sip of by-now-warm wine. "Has his father recovered?"

"He has adjusted, as well as he's likely to, to his hip replacement, and Johnny got him moved into an apartment complex for Jewish seniors. What he said—to me and apparently to his father—was that the only reason he'd ever return to Chicago was to arrange for the funeral."

"Good heavens. It seems even Johnny's patience has its limits."

"Is that a warning to me, Ma?" Verity's voice had a hint of sharpness.

"I didn't like the man you married, Verity. I do like Johnny. And while you've been old enough for some time to ignore your mother's opinions, I'm too old to feel I have to keep them to myself."

After a moment, her daughter grinned. "Touché, Ma. Anyway, I'm going down to the studio to clean up a bit before he gets here."

VERITY had just finished drying her hair when she heard a car drive into the yard. She draped a sweater over her shoulders, turned the lamp on the piano to low, and stepped outside.

Detective John Hebert, who topped Verity's nearly six feet by about five inches, was just uncoiling from his car. Under the motion-sensor yard lights his curly black hair gleamed with dampness, his short black beard looked freshly trimmed, his eyes were impossibly blue. And her sensible intentions were proving about as sturdy as her now-weakening knees. *Oh you beautiful man, I could eat you all up in tiny little bites.*

His eyes widened, and for a moment she was afraid she'd spoken aloud. *Just what I really do not need, a man who can read my mind,* she thought ruefully as he bounded across the yard to swoop her up in a hug, his beard soft against her cheek. "Lady, you look good. You *smell* good."

"You *feel* good," she told him. When he'd set her on her feet, she shook her hair back and took his hand. "Before we get too deeply into booze and conversation, would you like to come for

a look at what's been accomplished with my house? It's pretty impressive."

"What I'd really like right now is a glass of wine and a chance to stretch out in something a lot more spacious than an airlines seat. Then you can just tell me all about it, and I'll wait until maybe tomorrow to see for myself."

This section of Raccoon Lake Road was almost a mile east of the highway, just out of the fog belt. Not that there was fog tonight, but the air here was milder than it would be right at the coast, and there was no wind. Johnny stepped into the living room to say hello to Patience and to Zak, always quick to inspect any visitor, and to inquire after Sylvie. Then he went through the kitchen to the redwood deck behind the house and settled with a sigh of pleasure into one of two cushioned wooden lounges, while Verity opened a bottle of zinfandel and collected a pair of glasses.

"Stay where you are, I'll pour," she said, nudging the door shut with an elbow. "Have you really finished straightening out your father's life?"

"God, I hope so!" he said, and took the glass she handed him. "The apartment complex he finally settled on—number seven on the list, I think it was—has a dining hall, recreation rooms, medical care on site, shuttle buses to take the residents wherever. He's connected with some other old Jewish guys who go in for killer bridge games. And there's an assisted living facility right next door that's part of the same corporation." He had a sip of wine. "Good stuff. Thank you," he said and had another sip.

Verity pulled the second chaise closer and stretched out on it with her own glass. "Well, I'm sure he's grateful for all your help."

"Gratitude didn't enter into it, Verity. He considered it a debt owed. And I consider it a debt paid, in full. Fortunately, he has enough money to keep him in that place, or others like it, as long as he lasts. And he now has an attorney who will handle all his affairs."

"Johnny. I'm sorry." She touched his shoulder briefly.

"No, don't be sorry. I had a wonderful mother," he said, and lifted his glass in a gesture of thanks. "And her brothers were like two fathers to me. Two loving fathers."

"Your Uncle Max, in Lewiston. With his dogs. A contented man."

"That's right, you've met him. Yes, he is. And Uncle John— I'm named for him—is a building contractor in S.L.O. Residential, mostly, fine stuff. He's a guy who loves his work."

"And you, are you eager to get back to work? On that safe-coast stuff you were working on when you left?"

"So far as I've heard, that's mostly done," he said. "For the small north-coast communities, anyway. The mayors met in Eureka, and Rich Montez was the representative from PSPD. I think the south and central coast had similar conclaves."

"Who's going to be in charge of implementing whatever they decided?"

"Good question. Everybody's pretty sure that there'll be a special federal department for national protection set up eventually, in spite of the fact that the president seems to be resisting that so far."

An alarming possibility brought Verity nearly upright. "Johnny, are you thinking of joining the feds?"

"No! N-o! Not! Lady, I love my country, or try to; but if I didn't figure it would cost me a job I like, I'd be out there at the bridge with the anti-war folks carrying a big rude sign.

"But there's small chance of that," he added. "Chief Gutierrez made it clear, when he called me in Chicago, that my leave was up and he wanted me back here at work ASAP. Which suited me just fine." He finished the wine in his glass and sat up straight to reach for the bottle, but Verity beat him to it.

"I think you've been working harder than I have recently," she told him, and filled his glass and then her own. "Or at least, my work has been more pleasant. Is Chief Gutierrez seriously worried about the protests? I haven't paid a lot of attention, but it's obvious to anyone just driving around town that the numbers are growing."

He nodded. "Alma's been keeping me posted on local stuff, and she says one reason for the steady increase is that we've caught the attention of a lot of college kids and old lefties from the Bay Area who haven't had a righteous cause in a while."

"Alma Linhares?" Verity regretted the question the moment she'd asked it.

"Yeah, we talked a couple times a week. She says they've been beefing up patrol force recently, and shifting bodies around each

watch to put them where trouble's anticipated. Also reviewing crowd control techniques."

"Aren't most of the protestors pacifists? You'd think they'd be safe to have around."

"And you grew up in Berkeley?"

"Don't be snide, Detective. I carried a few signs in my idealistic youth, and I think 'preventive' or 'preemptive' war is a very bad idea; but I don't believe protest, peaceful or otherwise, will stop this one. Presently I'm in a 'we must cultivate our garden' phase."

"I'm sorry," he said, and let it go at that. "A good many of our protestors are not simon-pure pacifists, just people deeply opposed to a war with Iraq. The general feeling in the department is that some of them are so angry that they'd about as soon crack heads as wave placards.

"Meanwhile, on the other side are plenty of locals who believe Iraq is the logical next step, and families with members in the military, some of them already in Afghanistan. Most of these people are *really* not happy about attitudes that look critical of their boys or our leaders. It's potentially a bloody mess."

"Patience went to the memorial," Verity told him, "and she said it was peaceful but uneasy."

"A few yahoos got picked up afterwards, I understand. But they were a more specific bunch—from well-known local clans like the Dickersons or Markoviches."

"Hah," said Verity. "The local crime families, you mean."

"Probably 'crime family' is a bit high-toned," he said with a shrug. "I'd call them none-too-bright guys—and gals—who see law-abiding folks as impediments to free enterprise and always enjoy a good brawl. Anyway, with all our shifting of patrols to watch the protestors, people in the outlying areas are beginning to complain that they're getting no protection at all against ordinary criminals."

"Oh, my." Verity looked around at their big expanse of yard in an area that was definitely outlying. "I guess we should make a point of locking our gates. And leaving Zak out at night."

"I don't believe things are that bad. If they get that way, I'd suggest locking the gate, but keeping that big, tough dog inside with you. Along with your cell phone. Or maybe a big, tough cop."

"I'll keep that in mind."

"Good." He drained his glass and then lifted his left wrist to catch the light on his watch. "If you'll excuse me, I'd better call in before I have anything more to drink. Just to make sure I'm not needed tonight after all. My cell phone's in the car."

He came back up the deck stairs a short time later at an un-hurried pace and ambled across to where Verity still sat, to pick up the wine bottle and examine its level. "There's maybe a glass left. Split it with you?"

"I'm good," she said, showing him her half-full glass. "You go ahead. I gather you're not needed on the lines tonight?"

"Nope. It's a quiet night so far and seems likely to stay that way, so I'm off the hook until tomorrow morning." He poured the rest of the wine into his glass and settled back on his lounge, eas-ing the back to a lower tilt. "Figueiredo's on the desk tonight and asked me to say 'hey' to you."

"Did he."

"He did." Verity could feel him keeping his gaze resolutely on the sky.

"Dave found himself between girlfriends and started hitting on me, fairly politely. I'm surprised Alma didn't tell you about that."

"Verity, I didn't talk to Alma about you."

"Oh, good. Anyway, I made it clear, in a friendly way, that I wasn't interested, but he persisted. Then one night at The Spot he suggested a game of darts for the next round of drinks, and I said, why not?"

Johnny sputtered on a mouthful of wine. "Verity Mackellar, you're an evil woman," he said when he could speak. "Poor Dave."

"Well, he brought it on himself."

"Poor guy," he said again, and lay back in the lounge to gaze up at a sky showing more stars than usual this close to the coast. "Nice night."

It might be, indeed. "True. Enjoy it and let me tell you about the house." Verity pulled her sweater a bit closer, settled back against the lounge cushions, and gave him a lengthy progress report.

"So," she said after some fifteen minutes, "tomorrow Charlie Garcia will start work on the WC in what I'm grandiosely calling

the master bedroom. Monday, the tile guys are coming to do the kitchen counters. And I've decided to save some money and get some exercise by doing the interior painting myself, with help from Daniel Soto and Harley."

"Hey, count me in! I'm pretty good with a paint roller," he told her. "Are you having fun with this, Verity? As much as with your San Francisco house?"

"Oh, more. The San Francisco house wouldn't have been my choice; Aaron Blake, Ted's father, bought it for us as a wedding present. Whatever it needed we hired done; I was working a sixty-hour week at the time and had no time for stuff like painting walls.

"But I love this house. And I think this is a much nicer neighborhood." She lifted her glass in salute, and the wine shone richly red in the light from the small bulb over the kitchen door. "And a dandy bonus here, in the good weather we've been having, was getting to ogle the gorgeous half-naked guys sawing and hammering and carrying heavy stuff around."

Johnny snorted.

"I mean, there were a couple of prime, seriously tanned specimens on the roofing team, although they were a tad far away for real appreciation. A girl could hardly ask for a better example of a fine male body than Harley Apodaca's, as I told him to his embarrassment. Val is lean but with really nice muscle definition. And the other regular guy, Daniel Soto, is classic." Verity considered her wineglass for another moment, before sipping. "But he's not very friendly, or maybe just shy. So I tried not to be too obviously admiring."

"I've met the guy several times, but haven't ever worked with him," said Johnny, who did a little construction moonlighting himself, most often with Val Kuisma. "But Val says Soto's smart and knows a lot about construction. He's been around town for a couple of years, I think, and Val says he'd like to get into the fine woodworking program at College of the Redwoods."

"Good luck to him. The competition there is pretty stiff."

"I wish him well, but at the moment, it's not a problem that interests me much. I'm just glad to be back, right here." He reached over and took her hand.

"I'm glad to have you back."

They sat for a while with hands linked and listened to night noises: small scrabbling sounds in the hedges, a whisper of leaves as a breeze freshened, engine noises and the occasional squeal of tires from the highway.

The air had grown cooler, Verity noticed, chilling her through the light sweater she had over her shoulders. More noticeable was the fact that here in the dark sat two extremely articulate grown-up people who might as well have been tongue-tied adolescents.

"It's getting cold," she said, trying to contain the giggle rising in her throat.

"Oh. Is it?"

"Take my word for it. Of course, we could push these lounges together and cuddle up for warmth. Or we could just go inside and go to bed."

Johnny was on his feet in a flash, taking her hand to pull her up and wrap an arm around her. "What a fine idea. Let's go."

5

VERITY THREW THE COMFORTER OFF, swung her legs over the edge of the bed, and sat up. And dived right back in and pulled the comforter up over her ears. They'd left the studio windows open, and during the night Indian summer had departed and the November she'd sensed on Thursday had arrived early.

Not that she'd have noticed the change as it occurred, because in the confines of a double bed, Johnny Hebert was a heat source to rival a cast-iron stove. Now, disturbed by her movement or the brief touch of cold air, he muttered something and reached for her. She rolled over to stretch out against him, registered belatedly the clockface she'd seen when she sat up, aimed a quick kiss that landed between cheek and beard, and slid away and out of the bed, turning to tuck the comforter tight.

"Sorry, lover, not now. It's almost seven o'clock and I need to go unlock the house."

"House," he croaked, lifting his head to see her scrambling into clothes.

"My house. Charlie Garcia is coming this morning, and he's an early kind of guy." She pulled a sweatshirt over her head, shoved her feet into sneakers. "You stay there, I can handle it."

"Right." As the door closed after her, Johnny lurched to his feet and headed for the bathroom. He dressed quickly, paused to shut the studio windows, and followed footprints across the damp gravel and grass to the gate. Dew-damp, he noted; no rain yet, probably none likely for some time. But the sky was gray, there was surely fog at the coast, and the wind was picking up.

The white utility-body pickup truck with GARCIA PLUMBING painted on its door was parked with its rear toward the front stoop of the house, where Verity stood talking with Charlie Garcia, a short, solidly built man in his late forties with thick, gray-streaked black hair and a cheerful face.

"Hey, Charlie."

"Hey, Big John. Glad you're here; you can help me muscle this stuff inside and up the stairs. I was sort of counting on Harley."

"Harley doesn't do mornings well," Verity told him as she unlocked the door. "Give him another hour. And the other guy working for Val, Daniel Soto, wasn't sure he'd be able to come to work today."

"Well, it'll take me a while to get the pipes in through that old oak floor. The rest Harley and I can manage," said Charlie. "Once I get the stuff upstairs."

"YOU'VE made real progress in there," said Johnny ten minutes later as they left Charlie to exercise his professional skills. "Sorry I wasn't here to help."

"Don't worry, there's still plenty to do."

"I'm surprised Val hasn't arrived," Johnny said as he held the gate open. "Saturdays are his best work days."

"Oh, that's right; you're not up on all the local news." Verity stepped through, and he followed.

"True. So what is it?"

"Charlotte's pregnant again," she told him, "and it turns out she's always deathly sick for the first three months. So while they need the money from Val's extra work, Alice needs more Daddy than usual. He'll get here when he can." Alice was Charlotte Birdsong and Val Kuisma's four-year-old daughter, bright and full of zip and likely to make innovative use of any unsupervised time.

"Well, I don't have to be at work till eight. We could go back to bed."

"Not if you want breakfast." She tossed a glance at him. "Never mind. *I* want breakfast. And I promised to be at Sylvie's aikido class at ten."

"YES, I thought you did very well," Verity told Sylvie as they headed from the aikido studio to the car. Better than one-year-older Jessica, she added to herself. Sylvie, for all her gangling height, had good control of her body as well as a steely will and phenomenal powers of concentration. "Do you enjoy the class?"

"So far I do," Sylvie said after a moment's thought. "I think it'll be useful."

"Very possibly. For self-defense," Verity added.

"You mean I'm not supposed to go beat people up?" Verity turned to look at her and caught the glint in the dark eyes. She might as well have said, "Duh."

"Right. Okay, here's the car."

"Verity, did you know about the march today?" Sylvie asked as she belted herself in.

"March?"

"To protest against going to war in Iraq. We talked about that in school. Anyway," she went on, "Jess says her father is going to be in it, and her grandmother will be really mad at him."

"Maybe Margaret will protest on the other side," said Verity as she kept careful eyes on traffic that struck her as unusually heavy for a Saturday morning.

"Other side?"

Oh, joy, thought Verity. "Sylvie, there's always another side. Didn't your teachers mention that?"

"Uh, I don't think so. So that would be *for* going to war and killing people?"

"Well…"

"Are you on that side?"

"I…no. But you have to respect other people's opinions."

"Even when they're wrong?"

"Actually, yes. Or I guess what I mean is, they have a right to be wrong."

"Verity, that's silly."

What was silly, Verity noted, was diving unprepared into this kind of discussion with an incisively logical nine-year-old. "Sylvie, that's rude."

"Well, okay, I'm sorry. But I really think it sounds kind of dumb."

"The point is," said Verity, "you can't always be sure there's a right side and a wrong side."

"Then how do you ever *do* anything?"

"Very carefully. What would you like me to get for dinner?" Whatever it was, they wouldn't get it at Safeway, she thought as they drove past. The parking lot was jammed and people were milling about near the broad entry area.

"Could we go out for fish and chips, maybe?" The narrow, olive-skinned face suddenly belonged to an eager child rather than a potential prosecutor.

"Why not? Johnny got back last night, maybe he'll go with us."

"Goody!"

At home they found a note from Patience saying that she was gone for the day. "Work at the office, errands—expect me when you see me."

"You may as well fix yourself lunch," Verity told Sylvie. "And you should take Zak for a walk; better do that before the weather gets worse. I'm going to the new house to work for a couple of hours. If you need me, or if anyone calls, come and get me."

AT her office downtown, Patience read through the list of the missing Pete Flynn's friends and acquaintances and decided to begin her calls with a few names of her own. She knew two deputies in Humboldt County, and found that the second of them knew Pete, although he hadn't heard of his disappearance. When Patience explained the family's worry, he agreed to have a look at the campgrounds and fishing spots Pete had frequented in the past, particularly on the Lost Coast. "But if I do spot him," he told her, "I think I should just tell him they're real worried and ask him to call. To do so or not would be his decision."

Mendocino County was a bit easier; the first deputy she managed to connect with knew Pete well, as did several of his fellow officers. He also knew Allie Flynn, and thought she was entitled to know where her husband was.

Then on to Pete's friends and acquaintances. The first person on the list answered the phone with a barked "Yeah?" and broke in on her explanation before she'd finished. "Listen, Pete Flynn and I've been friends since grade school, and if Pete's took off for the woods it's sure as hell just to get a break from that wife of his."

The phone was set down with a bang, and Patience took a moment to consider this new view of Allie Flynn, who had struck her both three years earlier and recently as a pleasant, if worried, woman.

Her call to number-two friend reached an answering machine. She considered leaving a message, and decided that to do so would be indiscreet and possibly counterproductive. And on to friend number three, who was pleasant, really wished he could be helpful but didn't know anything; the whole rather lengthy conversation smacked of evasion. Mr. Hughes, Patience decided as she hung up the phone, would bear further pursuit.

But not today. Weary of sitting, she rolled her desk chair back and got up, pausing to wrap up the scraps of the lunch she'd picked up on her way into town some hours earlier. Outside, where the breeze had turned to chill gusts and the sky was now a lowering, heavy gray, she carried her garbage to the curbside trash can and was surprised to note much more traffic than usual at the nearby intersection, apparently headed for Main Street.

Traffic flow had seemed heavy as she drove in earlier, too, more people than usual out and about on a chilly, ordinary Saturday. Something was up downtown, maybe connected with conflicts between anti-war folk and others, maybe not; in either case, it might be interesting to go have a look.

She turned to go back inside and nearly bumped into Marilyn Ritter, who ran a word processing and editing service in the office next door. "Oops. Marilyn, where are you off to in such a hurry?"

Marilyn came to a screeching halt and swung around, straight white hair flaring out around her head. "I'm off to the march. Wanna come?"

"What march?"

"Patience, how do you stay so far out of the loop? There's a 'No War in Iraq' slow march from town to South Bluffs Park for a demonstration. I'm walking with Grannies Against War, and you should, too."

"Um, was this authorized?"

"Only by the U.S. Constitution, dear. So? Or would it bother you to call yourself a granny?"

"Of course not," said Patience, too quickly; Marilyn caught the implication, and grinned. "You and I will be be younger than some of the other ladies, it's true. But the good thing about being grannies is that nobody will expect us to do stuff like, oh, getting naked and spelling 'Peace' with our bodies."

"That's a *very* good thing. Okay, I'll join you. I have a warm jacket and a pair of good walking shoes in my car."

"You'll need a flashlight, too. We're carrying those instead of candles."

VERITY had spent several contented hours putting a good coat of white semi-gloss on window frames, pausing often to look in on Charlie and Harley. They had managed to get the overhead toilet

tank into place high on the wall and were working on the toilet itself. The little corner sink, Charlie told her, would be easier. Daniel had finished the ceiling texturing before leaving, and downstairs, Val Kuisma was at work in the kitchen, the sounds of Springsteen and Steve Earle and what sounded like Alison Krauss and Union Station filtering through the house from his boom box.

Some time after four o'clock she heard a cell phone ring and reached for the one on her belt, but found it silent; the sound came from downstairs. A few moments later Val appeared in the doorway. "Verity, the chief just called and I gotta go. More than the usual number of anti-war people are downtown, placards and all, and it looks like something might be building. If it's okay, I'll just leave my tools here and ask you to be sure to lock up when you leave."

Hadn't Sylvie said something this morning about a march? "Of course. Take care, Val."

As he turned to go back down the stairs, her phone did ring; and when she answered, she was not surprised to hear Johnny's voice. "Verity, it looks like I'll be on duty this evening. From right now, in fact."

"I heard about the anti-war gathering. Val just got a call."

"Yeah, we're bringing everybody in. The city council had refused to issue a permit for a demonstration at South Bluffs Park and we thought that was the end of the matter, so this took us by surprise."

"*Some* people knew. Sylvie mentioned it this morning."

"Only the right people, apparently; one of the blessings of the Internet. Anyway, there are now hundreds of people marching silently south toward the bridge and presumably the park, and the numbers grow by the minute."

"What are you going to do, arrest hundreds of people?"

"Not to give away department plans, but I'd guess we'll follow along, supervise, and take out any obvious troublemakers."

"Sounds sensible to me," she told him. "Take care, and call me when you can. I'll be at home."

"Good place to be. See you later."

VERITY hadn't bothered to tape the windows, counting on her own steady hand to avoid smearing the panes; but as she returned

to work now, she found her concentration slipping, along with the small brush she was using.

The weather was probably the cause, not only the gray, low-bellied clouds but the wind, gusts of it slapping at the house and bouncing an empty bucket across the yard, tugging at a loose corner of the tarp covering a stack of lumber and working to pull it away entirely. She peered at the clouds again, thought she could smell the threat of rain, and wondered at her own foolishness in putting fresh paint on windows she'd have to close before long.

"Hey, Verity?"

"Shit," she said under her breath as her painting hand slipped again. "Sorry, Harley. What's up?"

"Charlie says we're through with the bathroom. He's packing up to leave, and I thought…is it okay if I go, too? I've sort of got a date."

She turned to inspect him. His shorts and T-shirt, his hands and arms, and even his face wore smears of grease, and she could tell from clear across the room that the damp cling of the T-shirt came not just from water but from plenty of sweat.

"Go on home, Harley. You need a shower, maybe two showers. And thanks."

"Sure. It was interesting, working with Charlie. I learned a lot."

"That's good, Harley. Once, when I asked a friend why she was dumping her boyfriend, she said, 'What's the good of having a man around the house if he can't fix a toilet?' So you'll be safe on that score."

He grinned broadly, waved, and departed. Verity looked out at the weather again, and decided to do the same. Her brief bite of lunch was ancient history, her back was tired, and Harley was not the only person around here who could be smelled from across the room.

Only her Subaru was in the parking area at the cottage; where on earth was Patience? She hurried inside, to find Sylvie curled up on the couch with a book. "Has Patience called?" she asked.

"No, and I was wondering where she is."

"Working, probably. It's getting cold; I think I'll build us a little fire. Meanwhile, there's apparently an anti-war march going on in town. Let's see if our local TV channel is on this."

Port Silva's small television channel, devoted to local news, city council meetings, high school athletic and dramatic events, and cooking shows, was indeed on the air. Tonight the local broadcasters were breathless with importance as the cameras moved along Main Street, past the road leading down to the wharfs and the marina, and on to the north end of the Pomo River bridge itself, where cars inched their way between lines of people heading south on both sidewalks. They were moving steadily and purposefully, mostly two abreast, she noted, and every now and then she spotted a person with a bright orange armband—a monitor?—chivvying the marchers along like a careful sheepdog under the watchful eyes of quite a few uniformed cops.

"Holy shit," said Verity.

The television screen now showed a shot of the bridge from south and east, a steady flow of people with signs carried high in what was clearly a battle with the increasing wind.

Sylvie set her book down and got to her feet for a look. "Wow, look at that! How're we going to get to Cap'n Jack's, Verity?"

"I don't think —"

"Can we go early, like now? All those people, that looks really fun."

Verity, who'd been watching the scene as if it were a movie, focused more narrowly and saw a group of older women pass along the bridge, some of them in wind-whipped skirts struggling to keep their signs up and their skirts down. The camera came closer, and she read: GRANNIES AGAINST WAR. Not Jess's grandmother's group, she was pretty sure. In the forecourt of a gas station beside the wharf road, five teenagers with guitars and flutes had found something to stand on that raised them above the flowing-past crowd and were having a good time, wind or no. Maybe, she thought, playing "Where Have All the Flowers Gone?" a song right in the grannies' time-frame.

"Sylvie, this would be a bad time to go down to the wharf. Fish and chips will have to wait for another time."

"But you said…" Sylvie looked from the television set to Verity's face, and closed her mouth.

"We'll make pizza," Verity told her. "I'll mix up the dough now, and you can knead it."

"Verity!" Sylvie pointed at the TV. "Look! There's Patience!"

"It can't be." But it was. For a brief moment, her mother's small figure, bundled in her padded jacket, was unmistakeable. She carried a placard against one shoulder and walked with slow purpose beside a taller, white-haired woman: Marilyn. Then the camera shifted to other walkers, other views.

"Verity, let's go down there!"

"Oh, sweetie, I don't think so. Let's just sit here and keep our fingers crossed."

PATIENCE had found something quietly exciting in the slow, determined progress of the walkers. As instructed by the organizers, they didn't talk to each other beyond the occasional passed warning about obstacles, and they didn't respond by word or glance to bystanders shouting comments. Grannies Against War walked as a group, many of them wearing long skirts and two helped along by canes. Beyond that, there were people of all ages, even some children Sylvie's age or younger and a couple of little kids riding their fathers' shoulders.

Once in the park, marchers became people trying to find space for themselves and make space for those coming after them. Patience, quickly reminded of how much she disliked being a short person in a crowd, stood as tall as she could and looked for familiar faces. Within her range were Katy Halloran, Sylvie's sometime baby-sitter; a couple of the younger Silveiras; Mayor Riley's big, handsome son, and Daniel Soto, from the crew at Verity's house, both of them orange-banded monitors; Sean Flynn, apparently accompanying Soto but without the armband; Larry Klein, her own sometime client and attorney; many local-citizen acquaintances, some she was suprised to see here: who knew?

Blue uniforms ranged along the edges of the crowd, watching, addressing comments to collar mikes. She saw Val Kuisma grip the arm of a large, clearly angry man and yank him away from the crowd. Dave Figueiredo, Brad Coates, a sergeant whose name she didn't recall now patrolled the north edge—her edge—of the mass of people like guard dogs on the watch for wolves. There was no stage on the edge of the bluff for this event, as there had been for the memorial, but barricades resembling chunks of wooden fencing had been erected there.

"Oh, look," said Marilyn. "I didn't know Port Silva had mounted police."

"I'd guess that we have some policeman who own horses, and it occurred to Chief Gutierrez to use them. They can be quite useful in crowd control."

As the crowd continued to grow, Rev Bob, who ran a downtown homeless shelter for teenagers, apparently found a bench or something to stand on and roared a welcome. He was greeted with shouts, clapping, whistles. "Make room, friends, for your brothers and sisters. Let's all here be witnesses for peace." He stepped down, and the music began, not live music but a sound system blasting out something very familiar to Patience and her little tribe here. "My God," said Marilyn as 'Blowin' in the Wind' joined the very real wind buffeting the park. "Has early Bob Dylan been rediscovered?"

Suddenly a pair of young men pushed into the group of cheering older women and began snatching their signs. "Stop that!" snapped Patience, and grabbed the arm of the smaller man as he ran past her. Two other women moved to block his path. Patience twisted that arm high against his back, taking a glancing blow from his elbow in the process, and he gave a yelp of pain as the three of them forced him to the ground.

"Okay, I'll take him," said Sergeant—Dunnegan, that was his name. "You ladies did good work. Ma'am," he said to Patience as she got to her feet, "I think you're gonna have a shiner. There's a first-aid station down by the entrance if you want it looked at."

NO one noticed her drive into the yard at home, but when she walked in the front door, the two TV-watchers leapt to their feet.

"Mother!" said Verity, coming to give her a quick hug.

"Patience, you were on TV! We saw you!" said Sylvie.

"I was out doing my civic duty," she told them, pulling off her coat. "Which I have to admit was not all that onerous; people were mostly good-tempered, and the monitors knew their jobs."

"Right, that's how you got punched in the eye. Here, let me take your coat," Verity said, and did. "Pizza just went into the oven. Would you like a glass of wine?"

Patience put careful fingers to her face. "You should see the other guy. I think I'd prefer a touch of The Macallan."

The three of them settled in the living room, where Patience found it disconcerting to be viewing a scene she'd been part of not long before. It was nearly full dark now, but the streets and the bridge were well lighted, and the two high banks of lights at either side of the park cast a dimmer glow over the crowd itself. A few brave food vendors with trays moved along the outskirts of the crowd—selling hot coffee, Patience hoped. In what was obviously becoming a brutal wind, people who weren't bundled up were huddling together.

"Ah, the protestors are holding flashlights instead of candles. Very smart of them, and pretty," said Verity as she went to check on the pizza. While she was in the kitchen the telephone rang, and she picked it up.

"Oh, good. You're home, and warm."

"And while you're out there freezing, we're watching on television. Johnny, how do things look in person?"

"Hank says the crowd is at least as large as the one for the memorial. So far it's cool, because it's cold. The anti-war folks are listening to speeches, and to a couple of bands, and clapping along. Other folks who showed up are staying to the sides glaring and catcalling, and we've been able to put out little personal flareups before they spread."

"My mother was there for a while, but she got home safely except for an incipient black eye."

"I heard about that. Tell her to have a drink for me. I was hoping I'd see *you* tonight, but there's no telling what time I'll get away. Maybe tomorrow."

By common consent, they ate in the living room. At Patience's insistence, they turned the television's sound off, which reduced the scenes on the screen to the equivalent of a silent movie with a cast of thousands, actors all. At nine o'clock, pizza finished and dishes cleared away, Sylvie went off more or less willingly to bed. Verity poured more red wine for herself and her mother, put another small log on the fire, and pulled an ottoman over to the couch so she could stretch out.

"Look, the rain has started. And it's going to be nasty, with that wind behind it. People will turn into human icicles if they stay there much longer." In fact, there was a steady stream of hunched-up, chilly-looking figures departing the park and head-

ing mostly toward the bridge, few placards showing now. Probably got blown away or washed blank. Verity sipped wine and let the TV screen, out there beyond her toes, become meaningless movement behind glass.

"I should get to bed myself before long. There's a lot to do at the house tomorrow."

"Maybe I can help tomorrow. Verity," said Patience, a sharper note in her voice, "do you have the remote? Turn on the sound."

"...most of the crowd gone, but there's maybe a couple hundred or... Shit, they're really mixing it up!" And a different voice, high, "Wow! Stay tuned, folks, we've got a fuckin' *war* here. Oops." The sound was abruptly cut off, but it was clear that the miniature-from-here people still on the bluff had abandoned any effort at peaceful demonstration.

"Goddamn!" Verity pulled herself upright and leaned forward. "Where the hell are our guys? Well, there, and there, I guess," she added, watching uniformed men with batons or just long, reaching arms trying to pull combatants apart, trying to protect noncombatants.

"Oh, dear," said Patience. "I hope the other grannies were already on their way home." The rain was obviously heavier now, blown in shifting curtains by gusts of wind from north and west, obscuring one part of the mob and then another. "Look! They're getting close to the barricades!"

The fighting was swirling from small group to small group, police indistinguishable from civilians except for a couple of mounted cops successfully herding people back toward the road. "I can't see who's who!" Verity's voice was a wail as she sprang to her feet and moved closer to the set. She saw an enormous blue-uniformed man—Bo Jackson, the giant of the Port Silva force—methodically seizing people and tossing them along in the direction of the road; others were fleeing in various directions on their own while a handful of determined battlers... "Oh, shit!"

There was a *crack* that sounded like a shot, and one section of barricade fell before the onslaught of two or maybe three struggling men who disappeared over the edge of the bluff into the storming sea.

6

VERITY RELEASED HELD-IN BREATH. "I don't know who those guys were, but they're goners."

"I'm afraid so."

A burst of wind and wind-driven rain hit the house like a giant fist, rattling windows and the small Japanese cups on a wall-hung display shelf. As the two women stared at each other, another, bigger gust sent something outside crashing—furniture on the deck, probably—and roared down the chimney as well, driving ashes and live sparks through the fire screen onto the hearth rug. And with a third, the television set went black and all the lights went out.

"Well *there's* a perfect end to a really bad evening," said Verity. "My *God*, it's dark! You stay where you are, Ma, I'll get the flashlight." She headed for the kitchen, guiding herself by an outstretched hand on familiar edges, and reached the counter and—one, two, three down—the tool drawer. Put a hand inside, found the barrel of the small flashlight, pulled it out and turned it on and said, "Ooo-kay, here we—"

A chilling shriek split the darkness, and Verity dropped the flashlight and bumped her head diving to retrieve it. Another shriek, and then a keening wail: "No, no, noooo!" and Verity got herself upright with the light and ran along its path to Sylvie's bedroom. "Sylvie, sweetie, it's okay! Don't, please don't!"

In the beam of the flashlight, she was a thrashing, screaming figure bound in blankets and fighting to escape. Verity laid the light on the bedside table and dropped onto the bed to throw an arm across the panic-stricken child. "Sylvie, I'm here. It's okay, it's just a storm, it took the lights."

"The pigs will get me in the dark!"

Verity tugged the blankets loose, threw them aside, and pulled the little girl close, holding her tight in both arms. Sylvie's heart was beating so fast that Verity felt her own begin to race in

response. "See, not so dark," she said as light flooded in from the hallway; Patience had dug out the big propane lantern that every coastal household kept at hand.

Sylvie burrowed closer, tucking her head under Verity's chin and wrapping skinny arms around her. As screams subsided to choking sobs, Verity heard another sound, a soft, worried whine. "Zak?" she said, and the normally dignified dog broke training and leapt onto the bed, to push his nose into the tangle and lick whatever part of Sylvie's face he could reach.

A gulped sob, and Sylvie freed a hand to reach for the dog. "Zak. Good boy." More swallowed sobs, and then hiccups, and finally Sylvie sighed deeply and relaxed.

Verity loosened her grip and moved away slightly. "Okay. It's late and it's cold. Let's go make some cocoa to cheer us up."

Half an hour later, Sylvie and Verity sat side by side on the couch, wrapped in blankets and cradling mugs of cocoa, while Patience swept up in front of a fireplace that now contained only a wet, smelly heap of logs and ashes.

"I'm sorry I made a fuss," said Sylvie, and flinched slightly at a fresh blast of rain against the windows. "A loud noise woke me up from this dream I was having, and…and it really was dark," she added in a rush, and buried her face in the mug. "This is really good, Verity. Thank you."

"You're welcome. Yes, it is. And warm."

With the damper now closed, Patience dumped the ashes she'd swept up on top of the wet ones in the fireplace and took broom and pan back to the kitchen. When she returned to settle into the wing chair with a blanket of her own, it wasn't a mug of cocoa she set on the table beside her, but a squat glass of amber liquid with one ice cube. No fan of sweets, Patience, but a believer in the healing quality of single-malt scotch.

"What happened to everybody?" asked Sylvie. "At the protest?"

"They were getting very wet, and most of them heading for home, when the power went," Patience said quickly. "I guess we'll have to wait until tomorrow to find out."

"Oh. Okay." Sylvie's eyelids were beginning to droop, and she yawned as she lifted her mug for another mouthful of cocoa.

"I've never understood," Patience went on, "why a furnace

that runs on gas won't work without electricity. Why couldn't there be a way to just light it with a match?"

"Uh-huh," murmured Sylvie, and let her eyes close as she leaned against Verity's shoulder. Verity rescued the nearly empty mug and set it on the coffee table. "Sweetie? It's late. Are you ready to go back to bed?"

"Um." The eyes came halfway open. "I guess."

Verity got to her feet and pulled Sylvie with her. "We'll get your winter comforter out. And we'll leave a lighted lantern in the hall, and your door open. Okay?"

The only answer was another yawn.

TEN minutes later Verity paused in the kitchen to turn a flame on briefly under the rest of the cocoa before pouring it into her mug. "I asked her if she wanted me to sleep with her," she said as she joined Patience in the living room. "She just said *uh-uh*, and rolled over and was asleep. Children are amazing.

"But I wonder what's happening downtown," she said, and moved to the window to peer out into total blackness. "Do you think the whole town lost power?"

"Probably. It does that several times a year. But the Coast Guard will have lights and lead the rescue operation, to whatever extent any rescue is possible. As for the fighting mobs, they'll all have crept away in the dark."

"Probably. Well, I think I'll stay here tonight, on the couch. The studio will be even colder than this, and without Johnny to warm it up. I wonder," she added, reclaiming her couch seat and her blanket, "where he is. If he's okay. Maybe I should call him."

"He'll call when he's free, or Hank will. Verity, I think I know what's been amiss with Sylvie."

Verity tossed a glance in the direction of the bedrooms, then leaned forward. "What?"

"You don't sleep up here, so you wouldn't have noticed. But when she got back from her father's after Labor Day, she asked me to find a bulb for that little night-light we put in her bedroom when she first came to us, and she's turned it on every single night since. I suspect that at some point during her week with him, David Simonov shut her up in the dark. Accidentally, perhaps."

"Why would he possibly…?"

"She neither likes nor trusts him, and I can just imagine her digging her heels in over—oh, some request or other. You know how stubborn she can be even with us. *And,*" she added with emphasis, "in his defense, though mildly, I don't believe he ever heard about her ordeal at Christian Community."

"Maybe not, but he's still a son of a bitch."

"Indeed. I think, before I go to bed, I'll crank up my laptop and make a few notes for my David Simonov file." In response to Verity's look of surprise, she produced a tiny smile that gave her round, pleasant face a cat-at-the-birdcage intensity. "Yes indeed, I'm keeping a file. And when it occurs to Sylvie that whatever promise she may have made to him was coerced, I'm sure she'll have useful information to add."

"Let's hope." Verity finished her cocoa and got to her feet. "I don't see any point to going out in the rain. I'll sleep in my underwear, borrow a toothbrush, get the sleeping bag out of the attic. And just have faith that the studio, and my new house, will survive."

AS he pulled the sixth and last—this trip—handcuffed rioter out of the police van into the still-heavy rain, Johnny Hebert was tempted to to help him along with a boot in the ass.

Getting a good look at his captor under the bright lights in the police station parking lot, the hulking guy, probably still a teenager, cringed. "Hey, man, I'm sorry," he muttered, running a tongue gingerly along his bloody lip. "I'd known you were a cop, I sure wouldn't have punched you."

"Your bad luck," said Johnny with a mean grin. "You can mention that to the judge Monday, when he gets around to you and your friends."

"Listen, we was just exercising our First Amendment rights."

"First Amendment doesn't cover fists and clubs. Move it!" he added with a hard shove.

Thirty minutes later Detective Johnny Hebert, Sergeant Ray Chang, and Officer Val Kuisma came out the back door of the police station, pulling up the hoods of their rain jackets. "I'm headed for home," said Val, and yawned. "Give you a lift, Johnny?"

"Hey!"

The call came from one of a pair of hooded figures trotting

across the lot toward them. The tall man in the lead pushed his hood back to expose a shaggy dark head that obviously couldn't get any wetter. "Hey, we're headed back down to the bluffs. Any of you awake enough to come along, I'd appreciate it." Matty Matila, a fireman and a specialist in ocean rescue, recognized Johnny and lifted a hand. "Hebert. Come on, we've got lights and we're going to have a look south of the bluffs. You're big enough to belay."

Johnny, with eyes that felt glued open and nerves and muscles still on full alert, thought he might as well. "Sure, count me in. Kuisma's needed at home," he said, mostly to Val, who nodded. "Chang?"

Ray Chang, never one to waste words, shrugged and nodded. "Sure."

"Okay, the rescue van's out on the street. Come on."

Johnny and Ray slid onto the second seat as Matila took the wheel, and the other fireman, who'd introduced himself merely as Dolan, settled into the front passenger seat. "The park's about cleared out, I guess you know that," said Dolan.

"Right," from Ray Chang.

"Good thing, too," Johnny added. "They've stacked hooligans like cordwood in the holding cells. Anything new on the guys who went over?"

"Nope," replied Matila. "Not the two we know about or anybody else who might've gone in. Which is why we're still looking." A sheet of water suddenly made the wipers useless, and he hunched forward over the wheel. "Okay, God, please keep me on the road here."

Several mostly silent minutes later the van was on the entrance road to the park, and Matila pulled as far south as possible and stopped. "What we're gonna do," he said as they scrambled out of the van, "is move south real slow and get a look along the bottom of the bluffs. If anybody got swept down this way instead of out, he could have got tossed up against a break in the cliff face or caught in the sea stacks. And there's the occasional little flat bit of rock or sand, though any that're still visible in this rain won't be for long; tide's coming in.

"And watch your step, you hear me? Anybody trips and falls in, he's got a real long swim." He handed out big, powerful battery

lanterns, and he and Dolan slung coils of rope over their left shoulders. "Let's go."

As they slogged in single-file over a landscape broken by abrupt dips, little run-off streams, stands of stunted juniper, and rock outcroppings, Johnny tried to keep his mind on his feet and his eyes on the beam of light he was sharing between path and ocean. What he saw mostly was falling rain or the sea itself, which resembled a boiling cauldron. He couldn't believe anyone in that would be alive, even if he'd been swept high against the rocks and caught there. But ocean rescue people seemed emotionally conditioned to hold on to hope for longer than most people; and finding even the body of one of the missing men, should they spot it and be able to mark its location, would be important to surviving family.

After what seemed an hour but was probably less, Johnny calculated that they'd spotted plastic garbage about a ton, a forest of wood debris and small logs, heaps of tangled kelp and belly-up fish, and a shredded small inflatable boat. He was wearing out fast, with aches from earlier conflicts making themselves known and cold working its way up his legs from what were probably leaks in his boots. Looking for a brief respite from wind and rain, he turned away from the cliff's edge to veer inland and had taken maybe half a dozen strides when his reaching right foot landed on nothingness, and he tumbled forward into a huge hole.

He fell hard on something—somebody?—and rammed his head against what felt like solid rock. Momentarily groggy, he rolled to one side in tight, dank space and was trying to orient himself when blows began to land.

"Hey!" He got his hands up and found hair, beard, ears, and yanked hard. "Hey! Chang! Over here!" he yelled, and was astonished to see, in the light from the lamp he'd dropped, two people scrambling past him out of the hole. "What the hell? Chang!" His assailant yanked himself free, lurched upright, and slammed a booted foot against Johnny's head.

SLEEPING with an ear cocked toward Sylvie's room, Verity came instantly awake at the first ring of her cell phone and stretched an arm out of the sleeping bag to pick up the instrument. "Verity here," she said, low-voiced.

"Sorry to wake you."

Johnny, but his speech had a fuzzy edge. "I was sleeping very lightly," she said. "What's happening?"

"Nothing useful. Verity, I hate to ask…"

"Uh-huh. Do it anyway."

"I need a ride home."

"Sure." She poked her head out of her cocoon and found that the world beyond the front window was still black, but rain no longer pounded the glass. "Where are you?"

"Good Sam. Emergency Room." At the sound of her indrawn breath, he said quickly, "I'm mostly okay. But no wheels. And I don't know who's where right now."

"I'm here. And I'll be there in ten minutes."

Or maybe fifteen, she thought as she splashed water on her face at the kitchen sink before scrambling back into her clothes. "Four A.M.," she wrote on the message board. "Gone to pick up Johnny. I'll be in touch."

Although the rain had stopped and the wind had dropped, there were no lights showing on Raccoon Lake Road, or on the highway into town. Or anywhere at all, so far as she could tell. Except in some sections of the hospital, she noted as she pulled into the parking lot. No doubt Good Samaritan, or any decent hospital, would have generators available for times like this.

She found Emergency without trouble, where a single fluorescent lamp lighted the waiting-room desk and the several people waiting were just dim lumps in chairs. "Detective Hebert? Yes, Doctor has discharged him to go home. Back through that door," the clerk added, with a nod of her head.

Verity moved down a dimly lit corridor to a kind of bullpen where an attendant said, "Hebert? Number four," and waved her on to a much brighter corridor lined with curtained cubicles. One empty cubicle, two with curtains drawn, and then number four, where she pushed past the heavy curtain, stepped inside, and couldn't completely restrain a gasp of dismay.

"It's not as bad as it looks," said Johnny. "Or as bad as it feels, I'm told." He was stretched full-length on a high, narrow cot, bandaged head propped on a pillow and a blanket across his chest. "And I am really glad to see you. Give me a hand up?"

He reached across his body with his right hand, she gripped it

and planted her feet, and he pulled himself up, swinging his legs off the cot. Another, lighter tug on her hand, and he was on his feet. He seemed to tilt for just a moment, then steadied himself and moved with slow, cautious steps to the chair at the foot of the cot to pick up his leather jacket and drape it over his shoulders. "Thanks. Now let's get out of here."

"Johnny, can you walk to the car?"

"Oh yeah, maybe even run. I hate hospitals," he said through gritted teeth.

JOHNNY lived in an old residential neighborhood south of the river and east of the highway. As Verity pulled into the driveway behind his elderly Volvo, she noticed that the SUV usually parked on the street in front of the house was absent. "Looks like your tenant isn't home."

"He kept an eye on the place for me until I got back to town, but he's been living with his girlfriend since the first of the month." As Verity turned off the engine, he opened his door, swung his legs out, and followed them carefully, gripping the roof-edge of the door to stand erect. "Thanks, Verity. You go home now and finish your night's sleep."

"Right, and leave you here all alone to freeze in the dark." She dug her flashlight from the center console, got out, and moved quickly to his side. "Come on, let go of the car and take hold of me. You can go right to bed, or you can spend some time telling me about your interesting evening.

"But first I'll build a fire," she said when they were inside the chilly house. "As soon as I find your lantern. Johnny, sit down. Please." She pointed the flashlight beam at the couch, and he lowered himself carefully to the cushions.

"In the kitchen utility closet," he told her.

Verity put the lantern, a big propane-canister number like her mother's, on the coffee table and then set about building the fire, snatching an occasional look over her shoulder as she worked. Johnny's normally ruddy face was pale against his black beard, his mouth tight, and he sat with unnatural stiffness against the couch cushions. When the kindling had caught properly, she turned to face him, sitting back on her heels.

"So, love, where does it hurt?"

He grimaced and recited his list: a head wound, no concussion but lots of blood and eight stitches. Ribs maybe cracked but probably just bruised. "And a dislocated left shoulder," he said, touching it briefly with his right hand. "Not the first time for that, but putting it back is always a bitch."

"No pain meds?"

"Nope. I don't like pills."

She took a breath to offer protest, and then let it go. "So can I make you coffee? Tea? Cocoa?" she offered, with a feeling that she'd played this scene before.

"Tea, strong. With a good jolt of something."

He was still propped there, eyes still wide open, a short time later as she handed him a full mug and sat down with her own. He had a sip, and sighed. "Good. Good fire, too. And excellent company. Thank you, Verity."

"You're quite welcome." She watched him take another sip, and thought his color had improved. "Since you aren't ready to go to sleep, you can tell me about the mess last night. You probably know that the local television station broadcast the protest scene through the evening, until the power failed."

"Yeah, some of the folks down there at the Saturday night trauma-ward party talked about that. If you were watching, you saw how big that crowd was. The potential for explosion was always present, more so when it started to get dark, but actual violence was spotty, two or three guys here, three or four there. We thought we were keeping a handle on it. Then when the weather turned really mean, most of the demonstrators headed for shelter and it looked like we might get home free after all."

"Did you guys arrest anybody?"

"Not at that point. I think we were most interested in preventing people from getting hurt." He sipped tea, sipped again, shook his head and clearly wished he hadn't. "Then all hell broke loose, people who'd been fighting almost for fun suddenly trying to kill each other. I have no idea what lit the fuse, maybe some of the other guys know."

"And then," Verity said into a lengthening silence, "three guys went over the bluff. And the lights went out."

"Two guys, we think. And several others came close, in the dark. That was a wild scene you should be glad you missed,

panicky people running around blind and hitting out at anybody they ran into, guys who work rescue trying to find each other and get organized.

"And no, nobody found the guys who went in. Not the Coast Guard, not the firemen, not us." He leaned back against the cushions and closed his eyes. "The waves were the monsters you usually see in midwinter, it was raining like hell, blowing... Anyway, rescue people were out there for several hours with lights and ropes—Ray Chang and I were part of that for a while—but no one ever saw any sign of the guys in the water. Which is probably a good thing, because anyone who'd tried to go in even on a line wouldn't have had..." He fell silent again.

"Do you know who hit you in the head?"

He opened his eyes and gave her a half grin. "Oh, yeah. Four of us were working south along the bluffs, basically thinking we might spot the bodies caught in the rocks. Then I fell into a big hole in the ground."

"A fall did that to your head?"

"Not quite. It turned out I'd stumbled, literally, into an area where a bunch of trogs were tucked up, in what may have been the cellar of a former house. Whatever it started as, last night it was just a big hole that stank worse than the drunk tank after a busy weekend, and the trogs in it objected vigorously to my arrival."

"Trog" for troglodyte was a local term for the most combative of the homeless-by-preference types who lived wild along the coast. "What did you do to them?"

"I didn't do anything but lie there bleeding," he said. "My guys came to help, but it was dark as hell and lights got dropped and all but two of the bastards just melted away into the black. Probably laughing. Somebody did suggest throwing the remaining two over the edge." The even tone of Johnny's voice suggested he wasn't kidding. "But in the end, they just whacked 'em around some and called the wagon. The trogs went to jail and I got hauled off to Good Sam."

"And here you are." His eyes were drooping now, much like Sylvie's hours earlier. "I think you should probably go to bed."

"It'll be cold up there. Maybe I'll just stretch out here."

"Good idea. I'll go up and get you some blankets."

When she returned with a thick down comforter, a pillow, and a pair of sweats, he had tossed the back cushions of the couch aside and was trying to take off his boots.

"Here, let me." She pulled off the boots and helped him shed the waterstained and still slightly damp jeans and flannel shirt. "I can do the rest myself, thanks," he insisted, and peeled off underwear before stepping with awkward care into sweat pants and easing the shirt over his head. When he finally collapsed back onto the couch and stretched out in gingerly fashion, she tucked the comforter over him.

"Verity, I had serious plans for my first week at home. I meant to spend a whole week in bed with you."

"Rain check," she said, and leaned over to give him a careful kiss. "Your cell phone?"

"In my jacket pocket."

She fetched the phone, turned it on to check the charge, put it on the floor beside the couch. "Okay. Call me at home if you need anything."

"Verity? Thanks for all the TLC."

"Not my usual role, you mean?"

"That's *not* what I—"

"Hush. Maybe I'm a nicer, kinder person than either of us knew. Oh, here's what I meant to ask and forgot. Do you know who they were? The guys who fell off the bluff?"

He looked straight at her for a long moment, then rolled his head to look away.

"Johnny?"

"Okay. It's not official yet, but according to two people who were fairly close when it happened, one of them was probably that guy who's been working on your house. Danny Soto."

"Daniel," she said softly. "The tall man right in front of the barrier. I almost recognized him and then he—they—fell. That's dreadful. Oh, *damn,*" she said, her voice wavering.

"What?"

"He is—was—Grace Beaubien's boyfriend, they lived together. Poor Gracie, somebody will have to tell her."

7

"VERITY?"

"Mmph." Verity rolled over and burrowed deeper under the covers.

"Verity, we're going to church, and the lights are all back on, and Hank wants you to call him at the station."

Church. It must be midmorning. She yawned and sat up, dislodging the extra blankets she'd piled on when she crawled into bed in the studio at something after five A.M. "Good morning, Sylvie. You look lovely."

Sylvie grinned and pushed her hands into the pockets of her denim jumper, her only-on-Sundays concession to the wearing of a skirt. "Thank you. It's cold out and really windy, but it's not raining right now. Did you hear me about Hank?"

"I did. Flip the heater on for me, will you please? And I'll see you when you get back."

As the door closed on Sylvie, memories of the night before flooded into Verity's sleep-clogged mind; she pushed her feet into slippers, collected her long robe from the closet, and went to dig her cell phone from her bag.

"Verity, good." Captain Hank, second in command at the Port Silva police department, had his own direct telephone line. "Johnny tells me that you know Grace Beaubien?"

"I do, though not really well. She's Sylvie's chorus and guitar teacher; Sylvie's crazy about her, and I've enjoyed tallking with her. Hank, is this about Daniel Soto?"

"Right, it is. Or at least the guy we're pretty sure was Soto."

"Have they found him?"

"Nope, not him or the other guy, whoever he might be. The rain has stopped for the moment, but the wind hasn't, and the Coast Guard is right busy with boats in trouble.

"Thing is," he went on, "nobody knows anything about Soto, about any family, and I understand from Johnny that he's been living with Grace Beaubien."

"That's what Harley told me. No, Harley said she was Daniel's girlfriend, and then Sylvie told me he lives with her."

"I don't know Grace except to say 'hey' to," Hank told her, "but I know the parents; they grow organic produce out toward Comptche. Turns out they're on vacation, spending October in Italy. And since we about wore out all our people last night, I don't have a woman officer available this morning. What I'm wondering, would you be willing to come along with me to talk to Grace?"

"Sure." Feeling suddenly chilly, Verity tightened the belt of her robe. "Can you give me thirty minutes? I just got out of bed."

GRACE Beaubien lived in a nondescript little stucco bungalow about four blocks from Sylvie's school. As she got out of Hank's unmarked sedan and followed his sturdy, blue-uniformed frame up the walk to the front door, Verity regretted the two cups of coffee that had constituted her breakfast. What do you say to someone whose lover is…is what? Presumed dead?

Verity heard a voice singing scales just before Hank rang the bell. The singing stopped, and about three seconds later the door opened. "Yes? What can I…? Oh, Verity, hi," Grace Beaubien said, running a hand through curly hair not recently combed. "And Captain Svoboda?" Her welcoming expression faded to worried puzzlement. "Is it something about Sylvie?"

"No, ma'am, Miss Beaubien. Could we come in, please?" asked Hank, and Grace stepped back. Verity followed Hank inside and closed the door. "It's about your friend, Daniel Soto," Hank said.

"Danny?" She stared at them. "I don't know where he is. The quartet had a Friday night appearance in Santa Rosa, I stayed through Saturday night with an old friend and didn't come back until this morning. Danny wasn't here when I got home about an hour ago, and he didn't leave a note."

"So you haven't heard anything about the protest march yesterday afternoon, and the riot last night?"

She made a face. "Damn. I should have realized that when they didn't get permission, they'd do something on their own. So I guess he's in jail? Can I come down and arrange to get him out?"

"No, ma'am, he's not in jail. Maybe we should all sit down," he added, taking Grace's arm and leading her to the couch against the far wall.

"You're frightening me. What's happened to Danny? Verity?" she added in pleading tones as she sank onto the couch.

Verity sat down beside her and took her hand, but looked up at Hank.

"Miss Beaubien, a man we've tentatively identified as Daniel Soto has had an accident. I understand he's been living here?"

"We live here together. What kind of accident?"

"Several men, apparently protestors, were involved in a fight out on the bluffs last night during the storm, and witnesses tell us that Daniel Soto and an unidentified second man fell off into the water."

Color drained from Grace's face and her grip on Verity's hand tightened to the edge of pain. "You're telling me Danny's dead?" she whispered.

"We haven't recovered his body yet, but truth is, the Coast Guard says it's unlikely he survived. I'm real sorry."

She leaned against the couch back, her eyes closed but tears seeping from under her lashes. After a moment she wiped the tears away with the fingers of her free hand, opened her eyes, and sighed. "I'm sorry, too. When do you think they'll find him?"

"Probably not until the wind and waves slack off some." Hank pulled a chair up and sat down. "Miss Beaubien, nobody we've talked to could tell us anything about Daniel Soto or his family. Except for you, we got no idea who we should notify of his accident."

"I...I haven't, either. Danny didn't talk about his family."

"Nothing at all? About parents, brothers, sisters?"

She shook her head. "The closest to family talk he ever got was once when he said he wished he'd had parents like mine. He did quite a lot of work for them about a year ago; that's how I met him." Tears began to flow again, and Verity released Grace's hand to reach into her bag for a tissue.

"Do you know where he lived before he came to Port Silva?"

"Up around Eureka, I think."

"Is that where he grew up?"

"I don't know!" She used the tissue to wipe her eyes. "He

was—he *is*—a hard worker and a good man. He likes music. He loves me, and I love him."

Grace's voice shook, the last word snagging on a sob. Verity caught Hank's eye, gave him the slightest shake of her head, put her arm around the younger woman's shoulders.

"I understand," said Hank, his voice soft. "I have only one more question for now. Do you know whether he had any enemies hereabouts, anybody he'd had disputes with?"

That stiffened her spine. "You think somebody pushed him off the bluff on purpose?"

"We don't know. But it's something we need to consider."

"I don't think he had trouble with anybody. He got along well with the people he worked with, but most of his free time he spent with me." She paused. "There were the people planning the protests, he met with them sometimes, but he didn't come home angry from the meetings. Well, except about the idea of going to war."

"You know any of those people?"

She shook her head. "Not really. I didn't approve of his getting involved. I thought the protests were heading for trouble and it looks like I was right, wasn't that smart of me," she added in bitter tones.

Hank stood up and reached out a hand, which Grace took after a barely perceptible hesitation. "We'll leave you for now," he said. "But is there anyone we could call for you? To keep you company?"

"No, thank you." She got to her feet stiffly. "I need to practice. We have a local performance tonight."

"We'll be in touch later," he told her, "with any news. You call me if you remember anything you might want to tell us, or if there's anything we can do." He handed her a card.

"Gracie, would you like me to stay?" Verity asked.

"Not right now, thanks. But can I call you later?"

"You bet." Verity gave her a quick hug, wrote *cell phone* and the number on the back of her own card, and said, "Call me any time. Please."

THE new furnace drove the slight damp and the real chill from the air, making it possible for Verity to go on with the painting of

the upstairs windows in her house. Possible, but not comfortable; the big bedroom in particular seemed haunted by the ghost of Daniel Soto.

"Not ghost," she told herself aloud, firmly. For some reason, Grace's influence maybe, Verity was not quite willing to consider the man dead. But her strong sense of his presence was probably evoked by the evidence of his skills in the ceiling over her head. Practicality intruded for a moment: who would she get to finish painting the ceilings?

So she'd learn to do it herself, that's who. Verity set the brush across the bucket, wiped her hands, and went to collect company. In five minutes she was back with her old but good portable CD player and some music to lift her above the day's sorrows: von Karajan and the Berlin Phil playing Beethoven. She finished the third window speedily, switched from enamel to latex flat, and was putting the last touches on the walls in the master bedroom when she stopped, sat down on the tarp-covered floor, and let the final movement of the Ninth Symphony wash over her.

"I PUT in hours this afternoon at my house," said Verity. "Enough so I can probably finish the other bedrooms tomorrow while the tile guys and Charlie Garcia are working. Then I'd had enough of paint smells and decided that the wintry weather made me think about serious, non-broiled food. Real cooking."

"Bless you," said Hank Svoboda, piling the last dab of mashed potato on the last shred of lamb shank and popping the result into his mouth.

"Amen," said Johnny. He'd exchanged the piratical around-the-head bandage for a much less aggressive version; and although he still moved with stiff care, he'd insisted on driving himself rather than letting Verity pick him up.

"And it's apple season," she added as she got up to begin collecting empty plates. "Silveira's had Jonathans, if you can imagine my luck. And your luck; they're the world's most wonderful pie apple."

"Verity, may I be excused?" Sylvie asked.

Verity looked at the not-quite-empty plate. "Sweetie, you haven't...well, never mind. Don't you want pie?"

"I'm not very hungry." Sylvie pushed her chair back and got

to her feet. "I have some homework for tomorrow. If it's okay, I'll do it down in the office."

"Well. Okay, kid. Better put on your jacket. And be sure to turn on the heater."

When Sylvie, Zak at her heels, had left for the basement office, Verity brought plates of pie to the table while Patience poured coffee.

"That kid usually eats as much as I do," Hank remarked. "She having trouble with school work?"

Verity snorted. "Not likely. No, she heard us talking about Daniel Soto, and we told her what happened to him. Sylvie is very fond of Grace Beaubien, and she's—I guess you'd say she's empathizing. Losing somebody you love carries great weight with Sylvie."

"Is there anything new about the two men who went into the water?" asked Patience.

Hank swallowed his second bite of pie, said, "Perfect!" to Verity, and "Not exactly," to Patience. "We have three on-the-scene witnesses. Two positively identify Daniel Soto, one is pretty sure."

Verity was surprised to learn there had been only three witnesses, and said so.

"It was wild down there," Johnny told her. "Just before the two guys went over we'd been handling—trying to handle—about a dozen scraps, some of them leaving people injured." He shrugged. "When the power went, most of the warriors just called it quits and took off in the dark."

"It turned out none of our own people were close enough to see the fall, so we got only those three who were good citizens or wanted us to think they were," said Hank. "And when we viewed the videotapes at the TV studio, the cameras were bouncing from battle to battle and caught maybe two seconds of the guys who went over, just before they went. The one who looks to be Soto—Val Kuisma is pretty sure it's him—was facing inland, fortunately. The other one, they got just the back of a guy some shorter than Soto."

"So far we've had absolutely no information about that one," Johnny added. "But we'll put out a request to other good citizens who might want to come in to help us."

Verity frowned, trying to remember what she'd seen. "Did you get a sense, when you saw that two-second bit, of—of purpose? Or did it just look like an accident?"

Johnny simply shook his head, and Hank said, "Nope. I didn't. But we'll sure be looking at it again." He eyed his watch and got to his feet, patting his belly. "Great meal, Verity; I hope I'm not too full to stay awake. It turns out Patience has tickets to hear this group Grace Beaubien sings with, at the high school auditorium tonight, and we thought we'd go."

"Marilyn Ritter was selling tickets, and Marilyn is hard to resist," said Patience. "And I thought that if Grace is brave enough to go ahead with a performance tonight, I'd like to be there to support her. There are probably seats available, if you two are interested."

"You can represent the family, Ma," said Verity. "We'd have to take Sylvie, and I think that might be overload for her tonight."

"I'll pass, too, thanks," said Johnny. "Right now I wouldn't last ten minutes in those stiff little seats."

"YOU know that her group is a quartet called Old Music, New Voices?" asked Johnny, who had been firmly waved off when he offered to help Verity clear the table and load the dishwasher. "She mentioned that as we were driving her home from the television studio."

"I do. They began performing together this summer, and I think they're quite good. So, with better reason to know, does Charlotte Birdsong. But for tonight, in the same medieval vein, I have a CD from the extraordinary group that inspired Gracie and her colleagues, Anonymous Four. And the couch here is much more comfortable than the seats at the auditorium."

"And here we can sit and hold hands," said Johnny.

"At least. More coffee? Or should we finish the bottle of wine?"

"Wine," he said, and got stiffly to his feet to head for the living room and the couch.

Verity carried glasses and the bottle to the coffee table, and filled the glasses before turning to the CD player. "Which reminds me. You took Gracie for a look at the TV film?"

PORTVILLE FREE LIBRARY
Portville, New York 14770

"We did." The music began, and he sighed. "Wonderful."

Verity sat down beside him. "Did she identify the man as Daniel?"

"She said she couldn't be sure. I think she was trying to be truthful, but the business about Soto's van had distracted her."

Verity sat straighter. "What about Soto's van?" Johnny hesitated, and she grimaced. "Come on, Hebert. You'll tell me eventually."

"True. Okay, Grace Beaubien says that Soto's transportation was an older but well-kept Dodge van, light blue. She drove all around downtown and the wharf area this afternoon, and didn't spot it anywhere."

"Oh, my. So she's convinced he survived somehow, and drove off in his van?"

"She's trying hard to be, anyway. I told her it had most likely been stolen in the blackout, but I don't think she heard me. Anyway, we told her we'd look for it."

Verity hugged herself. "Poor Gracie. But I suppose a little bit of hope is better than… Never mind," she said, as much to herself as to him. "Let's listen to the music."

8

"I THINK WE SHOULD HAVE OUR lawyers present." This from Jonas Dietz, a shock-haired, gimlet-eyed six-footer whose weight Gutierrez estimated at about one thirty-five.

"Don't be an asshole, Jonas." Chris Matila, a redheaded kid as tall as Dietz but much broader, sounded more weary than irritated. "You take that kind of line, you won't get back to Berkeley any time soon."

"We brought you in this morning to talk about the anti-war demonstration you were involved in two days ago," Chief of Police Vince Gutierrez told the four people facing him. "If anyone would be more comfortable having charges filed, I'm sure we can arrange that."

When there was no response beyond a wince or two, he nodded. "Sit down, all of you. Please," he added, with a gesture at the chairs drawn up in a row before his desk. As Dietz, Matila, Mick Riley, and Rafaela Flores obeyed with varying degrees of composure, Officer Alma Linhares closed the office door and took her position on a chair against the wall, notebook in her lap.

Gutierrez eyed them all silently for a long moment, running over their résumés. All four were Port Silva natives. Dietz was now in his sophomore year at Cal in Berkeley, Matila a student at the local community college who planned to be a fireman like his older brother. Riley, the mayor's son, was taking a year off between college and law school, and Flores had come home from her senior year in Arcata to look after her sick mother. Except for a speeding ticket or two, this was as upright and admirable a group of kids—young adults, Gutierrez corrected himself—as Port Silva was likely to offer.

"As I recall, you were four of the people who requested permission to use South Bluffs Park as the site for an anti-war gathering next Saturday, October twenty-sixth. A request that the mayor and the city council officially denied."

"There were six names on the petition," Dietz began, and lapsed into silence as Gutierrez raised a quelling hand.

"We've spoken with the other two, and we'll get back to them later," Gutierrez said. "Rev Bob is at the jail counseling a few of his parishoners, and Dr. Elliot had two of her patients go into labor this morning. Now. A number of people, including me, saw you on the march and at the demonstration that followed *last* Saturday, October nineteenth. Guiding and directing, it appeared."

Only Rafaela Flores met his eyes. "Yes, we were."

"So let me get this straight. Your response to being denied a permit was to go ahead and organize the event right away."

"Look, that's a public park. I don't see how anybody can tell us—"

"Jonas, shut up," said Chris Matila. "Chief Gutierrez, we'd talked to a lot of people about how important it was to show peaceful opposition to war in Iraq. The response just built and got bigger and it was like this mass decision, to go for it."

"So if we actually broke a law, we'll take the consequences," said Riley.

"I see. How do you all suppose your families will feel about receiving the bill for the extra police presence and the damage done to the landscape? Not to mention what it will cost if someone who was hurt in the melee at the end decides to sue?"

Eyeing four stricken faces, he sat back in his chair. "It may not come to that. We'll see what the city council decides after some citizen input. What I need from you now is information about what happened when things went bad. You were all on the scene Saturday?" When they nodded, he said, "All day? From the march until the end?"

"Except for pee-breaks, we were there all day," said Riley. "We were monitors, along with a dozen others we picked up when we saw how large the crowd was getting."

"Smart of you. Give Officer Linhares those names, please, before you leave."

Riley took a breath, and then thought better of resistance. "Okay. But we didn't expect real trouble, not here in our own town. We'd emphasized the need for being peaceful. That was the whole point."

"Part of it," said Dietz.

"The whole of it," snapped Flores, glaring. "That march wasn't just a bunch of kids out to have a blast. It was people of all ages who don't believe in the necessity for the war they can see coming and wanted to say that in community and brotherhood.

"And the march *was* peaceful!" she added, leaning forward to fix her eyes on his. "The entire way, we walked in silence. When people watching yelled things, we ignored them."

"But after the march, later? What I want to know is when the trouble started, and why."

They spoke quickly, separately but nodding and agreeing with each other. No trouble except a few rude remarks along the march, things cool at the park even after the rain started but with such a large crowd, they'd been glad to note the presence of the cops. They'd kept moving, alert, checking with their own troops by walkie-talkie.

"Anyway, what needed saying had been said, and the weather was getting worse, so Rev Bob said something like, 'Bless you and go in peace,' and most people were leaving. Then it all of a sudden went to hell," said Riley. "Some asshole jumped me, I knocked him down and from then on I was breaking up fights and trying to get people out of there. All of us were."

Rafaela Flores nodded. "It was crazy. I kept thinking that if I fell down, I'd get trampled to death. I helped a couple of older women get out of the way, but I wish I could have done more. In my next incarnation, I'm going to be a lot bigger."

"Were any of you near the fight on the edge of the bluff, before the two men went over?"

Three slow head-shakes and a firm "No" from Riley, obviously the spokesman for the group. "We talked about that, too."

"Which of you knew Daniel Soto?"

All four knew him, and Matila had considered him a friend. "He didn't have a lot of free time, but he came to meetings whenever he could, and he had real strong feelings about going into Iraq. He was one of the monitors, we asked him because he was big and strong and could handle himself."

"Anybody see him after the fights started?"

"You couldn't see anybody except the guys fighting right next to you," said Dietz. "And I lost my walkie-talkie the first time I got hit."

"Me, too," said Matila.

"What do you think happened?" When he got blank looks and shrugs, Gutierrez said, "Did Soto have enemies?"

No one knew of any. "But he wasn't the kind of guy who'd have talked about something like that," said Matila. "In fact," he added in thoughtful tones, "he never talked about anything personal at all."

"But you knew he could handle himself?"

"Just by his—manner. He's—he was—real tall with this long, head-up stride. When you walked with him, you got a sense that he was always aware of whatever was happening around him," he added with a palms-out gesture.

"I'd agree with that," said Riley, slowly, "but I'd have to add that he struck me as a guy whose personal space you wouldn't want to invade. For instance, Danny's preferred sign said AFGHANISTAN YES — IRAQ NO."

"A man of few words," said Gutierrez.

"Right. And one day, when we were both coming back from the bridge, this guy stopped us and pushed him about it. Said if he felt that way, why hadn't he enlisted for Afghanistan? Soto told him that was none of his business, and the guy sneered something about 'Oh, so you're unfit to serve?' Danny said something along the lines of 'Let me show you,' and boy, he really did."

Before Gutierrez had a chance to comment, Rafaela broke in. "Chief Gutierrez, have they found Danny yet?"

"No, I'm sorry to say. There were divers out as soon as it was light enough yesterday, and again today. They'll keep trying."

Three faces were glum in acknowledgment of Soto's demise, but Dietz had a question. "What about the other guy? Have you found *him*? Do you know who he is?"

"No. Do *you* know who he is?" As Dietz reddened and shook his head, Gutierrez turned his gaze on the others. "Any of your friends or troops missing?"

"So far as we've heard, only two of them, and they're both in jail, or were." Chairman Riley again.

"What about Sean Flynn? We have a warrant out for him."

Riley shook his head. "Flynn was with us mostly because he was Danny's friend, but none of us knew him well." Or liked him much, was the subtext.

"Next question. Can any of you name any person or persons you saw commit an unprovoked assault?"

After a pause, Rafaela Flores gave her silent companions a disgusted glance. "I can, two of them. Greg Dodge and Billy Markovich—and his girlfriend, I don't know her name."

With a nod Gutierrez got to his feet. "Okay, I've got an appointment five minutes ago. You three guys, give the names of the other monitors to Officer Linhares as you leave. Spend some time trying to remember more about who did what to whom Saturday night and get back to us on that. And if you plan to leave town in the next day or two, check with us first."

"Ms. Flores," he went on as the males slouched off, "we'd appreciate it if you could stay a few minutes, please? To give Officer Linhares the details of what you saw."

WITH sunny, mild weather making what might be its last appearance of the year, Verity had the upstairs windows open while she painted the two smaller bedrooms. Downstairs, things were moving right along. The peninsula's butcher-block top was in place and awaited only verathane; Charlie Garcia had come before eight o'clock to install the kitchen sink and have a final look at the little WC. And Gary Peters and his two sons were even now laying the kitchen tile.

As she put down her brush and rotated her shoulders to ease their ache, she glanced out the rear window at the beginnings of the deck that could probably be finished over the coming weekend. And maybe the entire project could be complete by this time next week, except for furnishings. She would have a whole big, shiny house all her own, and... She gripped her elbows and hugged herself against a sudden chill. And then what?

The sound of an engine close by saved her from that path. She went downstairs and stepped outside to find only the Peters' truck in front of her house, but caught the metallic *thunk* of a slamming car door from the next yard. Patience, back already? Not so; Zak was barking, not fiercely but in attention-calling mode.

Verity hurried to the gate and through it, to find a small hatchback sedan in the gravel parking area and a figure scuttling up the steps to the front door of the cottage. "I beg your pardon?"

The figure turned, and Verity recognized her caller. "Gracie?"

"Oh, Verity." Grace Beaubien came hurtling back down the steps, her feet missing at least one, and Verity ran forward thinking she might need to catch a falling body. "It's okay, Zak, good boy," she called to the attentive dog.

"I'm sorry, I should have called but I couldn't find the card you gave me and you're not in the book. This place isn't, anyway, and I'm sorry I came here without asking but I remembered it from the time I brought Sylvie home...."

"Gracie." Verity put an arm around the girl's shoulders. "It's okay. Come on, let's go in and sit down, and you can tell me what's happened."

Inside, she led her visitor to the kitchen, and a seat at the table. Grace's face was pale except for splotches of color over her cheekbones, her eyes wide, and dry. "Just sit there and take deep breaths," Verity told her. "I'll put on water for tea, and then run next door to let the working guys know where to find me."

By the time the kettle boiled, Verity had set out cups and saucers, sugar, milk, shortbread cookies. Without asking for preferences, she put two Earl Grey tea bags in the pot, poured boiling water over them, sliced a lemon.

"So." She poured tea, and sat down. "Help yourself to whatever you want, and tell me what's up when you're ready."

Grace's color had evened out, and her hitched-high shoulders had settled into an easier line. She poured in milk, stirred in sugar, sighed and picked up the cup. "The Coast Guard found a body, and Chief Gutierrez called and asked me to come to look at it." She squeezed her eyes tight shut for a moment before lifting her cup for a sip. "This is good. Thank you."

"You're most welcome."

"It wasn't Danny."

Surprised at her own sense of relief, Verity reminded herself that *not found* didn't necessarily mean *alive*. "I'm glad."

"They knew it wasn't Danny; he was too short and had the wrong kind of hair." She had a restorative mouthful of tea. "They wanted to know if I recognized him, but I didn't. I don't know who would have, except maybe his mother. He was really, um, torn up."

And why the hell had the chief of police chosen to subject

this sorrowing girl to such an ordeal? "He didn't have any identification?"

Grace shook her head. "I think they're going to, oh, polish him up a bit and make pictures to show around town. Or maybe somebody will notice he's missing and report it. But what I thought..." She let the sentence trail off, eyes on Verity.

Who put on what she hoped was an encouraging look but said nothing.

"I want to hire you to find Danny."

Verity had a wild vision of herself in wet suit and flippers, leaping off the bluffs. "Gracie—"

"I have enough money to pay you, for starters at least," Grace added quickly, "and when my parents come home, I'm sure they'll help me out."

"Gracie, the chances are the Coast Guard will find Danny's body eventually. After all, the dead man, whoever he is, didn't make it."

"Danny is a very strong swimmer, more at home in the water than anybody I've ever known. He's been a surfer since he was a little kid. Besides," she said, and stopped.

"Besides what?"

Grace looked down at her cup and reached for the pot.

"Gracie." The girl kept her head down, and Verity realized that this soft-looking little person had more than music in common with Sylvie. "If you're asking for my help—not that I will, or won't, decide yet to give it—you have to be straight with me."

Grace seemed to gather herself up. "The police—Chief Gutierrez, Officer Linhares, and some blond guy whose name I don't remember—they all act as if Danny is some kind of crook or hoodlum."

"What—?"

But she was in full spate now. "They asked me if he had enemies. If he got into fights often. Even if he'd ever hit me!" She paused for breath. "They're acting like he killed that other poor guy. On purpose, even."

Verity thought, or hoped, that Grace had misread the police attitude. "So if Daniel Soto is in fact alive out there somewhere, the police themselves will make a serious effort to find him. And

they're better at that than I am, or my mother, either." Not en-
tirely true, but close enough.

"Yeah, and they'll probably shoot him on sight."

"No. They won't do that."

Grace Beaubien took a deep breath, expelled it loudly, and sat
back in her chair. "It was their fucking *attitude*. I mean, like I was
some sappy fifteen-year-old who'd been creaming her little pink
panties over this *sinister* stranger and look where it got me, hauled
off to the police station to look at dead bodies. Tell all, dear, and
then shut up and go home and next time keep your legs together."

Verity couldn't contain a snort of astonished laughter.

"Right. *You* probably didn't look like a sweet, innocent little
girl even when you *were* one," Grace said with a flip of one hand.
"Look, I wasn't a middle-school slut, I waited till I was seventeen
to purposely and happily get rid of my virginity. That was six years
ago, I've had two other boyfriends since—consecutively, not
simultaneously, my mom says I'm serially monogamous—and I'm
still friends with all three of them. Then last year I met Daniel
Soto, have lived with him now for almost six months, and
planned to keep doing that for a long, long time."

Verity couldn't resist asking the question that had struck her
earlier. "Why Daniel?"

Grace blinked, as if refocusing on another time and place. "I
think at first I just wanted to get *some* kind of response from this
guy who was so big and beautiful, and quiet and self-contained.
Then it turned out he was also smart, and kind."

She came back to the present with what looked like a small
shudder, and wrapped her arms around herself. "Whatever I look
like, I'm a realist, not a romantic, and I know Danny very well.
He's sometimes sad, he's never mean. He's pretty even-tempered;
the only thing that really pushes his buttons is people pushing
other people around. I feel, I *believe*, he's alive. And I want to find
him before some cop or cowboy shoots him, or scares him into fur-
ther flight.

"So. Will you help me?"

"I'VE worked for ol' Pete off and on for years, movin' his cows
from one pasture to another, or gettin' 'em in, ready to ship to the
sale." Roger Collins, whom Patience knew slightly from church,

was a weathered, stringy-muscled man in worn Levi's and bat-
tered cowboy boots. Now he shrugged and shook his head. "My
dad was a rancher and I still run a few head, but just out of habit,
like. I prob'ly make more driving truck for Selkirk Lumber than
Pete does with his whole spread."

"Did you know he was considering selling out?"

"Hell, yes. I told him, I was in his spot, I'd sell yesterday. But
Pete…" Another shrug.

Patience waited, and Roger shifted in his chair.

"Pete's got land he loves but can't afford to keep and a sick
wife who ain't old enough to get on Medicare. I got no land to
speak of, no wife, and a son who joined the army to get some
leverage on going to school after. Except the way the president's
talkin', he's likely to wind up in I-raq instead. I been tempted to
go out there and join those anti-war folks on the bridge, only it
would just get me fired."

"So what do you do instead?"

He grinned. "I get in my truck and drive off to San Francisco
or Oakland and find me a black church, preferably Baptist
acourse. And I listen to those folks sing about suffering and Jesus
and not being beat down, and I feel some better, for a while."

He unfolded his length from the chair, reaching out to shake
Patience's hand when she rose as well. "I'm real sorry I can't be
more help. Haven't talked to Pete for two-three months. Listen,
you tell Allie, Rog is thinking about her, and to call me if there's
anything I could do. And chances are, Pete will turn up any day
now."

That's what they all say, thought Patience as she ushered her
visitor to the door and thanked him for coming. Every bloody one
of them, even Father Wong, Father Lucchesi's temporary substi-
tute at Our Lady of Mercy, who had been much less friendly than
Roger Collins and showed little interest in providing aid and
comfort to Pete's non-R.C. family or information to a woman do-
ing unorthodox and perhaps unchristian work. Except for the
office chores she'd disposed of between her visit to Father Wong
and Collins's arrival—responding (or not) to messages on her
phone machine, organizing notes for reports, paying bills, sending
out bills—Monday morning had been a gigantic waste of time.

Now, clearing her desk for departure, she remembered that

her first call of the morning, to Allie Flynn, had reached only an answering machine, to which she had responded with a message of her own: please call me.

She disliked bothering that frail, sad-looking woman, but she had no alternative number for Allie's son, Tim, or his sister. She sighed and reached for the phone, tapped in the number, and got the same machine, same message.

Rats. She'd spent much of Sunday afternoon on the phone querying (politely) Pete Flynn's friends and associates, people he'd done ranch business with, even the veterinarian who'd provided medical care for his now-small herd of cattle when necessary. The results had been zilch, zero, zip. Most of these people knew the ranch wasn't doing well; a few, like Roger Collins, even knew he'd had offers to buy the place. None of them, so far as she'd been able to tell, knew what he meant to do about all this. Or where he might have gone to think it over, if that was what he was doing.

Patience knew that she was fairly good at telephone inquiries, with her low, pleasant voice and nonthreatening manner; but her real skills lay in personal contact. Well, except with irritable Catholic priests who disapproved of Baptists. The obvious next step, if there were to be one, was to go further afield, on the road. But before doing that, she needed to talk with the Flynns, to report on her lack of success so far, to learn whether they'd had any word from Pete, whether there'd been any credit card or bank account activity in the last day or two. If Allie Flynn, frail or not, wanted action, you'd think she would…

Never mind. Try to live up to your name. Patience turned on her laptop, added the results of the morning's interviews to the report she'd begun the day before. Ended with a note requesting a consultation on further efforts. Printed the four-page document, signed it, popped it into an envelope. She'd drop it off at the post office on her way home.

9

AT HOME TWO HOURS LATER, Patience returned Zak's polite greeting with a pat on his head and followed him up the front steps of the cottage to the open door. "Verity? Do you have company?"

"Sort of." Verity, seated at the kitchen table, looked up with a faint smile before hitting "Save" on her computer. "Grace Beaubien came calling just before noon with a plea for help."

"Oh my. And where is she? Since I presume that's her car out there." She dropped her purse and tote bag on the counter and went into the hall to hang up her coat.

"In the studio, having a nap."

"Of course." Patience pulled the padded wicker chair up to the table and sat down. "Have we adopted her?"

"Not quite. Something to drink? You look warm."

"A bottle of Calistoga would be nice. Verity…"

"Just a minute, Ma, and I'll tell all, before she wakes up and comes in for the next chapter." Verity brought two bottles of the bubbly mineral water to the table. "In fact, maybe you should start by reading the notes I just made," she said, and turned the laptop around so Patience could see the screen.

"She was right on a thin edge when she got here," she said when her mother had finished reading and closed the computer. "She was awake all last night waiting for word about Danny. Then your friends and mine at the cop shop hauled her in this morning to look at a battered body."

Patience made a face but offered no other comment.

"By the time she finished what she'd come to say, she looked as if she might keel over any minute. So I, in my weird new ministering-angel mode, fed her lunch and suggested she have a short nap. I told her we'd talk further when you got home."

"Hmm. Her parents are away, Hank said."

"Right. So what do you think?"

"Unless she has more information about Daniel Soto than she's told you, I don't see how we can be of much help. But since you've gone to the trouble of making notes, I assume you're willing to try."

"I…I think so. If you don't mind."

"I don't have much time available right now, so it will be largely your job."

"I'm okay with that."

"And I should add one caution." Patience put a hand on the laptop, and Verity waited. "You say Grace Beaubien told you that she's a realist, not a romantic. *I* can tell you that there is no such thing as a twenty-three-year-old realist."

Verity took breath for reply, and closed her mouth instead.

"Right." Patience got to her feet. "I'm going to put my things away and change clothes. Then you can go wake her up."

PATIENCE returned just in time to hear a knock at the front door. She opened it and found herself facing a Grace Beaubien who looked rumpled but clear-eyed and determined.

"Mrs. Mackellar, I'm glad you're here. Did Verity tell you I'm looking for help?"

"She did. Come in and we'll all talk about it. And this is a very first-name kind of family; please call me Patience."

"The first thing Verity told me," Patience said when they'd all found seats in the living room, "is that you believe Daniel Soto is still alive."

"Yes, I do." She sat straight and square in the wing chair, hands folded in her lap.

"It that's so, why do you suppose he hasn't come home to you?"

Patience heard Verity's quick intake of breath, but Grace sat even straighter, chin up. "He may be too badly hurt. He may be frightened."

When Patience made no reply beyond a raised eyebrow, Grace flushed slightly. "Look, in those TV tapes, it looked to me like that other guy was trying to push Danny off. So if Danny did survive, he might have decided…to run?"

"The most likely possibility," Patience said, "is still that

Daniel is dead, by drowning or being battered against the rocks. And his body will probably turn up eventually."

"But—"

"Beyond that there are the two possibilities you've mentioned: he's hurt, perhaps incapacitated, or he's frightened and hiding. But according to what you *did* tell Verity, you know virtually nothing about his background, his family, his place of origin. Without some of that information, I'm afraid Patience Smith, Investigations would be taking your money with little hope of success."

"But it's only money. Whether Danny's alive or dead, he's not some blank nobody to be just forgotten. Someone has to care about him, and I'm the one."

As Grace blinked hard and lowered her head to stare at her tightly clasped hands, Patience heard Verity shift position on the couch and turned to catch her daughter's eye. And her slight nod.

"Grace, let's make a tentative start this way. Let's go over what you told Verity about Danny's background to see if you've remembered anything else. And then you tell us all you can about Danny himself, what kind of person he was…" She saw the girl flinch, and said, "Sorry. What kind of person he *is*. And Verity, would you take notes?"

"Sure." Verity collected the laptop from the kitchen table, sat down on the couch, and opened it on her knees. "Ready."

Patience looked at the yellow pad on the arm of her chair. "About his family?"

"This came in pieces, and I tried to organize it in my mind before I went to sleep," Grace said, and folded her hands in her lap again as if to recite. "He said I was really lucky with my family, his was no good. He said his mother died when he was twelve, and things were really hard after that. He said his grandfather was a good man who got too old, whatever that meant. He said he had one good uncle, but he died when Danny was eighteen. And that's when he left home, for good."

"And that's it?"

Grace flushed. "You'll think I was dumb not to know more, but he just didn't respond to direct questions about his past. What I did learn came from inadvertent comments. I assumed the memories must be too painful for him."

"Nothing about where he grew up?"

"He knows a lot about California. He likes California. So maybe…" An embarrassed shrug.

"Did it occur to you that he might have been on the run from some kind of criminal charges?"

"These days, I think any young guys and most girls are lucky to make it through high school without getting arrested. If he got in trouble, I know it wasn't something really bad."

Oh, you sweet baby, thought Patience, and could feel Verity radiating the same thought. "Beyond his personal reticence, what is he like?" she asked. "What does he enjoy doing, besides construction work and surfing?"

"Danny is very strong. He likes to hike, for miles and miles. He likes to camp, he's done a lot of backpacking."

"In California?"

"I—think so."

"Do you think he'd had much education?"

"He said something once about wishing he'd gone to college. But he's really smart and he reads a lot, old stuff like Dickens and strange stuff like David Foster Wallace and Nick Hornby. He likes the library, goes there a lot. He loves music, has a nice voice, and is pretty good on guitar, although he doesn't have an instrument of his own. Oh, and he's very good with figures.

"He isn't perfect to live with," she added quickly. "He's messy in the kitchen and doesn't always clean up. He tracks stuff in from his work, and leaves tools around. And sometimes he's not very communicative."

Indeed. "Do other people like him?"

Grace came close to smiling. "He's quiet and doesn't do what my mom calls talking for noise, but he gets along with pretty much anybody. The homeless people around town know him for a soft touch; he almost always gives them money. In fact, one of the few times I saw him get mad was when he saw a couple of high school boys pushing a homeless guy around. Danny picked one boy up and just tossed him.

"And he'll stop and kid around with the guys down by Safeway waiting around for jobs."

"The guys down by Safeway," nearly all Hispanics from Mexico or Central America, gathered there mornings to be available

for homeowners or contractors looking for laborers. "He talks to them?"

"Oh, yeah, Danny speaks Spanish. Sometimes he'll translate for guys who've come to look for workers."

"But he isn't Hispanic himself?"

"No. Well, I guess his last name is, so maybe he had a Mexican father or something. Like I said, he didn't talk about his family. But he speaks ordinary English just like me, and he has fair skin and light eyes."

"Do you know how old he is?"

"Twenty-four. I kidded him one day about being an old man—because he wanted to stay home and read instead of coming along to a party—and he said he was only one year older than me."

"Healthy?"

"I never saw him sick. Eagle eye, lion heart—that's what I called him. He has a crooked nose, from a break, and scars on his hands and arms from work."

"Ah. Work," said Patience. "Tell me how your parents came to hire Danny."

"Maybe from a card on that bulletin board down at Safeway. My dad would look there when he wanted temporary help."

"And would they have asked him for references? That could be very helpful to us."

"I—don't know. My parents are smart, they both graduated from college, but they're old hippies. They like to make up their own minds about people, and they may just have sized Danny up and decided he was trustworthy. Which he was. And they let him live out there at the farm while he was working for them."

"He worked some for Linhares Brothers, I think," offered Verity. "And of course he's working—he has been working—for Val on my house."

Patience was watching Grace, whose face was bright with hope. "Grace, you have to know that the first possibility—that he didn't survive the fall—is still the most likely."

"Okay, I'll try to accept that. But by tracking him backwards, at least I'll know more about him, about what kind of life made him the man he was. It's worth a lot to me to find that out," she added, her voice unsteady.

Outside, Zak barked, a joyous bark. "Uh-oh," said Verity, and Patience put her notebook aside. "Grace, we'll have to wind this up for the present. I'm busy tomorrow, but I think Verity has time to explore some additional details with you."

Footsteps clattered on the porch steps, and the door opened moments later to admit Sylvie, Zak on her heels.

"Hi, you guys. Hi, Gracie! Did Danny come home yet?"

"Hi, Sylvie. No, not yet." Grace tossed a quick glance at the other two women. "I just came by to let you know I probably won't be giving lessons this week. I'm not even living at my house right now, just staying with a friend."

"Oh, sure. I'm sorry. But Gracie, you should get Patience and Verity to help you find Danny. Finding people is what they do, and they're really good at it."

10

"OH, GOOD. I WANTED TO CATCH YOU before you left."
Verity's old denim shirt and her painter's cap wore smudges of a
color that was somewhere between rose and apricot.

"Who would have expected our Sylvie to request a pink bed-
room?" Patience, dressed in better-than-jeans pants and loose
shirt, collected a scatter of papers from the table to slide them
into a leather manuscript case.

"It's not 'pink,' Mother. It's Island Coral mixed carefully with
Spring Dawn—I think. Sylvie's working on a name for it. So,
who's on duty this afternoon, you or me?"

"You, if you can manage it. I'll be out and about for the
Flynns, and I may be gone for most of the day."

"Ah! You have a lead?"

"Nothing specific. I'm sick of telephones and want to look the
people I'm talking to in the eye. What time are you seeing Grace
Beaubien?" Grace had left the Mackellars' house soon after
Sylvie's arrival the day before, promising that she'd be available,
and less bleary-eyed, the next day.

"We're meeting at her house in…half an hour," said Verity,
with a look at her watch. "We'll look through Daniel's stuff and
then work up a list of his friends and former employers and any-
body else who might know something about him."

"Good thinking. Verity…"

"Yes, ma'am. I'm listening." Verity touched the bill of her cap
in a brisk salute.

"Good. Grace is inclined to be protective, of herself and of
her lover. You'll need to dig, but carefully, for straight answers."

"You mean subtly, I bet," Verity said, and then rolled her eyes.
"Sorry. Poor Gracie. I'll start with my new kinder, gentler self, and
keep teeth and claws in reserve."

"As the Brits say, dear, horses for courses."

‿

AS Verity pulled up in front of the little stucco house at ten-thirty, Grace got up from her seat on the porch steps and stood there, waiting.

"I should have gone inside," she said as Verity approached. "But I haven't been in there since Sunday night when I came to pick up my stuff, so I waited for you."

"Have you talked with the police since yesterday afternoon?"

"I called them, on my cell phone. Nothing has changed." She turned and moved slowly up the steps and across the porch, key ring in hand. After a moment's fumbling with key and lock, she pushed the door open, took a breath, and stepped in, reaching to her right to flip a light switch.

Close behind, Verity nearly bumped into the smaller woman. "What?"

Grace was frozen in place, staring at a room in chaos. Seat and back cushions from a couch were tilted at angles or lay on the floor; a mission-style coffee table was on its side in a scatter of books. Music spilled from the rack of a piano and flooded the floor around the open piano bench, and an empty guitar case stood upright on an armless rocker, the guitar on the floor beside it. Seeing that, Grace gave a squeak of fury and plowed through the mess to snatch up the instrument and cradle it in her arms. "Poor baby! But she's not broken, not even the strings."

Verity noted speakers mounted high on the end wall; the low table against that wall bore a small portable television set and a not much bigger stereo–CD player. "They didn't take your music system."

Gracie tucked her guitar tenderly into its case before looking up. "Oh, that's just an old thing, the good one is in the shop. But the bastards missed the speakers, which are very good. Verity, I want to *kill* whoever did this!"

"I can understand that. What's through that way, the kitchen?"

"Yes." She moved to the doorway and stopped. "Oh, shit!"

Indeed. Drawers stood wide, flatware spilling from one; cupboard doors gaped and boxes of flour and corn meal had spilled their contents across the counter. The cupboard beneath the sink stood ajar, trash from a tipped plastic garbage bin trailing across the floor.

"Shit!" said Gracie, again, and paused on her careful way through the rubble to peer into an open drawer. "Well, the bastards got our household cash, which was all of about thirty dollars." She slapped the drawer shut in passing on her way to the back door, which she nudged with one foot. Aged, warped wood with a single old-fashioned keyhole, it opened wide at her touch. "I definitely locked it when I left Sunday night. But it doesn't have a deadbolt like the front door."

"I can see that. Okay, let's have a quick look through the rest of the house, just to see how bad it is. Then I'll call downtown."

Grace's chin came up. "I don't want to talk to the police. They'll probably say I did it myself."

"I don't think they'll do that," Verity said, by no means sure she was speaking the truth. "Gracie, do you know Detective Hebert? John Hebert?"

"Oh. I met him Sunday, I think. He was okay."

"He's a good friend of mine, and a very nice guy. I'll try to get in touch with him directly."

Grace sighed, and spread her hands. "Okay. I'm sorry to be so much trouble."

JOHNNY, bless him, answered his cell phone when Verity called him a few minutes later, and reached Grace Beaubien's house five minutes after that. Verity, waiting on the porch, felt her tense muscles ease as she watched him take the steps in long, effortless strides. He draped an arm across her shoulders for a two-second hug, and nodded a question at the open door.

"Come in and have a look. Gracie thinks, but isn't sure, that there are several things missing from the room she and Daniel Soto used as a study. For the rest, it's hard for her to know what's missing because the trashing was so thorough. What she is sure of is that this has happened since she was last here sometime late Sunday night. As I told you, the front door was locked when we arrived; the back wasn't, although she'd locked it."

Grace came into the living room as they entered. "Ms. Beaubien, we met briefly on Sunday. Detective Johnny Hebert," he said, settling into the easy slouch he knew diminished his own size, "and I hope I can help you."

Her troubled expression eased a bit as she took the hand he

extended. "Thank you for coming. I'm a singer with a quartet named Old Music, New Voices, and we had a concert Sunday night, and a late dinner afterwards. Then I came home and— didn't feel like staying here alone, so I tossed clothes and stuff in my car and locked up and went to stay with a friend. Sometime between midnight Sunday and ten-thirty today when Verity and I met here, somebody broke in."

"Who besides you has keys?"

"Daniel Soto, my boyfriend." Her voice faded on the last word, and she paused to swallow. "My parents, they own the house. But they're in Europe, and they wouldn't have given the keys to anyone else."

"Would your neighbors have noticed any activity here?"

Gracie shook her head. "This street is mostly students, three or four to a house, and a few young couples. There are people coming and going at all hours."

"Why don't you show me the back door," he suggested, and followed her into the kitchen. When he reached for the door-knob, she winced, and he shook his head. "That old glass knob has smears all over it, not to mention drops of paint. In an old, lived-in house like this there are so many fingerprints everywhere that it's rarely worth checking. Ms. Beaubien," he went on, eyeing the lock, "I could open this with anything—icepick, needle-nose tweezers, maybe even a straightened-out paper clip."

"I'm sorry," she whispered.

"Not your fault," he said cheerfully. "Would you like to show me through the rest of the house, and point out what you think is moved or missing?"

The two of them, with Verity following, moved back through the mess of the living room, and on into a tiny hall that led to a small bathroom and a bedroom, both doors open. A door in the rear wall of the bedroom was also open, onto what had probably been a sleeping porch or sun room.

"The medicine cabinet was open," Gracie said, "but I couldn't see anything missing. And the bedroom…" she stepped inside and the others followed "…is a mess, but I'm not sure that wasn't just me, when I came in Sunday night and stuffed two or three days' clothes in my duffel." A jutting drawer showed a tan-gle of underwear, and the open closet door revealed some gaps in

the hanging clothes and a pile of what looked like jeans and shirts on the floor.

"And I can't tell if any of Danny's clothes are missing. He doesn't have many, and they're all pretty much the same, jeans and sweatshirts." She turned away and moved toward the adjoining room.

"This is our study, office, whatever." There was a desk against one wall, a wooden door supported on a pair of two-drawer filing cabinets. An oak table probably two feet by four feet set against an adjoining wall held a computer monitor and a printer, neither of them new. "That's where Danny worked on his laptop, a Gateway, I think, and pretty old. It's gone. Good thing I took mine with me Sunday night."

Johnny pulled a small notebook from his pocket, made a quick note, and looked at her questioningly.

"And his digital camera is gone, from that cupboard in the corner. But he used it at work, and sometimes he kept it in his van."

Johnny made another note. An ancient Gateway wouldn't be worth much, but a digital camera might be. "Anything else?"

She sighed. "Yes. The biggest thing, I guess, is Danny's lock-box. From his drawer of the filing cabinet, the bottom drawer on the right. In the back. It's empty now."

"And what was in the lock-box?" Johnny hooked his pen in the handle and pulled the drawer wide.

"Money, but I don't know how much. He didn't want to bother with a checking account, so he put his pay there and took out what he needed."

"Was it a metal box, with a good lock?"

"It was metal, and heavy, and the lock looked serious."

"Where did he keep the key?"

"On his key ring. "

Johnny turned to the drawer again. "Was there anything else in here?"

"A folder of class hand-outs and notes from a course on electricity at the skills center, and another from a class in—physics?—at the community college. And his work notebooks," she added, sketching an oblong rectangle in the air. "He kept—keeps—his own notes and sketches for any job he's doing."

"And that's it?" he said, half to himself. "Ms. Beaubien, did he have a pink slip for his van? Auto insurance, tax records?"

"I'm sure he did, but I didn't ever have occasion to see them. Danny has lived with me for six months, but I didn't do his laundry or pay his bills or file stuff for him. Maybe those things were in the lock-box."

"Did he use a credit card?"

"Not that I ever saw," Grace said.

"I realize this is private, but did he help you with the rent?"

"I don't pay rent to my parents, and it never occurred to me to ask him to. He paid half the expenses." Grace's voice was high and thin, and Johnny thought she might be near tears.

"I see. Is there anything of yours missing from here?"

"Not that I could tell. But most of what's in my drawers is music. My correspondence is almost all by e-mail, and I don't always bother with hard copies. Major stuff I keep in my safety-deposit box, or out at my folks' house, because I travel some and you never know."

"Money? Jewelry?"

"We usually kept a small stash in a drawer in the kitchen, for walking-around money, and that's gone. I don't have any jewelry except costume stuff and a Navajo ring that I always wear, either on my hand or on a chain." She held out her right hand to display it. "Danny gave it to me."

"That's very nice," he said, bending his head for a closer look at the big turquoise set in heavy, worked silver. "And fairly old, I'd think."

"I guess," she said, and stroked the ring with the fingers of her other hand.

He turned his gaze on her again. "No pot or coke, that kind of stuff?" She stiffened, and he added, "Sorry, but that's often what housebreakers are looking for."

"I'm a singer, I don't smoke *anything*. Or put anything up my nose. We don't either of us mess with drugs, they're not worth the trouble."

"Very sensible of you. Well." He cast a glance around the sparse little room. "It's possible this was kids playing bad guy, or somebody really desperate for something that would get him quick cash, probably for dope. And lucked out finding a money

box. Do you know whether there've been other break-ins or vandalism in this neighborhood?"

She shook her head. "I don't know of any kids around here except a baby or two. And this is a really low-income area, not much fancy gear to steal. I don't feel very good. Could I sit down?"

"Of course. " He pulled out her desk chair, turned it, and watched her settle onto it.

"I won't keep you much longer," he assured her, and backed away to give her space, propping his rear against the oak table. "I know you were asked about this earlier, Ms. Beaubien, but have you thought of any enemies Daniel Soto may have had?"

"I guess he might have made somebody mad and not told me about it; we were both busy. But I can't imagine how, or why."

"You're an attractive young woman. Was he protective of you with other men?"

"Well, now and then, after a performance, some guy would get a little too friendly, and Danny would step in the way. But he's almost as big as you," she added. "He didn't need to do anything except loom."

"Can you recall anything out of the ordinary that had happened to him recently? Something that seemed to upset him, even if he didn't talk about it?"

"No, I..." She closed her mouth and frowned. "I'm sorry. I almost forgot."

Watching her, he tipped his head to listen.

"One afternoon last week...Thursday," she went on after a moment. "Because Sylvie was just leaving after her guitar lesson. Anyway, Danny came home from work tired and dusty and kind of *down*, and finally said something dumb about, maybe I could have done better than him."

"And you asked him why?"

"I snapped at him," she said, and sighed. "What he said was that he'd been on an errand downtown and thought he saw somebody from another time but it couldn't have been. When I asked who, he said it was nobody I'd know.

"And then we had supper and he went off to a meeting with the protest people, and this 'somebody' never came up again." She looked down at her clasped hands. "And Friday morning I

made breakfast and told him I'd be leaving around noon and would see him Sunday. And I kissed him good-bye and he went to work, and that's the last time I saw him."

"Thank you, Ms. Beaubien. That may be helpful." Pretending not to notice her tears, he made a last quick note, slid the note-book into one pocket and took a business card from another, to lay it on her desk. "I think this room may be worth printing, so I'll send somebody over. And somebody, maybe me, will be back later today to see whether any of your neighbors noticed anything."

"Okay."

"If anything further happens to frighten you, or if you remember anything more, give me a call. I've always got my cell phone with me. If I were you, I'd get a locksmith in to put a deadbolt on that back door before sleeping here again."

"Thank you, I will." Grace stayed where she was as he sketched a salute to her and headed for the door. Verity, stepping out of his way, caught his look and was about to follow when the telephone rang.

"It's okay, I'll get it," said Grace, and reached for the instrument on her desk.

"I'll be right back," Verity told her.

"Did Chief Gutierrez send you out to win Gracie's confidence or something?" she demanded as she caught up with Johnny on the sidewalk in front of the house. "God knows *he* didn't do a good job of that."

He grinned at her. "I registered your displeasure when I started with the questions about Soto. No, it was just cop's second nature: somebody's talking, encourage him. Her. Although when the department gets out from under the load of dealing with riots past and to come, we'll try to find out more about who this presumably dead guy is."

"Presumably?"

"Damn near surely, okay?" He stopped beside his car and turned to look at her. Color high from irritation or maybe the brisk wind, she lifted her chin and met his gaze. "I gather this was a serious relationship?"

"She thought so. Why?"

"Because every now and then, underneath her real fear and worry, there's something else. Almost a sense of excitement."

At her astonished look, he spread his hands. "Okay, give me a better word. Anticipation? For all her baby face, is she the kind of person to get off on mayhem and bad actors?"

"No! At least, I don't think so," she added, lowering her voice.

"Then how 'bout this. She thinks Soto is the housebreaker. Which would mean he's alive."

As she simply looked at him, he went on. "Except for what I gather was a small amount of cash, all the stuff missing is his. And the mess could have been for distraction. Add to that the fact Soto wasn't quite the teddy-bear she makes him out to be; his anti-war buddies told us he beat the shit out of a heckler who challenged him.

"This is conjecture, Verity; don't repeat it, don't give it too much credence. But don't forget it, either, since I gather Patience Smith is involved?"

As he watched her decide how to respond, he realized that Verity's face was much easier to read than, say, Grace Beaubien's. At least for him. Should he tell her this, sometime?

"Grace has asked us for help, yes. And since you've provided me with answers to questions I hadn't yet gotten around to asking, I'll tell you that she does half believe that Daniel could have survived that fall somehow and might be…who knows where?"

"And you agree with her?"

She shook her head. "She wishes it true, but she's a smart woman and reality will settle in soon enough. In any case, she wants to find out what she can about his origins."

They stared at each other for a moment, and he looked away first. "Okay. I trust that if you find out something the police really need to know, you'll tell us."

"I'm aware of my legal responsibilities—or at least, Patience is." Her chin was up again, her gray-blue eyes chilly.

"But this situation has troublesome overtones, Verity. Please be careful."

"Right. Maybe I'll swap jobs with Patience and go looking for lost dogs."

"Good idea," he said with a grin. "Okay, gotta go, I'll be in touch. And if you want help with your house, I expect to be available this weekend."

"Wait," she said, and put a hand on his arm. "I understand there's been nothing new on Daniel Soto, or his body?"

"Nothing. Sometimes bodies just never turn up. And to bring you fully if unprofessionally up to date—we've got no ID as yet on the dead second guy, either." He bent to touch his lips briefly to hers, and went to get into his car. As he drove away, a glance in his rearview mirror showed her hurrying back to Grace Beaubien's house.

INSIDE, Gracie had put a pair of cushions back on the living room couch and sat there cradling her guitar, swiftly moving fingers producing a gentle melody Verity found familiar. Fernando Sor, maybe?

"Anything important on the phone?" Verity asked.

"Chief Gutierrez called to tell me there was nothing new on Danny or the other guy. And to apologize."

"Apologize?"

"For being so sharp with me yesterday. He said that was not the way public officials should treat citizens, and he was sorry."

"Good heavens," said Verity, and revised slightly her opinion of the city's volatile police chief. "Well, if you still want me to work for you…"

"Oh, I do!" Grace laid a stilling palm on the strings and looked up.

"Then we need to put together as much of a list as we can: friends, employers, anything you can think of. Have you the energy for that now?"

"Sure. But please, not here," she added softly, looking around the disordered room.

"I agree," said Verity. "Tell you what, let's go down to Armino's. It's early for lunch crowds, so we can probably find a quiet booth. And if you like, I'll drive, and then bring you back here."

"Thank you."

11

ARMINO'S COFFEE SHOP AND BAKERY was a Port Silva landmark, now run by a second generation of Arminos with occasional help from a third. By the time the two women were settled into a back booth, Verity with a Peet's Mocha-Java and a scone, Grace with a latte and a sticky bun, Grace's color was near normal and her posture visibly less tense.

"This place is one of the things that made me feel not so bad about coming back here," she said.

"What brought you back?"

"I'd finally finished at Davis after switching majors from ecology to music, and I heard about the course in early music at the community college here. That was the direction my own interest was taking.

"Meanwhile, Ethan, my baby brother, had graduated from high school and was working for my folks at the farm while he decided what he really wanted to do—and then September eleventh happened. He joined the Marines like the next day," she added with a shake of her head. "So I ran back and forth between here and there for a while, helping out with stuff Ethan had been doing and mostly trying to help my parents feel better. That's when I really got to know Danny."

Verity set her notebook on the table, she hoped unobtrusively. "He was working for them?"

She nodded. "Since, oh, about August. He'd done some work on the greenhouses, and put solar panels on the farmhouse. Then Dad showed him this old building they'd been using as storage and potting shed and said he'd been thinking of it as a place to move the office into, from the house. Danny said that with a little research and maybe some day help when he needed it, he could do it. And he did," she finished, blinking hard.

"And then went to work where?"

"For a friend of my dad's who was remodeling a house in town

for a restaurant; that took quite a while. And he did some smaller jobs, like the one at your house. He worked a lot."

"Yesterday you said your parents might, or might not, have asked for references on earlier work?"

She shrugged. "They often as not don't bother. As I recall, my dad said he'd called two people Danny had worked for, Joe Linhares and an architect named Matthew Evers, and they basically told him Danny was a good guy and did good work. I'd be really surprised if he asked them for anything in writing.

"But I can go out to the farm and check the files, if you like," she added.

Joe Linhares was a friendly guy who probably had comfortable personal exchanges with his valued employees. Verity certainly hoped so, anyway. "Okay. I'd presume those files would have his social security number, too?"

"I'll look for it." Grace turned her attention to her sticky bun, which looked yummy. But so was the currant-stuffed scone. Verity took another thoughtful bite, and returned to the issue at hand.

"Yesterday I think you said something about Eureka?"

"That was just a passing remark, and I don't remember the context. I think we were probably just talking about the north coast, and he said something about liking Eureka and the area north of there."

"And you said Danny lived at the farm while he was working there?"

"Yes, but I didn't." Verity raised an eyebrow, and Gracie blushed just a bit. "My mom is a soft touch, and she likes having people around, cooking for them, like that. So after she'd got to know him, she insisted on giving him the spare bedroom. But my dad would have thought it—unseemly—for his daughter to be sleeping with one of his employees right on the job, so to speak. Later, when he moved in with me in town, nobody seemed to mind."

Just not in our house struck Verity as an odd rule for a pair of old hippies. "Have you thought further about any local friends Danny had? Somebody he jogged with, worked out with? Drank with? Shot pool with?" Verity added, as she received nothing but head-shakes in response. "Grace, there must have been *somebody.*"

"I don't…well, a couple of people involved with the protests might count. Chris Matila for one, Danny brought him home for a beer a time or two. He's a nice guy. And I guess Sean Flynn." Verity looked up from her notebook at this, and caught a look of distaste on Grace's face.

"What's the matter with Sean Flynn?"

"Oh, he's just a mean-spirited jerk. Always looking pissed off, never a good thing to say about anybody. Except Danny, I think maybe he has a crush on Danny." Grace paused, shook her head. "Sorry, that's not fair. Danny told me Sean had a rotten time growing up, and I think he felt a kind of kinship with him. But I told him Sean made me uncomfortable, and he agreed not to bring him to the house anymore."

"Seems fair," said Verity.

"I thought so. Anyway, for the rest of it, Danny didn't need to work out," Grace went on, "and he ran by himself. He didn't drink much, but he played pool, sometimes, at Red's on Heber Street. Mostly he went places with me, and sometimes my friends, or he went to the library, to do his research or read newspapers. I'm sorry, Verity," she said, looking once again on the edge of tears. "We were still kind of—new to each other, and in love. So we didn't notice other people much."

"I understand. Just keep thinking and maybe something, or someone, will occur to you." Verity looked at her watch, and picked up the last piece of scone. "Let's finish here, and I'll take you home. Clearly I have some work to do."

Fifteen minutes later, she pulled up in front of Grace's house and turned to face her passenger. "Gracie, do you want me to come in with you?"

Grace shook her head. "Thanks, I'll be okay. But I don't think I'll stay here." She opened the door and slid out. "Either I'll stay out at the farm, or I'll go back to my friend's place," she said. "I'll let you know."

IT was getting late, and she'd be expected at home, but Patience couldn't resist stopping at the Flynn farmhouse. When she pulled into the gravelled parking area before the farmhouse and saw that Allie's small gray sedan was there, next to a late-model pickup, she said, "Aha!" aloud. She was out of her car and on her way to

the front door when it opened, and Allie Flynn came hurrying out, closing the door behind her with exaggerated care.

"Oh, Patience, I'm so glad to see you! Around here, where he won't hear."

"Who?" she asked, but Allie put a finger to her lips and led the way to a white-painted gazebo, where she dropped onto the built-in bench seat and patted an adjoining cushion. "It's Dennis, he's driving me crazy. Please, have you found Pete?" She tossed a quick look over her shoulder toward the house.

Patience sat down. "I believe I have, and I can tell you where to get in touch with him. Allie, what's the matter with your brother-in-law?"

"I think he's lost his mind. The police came Sunday with a warrant for Sean, because he apparently attacked someone at that riot on Saturday night; and Dennis flew into a rage. When they finally left, he took off looking for Sean, and of course didn't find him, they'd been on the outs for at least a week. Since then he's been haunting the police station, or stalking around here drinking and cursing." She cast another fearful look toward the house.

"Allie, would you like me to take you somewhere?"

"Oh, no. The children might call, and truly, Dennis won't hurt me. So where's Pete? The rat."

Patience took a slip of paper from her bag. "I haven't had time to put together a full report yet, but earlier this afternoon I found Pete's truck parked at the Redwood Monastery in the Whitethorn Valley. Here's the telephone number there; I felt I should leave it to you to make contact."

Allie took the piece of paper, tucked it into her shirt pocket, and leaned close to give Patience a hug. "Thank you, thank you! You've saved my life, or at least my sanity, and I know Pete will come at once when I tell him what's happened. Now I'd better get back inside and make sure that idiot doesn't burn the house down or something."

WHEN Patience drove into her own yard at around seven-thirty, she was hungry, weary, and pleased with herself. She heard piano music from the studio: Sylvie practicing, or just having a good time. As she trudged up the front steps, she caught a strong odor of garlic, proving Verity was at work. Life could be good.

"I'm home," she called. "And hungry. But maybe even more thirsty," she added as she reached the kitchen.

Verity, in shorts and T-shirt, looked up from the wheeled butcher-block she'd bought recently for her kitchen-to-come. Patience spotted a pan of what looked like chicken breasts on the counter, dotted liberally with bits of butter and green flecks of some herb.

"Hi, Ma," said Verity, and gathered up a handful of minced garlic to strew it over the chicken. "There's plenty of time for a pre-dinner drink. And you can tell me what weird stuff you've been up to."

"I can now inform you that I have had an interesting and successful day," Patience said as she put ice in a squat glass and tipped in a good jolt of The Macallan. "For a change."

"Glad to hear it, Ma." Verity eyed her bright-eyed, cheerful mother and realized belatedly that while she herself was engrossed in the demands of her new house over recent weeks, Patience had put in a lot of time at Grandma duty and mindless household chores. "Let me get a glass of wine, and you can tell me about it." She poured wine over the chicken, covered the pan, and put it in the oven before pouring a glassful from a different bottle to take into the living room.

Patience, ensconced in her favorite corner of the couch, took a sip from her glass and smiled. "I have found Pete Flynn. Or I'm ninety-nine percent sure that he's found, leaving a one-percent chance he might take off again before his family gets to him. So I stopped on the way home to tell Allie Flynn in person."

"Mother, where? And how?"

Another sip, very small. "One of the friends-of-Pete I spoke with by phone Saturday afternoon was particularly evasive. He's a dairy farmer who lives up near Ferndale."

"In Humboldt County just above the Lost Coast?"

"Right. Then after an interesting conversation yesterday with another friend of Pete's named Roger Collins—a man from church, I don't think you know him—I decided to try the evasive dairy farmer again, but in person."

"So you drove up to Ferndale? That's what, a hundred miles?"

"More like a hundred twenty-five. Anyway, at first he was un-accommodating, but I was sweetly persistent. And he finally said

yes, he'd seen Pete briefly at his own farm on October eleventh or twelfth, he wasn't sure which. That would be about ten days after he'd disappeared."

"And he knew where Pete was going?"

"No, or at least he said not. But Pete's presence in the area fit with what I was thinking. So I went on to—"

"Mother!"

"Verity, let me tell my story. I backtracked about sixty-five miles to Honeydew, on the Lost Coast, a place where everybody stops. And it turns out Pete Flynn did stop there, on October sixteenth; it was a Wednesday afternoon and there was an after-school ballgame going on in the field across from the store. The woman from the store remembered that Pete bought a sandwich and a beer and watched the game for a while."

"You, um, deduced where he went from there?"

"Indeed, and don't be snippy. When Roger Collins, a good Baptist, is depressed, he goes to hear the singing at black churches. It turns out that sad, depressed, Catholic Pete Flynn went to the Redwood Monastery in the Whitethorn Valley. At any rate, his truck is parked there, or was three hours ago."

"And you believe Pete Flynn has become a monk."

"Well, probably not. I think he went there for a retreat. I've heard about the monastery now and then over the years, and having met the acting priest at Our Lady of Mercy here in Port Silva, I'm sure that a troubled man needing the consolation of his faith would try someone, or somewhere, else."

"So you drove, what, another hundred miles? And didn't go up and ring the bell and say please, Brother Whoever, may I speak with Pete Flynn, his family is looking for him?"

"More like thirty. And Sister Whoever, it would be; the monastery belongs to a group of Cistercian nuns. I didn't feel it was my place to be the interruptor of whatever relief Pete is getting from his time there. That's up to his family, which is what I told Allie."

"I see. Actually, that makes sense even to an unbeliever like me."

"Good. Thank you. My, that chicken is beginning to smell good. I'm starved."

"Thirty minutes, max. And you stay right there, after your truck-driver's day. Everything else is ready."

"Lovely. Now tell me about *your* day."

"It wasn't as much fun as yours. Main fact—not that there are many of those, facts—somebody broke into Grace Beaubien's house by picking a very pickable lock on the back door."

"Grace wasn't hurt?"

"She hadn't been back to that house since Sunday night, so by the time I got there and we went in together, any intruder was long gone. But he, or she or they, had left a hell of a mess."

"Poor Grace. Did she lose anything important?"

Verity shook her head. "Nothing vital of hers. Most of what was taken belonged to Daniel. We looked it over and called Johnny, and he came out. And Ma, I have to tell you, that man has an interview technique I'd love to learn, except I think it's too subtle for me."

"Voice and physical demeanor, in addition to unsentimental good sense and an honest interest in the well-being of others. I doubt one can learn that."

"Probably not. Anyway, he questioned her thoroughly but gently, and finally coaxed this from her. It seems that Danny came home from work last Thursday very 'down,' as Gracie put it, and told her he thought he'd seen someone downtown that afternoon from 'another time.' When she asked who it was, he told her never mind, it was nobody she'd know."

"This is where one of the old-timey detectives says, 'The plot thickens.'"

"More than you know, actually. Johnny suspects—not that I necessarily agree with him—that Grace thinks her burglar may have been Danny. Just his impression, he insisted, and not to be taken as gospel. "

"Then we won't."

"Right," said Verity. "Anyway, after Johnny had left, Grace and I adjourned to Armino's for solace and more information; I'll print out my notes for you after dinner. She's going out to the farm for a look at her parents' files; and then she'll either stay there for a few days, or with a friend in town." She paused, sniffed the air, and looked at her watch.

"I think the chicken's ready to be uncovered, which means the rice is nearly done. I'll go call Sylvie," she said, and got to her feet.

"She was playing the piano very enthusiastically as I came by."

"Good. She ran into Katy Halloran after school today, and Katy had the remains of a black eye—just like you. Turns out she was also one of the participants in Saturday's protest, and didn't leave the park quite soon enough."

"Oh dear."

"Yeah. I suspect Sylvie and some of her friends are thinking of forming a Children's Brigade. Kind of a political Brownie troop."

"What a very—*interesting* idea."

12

THE LONG, CURVED TABLE ON THE dais in the city council chamber was crowded, the added chairs presently occupied by people in uniform. The hall was equally crowded, with the double doors at the rear open so people standing in the hall outside could observe or at least hear what was going on inside.

Mayor Ed Riley, a tall man with an amiable face under a shock of prematurely white hair, got to his feet and moved to the lectern at the front of the dais, lifting a hand in a signal for quiet. "Good evening. The council members and I decided to call this extraordinary meeting to address the questions we've been hearing about the events of last weekend and the days since. And I must say it's rewarding to see that so many of our citizens could find time to come out on a chilly evening. As you can see, our chief of police and several members of his force are here, along with your city council members, to respond to your concerns."

There was a murmur of response, not entirely friendly.

"First, the background. A group of local people had asked permission to stage an anti-war demonstration at South Bluffs Park next weekend. The council considered that request, a majority of us felt there would be too many problems, and we decided Thursday night that we would not issue a permit for the demonstration.

"As you all know by now, the demonstrators decided to ignore our decision, and on Saturday they gathered in town, marched to the park, and held their anti-war protest, which ended in a riot. A number of people were hurt, and two unfortunate men either fell or were pushed from the bluff into the ocean. Some of you may already be aware that one of the men, or his body, was found yesterday. No one has come forward to name or claim him so far. The other has been identified by people on the scene as Daniel Soto, a young man who had lived in Port Silva for about two years and worked in construction. Daniel's body has not yet been found."

Riley paused for breath. "Now. Chief of Police Vincent Guti-
errez, who was on the scene with his officers during most of the
day and evening, will give you his view of the demonstration and
its outcome. After that, he, other members of his force, and the
entire council will take questions. Jason Lee, from my office, is in
the chamber with a microphone for any questioner who wants it."

Gutierrez got to his feet and moved to stand behind the lec-
tern in square-shouldered parade rest. "We—the police—knew
about the request for a permit for an anti-war demonstration, and
knew it had been denied Thursday. From then until just after one
P.M. on Saturday, no one on the force picked up any noise about
plans to go ahead without a permit. Then we began to get calls
about unusual numbers of people gathering at the baseball park
and on the streets. We immediately called in all off-duty person-
nel, geared up, and moved out.

"My view, once I saw what was underway, was that our best
action would be to move with the march and keep order in any
way necessary. There were in fact no real problems on the march
to South Bluffs, and the demonstration once it reached the park
was crowded but mostly peaceful. The organizers had appointed a
number of monitors who were alert and equipped with walkie-
talkies."

"Why the hell—?" A large, red-faced man stood up in the
center of the audience and waved off the microphone quickly of-
fered. "Never mind. Why the hell didn't you cops just stop the
bastards? Throw 'em in jail. They were breaking the law."

"The First Amendment states that Congress may not abridge
'the right of the people peaceably to assemble and petition the
government for a redress of grievances.'" Gutierrez's voice put
quotation marks in place. "So it's not clear that the march itself
broke any laws. But what was clear," he said, raising his voice
against sounds of protest, "was that at least a thousand people—
and several hundred more by the end of the march—were moving
peacefully along, and stopping them physically would have been
difficult for us and probably dangerous for them. There were older
people and even some children in that crowd."

"Hey, where'd you grow up, Berkeley?" called out another
man. "I mean, I saw you guys, you didn't even have riot gear on."

"I grew up in Port Silva," said Gutierrez in even tones. "And

we had batons, sidearms, and vests. My personal and professional opinion is that full riot gear with face masks can be more incitement than help. Those people were our fellow citizens, and they deserved to see our faces."

"But people *were* hurt, in the park." The speaker was a tall woman with gray hair; she'd accepted the microphone. "Couldn't you have stopped that?"

"I can't offer any excuses for our failure there. Most of the crowd had left or was well on its way out, and we didn't read the people still there quickly enough. By the time it was over, we'd made twenty-six arrests. Beyond the two men who died, apparently fighting each other on the edge of the bluff, the worst injuries were a broken arm, a mild concussion, and the loss of several teeth. The weapons were fists, rocks, and a couple of baseball bats. Now, is there anything else I can help you with?"

"Yeah, I want to know how you voted on the permit." Another large man, this one fair-haired with muscular shoulders and a weathered face.

"I don't have a vote. The council is our city government, I'm an employee."

"Yeah, but which side did you agree with? I want to know if the chief of police my taxes pay for is a lily-ass liberal too chicken to fight for our country, like the rest of those guys you just let mess up our streets."

"Mr. Olson, my 'side' is none of your business. I offer opinions to the council, and then I follow their instructions unless it's against the law or my conscience. In either of those cases, I'd just resign. And so far as defending our country, I did two tours with the Marines in Vietnam."

"We appreciate that, Chief Gutierrez, and your work here as well," said Mayor Riley. "Those protestors were indeed our fellow citizens, and my own son was one of them."

"So was my daughter," said Gutierrez.

Another man stood up and reached for the microphone. "So the entire police force was out there, grabbing people and tossing them in the wagon and then turning them loose an hour later to go and sin again. Did you guys ever actually charge anybody with a crime? Like something they'd be locked up for, or at least pay a fine?"

"Some of those arrested were released without charge, and I suppose some of them are now sinning. Officer Coates, who's been doing the booking, will give you some figures on those who were charged." Gutierrez nodded at another uniformed man and moved back a few feet to remain standing.

Oh, Vince, watch your tongue. Meg Halloran, seated toward the rear of the hall, kept her expression serene with difficulty. Katy, beside her, lifted a hand to cover her own grin. At the lectern, Brad Coates gave the names of the nine who had actually been charged with assault, vandalism, and/or resisting arrest. "Four were bailed or OR'd, three are still locked up. We have warrants for the last two, but haven't been able to find 'em yet," he added, and sat down.

The questioning went on, directed mostly to the police: Why were protestors, any protestors, still allowed on the city sidewalks and the bridge after Saturday night's troubles? Could more officers be posted downtown, to protect businesses against vandalism? Could residential areas be patrolled more frequently to stop the current rash of housebreaking? Would the city grant a permit for people who wanted to demonstrate at the park in *support* of our government? Would the police consider picking up outside agitators from Berkeley or San Francisco and putting them on buses home, and if not, why not?

To each question, Gutierrez gave the nod to one of the others of his crew: Coates, Captain Svoboda, Lieutenant Hansen, Detective Hebert, Sergeant Chang, Officer Linhares. After more than an hour, as questions continued, another man in uniform came up to speak quietly to Gutierrez, who nodded.

A small, dark man stood up from near the rear of the room and accepted the offered mike. "I been checking names with neighbors here, and I want to know how come you only charged three of those pacifist bastards, while the other six were patriotic Port Silva citizens."

Gutierrez moved forward. "Mr. Ricci, I'll take that one. Every man and woman on the Port Silva police force understands that our purpose is to *protect and serve*. You may have read that on the doors of our patrol cars."

Meg heard the implied "If you could read" and hoped no one else did.

"Saturday, before sending almost every Port Silva officer out to deal with the protests, I made it very clear once again that a police officer in uniform on the street *has no politics.* We patrol the streets, endeavor to stop *any* criminal behavior as it occurs or before if possible. We rescue *any* people who are in danger and control and arrest *any* perpetrator, with the minimum necessary force. An officer who doesn't follow those principles knows that he or she won't be with us long. Now, if you'll excuse me, I'm needed at my office. Captain Svoboda will act here in my place."

"Good timing. I was beginning to feel the urge to contribute a question," Meg said very softly for Katy's ears only.

They got to their feet and moved quietly out into the hall, Katy ignoring the glances her colorfully bruised eye drew from the people standing there. "What do you suppose Dad will do with himself if he gets fired?" Katy asked when they had gained the street .

"God knows. Take up fly fishing, maybe?" Meg suggested, and Katy giggled. "Ah, there he is. Shall we ask him?"

"Oh, probably not. Hi, Dad. Good show."

"Thanks, kid. I always appreciate a good review from a serious observer." Gutierrez put an arm around her shoulders for a quick squeeze. "So, are you ladies free to join me for a late dinner? I took care of the office problem via cell phone," he added in response to Meg's questioning look.

"Thanks, but I can't," said Katy, with a grimace. "This was an interesting break, but now I've got calculus and *King Lear* to deal with."

"I can," said Meg. "Here, sweetie." She pulled a set of keys from her purse, to hand them to Katy. "You take the car and go on home, and the chief of police will bring me along later."

THE Dock was sparsely populated on a Tuesday night, and they were able to get a corner table against the windows looking out over the river-mouth. When their martinis had been delivered and tasted, Meg looked out at the channel lights and the peaceful waves beyond. "Eight years here," she said, "and the ocean after a storm is still a surprise to me."

"Yeah, just like people. Out for murder one minute, full of peace and brotherly love the next."

"Vince, drink your drink and forget that you had to hold your temper tonight and talk about yourself. You probably won't have to do that again for weeks. Months?" she added, holding up a hand with fingers crossed.

"We can but hope," he muttered, but his grim face eased a bit. "At least there's still wild salmon, even if it's not local."

"And soon there'll be Dungeness crab. Much to be thankful for."

"Small, good things," he said. "But the big, mean stuff is still going to happen. Peace may be patriotic, like the badges say, but I'll lay odds we're going into Iraq."

"But that doesn't make sense!"

"To a lot of people, particularly in Washington, it does. And who knows, maybe they're right?"

"Vince, you don't believe that." Meg frowned at him over the rim of her glass.

"In my personal opinion, there a lot of other things we should be considering instead. But for now, we'll try to keep the lid on in our own town, for everybody."

"And protect our daughter."

"Oh, yeah. That'll be even harder. You know," he said, in a change of tone, "I'd wondered why Ed Riley voted to deny the permit. He's no flaming liberal, but he's pretty much a live-and-let-live guy. Now I get it. He was worried about his son getting all involved in something that might screw up his future."

"Will it? Was his son in the march?"

Gutierrez nodded. "One of the original organizers. This time, there won't be any official charges against him; he was clearly doing his best during the riot to help quell the fighting. But he's a big, bright, idealistic kid, and his dad would hate to see him do something that would interfere with his admittance to law school."

"Well, so far as I know Katy has no interest in law school. But that nice, and quite handsome, Daniel Soto probably had some kind of future in mind, too. Is everyone sure he's the one who went over?"

"Very little doubt. I didn't know you knew him."

"Katy knew him, a bit. He was in some of the protests she took part in, down at the bridge, and one day when I picked her

up, she introduced him. He struck me as shy to the point of being inarticulate, but Katy said he was smart when you got him talking, and played guitar, too. And when he was there, nobody was brave enough to make rude remarks to her. Is there any possibility that his fall wasn't an accident?"

"Possibility, sure. Suspicion, not yet. Ah, here comes our salmon."

13

"MR. FLYNN."

Not exactly the caller he'd have chosen to begin his day, Gutierrez noted as he rose from his desk to greet the man who stood in the doorway of his office. But at least he didn't look to be spoiling for a fight this morning. "I'm sorry, but I don't have any new information for you about Sean. We've spoken to his local acquaintances, as stated in the report we gave you yesterday. We've searched our own area thoroughly and alerted the sheriffs in Mendocino, Humboldt, and even Del Norte counties. And we've come up with zilch so far."

"I know." Dennis Flynn leaned heavily on his cane as he came across the room. "Mind if I sit down?" he asked, and dropped into the chair nearest the desk without waiting for a reply.

"Not at all." Gutierrez sat down in his own chair and waited.

"I've talked to all the people you listed in the report. Some of them were friendly, some weren't, but I don't think any were being evasive."

"We made it pretty clear to them that evasiveness would be a bad idea."

"I appreciate that. Anyway, the ones who happened to be near him in the melee that night said he'd been building up to an edge all day and then got into several nasty punch-ups once fights broke out. Then when the police waded in and everybody ran, they figured he was just doing what they were, trying to avoid arrest. But none of them talked to him, or paid any attention to where he was going. And none of them saw him later."

"That's what they told us, too," Gutierrez said, "and we haven't seen, or heard, anything to the contrary."

Flynn nodded, and drew his mouth tight. "My boy is…not an easy person. Pigheaded about his opinions, and likely to blow up when he meets opposition."

Gutierrez had heard this from several of Sean Flynn's acquaintances, but before today, not from his father.

"He had a rag-tag childhood," said Flynn, hunching his shoulders as if in defense. "My fault, partly. Maybe mostly. And he figures, I guess, that he has to be ready to take on the rest of the world, including me, at any time. I didn't even know until I read your report that he hadn't registered at Humboldt State for the fall semester.

"Anyhow," he went on, "I've looked everywhere, called everybody, and I'm here to ask you humbly if there's anything else I can do."

"You haven't had any further thoughts about where he might have been staying here?"

Flynn shook his head. "When I came down from Red Bluff a couple weeks ago, I stayed at the cottage on the ranch, out behind the big house. And Sean— he'd been in touch with me and knew I was upset about the proposed sale of the place—he turned up there, and stayed with me for several days. But then he took off, and I figured he'd gone back to Arcata, to school."

"Mr. Flynn, the most likely possibility is that he's off on his own and will get in touch when he feels like it. You said he's a woodsman and a camper. And our department," he added quickly as Flynn opened his mouth to protest, "will continue to look for him, as will the other agencies we've alerted. I assume you're planning to stay in the area?" Gutierrez added, getting to his feet.

"Yeah, I'm still in the cottage at the ranch. Not that my brother and sister-in-law wouldn't be happy to kick me out," he said with a shrug, "but I'm part owner, so they can't."

"We have the number there," Gutierrez said, and moved toward the door as the other man pulled his cane close and used it to stand up.

"Fine. Thank you for your efforts."

OFFICER Alma Linhares, temporarily covering the front desk for Brad Coates Wednesday morning, looked up when the door into the outer office opened to admit a young guy who appeared very uneasy about being there. She catalogued his appearance: jeans and white T-shirt, both reasonably clean; black leather jacket.

Buzz-cut black hair; the two-day growth of whiskers some kids considered cool; big, brown heartbreaker eyes now blinking nervously. Local, she thought, but couldn't quite place him. "Do something for you?" she asked.

"Uh, yeah. I need to know…" He came closer, to speak into the opening on the glass shield. "That is, I was wondering…"

Alma said nothing but kept her gaze fixed on his face.

"Look, I read about that guy fell off the cliff Saturday night? And nobody knows who he is? What I wondered, could I maybe, uh, see what he looks like?"

Alma touched a button under the desk. The guy was below medium height, broad-shouldered but skinny, somebody she could probably handle herself but there'd be hell to pay if he got out of here and away before she could try. "We could probably arrange that," she said as she got to her feet and touched the second button, the one would let her visitor into the inner office.

He hesitated, then stepped inside as the door in the rear wall opened and to Alma's surprise as well their visitor's, the chief appeared. "Vince Gutierrez," he said, reaching out a hand that the boy hesitated before taking. "Maybe I can help?"

Probably the chief was trying to get away from Dennis Flynn, who'd been coming in daily to raise hell, first about the warrant for his son's arrest and then about his disappearance. Alma stepped around the pair to cover any attempt at retreat on the boy's part.

"Yeah, like I told *her*. I was wondering if, maybe, I could see, maybe, a picture of the guy—the body—you guys pulled out of the water. From Saturday night?"

"And your name?"

"I don't see why… Well, sure," he said, as Gutierrez stood rocklike, unmistakably a cop in spite of the casual slacks and shirt he wore today. "Eddie Grijalva."

Right! thought Alma. His widowed mother and her two daughters ran El Charro, the popular Mexican restaurant in a strip mall on Jefferson Street, and another daughter and son-in-law managed the second family business, a small motel on a side street at the south end of town. Eddie was the last lone pup in a large and hardworking litter.

"Hello, Eddie, I know your mother. And do you think you might know something about this person?"

"I won't know that until I see his picture, will I?" He shoved his hands into the pockets of his jacket and squared his shoulders.

"Unfortunately, we don't have a picture available at the moment. But I'd be happy to take you down to Good Sam for a look."

"Good Sam? He's alive?" he breathed, eyes widening.

"No, Eddie, he's not. He's in the morgue there at the hospital. But if you think there's a chance you might know this man, we'd really appreciate your help."

Eddie—Alma judged his age to be very early twenties—shifted his booted feet and rolled his shoulders as if to ease an ache between them. "Jeeze, I don't know. I thought…"

"Come on, son, we'll go in my car. It's out back. Officer Linhares will come along with us," he added, opening the inner door and urging the younger man through with an arm across his shoulders.

Alma, following, spotted Brad Coates coming out of the men's locker room and jerked a thumb in the direction of the front office. "It's all yours."

In the rear parking lot, Alma got behind the wheel of the chief's white sedan, unmarked except for its license plate. Gutierrez settled Eddie Grijalva in the right rear seat and took the front passenger seat for himself, turning to keep up a soft-voiced, mostly one-way conversation during the short trip.

The main building of Good Samaritan Hospital, built in the thirties, was three stories of gray stone and pebbly-looking gray stucco with a vaguely ecclesiastical appearance, as befitted its Catholic origin. Alma pulled into one of the reserved slots near the building and tipped the visor down to show the official PSPD card as Gutierrez got out and opened the rear door. Then, with Alma leading the way, they headed not for the steps up to the big main doors but toward a smaller flight to the left, leading down to the basement.

Inside, she showed her identification to an attendant, who glanced at it and then past her. "Hey, Chief, I don't think we've got any new stiffs for you."

"One of the old stiffs will do this morning, Carl."

"Well, you know where to go," Carl told him with a nod, and Alma, who also knew, set off down a long, brightly lighted hall to a set of double swing doors on the right. She pushed the right-

side door open to reveal a room lined with rows of stainless-steel drawers.

"I don't think I want to go in there," said Eddie, his voice high and tight.

"You'll be fine," Gutierrez told him crisply. "It won't take long, I'll be right with you, and you'll find out what you need to know." Alma held the door open for them, then stepped out and let it swing shut. She'd seen more than a few dead bodies in her eight years on the force and had no particular wish to look at this one again.

The doors were solid and well-hung and the old walls thick; Alma could hear voices but not the words. In less than two minutes, one door flew open and Eddie Grijalva stumbled out, wiping his mouth on somebody's big handkerchief. "I'm sorry, I'm sorry," he moaned, and gagged a bit but swallowed hard and pressed the handkerchief against his mouth.

"It's okay, Eddie, happens to everybody the first time. There's a men's room down this way where you can rinse your mouth and wash your face," Gutierrez told him. And to Alma, "Find a room." He led the boy away.

When Eddie and Chief Gutierrez came out of the men's room some time later, Alma was waiting in the hall. "You're looking much better, Eddie," she told him. "Come on, let's go sit down for a few minutes." With her smiling back over her shoulder and Gutierrez serving as an alert herd-dog who might nip ankles, they got Eddie into a nearby small office with a desk and several chairs.

"Now," said Gutierrez, "why don't you have a seat, Eddie, and help us out here. I believe you know the man whose body we just viewed?"

As Alma closed the door and sat down in the chair beside it with her notebook out, Eddie covered his mouth again and closed his eyes.

"Maybe you'd like a Coke?" Alma suggested.

"Uh, yeah. Or maybe a Pepsi?"

"I'll get it," said Alma, and was gone and back quickly, to hand him a can. "Pepsi it is."

"Thanks." Eddie popped the top, took a sip and another, and sighed. "Yeah, I know him. I wasn't *real* sure at first, from that messed-up face. But the guy been stayin' out at Sea Breeze was

about the hairiest guy I ever saw, even on his back, so I'm pretty sure that's him in there."

Sea Breeze was the family motel. "Does he have a name?" asked Gutierrez.

"He registered as Rudy Diaz. I don't know if that's his real name or not."

This last caught Gutierrez's attention. "What makes you doubt it?"

Eddie shrugged. "Just—something."

Gutierrez, who'd been standing erect, now propped his butt on the edge of the desk and crossed his arms on his chest. "Tell us about it, Eddie."

With some distance from the body, and an interested audience, Eddie relaxed a bit. "Well, he came just over a week ago—October fifteenth, I checked back—and my brother-in-law says he looked the place over and wanted the end room, the one that's way back from the street. And he paid for a week."

"Did he pay with a credit card?"

Eddie thought for a moment. "Nope. Cash."

"Isn't that unusual?" Gutierrez asked.

He shrugged. "Not really. Anyway, that week was up Monday, and I figured he'd been in to pay for another week—I wasn't working that morning—but my brother-in-law said he never turned up."

"He'd moved on?"

Eddie shook his head, and looked uneasy again. "His stuff is still in the room. And his car is parked behind the unit."

"Did you report this to anyone?" At another head-shake, Gutierrez asked, sharply, "Why not?"

"He was a weird guy and I didn't want to get across him. I figured he'd come back eventually."

"Tell me how he was weird, Eddie."

The boy slumped in his chair and sucked at his Pepsi can for a moment. "I work the place usually Monday through Thursday afternoons and evenings, and sometimes I stay in one of the units overnight. Times I was there, Mr. Diaz was in and out all day, and at night, too. But he never had anybody in, or not that I ever saw. Though there was this one guy, or at least somebody in this one car, that came to pick him up a couple times."

Gutierrez waited, and after a moment Eddie went on. "One of the women who cleans the rooms told me that he must have sat around and drank beer a lot, because there were always a bunch of cans. And movies for the VCR. And she told me he had a hot plate and some pans and stuff, and nobody's supposed to cook in those rooms without special permission, we tell them that when they register and the rules are posted on the inside of the door."

"Did you remind him of the rule?"

Eddie flinched. "Yeah. He, uh, he said what he did in the room he'd paid for was nobody's business, and he'd better not hear any more about that or I'd maybe wind up with two broken legs. He said it kind of *ho-ho*, like he was kidding," Eddie said, and added, softly, "but I knew he wasn't."

"And you didn't tell anybody about that?"

"You wouldn't have, either."

Gutierrez gave a moment's thought to the body on the slab: only five feet nine, according to the coroner's measurements, but broad and heavily muscled beneath all that hair. More than a match for two like Eddie Grijalva.

Who was beginning to shift restlessly and eye the clock. Gutierrez had other, pressing matters to deal with, and could take Eddie downtown and let someone else finish this, but he hated to break the momentum.

"Eddie, when was the last time you saw Mr. Diaz?"

The answer was quick. "Saturday afternoon."

"The day of the protest march. Were you interested in that?"

"Nah, I thought it was crap, and so did my buddies. Late that afternoon a bunch of us were sitting around the pool there at the motel having a few beers, and a couple of the guys had seen the marchers and found out where they were heading. And they said maybe we should go down there and beat up a few of those pussies with their PEACE IS PATRIOTIC signs.

"But my girlfriend—she was inside making guacamole—came out and heard some of this, and got really pissed. I mean, she was like…" He spat out a short, explosive-sounding stream of Spanish.

To Alma's ear, early tuned to Portuguese, the girl's remarks were clear enough: "Get your sorry ass involved in this and I'll serve your balls to you for breakfast." Gutierrez, who to his widely

known regrets possessed very little Spanish, nevertheless got the general intent.

"Then she smacked me," Eddie muttered, cupping a hand tenderly to his left ear at the memory, "and told me to grow up. So I guess I did. Anyway, I took her to hear a band in Caspar that night instead."

"Was Mr. Diaz there while you and your buddies were kicking this plan around?"

"It wasn't a real plan. Yeah, he came out to the pool to swim laps. When he got out, he grabbed one of our beers and listened for a little while and said it sounded real interesting. Then he left. And that was the last time I saw him."

"Left in his own car?"

"Oh. No, his friend came by and drove around the back, so I guess they went together."

"What kind of car did the friend have?"

"One of those SUVs. Black, with the tinted windows."

Alma, who'd been waiting a chance, interrupted. "Eddie, did this Rudy Diaz speak Spanish?"

"Oh yeah," he said without having to think about it. "Just like me and my buddies."

"But he had some English?"

"I guess. He had to've talked English to Frank, anyway. My sis married an Anglo."

Gutierrez straightened, walked to the door, walked slowly back. "Thank you, Eddie. That was helpful. Now, one more thing, for the moment anyway. We'll need the names of the buddies who were with you Saturday afternoon."

"Hey! I don't see why… I can't tell you that, man."

"Some of them might know more about this Rudy Diaz than you think," Gutierrez said. "Or could possibly have seen him later Saturday. Of course, if you want to play grade-school games about something this serious, we could ask your girlfriend for names. Or your mother, she probably knows who your friends are."

"Oh shit, don't do that." Eddie hunched his shoulders and recited three names, paused, added a fourth. "That's it. Those are the guys who were there Saturday." He watched glumly as Alma wrote the names down, and then raised her head to look at him.

"Hey, Eddie? Why did you come in today?"

He rolled his eyes. "My girlfriend hears the guy's description on the news last night, and she's…well, I told you. So I came."

"That's it, then, for now," Gutierrez said, and moved toward the door. "We appreciate your help, Eddie. We'll drive you back to the station now. Then Officer Linhares will put together a statement for you, and we'll ask you to come by tomorrow morning to read it, and sign it."

"Okay." Eddie was on his feet quickly, a much happier man than he'd been an hour earlier. Probably happier than he'd been in at least a week, Alma figured.

"And Eddie?" Gutierrez opened the door.

"Yeah? Yes, sir."

"Tell your mother what you've told us. She'll need to know why the police are interested in her nice motel."

Eddie heaved a big sigh. "I'll tell her. And if I can still walk tomorrow, I'll come in to sign the statement."

14

"MA, I GOT DANIEL H. SOTO'S SOCIAL security number and date of birth from Gracie and sent them right off to Harley, for information ASAP. Probably could have begged the info from Johnny," Verity added, "but that seemed, um, unethical?"

"Probably. And Harley may well be illegal. Always, decisions."

"True. Now I'm off to have some of the face-to-face interviews you advise, with two people Daniel had worked for: Joe Linhares and an architect named Matthew Evers, in Westport. Any advice?"

"Be polite. And grateful."

"Wow. I'll try. Incidentally, Grace was uneasy out at the family farm, with nobody much around, so she's back at her house about to have her locks improved."

"Sensible of her. Do you need me to be available after school for Sylvie? I have a new worried-father job I should move on."

"Uh, no. I'll be here." At her mother's questioning look, she felt herself flush. "She and I had a chat yesterday, while we were playing rummy, about how some of her cool friends have been down at the bridge carrying signs after school. In retrospect, especially after what Johnny said about activity down there when he called last night, I think I have a misunderstanding to clear up with her."

"Good luck."

MATTHEW Evers lived in an angled and turreted Victorian castle that would not have been out of place in San Francisco. Evers himself turned out to be a tall, angular man well-suited to the house—which, he explained happily as he led her inside, was still under restoration. "Restoration, you understand, not renovation. Come into my kitchen, which is 1898 in appearance but efficiently twenty-first century in function, and I'll make you a cup of—coffee?"

"Coffee would be lovely, thank you." He pulled out a chair from the scrubbed pine table, and she sat down and took out notebook and pen.

Evers turned on a flame—by electronic ignition, Verity noted—under a teakettle on a handsomely refinished O'Keefe & Merritt gas range and touched the button on a coffee grinder. As he set up coffee mugs and paper filters and added the aromatic ground coffee, Verity eyed his trim but not tight gray flannel trousers and surely-purest-cotton white shirt with big cuffs rolled once, and decided he looked like a Victorian gentleman momentarily filling in for the cook.

The kettle sang. He poured water into the filters and turned to her with a flip of his head that sent a long lock of gray-brown hair neatly back into place. "I've heard good things about you and your mother from my friend, Jake Jacobs. Must be an interesting job, detective work. Although you look like the modern kind of detective who'd search for information electronically rather than in person."

"My mother's the old-fashioned kind who believes in personal contact. That smells wonderful," she said as he put a cup before her. "No, nothing additional, thanks."

He sat down across from her and poured cream into his coffee. "Daniel Soto worked with me over a period of about six months that ended in early May 2001. That was the point at which I'd run out of spendable funds and needed to get back to my office in Eureka on a full-time basis for a while. Otherwise, I'd hope to have him still working here."

"What did he do for you?"

"Let's see. We were pulling down the nasty cottage-cheese ceilings in the bedrooms upstairs—with little shiny flecks meant to suggest stars, if you can imagine. Then scraping about seventeen layers of paint and paper from the walls, and replacing some dreadful aluminum windows. And scouting out replacements for the original crown moldings, Daniel had a very good eye for that."

"Mr. Evers, you make me glad that the 1920-something house I'm working on has only been used hard, not mistreated."

"Matt, please. And so you should be. But it's a shame you don't have Daniel to help you further." His wide mouth drew

down in a grimace. "I was very sorry to hear about his death. He was a fine young man."

He paused for a moment, and she waited.

"He was strong, willing to work hard, and followed directions very well. But somewhere, young as he was, he'd acquired an understanding of basic construction. And he had an intuitive grasp of such things as the *effects* of spaces; it made him *feel* good when we pulled down an unfortunate dividing wall some idiot had put in. In fact, I gave him a copy of A *Pattern Language*, which of course he wasn't familiar with."

Neither was Verity, but she'd find out about it some other time. "Someone told me he was interested in the fine woodworking program at College of the Redwoods."

"He'd have done well there, I suppose," Evers said dismissively, "but he'd have been better occupied building bigger things than tables and chests. May I ask, what exactly is it you're looking for with all this? What you said when you called was that you'd been hired by Daniel's girlfriend."

"Grace Beaubien had known Daniel for about a year, and they'd lived together for half that time. She loved him, but she doesn't know where he came from, or even whom to notify about his death. She's trying to find out who he was."

"She, or you, will be lucky. He was bright and I'd guess properly raised but not formally educated beyond that. He had understanding and talent of the sort I've described. He was easy to have around, polite and good-tempered. He listened to music, but that's not an interest of mine so all I can say is that it wasn't loud rock or rap. He enjoyed my two cats, who are..." he looked around the room "...lurking somewhere, as they always do when visitors come.

"He loved the ocean, placid or stormy. This house has a widow's walk, and he'd go up there to eat his lunch, or watch the sunset. And that's it. Daniel Soto neatly and politely avoided any personal questions, any attempt to get closer to him. I can assure you that he was aware of what you've perhaps noticed, that I'm gay as a goose," he said with a white-toothed grin, "and so far as I could see, it didn't bother him. I have a loving partner in Eureka, I don't cheat on him, and if I did I wouldn't put moves on an obviously straight young man who could beat me to a pulp."

"Sensible of you," said Verity, returning the grin. "Matt, do you have any idea where he might have come from, where he'd grown up?"

"Coastal California would be my guess. There's a mental and physical attitude that seems endemic to young people out here. And maybe southern California; I get half a dozen newspapers, mostly by mail, and the only one other than the little Port Silva rag he ever bothered with was the *L.A. Times.*"

"You're an observant man," she told him. "Have you any thoughts about what he might have been running from, if that's what he was doing?"

"Something that had been done to him, probably in his childhood. Or," he added with a grimace, "something he'd done to someone else. But those are the things anyone runs from. Whatever it was in his case, I'd say that he hadn't yet come to terms with it. Sorry I can't be more helpful."

"I appreciate everything you've told me, and so will Grace Beaubien." Verity set her empty mug aside and got to her feet, but Evers reached out to put a hand on her arm.

"My understanding was that his fall was an accident. Is something more than that involved here?"

"Not so far as I know. There was a full-fledged riot in South Bluffs Park that night, and it's probably a miracle that more people didn't wind up in the water."

"Hmm. Well, I'd appreciate your letting me know if anything new comes up."

Verity tucked her notebook away in her bag. "I can do that. But I have one last question that you may or may not care to answer."

"Try me."

"The Beaubiens' records show a social security number for Daniel Soto, but he was apparently paid off the books. Was that your arrangement, too?"

"It was, with Daniel and with other independent laborers. That way, I pay them what they earn instead of giving part of it to the government, and there's a lot less paperwork."

VERITY drove the short distance back to the highway and when she reached it, hesitated only a moment before turning briefly

north and almost as quickly east, onto Branscomb Road. It would be only decent to stop by Jake Jacobs's place and thank him for helping her out with Matt Evers.

After a slow five miles on the forest-edged road made of abrupt hills and sharp curves and potholes, she turned off at a mailbox, pulled slowly ahead to a gate, and stopped. And turned her engine off. Jake Jacobs, a longtime ex-cop closer to her mother's age than hers, was the first man she'd slept with after her divorce a year ago. It had happened only once, and "happened" was the operative word; but it was a fine and satisfying experience, and did a lot for her emotional balance at the time.

But now was another time. She hadn't been out here since, although she'd seen Jake several times in town, usually at the police bar called The Spot. Maybe this visit was a serious mistake. She started her engine, lowered her window, and tapped her horn lightly three times.

The dogs arrived quickly, large mixed breeds named Ace, Buck, and Chloe. They barked and Jake appeared at once, lean and rancher-looking in jeans and work shirt and heeled boots. Sunlight picked out a few threads of gray in his straight, shoulder-length black hair and beads of sweat on his dark face.

"Hi, Jake."

"Hey, Red. Come on in." He opened the gate, waited for her to drive past, and closed it, to follow her to the gravelled area in front of his house. She was out of the car before he reached it, and turned to face him.

"Red, you're lookin' good."

"So are you, Jake. Working hard?" She gestured at the chain saw dangling from his left hand.

"All done. I was about to stop for a beer. Join me?"

At eleven A.M.? "Sure." But not in the house. She sat down on the bench of the picnic table that occupied a sunny spot beside the squarish little redwood cabin; Jake laid the saw down on the other end of the table and went inside.

"Here you go. Cheers." He handed her a brown bottle of an ale she didn't recognize, clinked his against hers, and tipped it up for a long swallow. "Good stuff after hot work."

She tried it. "I like it. Etna Brewery Phoenix Red?" she asked, inspecting the label.

"Little bitty town up in the Salmon Mountains in Siskiyou County. Some folks bought a real old brewery up there and are making pretty good stuff." He sat down on the other bench.

"Jake, do you know all of northern California by heart?"

"Pretty much. Lots of space, trees, mountains, rivers. Not that many people, some of 'em Indians."

"Sounds good," she said, and smiled at him, half Indian himself and looking it. "I came to thank you for giving me a good reference with Matt Evers. He was helpful in giving me a better picture of Daniel Soto."

"Evers is a man with a wide range of vision, and a noticing way."

"That's how he struck me, too. I should tell you that I knew Daniel personally, though not *very* personally, because he'd been working with Val Kuisma on the house I recently bought."

"Hey, you're a homeowner!" He lifted his bottle in salute.

"Yup, with the bills and sore muscles to prove it. I'm turning into a pretty good painter." She matched his salute with her own. "But beyond that, Patience and I—and Sylvie—are fond of Daniel's girlfriend, Grace Beaubien. She's very upset by his death and wants to find out more about where he came from. I guess you heard about the riot?"

"Things like politics and riots are why I try to stay out of towns. But yeah, I heard about the Soto kid's death. I met him a time or two in Westport when he was working for Evers."

"You're a noticing man, too. How did he strike you?"

"He was polite but wary when we met, probably because Evers introduced me as an ex-cop 'if you can say any cop is really ex.' Any male between the ages of fifteen and twenty-five would show some eye-white at that. Then another time I saw him walking the roof ridge on that high old barn of a house, and he was as easy up there as one of Evers's cats. Makes it real hard to believe that he fell off a cliff by accident."

Verity, who had watched Daniel on her own roof, could only nod agreement.

"Beyond that, all I could add to the specifics I'm sure Evers gave you is that Soto reminded me a lot of my own kid, who had an overburdened mother and damn-all of a father during the years he was growing up."

"I'm sorry."

"So am I. But he's in pretty good shape now, at just short of thirty. No thanks to me, just his own good character."

"Which must owe something to you."

"God, I'd like to think so. Other than busting your ass fixing up your house, how're you doing?"

"I'm good, I think."

"Somebody mentioned that big boyfriend of yours is back in town."

"Johnny. Yes, he is."

"You happy about that?" His gaze direct and his face sober, it was a serious question.

Verity gave it serious thought, eyes on the bottle she was rolling between her hands. "Yes," she said finally. "Yes, I am."

"Glad to hear it."

"Me, too," she said, and grinned at him and raised her bottle to drain it. "Now, I'd better get going. I have another Soto meeting, with Joe Linhares."

"Another man who sees a lot." Jake got up, too, and came around the table to wrap her in a big, hard hug. "And blessings on you, my dear, as my granny used to say." He dropped a kiss on her forehead and released her.

And what did she feel for Jake Jacobs, she asked herself as she drove away. Admiration, affection, and a reminiscent little flicker of lust. Life could use more relationships like that.

A few minutes later, spotting a dusty flat spot beside the road that had obviously been used by other cars before hers, she pulled off, parked, and took out her laptop. She'd taken a few pen-and-paper notes at Evers's house, none at Jake's. Better to set down the various little bits now, to help make connections later.

VERITY eyed the crowded parking lot in the little strip mall, drove on past, and found a parking place a half block down the immediate side street. She was a few minutes late, but Joe had said he had a site inspection nearby and would get there to save a table.

Inside El Charro the noise level was high and the aromas wonderful. As Verity's eyes adjusted from bright sunlight and she scanned the room for Joe Linhares, her friend Alma's oldest

brother, a young woman came out from behind the bar and approached her. "Verity Mackellar?"

"Yes," Verity said, and with a "Follow me," she led the way past other diners to the rear dining room. The person who rose from a table near the back of the room was not Joe Linhares but a sturdy woman in her late thirties or early forties with curly hair of a flaming red and the pale complexion to match.

"Verity? You don't know me, but I'm Cathy Linhares, Joe's wife. Please join me. There's been a meltdown on one of the job sites," she added, as Verity took a chair, "as usual. So Joe called me, and I told him I was the person who should be having this meeting anyway."

The waitress, who'd been hovering, handed the two of them menus and asked brightly, "Margaritas?"

Verity was about to decline, but Cathy grinned. "Oh, you bet, a nice big one. A day away from kitchen, kids, and livestock deserves a margarita."

"I'll join you." When the waitress had departed with their orders, Verity said, "How many kids and what kind of livestock?"

"Four kids, boys seventeen and twelve, that's Joey and Ben, and girls sixteen and seven, Maura and Ivy. And let's see, two dogs, two cats, one caged rat, and one horse, none of whose names I remember at the moment. And one husband."

"Makes one kid and one dog sound puny," said Verity.

"Actually, it sounds lovely," Cathy said, and fell silent as the waitress set glasses before them, poured them full from separate pitchers, and set the pitchers down as well.

"Cheers," said Cathy, and the two of them clinked glasses.

"Yum," said Verity, setting her glass down after a salty sip. "Cathy, why are you best suited for talking about Daniel Soto?"

"Because I knew him first," she said. "See, my older sister used to live in Crescent City, and in July four years ago she invited me up to spend a few weeks with her and her brood in the big house they had there. I was exhausted with all the kids home from school, and Joe was up to his ass in work, so I packed my kids into the van we had then and off we went." She picked up her glass. "It was great. Lots of room, a flock of cousins for my kids to play with, a big park and a beach nearby."

The waitress set plates before them—beef fajitas for Cathy

and beef enchiladas and black beans for Verity—warned that the plates were hot, and departed.

"Oh my God, that smells good," Cathy sighed. "Bless you, Verity. On my own, I'd have been eating a peanut butter sandwich and a banana at my kitchen counter." She scooped strips of beef and onions onto a tortilla, added chopped tomatoes and avocado, had a very big bite, and after a moment sighed again. "Okay, I can talk and eat at the same time."

"I gather you met Daniel Soto in Crescent City?" Verity took a bite of her enchilada.

Cathy nodded. "My sis is a good Catholic girl, and she worked two days a week in the lunch program at Saint Paul's. You know, for poor folks and the homeless. And she'd met Danny there. He wasn't homeless exactly; he had an old trailer out in the woods, Sheila said, and an old van he pulled it with. What he was, was skinny and obviously hungry.

"Actually," she added, pausing for a sip from her glass, "Sheila said he reminded her of one of our brothers. Jack got his growth really late, shot up about ten inches his senior year in high school. It took him the next two years to get any solid flesh on those big, long bones."

"So she helped him?"

"He didn't want 'help,' so she got the priest to hire him to do some work around the church and rectory. It turned out he had skills you wouldn't have expected in a kid of, I guess maybe twenty."

"Grace Beaubien, his girlfriend, says he's now twenty-four. Or was."

Cathy winced. "I shouldn't be so flip about all this. He was obviously lost and maybe scared, but a nice kid, and Joe and I are sick about what happened to him. In fact, that's another reason I'm filling in here. I don't know that Joe could have talked about Danny without tearing up."

"Did you or your sister find out anything about his background?"

"Not really. He was mannerly. He wasn't used to little kids, although he was nice enough with mine. He did say that he was happy to be living near the ocean. He wasn't Catholic. And we think his real name, or his former name, was Luke."

Verity sat straighter, picked up her glass, and waited.

"One of Sheila's kids, a very active boy, to put it kindly, is named Luke. When she yelled at him one day for raising hell there at the church, Danny was nearby and really jumped at the name. She was pretty sure."

"That's very interesting," said Verity. She scooped beans onto her next bite of enchilada. "Do you happen to know what brought him here?"

"Sort of." Cathy poured the rest of the margaritas from pitchers to glasses. "When I was getting ready to head for home, Sheila suggested I tell him about Joe's business. So I went to the church, and found him at work, and gave him Joe's card. Told him it's a family business, and if he should come down this way, he might want to look Joe up."

"And he did."

"Yeah, about a year and a half later. He worked for Joe for almost a year, and Joe said he behaved like somebody who'd grown up in a construction yard. He said Danny just knew more about more things than he could have picked up all by himself out working at the grunt jobs."

"Interesting. Cathy, everybody knows Joe is a good guy to work for. Why did Daniel Soto leave Linhares Brothers to go work elsewhere?"

Cathy snorted. "He had a run-in with Mikey, Joe's shithead of a baby brother."

"What about?"

"Joe only lets Mikey work for him because his mother gets on him about 'family.' Anyhow, Mikey likes to let people know he's a Linhares of Linhares Brothers and ordinary people ought to pull their forelocks or something. Most guys just ignore him and he eventually loses interest, but Joe says that for some reason he kept on at Danny. Then one day he apparently went too far and Danny cleaned his clock, right there in the yard."

"Oh, my."

"Yeah, I think everybody, including Joe, enjoyed watching that."

"But Joe fired Danny?"

She shook her head. "No, he came around next day and told Joe he couldn't continue working for him because he didn't want

to be responsible for a disruption in the family. Wouldn't change his mind, either."

They finished their meal in a silence punctuated by a few desultory remarks, and decided against dessert. "Cathy, thank you," Verity said as she put her napkin aside and reached for the check.

But Cathy's reach was quicker. "This is on me. I just wish I could have been more help. Joe and I have known Gracie Beaubien since she was just a big-eyed little kid. Tell her that if she wants to arrange for a memorial service, I'll be happy to help out. Except," she added quickly, "I guess that will have to wait until they find him."

"I suppose so." Probably coastal towns sometimes held memorials for people whose bodies never did surface. "But I will tell her."

"Verity, you take care now." Cathy said.

"You, too. And thanks again."

15

MIGHT BE INTERESTING, VERITY decided, to swing south on Main Street to observe the protest scene, if any. Within four blocks of the bridge, she spotted a police cruiser, then a uniformed figure, then two more. Another cruiser sat on the Main Street side of the big Safeway lot, and there was a uniform at this end of the bridge directing the sparse stream of traffic and another, she thought, at the far end. She turned left onto the street at the south edge of the Safeway lot, drove to the end of that block and parked and got out for a closer look.

The walkway on the western, ocean side of the bridge was the most crowded, although it wasn't a crush. This was still the anti-war side, covering a wide span in ages with nearly every person carrying a sign. PEACE IS PATRIOTIC was still popular, she noted, but there were other messages, none of them that she could read from here either vitriolic or obscene. Trying to pick out individuals, she didn't spot Katy Halloran; perhaps high school wasn't out yet. But a woman with a head of wildly curly brown hair, a woman who looked alarmingly small in the group of mostly taller folk, was quite familiar. And why aren't you at home practicing, Gracie?

The group on the eastern walkway was somewhat smaller but also a mix of youth and gray-beards (or -heads), their signs requesting support for our troops, asking God to bless America, and a few claiming in varied words that peaceniks were damned to hell. One large sign, held upright by two young men, startled and amused her: COWARDS DIE MANY TIMES BEFORE THEIR DEATHS! Shakespeare from the war supporters, who knew? And reminding herself of the universal danger of stereotypes: why not?

Then she pulled her gaze closer, into the foreground, and hoped that the cops in view would be enough. On both sides of the street a scatter of young guys (and a girl or two, she thought) hovered, watched, paused to connect with one another, moved on, or back. Trouble waiting to happen.

Verity returned to her car with a little over an hour to spare before going home to face Sylvie; might as well make good use of it, at the library, for instance. But first, since she was here, she could pick up milk, and yogurt, and maybe bacon.

In the crowded Safeway lot, she pulled around to the side of the building to park and found herself walking past the jobs bulletin board on her way to the entrance. No Hispanic job-seekers were here at this time of the day, but she went over for a look anyway, to see who might be seeking laborers, and found herself looking at what she could only think of as a memorial. Someone had posted a fuzzy snapshot on the board, with "Danny Soto" scrawled across the bottom. A plastic cross was pinned next to it, and there were two little wilting bunches of flowers on the ground beneath.

Oh, my. She wished she had a camera, to take a picture of this for Grace. Or maybe she'd seen it already? Verity was in her car and halfway to the library before realizing she still needed milk and yogurt.

The big library was busy as usual, with kids, mostly high school age kids, in the reference room, the computer room, and the high-ceilinged reading room. Behind the desk in the reading room was Mrs. Jenkins, who'd been on guard here for about a million years and probably remembered Verity as the tall, skinny, no doubt sweaty-smelling kid in soccer clothes who had haunted the place on late summer afternoons.

"Verity Mackellar, how nice to see you. What may I help you with?"

"Hi, Mrs. Jenkins. Our agency, my mother's and mine, is trying to put together some information about Daniel Soto, who was killed in the riot at South Bluffs Park last Saturday. And —"

"For whom? the police?"

"No, ma'am, for his girlfriend, Grace Beaubien. But the police would benefit, too, if we can figure out where Daniel came from. They had no one to notify about his death except Ms. Beaubien."

"Well." Mrs. Jenkins rested plump elbows on the counter and clasped her hands. "Daniel was a nice boy. I was—we all were— sorry to hear of his accident."

"I knew him slightly," Verity told her. "He was doing some work on a house I just bought."

"Yes, I'd heard he was a skilled carpenter. He was in here once or twice a week, often to read manuals on woodworking or various elements of construction."

"Grace told me he came here to do research, and also to read newspapers. Could you tell me what particular newspapers he read, or what area's newspapers he was interested in?"

"Probably."

"Would you be willing to? I don't think the knowledge can do him any harm now."

Mrs. Jenkins sighed, and came around the end of the counter. "My apologies. Librarians these days are very edgy about being asked to reveal patrons' reading habits to the FBI or some other snoopy organization. But let's go see what I can find for you in the periodical room."

One end of the periodical annex was crowded with racks holding newspapers draped over wooden dowels. "Let's see. We have the *New York Times*, the *Wall Street Journal*, and major California newspapers, as well as a few from smaller California cities. I'm in and out of this room frequently," she added, "to make sure people, especially students, are handling the newspapers carefully and putting them back in their proper places. I believe I remember seeing Daniel Soto with the Santa Barbara *News-Press*; we have that because a number of people who've moved here from the central coast requested it."

"That's interesting," Verity said. "Do you have back issues on microfiche?"

"Only for the most important papers. Most papers of any size have a web site with extensive archives, and we have quite a few computers with Internet connections."

"I know what Danny Soto was interested in," said a soft voice, and both women turned to look at a slim, jeans-clad girl with a dark ponytail.

"Miss Mackellar, this is Linda," said the librarian. "She's one of our student volunteers."

"Danny Soto was—nice," said Linda. "And I'm really, really sorry about what happened to him. Anyway, I, um, looked over his shoulder a couple times, when I was picking up the papers other people had left on the table. And once I noticed…wait." She moved to the racks, selected a paper, and spread it on the table.

"See, this section here is what he was reading." Verity moved closer, to view a page in the Santa Barbara *News-Press* headed FROM THE CENTRAL COAST COMMUNITIES. In this issue, the three communities covered in reports of varying length were San Luis Obispo, Atascadero, and Arroyo Grande.

"San Luis was one of the pieces that day, too," Linda said. "I told him that San Luis had a newspaper of its own, I know because my grandmother lives there. And I told him he could Google San Luis, and any other town he was interested in, to find its newspaper if there was one. He said thanks a lot, that was really nice of me," she added, and blushed.

"Linda, it's really not appropriate for library helpers, or librarians for that matter, to pry into patrons' reading matter," said Mrs. Jenkins.

"Of course it's not," said Verity quickly. "But today it was very helpful to me, so I hope she'll be forgiven. Thank you, Linda."

The girl ducked her head and scurried off, and Verity gave the librarian a rueful smile. "Sorry. But that could be useful information. I think I'll head home and get on my computer."

"Oh, Linda's a good girl, and I suspect Daniel Soto was a bit overwhelming to a seventeen-year-old, even though he made no obvious effort to be." She gathered up the paper Linda had neglected to put back on the rack. "Good luck to you in your quest, dear. If anyone plans a memorial for Daniel, let me know and we'll post a notice here at the library."

"Thank you. I'll be sure to do that."

Back in her car, Verity congratulated herself for having luck if not necessarily skill, and decided to be efficient in her "quest" and make one more stop. Red's Pool Hall, two blocks north of Main on Heber Street, was one of three businesses in a nondescript single-story building with a parking lot in the rear. Verity parked in the lot and found a rear door with a smaller "Red's" sign. The big room inside was not crowded in midafternoon; only two of the six tables were in use, and none of the players looked to be working very hard at the game. Verity nodded as she passed on her way to the bar along the wall, where a chunky, freckle-faced man whose sparse gray hair had hints of the original red was polishing glasses.

"Lookin' for a game, miss?"

"Not today, thanks," she said, and handed him her card. "I'm working for a friend of Daniel Soto's, looking for background information, and I'm told he occasionally played pool here."

"True. Get you somethin'?"

"Sure," she said, and gestured at a tap that said "North Coast Brewery." "A small glass of that, please."

"You got it," he said, and a moment later set a foam-topped glass before her. She thanked him, took a sip, and put a five on the bar.

"Nope, on me," he said, and pushed the bill back to her. "Yeah, Danny came in for a game now and then. Had a beer, never more than two. Big guy, and quiet, but the kind, if you were smart, you knew he wouldn't stand for any shit. Real rotten luck, that accident."

"Yes, it was. Did Danny play with anyone in particular?"

"Sometimes he'd come in with a guy who was kind of a local, Sean Flynn. Other times, he'd play with whoever was standin' around lookin' for a game. Danny was pretty good, not flashy but okay."

"Did you ever hear him talking about himself, where he was from, what he did?"

Red shook his head. "Didn't talk much at all. I knew, though, that he was some kind of builder, carpenter, whatever. Somebody said he'd worked for Linhares Brothers."

"What about Sean Flynn? Was he a good player?"

"Huh. He thought he was, but what he was good at was trouble, gettin' people's backs up. When he was with Soto, though, he mostly behaved himself."

"Do you remember the last time Danny Soto was in?"

He shook his head. "Not for two-three weeks, I don't think. Somebody said he was one of them peaceniks, and I figured he knew there was guys here didn't take kindly to that stand. Not that I myself think war's a good idea, this particular one they got in mind, anyhow. But I got a business to run."

"What about Sean Flynn?"

"Haven't seen him, either. His dad was in here yesterday askin' the same thing."

"I'd heard he was missing."

"Missing, maybe, but not missed. Sorry," he said with a

grimace. "It's not my place to have opinions about customers. But that Flynn was a pain in the butt."

"I've heard that, too," she said with a smile, and had another small sip of beer and looked at her watch. "Oops. I'll be late getting home for my little girl. Thanks for your time," she added, and set the nearly full glass down.

"No problem. Hey, if I hear anything about Danny, I'll call you. Guy like that, he must have people someplace should hear what happened to him."

"I agree."

ZAK was ecstatic, in his own very dignified way, at the sight of Verity. She rubbed his head, thumped his ribs, tossed him a treat, and refilled his water dish. She was in her studio changing clothes when she heard his "Here's Sylvie's bus!" chortle.

"Hi, Verity!" Sylvie was shedding her backpack as she trotted across the yard. "Can I get a drink before we go? And it's probably chilly down there on the bridge, maybe I should change clothes."

"Sylvie, the bridge would not be a good place for us today."

Sylvie stopped in her tracks and straightened to her full height, which seemed to be higher every week. "But you promised we'd go."

"I didn't. We only talked about it."

"But you said... I told everybody we were going."

"I'm sorry. But I drove by there an hour ago, and there are lots of cops on the scene, and quite a few people who aren't carrying signs but just hanging around and in my view, ready to make trouble."

"Well, if there are cops, they can protect us."

"Sylvie, the cops have enough worries." As Sylvie opened her mouth to protest further, Verity held up a hand. "Look, I don't want to argue about this. Your safety is up to me, I've looked the situation over, and I don't think that's a safe place for you to be. So we're not going."

Sylvie took a deep breath and another, her eyes flashing. "I can get there by myself."

"No, Sylvie. You can't and you may not."

"That's not fair! You're not my mother!"

Looking at the heaving chest and narrowed eyes, Verity had a

dizzying sense of past and future melting together: who was this tall, skinny girl, or the shade looming just behind her, brighter of hair and paler of eyes but equally furious? She took a long breath of her own and said, quietly, "That's true."

Sylvie stared for a moment longer and then stumbled forward to fling herself into Verity's arms and burst into tears. "But not the way I said it! I'm sorry, I'm sorry."

"I know. Me, too." She put her cheek against the top of Sylvie's head and hugged her close.

"Lily was my mother, but you're my mom."

"And just like Lily, I want you to be safe." She freed one arm and reached down to pat the whining dog trying to press between them. "Look at poor Zak, we're scaring him. Do you want a snack?"

In the kitchen, Sylvie washed off an apple, then quartered and cored it and cut off a slice to toss to Zak. "So, I don't have much homework. Could I maybe call Jess and ask her to come over?"

VERITY settled into the basement office to pore over the computer archives of central coast newspapers, which was easier on the muscles than hefting volumes of bound copies, but harder on the eyes. In something over two hours, interrupted by a trip upstairs for a bottle of Calistoga, she learned a lot about central coast wineries, festivals, and social patterns. More interesting were ongoing stories about a county-wide investigation of corruption in the construction industry: agencies and inspectors being paid off, building codes ignored.

"Hey, Ma," she said when Patience appeared at the office door. "Just about finished here; give me another fifteen minutes and I'll be able to print up my day's notes for you."

"Fine. Meanwhile, where's Sylvie?"

"At Jess's. Russ Kjelland picked her up around four o'clock, and he'll bring her home after dinner."

"How nice," said Patience. "You go ahead and finish, and I'll go upstairs and build a fire."

"OH, good fire," said Verity half an hour later, and handed a sheaf of papers to her mother. "Why don't you give these a quick look-

over while I go make a pot of tea. Can I get you a drink?" she asked as she headed for the kitchen.

"Tea will be fine for me, too; I'm going out later," said Patience, who had picked up her glasses from the coffee table and was already reading. Verity returned shortly with the tea tray, sat down in the wing chair and had time for only a sip or two before her mother set the papers aside and took off her glasses. "It appears that we each had an eventful day. So who goes first, you or me?"

"You, please."

"Fine. Of major interest, I suppose, are the results of a computer search for Daniel Soto," Patience said. "Harley called, with apologies, to say his computer system was down, so I spent a while poking around looking for Daniel or Daniel H. Soto who was born on May 27, 1978, the date Grace gave us. No luck, there are lots of Sotos but none that matched ours. So I finally decided, ethics aside, to hit Hank up for what he could find out. It turns out that social security number was issued in Riverside County, to a Daniel H. Soto born July 17, 1976."

"Oops."

"Right. Two years older than our Daniel claimed to be. And Hank was able to access birth records in that county and found that Daniel H.'s father was Hector D. Soto, his mother Juana Andrade. There are no juvenile records of any kind in that name. Probably he was a dependent on his father's income tax forms, if any, but even the police can't tap into I.R.S. files without a really good reason.

"And then," she went on, "a Daniel H. Soto with that number sprang into current existence in 1996, with a driver's license and an auto registration. No credit record, no education record, no marks on his driving record, no criminal record. Nothing."

"And this is our Danny?"

Patience shrugged. "So it appears, but it's hard to see why he'd have lied about his age to Grace. Nothing comes immediately to view on Hector, either, at least not in recent years. Hank didn't take time for a deeper search."

"From people I talked to today, it appears Danny mostly worked off the books. Did you run across a Luke or Lucas Soto while you were searching?"

"Oh, the suggestion Cathy Linhares made to you," she said, with a glance at the notes. "I don't think so, but I can have another look."

"Probably not necessary, Ma. Her memory of Daniel's response to that name was just an impression, and it was four years ago."

"Well, I'll think about it. Meanwhile, in reading your notes I was struck by the number of insightful people you spoke to who'd found Daniel Soto...interesting. He comes across as a much more complicated character than that quiet boy who did his work and went home to his nice girlfriend."

Verity had a slow sip of tea before nodding. "He was quiet, helpful, hardworking, very nice to Gracie, apparently able to tolerate disagreeable people like Sean Flynn. But he clearly had a flash point, because at least twice he beat the shit out of somebody who'd challenged him. And Gracie earlier described him picking up and throwing some kid who'd baited a homeless man. And," she added in afterthought, "Red, at the pool hall, remarked that Danny was somebody who clearly wouldn't stand for any shit. Direct quote.

"However," she went on, "it was the information I got from the library that I thought might be really useful. That and the fact that the unusual level of Daniel's work skills for someone his age—and his circumstance—was mentioned by almost everyone I spoke with. So as soon as Sylvie left for Jess's this afternoon, I got on the computer and spent about two hours looking up stories about construction companies in central coast towns, mostly in the archives of the Santa Barbara and San Luis Obispo newspapers."

Patience glanced again at the notes. "And the two you found mentioned most frequently were MacWhorter's General Contracting in Atascadero and Central Coast Constuction in San Luis Obispo."

"Right. There were four other outfits that got mention more than once, but those two had ongoing stories, particularly in recent months. And Mrs. Jenkins said that Daniel had recently begun coming to the library more frequently. Anyway, as you saw, MacWhorter's is being investigated for possibly inadequate

work on at least one mall project, and Central Coast is accused of political manipulation and possible bribes in winning a contract for a housing development.

"So here's what I need to know from you," she went on. "How do we find out anything about those companies? Like the names of their owners?"

"We start by checking at the county offices. Which county is involved?"

"With these two companies, just San Luis Obispo."

Patience closed her eyes for a moment and visualized the central coast. "If this were a case for a client with the resources of my current worried father, I could fly down, rent a car, and check out both companies."

"Grace Beaubien might be happy to have us do that, but I really don't think she can afford it."

"Pity. But I'm sure you're right. And it would be a longish trip by car from here. So, second option. We try to get some names from the county offices, either by phone or by e-mail. Success in that will probably depend on how helpful the county people choose to be.

"And a third option would be for me to call a colleague, a woman I've known for ages who moved her agency to San Luis Obispo city from Oakland some years ago. She could get the information, and if anything useful turns up, she could either speak with people involved, or—"

Verity's head came up sharply, and Patience said, "What?"

"Is she as nonthreatening and subtle as you are, Mother? Because Daniel Soto was serious about hiding from something. His family, if any, may be pretty nasty."

"She's good, Verity. But you raise a valid point and if I do call her, I'll caution her, subtly." She picked up the sheaf of notes, flipped through them quickly, and paused at one page. "I wonder what happened to Daniel Soto's trailer."

"Trailer?"

"Cathy Linhares said he was living in a trailer when she met him in Crescent City. I wonder if he brought it with him when he came south?"

Verity shrugged. "I have no idea. But if you think it might be

important, I'll certainly ask Gracie. I tried to call her at home this afternoon and got no answer, and I can't find her cell number. Maybe I'll just e-mail her."

"Sounds like a plan." Patience looked at her watch, and got to her feet. "Hank is worn out from work, and maybe life in general—don't ask!" she added, holding up a quelling palm. "So I'm taking him to dinner at Mary's, and then we'll probably go to his house and watch a movie. "

"Have a good time. I intend to listen to music, the kind without words, and read, quietly. I'll see you…later tonight?"

"Probably. If I decide to stay over, I'll call to say so."

16

"NO." THE SINGLE WORD WAS FLAT, as uncompromising as Vince Gutierrez's expression.

"But..." Ed Riley's round, ruddy face grew a bit more ruddy. "Chief Gutierrez, I'll make that a mayoral order if necessary. We have citizens who need explanations of ongoing events, and they're going to be in City Hall at seven-thirty this evening, along with the cameras of our local television station. We all expect the presence of our chief of police in this troubled time."

"Expect away, Riley. Like most of my officers, I've been pulling double shifts since Saturday. I spent hours I couldn't spare at a meeting just like that two days ago, as well as giving you an extensive daily report. Tonight I'm going home for dinner, and if you make your request an order, I'll pull my resignation out of my folder, sign it, and hand it over."

Riley's shoulders slumped, and he shook his head. "No, no, that's a very bad idea. How about this: could you send several of your officers over to field questions, the way they did, uh, Tuesday I think it was?"

"It was. No, I can't justify taking take several officers off the streets again, or out of their beds, where most of them have spent too little time lately. If he's available, and I think he can be, I'll send Captain Svoboda, who's well known in town and well informed about everything that's going on with the department."

"Hank Svoboda was a young officer on the Port Silva streets when I was in high school. A fine man. We'd be pleased to have him help us out tonight." Gutierrez thought there was a glint of relief in the mayor's eye. Hank was a man who could be direct and truthful without ruffling feathers, an ability Gutierrez envied but couldn't come close to matching.

"Fine. I'll get in touch with him right away. Now, is there anything else?"

"There is." Mayor Riley, yielding in the battle for position,

pulled up the visitor's chair and sat down. "The council is divided about the good sense of letting the anti-war group set up a vigil site, as they call it, beside the library. Apparently you feel that it should be permitted?"

"That site is public property, the vigil will be the kind of thing that's going on in a good many other cities. We always have a police presence at the library anyway because it's popular for various reasons with people of all ages and economic levels including the homeless. I think we can supervise there without looking like riot cops. However, it's the council's call."

"Well. I'll present that argument, and see how it sails. Now, about the peculiar community service sentences being handed out for misdemeanor convictions: were those your idea? Because people are upset."

"Believe me, I do not tell Judge Eberhardt what to do. Gotta say, though, I think forty hours of work at the Coast Guard Station or the assisted-living center will get troublemakers off the streets and into useful activity for a while, and shouldn't offend anybody's political point of view. Whoever disagrees is free to choose five days in jail. And that's something I hadn't got around to mentioning to you," he added.

"Jail?" said Riley, picking up uneasily on that word.

"Right. The city attorney met yesterday with a group of citizens who have come together in the interests of public safety. What they suggested was, well, a 'two strikes' approach. For the time being at least, we'd consider all uncontested pleas or convictions for assault or serious vandalism or resisting arrest a kind of first strike, with the understanding that a second conviction would require jail time. For anybody at all."

"I don't think that would be legal," Riley said, and then, "would it?"

"I'm not a lawyer. We're having it looked into."

"I'd like the names of the people on that committee."

"Go by the city attorney's office; I'm sure he has them."

"I'll do that. Now, last thing. There have been less than accurate stories in the newspapers, mainly the San Francisco *Chronicle* and the San Jose *Mercury-News*, about our troubles. I'd like you to prepare a press release to be handed out, say, tomorrow."

Gutierrez got to his feet and pulled a manila folder from a

rack on his desk. "I've done that, or tried to. Why don't you have a look at this, and let me know later today what changes or additions you'd suggest."

"Thanks, I will." Riley took the folder, his face a mask of weariness. "Lord knows, I don't want to make your job harder. It's just that there's so much pressure right now."

"Believe me, Ed, I know." Gutierrez put a hand on the taller man's shoulder as they headed for the door. "I'll be here until six o'clock, probably. And then have a night off to spend with my wife, I hope. Good luck with your meeting."

"MARIA, I swear you're not in any trouble here."

Maria Gonzales, about twenty years old and at least six months pregnant, looked toward the door and murmured something about *"mi esposo."*

"You want me to talk to your husband?"

"No, no!"

Officer Alma Linhares tried another tack. "You think your husband is in trouble?"

No answer, but her worried look was a giveaway. "Maria, your husband is not in trouble either," silently adding *so far as I know.* "Look, I'm Portagee and I can understand some Spanish even if I don't speak it. And I really need your help. Your boss told me you're a good person and a good worker and he hoped you could answer my questions."

Maria sighed and let her tight shoulders slump. "I speak pretty good English. Just slow."

"Okay. You want to sit down, rest your feet?"

Maria sat on the edge of the bed and put her hands in her almost-nonexistent lap.

"Okay. The man who had this room until last Saturday is dead. *Muerto.*"

Maria nodded. She did not seem sorry to hear this.

Alma pulled up a straight-backed chair and sat down. "We need to find out more about him, mainly what he was doing here. Did he talk to you?"

"Just to tell what to do. Like fix bed, pick up towels." She lifted one hand and snapped her fingers three times.

"Did he bother you?"

"He yell, but mostly, he don't look at me." She patted her belly with a faint smile.

Pregnancy as protection against unwanted advances. Made sense. "Did he have visitors? People who came to see him?"

She shrugged. "A man in a car, couple times. Didn't get out."

"Did you see what he looked like?"

"Anglo. Big."

"The car? The license plate?" This drew two head-shakes.

"When you cleaned his room, what did you find?"

"Mess," she said with a look of distaste. "Beer cans, beer bottles, whiskey bottles. Pizza boxes."

Alma perked up at this. "What kind of pizza?"

"From Roma. They have a card," she said, pointing to the desk that held the telephone.

Ah. Roma's was not much more than a mile from here, and did a lot of delivering. And there were at least two liquor stores even closer than that.

"Maria, did this man leave any personal papers around? In the wastebasket, say?"

She shook her head. "If they do, we bring it to the office." She glanced at the clock-radio on the bedside table, and levered herself to her feet. "I got a lot of work to do."

"I'm sure. Okay, I want you to take this card, and call me if you remember anything more about Mr. Diaz." She held out the card, and Maria took it gingerly and dropped it into her apron pocket.

"We need to know why he was here. And we need to find out more about where he came from. Somewhere he probably has a wife who's worried about him."

"Yeah. But she's maybe better off now." With that Maria stood waiting for permission to leave.

"Thank you, Maria. Go ahead with your work. Good luck," Alma added, and followed the other woman outside, where Maria put her hands on the push-bar of a large cart stocked with linens and cleaning supplies and set off wearily along the walkway.

Alma paid another quick visit to the motel office before returning to her car, where she spent several minutes tapping her interview results so far into her notebook computer. The "boss" on duty today at Sea Breeze, Eddie Grijalva's brother-in-law,

Frank Morgan, taught math at the community college and was either too uninterested or too overworked to pay a lot of attention here at the motel. However, he did like cars, and had happened to be working outside one day when Diaz answered a quick horn-honk and came out to get into his visitor's car. "Black Toyota Highlander, tinted windows. Smaller rig than the Four-Runner, my personal preference," he added. Unfortunately, his interest in license numbers was limited to checking those provided by people registering to stay.

It was now ten-thirty of a Thursday morning. She noted that fact in her report, tucked the neat little computer away, and set off for Roma's Pizza, which should be open by now. And it was, but the delivery people weren't in yet.

"Sure, we make deliveries to that motel all the time, but we don't keep any information on the customer unless he pays by credit card. Nobody named Diaz did that last week."

"Maybe your delivery people would remember him?"

"Only if he stiffed 'em on the tip."

"I'd like the names, phone numbers, and addresses of all the people who worked delivering for you from October fifteenth through October nineteenth. Please," she added, softening her tone only slightly. "I'll be back for it in, say, thirty minutes."

And on to Regal Liquors, where the clerk had no recollection of purchases by a muscular, surly Mexican man over the last week. "The owner will be in around noon, if you want to talk to him, and we have another clerk part-time. But we're a little high-end for somebody like that," he told Alma with a gesture at the expensive bottles of wine in racks along the wall. "You might have better luck at Buy-Rite, over on Grove Street."

Alma left her card, asked him to have the owner call her if he had any information, and drove off to Buy-Rite Liquors, where the parking lot was almost empty. "Hey," said the large man behind the counter when she and her uniform walked in, "we got rid of the guys used to drink out there in the lot. Chase 'em off regularly, or call you guys if they won't go."

"We appreciate that," said Alma, and introduced herself and her mission. "This Mr. Diaz —"

"Jeeze, I think I heard about him last night on the local news. He's the dead guy from the riot they pulled out of the water?"

"True. But before he was dead, he was staying at a motel near here and drinking a lot of beer, mostly. And he had to buy it someplace."

Mack Williams, Buy-Rite manager, listened carefully to Alma's description of Rudy Diaz, and nodded. "Yeah. For about a week, he was in here every day. Wasn't a chatty guy, but he didn't make any trouble. Always paid in cash. Bought Bud and Coors, mostly. Except for one time…"

Alma kept her mouth shut and a bright look on her face, and he went on. "I dunno know which day it was, maybe last Friday. He came in and loaded up on the kind of beer that costs about eight bucks a six-pack and a bottle of real good scotch. The bill was so high he didn't have enough cash on him, so he went out the door, and I followed him, figuring I was gonna have to put all that stuff back on the shelves.

"But he had a buddy with him in the car. The guy got out and dug in his pockets and handed over the dough, and I got paid after all."

"What kind of car?"

"Black SUV is all I know. And no, I didn't look at the license number."

"What did this buddy look like?"

"White. Big, probably not as tall as me, I'm six-two, but he was heftier. Overweight," he added, and patted his own flat belly.

"Anything else you noticed about him?"

Mack pulled on one ear as he thought. "Real fancy dark glasses, and a classy leather jacket. And lots of hair, kinda long." This last was said regretfully, by a man whose sparse hair struggled to cover his large head.

"Color?"

He shrugged. "Brown, I think. Anyway, he got back in the car, and the Mex guy came in and paid for the booze and carried it out. That was the last time he was in."

"The big guy was driving?"

"Yep."

"Thanks, Mack." She did her card-and-call routine, and added, "Next time I need some good beer, I'll come by."

"You do that."

WHEN there was no response on Thursday, not even a ring, from Grace Beaubien's phone or cell phone, Verity decided to drive by her house, where she was relieved to see the black Honda at the curb. The front door was closed, but a window was open, and she heard music. Not, oddly enough, singing, but rapid-fire guitar picking. "Gracie," she called as she knocked, "it's Verity Mackellar."

Gracie answered the door, guitar in hand. Her curly hair was unrestrained, and she wore jeans and a too-large blue T-shirt with words painted on it in bright white letters: WAR IS A BAD IDEA.

"Hi, Verity. Come in."

"You aren't answering your phone?"

"I'd been getting calls from cranks and newspaper people, so I cancelled the landline phone yesterday. And I guess I'd turned my cell off. Sorry." As Verity stepped inside, Gracie set her guitar down on the couch. "What have you found out about Danny?"

"That any public records on Daniel H. Soto are sparse, and some parts don't quite match." Verity pulled a manila envelope from her bag and handed it over. "Here's the report of what I've learned so far, which isn't much. Why don't you read it, and then we can talk." As Gracie sat down beside her guitar and took several sheets of paper from the envelope, Verity went back out onto the porch to check her own cell phone for messages.

"Thank you, Verity." The voice from inside had no hint of the edge that had sharpened Gracie's first words. Verity put the phone away and returned to the living room.

"I'm really grateful. All this stuff people told you about Danny, it makes him seem real again." Gracie blinked hard for a moment. "I haven't been to Safeway the last few days, so I didn't know about the memorial. I want to go see it."

"I thought you might. Gracie, what about Cathy Linhares's suggestion that Danny's name might be Luke? Or I suppose, something similar to Luke."

She shook her head. "One more thing I should know but don't."

"Did he ever talk to you about, or show any particular interest in, the central coast or the towns there?"

Another head-shake. "He said once he couldn't see any point in ever going south of Bodega Bay. And I'm sure he never said

a word to me about those construction companies. Are you thinking about going down there?"

"Not for the moment. It's a bit vague, it would be an expensive trip...."

"Just don't worry about the money if you decide it's necessary."

"I won't. Gracie, what about his trailer?" At the other woman's blank look, Verity said, "Cathy Linhares said he was living in an old trailer when he was in Crescent City."

An "Oh, *that* trailer" look dawned on Gracie's face. "I'd forgotten about that battered old thing. Danny parked it at my folks' place when he first went to work there. Not long after he came, the weather got bad and my mom talked him into moving into the spare bedroom in the house."

"Do you know where the trailer is now?"

"I suppose it's still out behind the greenhouses, where we usually parked our own trailers."

"Perhaps we could go have a look at it?" Verity suggested.

"Okay. After the memorial at Safeway." Gracie got to her feet, but Verity stayed where she was.

"There's one more thing. Patience told me only this morning that the police have identified the dead man from the bluffs— more or less."

"More or less?"

"They found the motel where he'd been staying, and his car and belongings were there. The name on his driver's license is Rudy Diaz, but the license is a fake and the car is an old one he'd just bought in San Jose. Does the name mean anything to you?"

"No." She sat back down. "An illegal?"

"Probably. All that's known about him is that he'd turned up in town over a week ago, he was probably a native speaker of Spanish, and he was somewhat intimidating."

"Are you thinking that this guy tried to hurt Danny, and got killed himself?"

"Gracie, I don't know. The police are investigating, of course, and if and when they find anything out, I'm sure they'll let us know."

"Hah! The police are too busy hassling us to have time for much else, I'd think."

"Us?"

"Us anti-war people. They've said we can't demonstrate on the bridge, which I'd think might be unconstitutional. I mean, it's a public bridge."

Verity took a deep breath. "I was surprised to see you down there yesterday. I didn't think this was your fight."

"It is now." Fierceness sat oddly on Gracie's small face.

"Won't demonstrating interfere with your professional commitments?"

"My place in the quartet was just a lucky happenstance, Verity, because one of the women was having a difficult first pregnancy and one of the others knew me and suggested I take Jeanine's place. But her baby's here now, and I have other work to do."

"But…"

"See, I used to be involved in a different kind of ancient music: traditional folk music. So I called up my former guys, a mandolin player and another guitarist; we worked together well, and fortunately, they're both still around. And they're both really anti-war, so we're working on a new gig: singing at anti-war protests. I'm doing research now on appropriate songs."

Verity took an even deeper breath, trying to come up with a reasonable tone. "From what I've heard, you were building a fine reputation with the quartet. Out there on the streets with so much turmoil going on, you could get in trouble, even get arrested."

"Verity, you're not my mother."

Now *there* were words with a familiar ring. "You're absolutely right about that."

Gracie flinched. "Sorry, but I really need to do this. I loved Danny, and I should have made more effort to share his commitments. If I'd been home last weekend instead of off singing six-hundred-year-old religious music to dressed-up people, I could have taken part in that protest with him, and kept him out of trouble."

Verity could think of no adequate response to this beyond a nod. "Well, if we're going to Safeway, and the farm, we should be on our way."

17

VERITY PARKED AT THE EDGE OF the Safeway lot and waited until Grace's Honda had pulled up behind her before getting out. "It's over there on the jobs board," she said. "My guess is, the Hispanic guys who wait here to be picked up for casual labor put it up, maybe at the suggestion of a girlfriend or wife." She glanced around the area, but saw only people moving purposefully, many of them with grocery carts.

"None of them here at the moment," she added. "I suppose it's too late in the day to expect an employer to come along."

The blurry photo was still on the board, and someone had added a string of rosary beads to the display. On the ground below were the wilted clumps of real flowers, a bouquet of plastic flowers, and a small picture of Jesus in a tin frame. Verity stayed back a few feet while Gracie went close to look.

"That's...really kind," said Gracie after some moments. She sniffed a bit and patted tears away with the sleeve of her jacket. "I need to find the guys and thank them."

"I suppose they'll be here tomorrow morning," Verity said.

"Let's do it now. I know Victor Aguilar, because he worked for my dad several times; and Danny introduced me to Carlos Mendoza, I think they're friends. If you'll drive us to some of the places they usually work, maybe I'll spot one of them."

They got into Verity's Subaru and Gracie gave instructions, first to a construction site four blocks off Main Street. "This is where I saw Victor about two weeks ago," Gracie said, "but it doesn't look like there's any work going on right now. Let's try the rhododendron gardens; the gardeners there sometimes hire laborers to help them."

At the gardens, Gracie got out to inquire, and returned to say that there were no casual laborers being brought in this week. "Okay, head out toward the east end of Maple Street. Danny said there were jobs out there where a county park is being

re-habbed." She kept a hand braced on the dash as Verity maneu-
vered around potholes on the road that had dwindled from tar-
mac to gravel.

"Okay, there's the park. Pull over here, and...Ha! There's
work here. And I think I see Carlos."

"Do you want me to come with you?"

"No, that's okay," Gracie said, opening the door. "I have a lit-
tle basic Spanish and Carlos is pretty good with English. Besides,
he's an illegal and they're pretty reserved around anybody they
don't know."

Verity watched her trot toward the bleachers, where new
board seats were being hammered into place, and approach a
black-haired, brown-skinned man only a few inches taller than
she was. He turned at her approach, laid his hammer down, put
out a hand.

Clearly no danger there. Verity touched the button on her ra-
dio and found the local sometimes-classical music station, which
turned out to be presenting Richard Goode and a Beethoven
sonata.

Gracie was back in ten minutes, to open the door and slump
into the seat.

"Gracie? Is there a problem?"

"Yeah, sort of. I guess. Let's head back to town, and I'll try to
make sense of this." She fastened her seat belt and stared blankly
out the windshield as Verity turned the car around.

"Okay. Carlos said how sorry he was, he and the other guys,
too, about what happened to Danny. He'd been thinking of trying
to find me to tell me that. He also thought he ought to tell me
about this stranger who came down to the pick-up place asking
questions about Danny one day last week. Thursday, he thinks it
was."

Verity kept her eyes on the rough road, her ears alert to her
passenger's voice. "What guy? Asking what?"

"Carlos didn't see him, he'd already got a job, but a young guy,
a fairly recent arrival in town, did. The stranger had a picture that
looked like Danny and asked whether Jesús, that's the young guy,
knew the man in the picture or anything about him. When Jesús
gave him Danny's name, and said he lived in town, he paid him.

"Then next morning, when this Jesús went to the taco wagon

with a twenty-dollar bill, the other guys wondered where he'd suddenly come up rich, for him. And he told them."

"Did he tell them anything about the man who approached him?"

"He was a Mexican, some bigger than the other guys, and seemed kind of tough. Carlos said the guy had obviously scared Jesús."

"No name?"

"He said no. Anyhow, the rest of the guys were mad at Jesús for talking to a stranger about a friend, and gave him a hard time. They haven't seen him since, and figure he's found another place."

"Gracie, I think we should—"

"What I'm wondering, could that strange guy have been the one you told me about? What was his name, Rudy Diaz? What do you think?"

"I think we should drive to the police station to talk with Captain Svoboda, and let him decide. In fact, I'm going to stop right here and call him."

Hank was waiting for them when they arrived, and ushered them back to his office. "Thanks for coming, ladies. Now, Miss Beaubien, why don't you tell me what you found out."

Gracie folded her hands in her lap like a good child and told of her talk with Carlos Mendoza, ending with her question: could that have been Rudy Diaz? Hank led her through the brief tale again, and thanked her. "That's very interesting, and we'd better look into it."

"If you like, I could take you to Carlos, and introduce you," Gracie said.

"Thank you, ma'am, but I know Carlos Mendoza. I've hired him for work out at my place several times, so I don't think he'll mind talking to me. He's at the county park out at the end of Maple Street, you say?"

"He was there fifteen minutes ago, and work was still going on. Will you let me know what you find out?"

"If I find out anything, I surely will be in touch." He rose, both women followed suit, and he ushered them to the door. "You both take care now. Verity, you could say 'hey' to Patience for me, tell her I'm tied up tonight, but I'll call her maybe tomorrow."

Gracie was silent on the walk back to the car. "So," said Verity as she hit the "unlock" button on her key ring, "shall we go to your parents' place in my car, or would you rather I take you back to Safeway so you can drive your own?"

"I'm thinking. Maybe take me back," Gracie replied, and was silent during the short drive.

When Verity pulled up next to the parked Honda, she didn't turn off her own engine but turned to look at her passenger, and after a long moment Gracie met her gaze. "I don't think we should have talked to the police. I don't think you should have asked me to do that."

Verity shut the engine down. "Grace, I don't think you understand my situation. As a citizen, particularly one working for a licensed private investigator, I am required to tell the police anything I find out concerning an open criminal case. So if you hadn't told Captain Svoboda, I would have."

"But now he'll think Danny killed that Diaz guy."

Which will hardly matter because nobody except you thinks Daniel Soto is alive. "If he does, he will probably see it as self-defense."

"But Danny would *never*..." She fell silent.

Verity looked at her watch. "This has taken more time than I'd expected, and I need to be home when Sylvie comes in from school. Could you possibly go check out the trailer on your own?"

Gracie sighed. "It's just an old trailer. He hadn't lived in it for ages, and he brought all his clothes and stuff with him when he moved here."

"You think he did. But by now you have to admit that there are many things you didn't know about Daniel Soto."

After a pause, Gracie said, "That's true. Okay, it won't take me long to run out there and have a look." She got out of the car and headed for her own.

Verity called after her. "Gracie, please call me if you find anything that might be helpful."

"Okay."

Verity watched her drive off before starting her own car. Never mind Safeway, she'd do her shopping today at Silveira's, a locally owned supermarket and general store that was a bit more expensive but carried produce and even meats that were local.

Perhaps there she could find something interesting and challenging to cook for supper. In fact, maybe she should just get her ass in gear and look for a restaurant job. Although her mother was skilled at fielding her clients' complicated problems without getting personally involved, Verity was finding that a tricky balancing act for which she seemed to have little natural aptitude.

Heading north forty-five minutes later, she caught sight of the Bistro D name on the marquee over the entrance to an elegantly remodeled oceanfront motel, and made a mental note. She'd had good reason—several good reasons—to say no some months earlier when Paul Dufresne, a friend from grad school who'd recently moved to Port Silva, asked her whether she'd be interested in being sous-chef at his new restaurant. But recently, someone had told her he was considering opening the bistro for lunch, and that might be worth thinking about.

No one was at the cottage on Raccoon Lake Road except Zak, who was extremely happy to see her. "Yes, I know, you get lonesome," Verity told him, rubbing his head and fetching him a piece of jerky from the jar in the basement office. "Sylvie will be home soon. Right now, I hear what sounds like work going on next door, so I'm going over for a few minutes, and you can come along."

He swallowed his treat without any apparent chewing and trotted beside her through the gate in the side yard. The only vehicle parked at her house was Harley's little truck, and the hammering sound she'd heard was coming from the rear of the building.

Harley was on the half-finished deck, next to a stack of the redwood lumber Val referred to, for some reason, as two-by-sixes although they measured rather less than that. As she came up the not-yet-finished steps to the deck, Harley sighted on the nail he was holding and drove it into place with three precise blows. "Hey, Verity," he said, and sat back on his heels. "Sorry I washed out on the computer search."

"No problem, Patience took care of it. I just stopped by to see what's happening over here."

"It's just me today, Val's on double shift again. But he'd measured and cut the redwood, and I had some free time and know how to nail it down."

"I can see that you do."

He grinned. "Yeah, I'm learning a lot this year. Anyway, before I leave I'll check around to make sure everything's under cover or stashed in the basement. Looks like rain sometime tonight."

"Thank you, Harley. I'm going home to start work on dinner. I'm sure there'll be plenty, if you'd like to stay."

"Thanks, but my mom just got back to town, and I'm taking her to dinner. Do you know what might be going on down by the bridge?"

She shook her head. "I haven't been down there today. But I understand from Gracie that there's planning going on for a new demonstration site, a place for what she called a 'vigil' somewhere near the library."

"God, I hope they don't do more marches. Angie was in a couple of the big ones in San Francisco, and I'm afraid she'll leap right into the battle here. I hope I can distract her."

"Good luck, Harley." Angie Apodaca was in all ways except her devotion to her son a completely free spirit, and probably very difficult to distract.

FIND a simple task and put your simple mind to it. This was a suggestion one character made to another in a novel, and today it struck Verity as particularly appropriate. After Sylvie fixed herself an after-school snack and took off with Zak for a walk, Verity poured red wine and olive oil into a bowl and whisked in a bit of stone-ground mustard, a little soy sauce, several smashed garlic cloves, a couple of bay leaves, some fresh-ground pepper, and a few sprigs of rosemary she'd harvested from the patch beside the cottage. She pierced two little tri-tip roasts several times each with an icepick, slid them into a plastic bag, poured in the marinade and sealed the bag.

"Can I do something?" asked Patience, a question they both knew was purely *pro forma*.

"No, thank you. Did I see you getting your suitcase down?"

"Advance preparation." Patience, who had changed out of business-lady garb and was now comfortable in jeans, sat down in the padded wicker chair and stretched her legs out. "I may need to go to Sacramento tomorrow. I think I told you I've been working for a father who's upset about his daughter's current boyfriend? A

former business colleague of the boyfriend is proving unavailable by phone, so I'm considering calling on him in person."

"Better you than me. Have you heard anything from your detective friend in San Luis?"

"I have. Her name is Barbara Grant, I may have told you that already, and her number is in my Rolodex. Barbara will be glad to do some research for us at the county courthouse, and will try to get back to us tomorrow with whatever she finds out."

"Lovely." Verity wheeled her butcher block close to the sink, fished potatoes she'd peeled earlier from a bowl of water there, and began cutting them swiftly into thin slices with her chef's knife.

"Every time I used a knife like that," said Patience, "I expected to chop off at least one finger. So I didn't do it often. Did you see Grace today?"

"I did, and I think I'm better at slicing potatoes. Gracie has given up the quartet, for a while at least, to devote herself to filling in for Daniel in the protest ranks. She's going to play her guitar and sing anti-war songs, if she can find any."

"Oh dear."

"Right. And she made clear that she's not open to helpful advice about it. Then we went to Safeway to see the little memorial." Verity put the sliced potatoes back in cold water and set about washing a bag of baby spinach as she told of Grace's talk with the man named Carlos.

"Hank was quite interested in that," she added.

"I can imagine."

"By then it was getting a bit late for me, so I sent a rather reluctant Gracie out on her own to have a look at your trailer, which Danny had parked out at her parents' farm and so far as she knew, left there when he moved in with her."

Patience, about to object to the "your trailer" phrase, was caught instead by Verity's pause. "And?"

"And it's not there. Grace doesn't remember when she last saw it, and when she called the farm manager, he said he didn't remember anybody moving it, but hadn't actually seen it to notice for at least a month." She put all the supper-to-come into the fridge and sank into a chair at the table.

"And she believes Daniel took the trailer," Patience said. "Climbed out of that raging sea and drove off in his van and picked up his trailer and hit the road. Verity, please get your poor old mother a drink."

Verity got up again and went to the fridge for ice. "She does. I could hear that little electric tingle in her voice even over the phone: *Danny's alive.*"

Feet clattered on the deck, and Sylvie opened the back door on Verity's last words.

"Who says so? Gracie?"

Verity poured scotch over the ice and handed the glass to Patience. "More or less." She found a bottle of white wine and poured herself a glassful.

"Verity, everybody says Danny's dead for sure. This kid at school says that last year, this woman went out in a kayak down below Mendocino and they found her kayak out there next day. But they didn't find her body until six weeks later, way upcoast."

"'A' kid, and 'a' woman, Sylvie. Not 'this,'" said Patience.

Probably many of the kids at school knew Grace Beaubien from music lessons or from chorus or possibly from performances in town. "It's very likely that he *is* dead, Sylvie," Verity said. "But Gracie doesn't want to believe it."

"Okay, I can understand that. Poor Gracie. I'll have to go see her and tell her what we're doing at school."

"Oh?"

"Yeah, me and Jess, and Eamon and Dylan, those are boys you don't know, we've decided to start a 'Kids Against War' group. We'll get T-shirts, and go out together after school or on weekends to places like this new protest spot by the library we heard about. Not on the bridge, Eamon says they're not letting anyone stand there now."

"'Jess and I,'" said Verity, adopting Patience's mode as she assimilated this new challenge. "I think we'll need to talk this over later, Sylvie. And I hope protest is not the only thing happening at school these days."

With a "slid that one past" look of satisfaction, Sylvie launched into tales of recess soccer games disrupted by mean boys,

a smart new girl in the mixed-grades math class who might or might not be a nice person, a substitute teacher who'd broken down in tears right in front of everybody.

As Sylvie set off for the studio to practice her piano or perhaps her guitar, Verity grinned at her mother. "And you went to college planning to be a school teacher! Mother, you should thank the goddess that you got distracted by whatever it was."

"By sex, actually. I met your father."

18

AT SIX O'CLOCK JOHNNY HEBERT added a final sentence to the report he was typing, saved the document, and shut down his computer. If he was quick and quiet about getting out of here, he might have time to pick up a good bottle of wine, stop at home for a shower, and make it to Verity's before the rain hit. He had just pushed back his desk chair when the door to the squad room opened and Vince Gutierrez put his head in and spotted him. Shit.

"Hebert! Grab your rain gear and come on."

"Yessir." It wasn't until he was behind the wheel of the un-marked sedan that Johnny had a chance to ask, "Where to? What's up?"

"South on One to Old Quarry Road, and turn east. There's a farmhouse up the hill about a half mile along, used to be a bed-and-breakfast. People there, the Jorgensens, retired and moved to Santa Rosa maybe three years back. We're out of the forty-five-mile zone now."

"Right." Johnny let his foot get heavier on the gas pedal. "Friends of yours?"

"I've known them for years. Their daughter's living there now, going to the community college and working in Mendocino. She's been in San Francisco for ten days helping out with a friend's wedding, and just got back."

"Oops." Empty houses, especially isolated ones, were prime targets of thieves, vandals, or just derelicts looking for a place to sleep.

"Worse than that, I think. Andy—Andrea—called me direct because she knows me. The door was unlocked so she didn't go in, just pushed it open to look. The place is a mess, like after a fight, and she says the smell's so bad she couldn't get any closer. She went back to her car and called me on her cell phone. I figure she's having hysterics about now."

Johnny made the left turn onto Old Quarry Road, and soon after that turned right onto the steep driveway that led up to a two-story white house. They were cresting the hill when head-lights flared suddenly just ahead and an engine roared to life. Johnny hit the gas, hammered the horn, swung the wheel quick left and then hard right and stopped, a large white obstacle to whoever was aiming at that driveway.

"Goddamn!" Gutierrez was out of the car before it had stopped, running toward a high, square vehicle that Johnny thought was an old Jeep wagon. The driver hit the brakes with a force that dipped the nose and killed the engine, and the driver's door flew open to spill out a tall, jeans-clad girl whose pale hair swung loose around her face. She flung herself at Gutierrez, who caught her and held her upright. "I've got her," he called to Johnny, "you go up to the house and have a look."

The girl's wails rang in Johnny's ears as he edged past the Jeep and drove to the house, to park nose-in against the latticework beneath the porch running the width of the house. He shut off engine and lights and got out, listening for a moment before mov-ing slowly up the five steps to the porch to approach the wide-open door. Although it was only a little past sunset, the heavy overcast had brought on a near-darkness that turned the lighted space ahead of him into a bright stage. Beyond a small entry area with a rumpled rug, the living room was a mess of tumbled furni-ture, and he didn't need to step inside to catch the smell; some-thing, probably somebody, was dead in there and had been for a while.

There was no body visible from the doorway, but when he moved to the big window to the right, he could make out what he thought was a foot protruding from behind an overturned couch. Time to get the crime-scene people out here, but he'd better check with the chief before calling them in.

Johnny started back across the parking area to where Gutier-rez, his arm across the girl's shaking shoulders, was trying to talk to her while she simply huddled into herself and kept repeating, "No, no, I don't want to! I can't!" At the sound of Johnny's boots on the gravel, Gutierrez looked up and gave a small shrug.

"Okay, Andy, okay. You don't have to go in there. What you can do is sit in your car while—"

"No! No, I need to get away! I can still smell it all the way out here! *Please* let me go-o-o."

Johnny held up the car keys, jingled them lightly, and gestured toward the driveway. Gutierrez nodded.

"Okay, Andy. This is Johnny Hebert, and he's big enough to protect you from anybody. He'll take you..."

"Maybe up the road to Jerry's?" suggested Johnny. "It's early for serious drinking, so the place won't be busy, and he makes good coffee. We can wait there while you decide what you want to do. Meanwhile, we'll get some people in to handle what's in the house."

"Oh, yes. Please."

"Fine," said Gutierrez. He pulled a cell phone from his pocket, turned it on, and nodded. "Got a good signal here. You take my car, and I'll call the crime scene people."

Eyeing the girl, who looked toward the house and began to shake again, Johnny said, "You two wait right here and I'll get the car." He moved quickly to the car, and once inside flipped his own cell phone open and hit the first number in the call-list.

"Verity? Something has come up and I won't be able to make it for dinner. Probably not at all."

A silence, and then, "Oh."

"I'm sorry," he said as he put the keys in the ignition.

"Okay." And after a one-beat pause, "Come by later, if you can."

JERRY'S, a mile north on Highway One, was a low-roofed wooden building, its opaque windows displaying neon signs for various brands of beer. Not disreputable, exactly, but it was thoroughly unclassy. Relieved to see only six cars in the big parking lot, Johnny pulled in, parked close to the building, and turned to look at his silent passenger. "This okay with you?"

"Sure, why not. It's sure better than... Never mind," she said, making no effort to move beyond wrapping her arms close across her body. "Say, I don't suppose you'd happen to have a joint on you?"

"I don't suppose," Johnny agreed, and remembering that he wasn't in uniform, added, "You do know I'm a cop?"

"Sure. So what?"

Seeing no obvious answer to that, he unbuckled his seat belt. "So let's go inside and find you something legal. You are over twenty-one?"

"Oh yeah. Twenty-two." She freed herself from her belt and fumbled for a moment before managing to get her door open. Johnny reached into the center console for the small tape recorder he knew was there, pocketed it, and was out and around the car by the time she was on her feet.

"So, Andrea—Jorgensen, isn't it?"

"Andy."

"Detective John Hebert of the Port Silva Police Department, at your service."

"Okay," she said in a small voice that reminded both of them why he was here. He took her arm gently and led her inside, where he paused in the dimness for a moment before spotting the booths against the wall. "Over here."

Jerry, a small, sharp-featured man with close-cut graying hair, waited patiently while Andy considered one beer, then another, and finally said, "Oh, just bring me a glass of white wine."

About to ask properly for a Coke, Johnny eyed his pale, edgy companion and decided it would be counterproductive to look like a puritanical jerk. "Red for me," he told Jerry.

He made a bit of small talk while they waited for their drinks, asking her what she was studying at the community college (introduction to Western philosophy and pre-nursing), what she thought about the local anti-war protests (she was definitely opposed to going to war). When the wine and a dish of pretzels arrived, she snatched up her glass and drank half of it in two gulps.

She set the glass down, sighed, and reached for a pretzel, while he considered and rejected the introduction of the tape recorder. She was not, after all, any kind of suspect. Not yet. Instead, he picked up his own glass, had a thoughtful sip, and said, softly, "Andy, can we talk about what happened at your house?"

Shaken by a visible shudder, she picked up the glass again, drained it, took a deep breath, and said, "Sure. What do you want to know?"

Johnny signaled Jerry, pointed to the empty glass, and turned

his full attention to Andy. "Why don't you tell me what happened, just as you remember it."

She had reached home just minutes before calling the police. She was weary from a socially energetic visit and a final late night of partying. She parked in front of the house instead of putting her Jeep in the garage, thinking it would be easier to unload there. Everything was quiet and dark. She climbed the porch steps and opened the front door and turned the light on and realized at once that... "Something was really, really wrong."

"Was the door locked when you got there?"

She shook her head, looking not at him but at the table. At that moment Jerry arrived on what Johnny thought must be little cat feet. He set a full glass before the silent girl and departed as quietly as he'd come.

"I looked at the door. It hadn't been damaged." When she didn't answer, he said, "So either someone was good with a set of picklocks, or someone had a key."

She picked up her glass and tasted the wine. "This is good." Another taste. "He had a key. At least, I suppose that's him I...smelled." Tears began to spill from her eyes and run slowly down her cheeks.

"Who is 'he,' Andy?"

"Maybe it's not. I hope it's not. But I gave him a key the day before I left for San Francisco. I knew he was having trouble with his family, and I told him he might as well sleep in the guest room while I was gone."

"Who?" he asked again, softly.

She sniffed and wiped her eyes. "Sean Flynn."

"I WISH Johnny had come. I wanted to show him how much better I'm getting at chess. I might even be able to beat him." Sylvie scooped up the last bite of potatoes and set the fork down on her empty plate.

"Sylvie, he called to say he had to work. And I think it might be a while before you can beat him." Johnny, who'd probably been playing chess since before he could walk, had found an apt and willing pupil in Sylvie. Which had at least kept him from trying to make a player of Verity, who didn't care for games that involved sitting down.

"But you said he's coming later."

"I said probably."

"So you shouldn't be going out with that guy with the pony-tail. Besides, I don't like him."

"Sylvie, I don't think…" Verity took a deep breath. "I'm sorry you don't like him, but as I think I've told you, Paul Dufresne is an old friend from college. Anyway, I won't be out late."

Patience, who'd been listening quietly, now weighed in on the issue. "You go ahead, dear. You did the cooking, Sylvie and I will take care of the dishes."

"Yeah, okay." Sylvie got up from the table, carried her dishes to the sink, and headed for the door. "But first I'm going to go talk to Zak."

"It seems the atmosphere in an all-female household can get a bit shrill," said Patience as the back door slammed. "Maybe we should take in a ten-year-old boy."

Verity said, "Well, Paul Dufresne has an eight-year-old son." And laughed at Patience's look of horror. "Fear not, Ma. It's just that I'd had a long, busy day, and was harboring kind thoughts about a restaurant job as I drove past Paul D's on the way home. Then Johnny called. Then Paul called, as if he'd received a message by telepathy or something. So I said I'd be happy to meet him for a drink."

"You don't owe me an explanation, Verity. Nor do you owe one to Sylvie."

"I understand that. What I'm really wondering is, what the hell is she going to be like as a teenager?"

"It will be a complete flip. You'll need to be even more atten-tive to her life, while she'll be barely interested in yours."

"Ma, is that a gloat I see on your face?"

"Oh dear, I certainly hope not."

19

"I APPRECIATE YOUR ADVICE about my baby, here," said Paul Dufresne. "May I call you for more of the same?"

"Of course," Verity told him.

He pushed his chair back and gazed at her. "Okay, Verity Mackellar, what I'm wondering is, how come we were just friends at Stanford instead of, oh, something more?"

She grinned at him, remembering the frat-boy swagger, the smooth manners, the sleepy brown eyes. She'd fallen for somebody a lot like him, and look where it got her. "Friends are good, Paul. It's nice to see you again," she told him as she got to her feet.

He rose, too. "I'll walk you to your car," he said, and then turned at the raised voices from a table in the far corner, where a young waitress was clearly at a loss. "Listen, I'll call you."

"Life of a restaurateur," she said, and he made a face at her as he hurried back to work.

"Which is a lot easier than the life of a cop," she said to herself as she pulled up the hood of her jacket against a spatter of sharp, chilly raindrops that promised worse to come. Pleasant distraction ended, she was hearing Johnny's voice on the phone again, not brusque exactly, but full of tension. Where was he now?

She had just settled into her car when her cell phone rang. She dug it from her bag, flipped it open, and saw with a twinge of apprehension that it was a call from the police station. "Hello?"

"Verity, it's Alma."

"Alma. What's up?"

"You can come down here and collect your friend, before I have to lock her up with the drunks."

Her, she thought with relief, and put the keys in the ignition. "What friend?"

"Grace Beaubien."

"Tell her I'll be right there," she said, and started the engine.

"Oh, she's not the one who wants you, it's me. Just come around to the back and I'll let you in."

"Right."

Verity reached the station in five minutes, parked in the lot, and knocked on the back door, to be admitted almost at once by her harried-looking police-officer friend.

"Alma, what did she do?"

"I guess you'd call it resisting an officer."

"An officer doing what?"

"Trying to get her off the bridge, where we've posted signs forbidding protesting or loitering. I'm told she hit him with her guitar, which was harder on the guitar than on him, but still... Come on, she's in the squad room. Coates wanted to put her in the drunk tank, but I intervened."

Like the back lot, the station seemed quiet even for ten in the evening. No computers clicking, no chatter. "Where is everybody?"

"Something is going on, beyond a few provos at the bridge, but I don't know what. Svoboda got back from the city council meeting and disappeared, the chief hasn't been around." She pushed open the door, said brightly, "Here's your friend, Ms. Beaubien," handed Verity a small handcuff key, and left.

Huddled in a chair in jeans and oversized jacket, her hair a mass of frizz from the moisture-laden air, Grace looked about five years old. "Hello, Gracie. I understand you broke your guitar." The guitar lay on the nearby desk, a cracked depression marring its top.

Grace, her cuffed hands in her lap, sniffled. "I'm sorry about that. It wasn't my best guitar, but I've had it a long time. It was the one Danny sometimes played."

"Maybe it can be repaired. Would you like me to take your cuffs off?"

"Yes, please," she said, and held her wrists out.

"I'll do it if you promise me not to go back to the bridge tonight. And not to hit any more cops."

"Tonight. Okay, I promise."

Verity took off the cuffs and put them on the nearby desk, while Gracie rubbed her wrists. "Am I free to go home now?"

Alma hadn't said Grace could leave, exactly, but her original request had been for Verity to "collect" her friend. "I guess so. Do you need a ride?"

"Yes, please. I came to town with some other people, but they, um, didn't get arrested."

"I'll take you. Wait right here while I check with Officer Linhares."

Alma was at the front desk, and looked up at Verity's approach. "Get her quieted down?"

"She's promised no more bridge walking and no more attacks on cops for tonight, so I'll take her home."

"Good. But Verity, I'll tell you, and hope you can make clear to her, that everybody's about had it with disruptions of business and traffic. That bridge is the only reasonable route into town, and the city council insists and the chief agrees, nobody's going to be allowed to block it. Unless she really wants to live in a jail cell for a while, she'd better cool it."

"What about the new vigil site at the library?"

"So far that's working out well enough, because the librarians are more tolerant of disruptions than the downtown businesses. But it'd better stay peaceful."

"I understand. I agree. I'll try hard to get it across to Grace."

"Fine. How's your search for the real Daniel Soto coming?"

"It's slow, very slow."

"I bet. He's not highest priority around here right now, but we'd like any information you come across about his family. Like where to send the body when it finally surfaces."

"Yes, ma'am. And thank you, Alma. Grace is really a nice, quiet musician devastated by what happened to her boyfriend."

"Tell her she might find more comfort in church than on the streets carrying signs. You can take her out the back."

Gracie came quietly and settled into the Subaru without a word, guitar in her lap. When they were out of the lot and on their way, Verity said, "Grace, you're a grown woman, but I'm older and more experienced, if not necessarily wiser. I do not believe you'll accomplish anything for Daniel's memory or for the anti-war protest movement by spending time in jail."

"They won't—"

"Don't be silly!" Verity snapped. "Of course they will. The

city will not tolerate the constant blocking of major roads and the terrorizing of citizens."

"We're not terrorizing anyone!"

"That may be true, but you're creating a situation wherein other people think they can." Hearing herself, she sighed. "Shit. I sound like a…I don't know what. But I believe it would be sane and sensible for all of you to cool it for a while.

"End of sermon," she added as she pulled up in front of Grace's house. "Do you want me to come in with you?"

"No. The locks are good, and the neighbors are keeping kind of a watch now," she said as she unbuckled her seat belt.

"Gracie, one more thing. It would be helpful for us to have a good photo of Daniel. Is there one you can spare?"

That brought another sniff. "I don't have any. Not a single one."

Looking at the woebegone little face, Verity was sorry she'd asked. "That's okay, Gracie. We'll manage without a picture."

Grace slid out of the car carrying her guitar and trudged up the walk to her house. Verity reached across to close the car door, and watched until Grace had opened her front door, turned on a light, closed the door. And presumably locked it. Then, wearily, she headed for home.

WHEN the phone rang, Verity was so deep in Jim Harrison's wonderful memoir, *Off to the Side*, that it rang twice more before she surfaced to reach for her cell phone.

"Hello?"

"Verity, I'm sorry." Johnny's words came at half speed and about an octave below his normal tone. "I won't be coming by, it's too late and I'm…shot."

"Shot?" She sat bolt upright on the couch, the book sliding to the floor.

"Poor choice of words. It was a bad, messy scene. I'm going to have a shower and probably suck on a brandy bottle until I fall down asleep."

"Have you had anything to eat? You can have a shower here, and I'll feed you."

"Verity, I wouldn't make it that far. I'll see you tomorrow."

She got to her feet and bent to pick up the book. "Okay, have

your shower. But leave the front door unlocked," she added, and hung up.

Seeing that the light in Patience's bedroom was still on, Verity crept into the hall and tapped softly on the door jamb. Patience, propped on her big reading pillow, looked up from her book.

"Johnny just called. Whatever he's been involved with, he's had a rotten time and is too tired to drive out here. I'm going to take him something to eat."

"That's kind of you, dear. When your house is finished, perhaps you can rent him a room and avoid all this travel."

AT a little past midnight, a few people were still out on the rainy streets downtown, but there didn't seem to be any protestors, at least on the main thoroughfares. Verity pulled into Johnny's driveway behind his Volvo, noting with relief a light upstairs and one in the kitchen. She pulled up the hood of her rain jacket and climbed out, grabbed a big paper bag from the rear seat, and hurried up the front steps, to find that the door was indeed unlocked.

"Johnny?" She closed the door behind her and set the deadbolt.

"Here," from the kitchen.

Clad in sweats and ankle-high shearling slippers, he was sprawled in a chair at the table, a brandy glass in front of him and the bottle nearby. In the circle of light from the over-the-table fixture, his hair and beard gleamed wetly, but his eyes were hooded, their bright blue just a gleam.

"You didn't need to come out in the rain. In the middle of the night."

"True. Do you want something to eat?"

"Oh. I don't think so."

."Well, I might." She scooped some potatoes onto a plate, added slices of beef, covered the plate and put it in the microwave oven. She found an open bottle of white wine in the fridge, along with a six-pack of ale. No milk. There was a bottle of red—pinot noir—on the counter beside the fridge. When the oven dinged, she pulled out the plate and took it to the table along with a fork.

"Eat or not, as you wish," she said, and collected brandy glass and bottle to carry them away. "Water? Beer? Red wine?"

"Uh, red wine." He picked up the fork, looked at it as if he didn't understand its purpose, and began to eat. She poured herself a glass of chardonnay; went into the living room to build a small fire, returned to fill his plate again, and sat down with her wine to watch him eat.

"So," she said when he finally pushed the plate away. "Shall we go in by the fire?"

"Okay."

When he was stretched out with his feet on an ottoman, she sat down beside him. "I missed you tonight," she said. Which was true, but not something she'd care to elaborate on. "Do you want to tell me what happened?"

He draped an arm across her shoulders and leaned his head back. "No. Tell me what *you* did today."

"Mostly I ferried Gracie here and there. I took her to see a little memorial some of Danny's Hispanic friends had put on the jobs board at Safeway. Then we drove around and found one of the guys who put it up, somebody she knew slightly, and that proved interesting." She related Carlos's story.

"Hank Svoboda was quite interested in that," she added.

"I bet."

"Then Gracie discovered that Daniel Soto's old trailer, which had been parked at the Beaubien farm, is no longer there."

"Since when?"

"Nobody is sure. Gracie thinks, but doesn't say, since Saturday night. Or maybe Sunday night."

Johnny turned his full, bright gaze on her for the first time tonight, but she didn't wait for his comment. "Then this evening Gracie got herself arrested for resisting an officer with her guitar, and Alma called me to come and take her home. And I did."

"Sounds like you've had more than enough of Grace Beaubien."

"Oh, yes. Now what about you?"

Silence stretched for long seconds, and then he sighed. "We found a body tonight."

"Danny?"

"I wish," he said, and registered the twitch of her shoulders under his arm. "Sorry. But a floater isn't the worst kind of body to have to look at. It was Sean Flynn."

Verity leaned closer against him for warmth no fire could provide.

"There's a local girl, Andrea Jorgensen, who's been a friend of Flynn's for a while, maybe a girlfriend. She has a house out on Old Quarry Road, and she knew he was having trouble with his family, so when she left for a longish visit to San Francisco, she gave him a key. She came back this afternoon."

"And found him? How long…"

Johnny's arm tightened briefly. "The coroner says he'd been there for days. Maybe since Saturday night. She opened the door when she got home, and couldn't even go inside." He got to his feet, to stand before the fire and take several long, deep breaths.

"Sorry. I'm not very good about dead bodies. Serious failing in a cop," he added, and began to pace slowly in front of the fireplace, slippered feet making no noise. "Although I gotta say, Chief Gutierrez looked pretty green, too. We caught this particular call together."

"How was Sean Flynn killed?"

"Shot, at close range. The living room was a mess, there'd obviously been a fight. Flynn was a good-sized guy, and known to be a hiker and backpacker, but the other guy had the gun. At least, there's no record of Flynn's having owned a gun."

"The poor girl," said Verity, and flinched inwardly at her involuntary emphasis. Would anyone think, instead, "poor Sean"?

"Oh, yeah. She's a tall, bright, probably smart-ass kind of girl under normal circumstances, twenty-two years old. And she was really unstrung." He paused and turned to face the fireplace, as if the flames had caught his attention. "I took her down to Jerry's to get her away from the house and find out what she knew, and when we were getting ready to go in, she asked if I maybe had a joint. I was tempted to go look one up for her, and maybe one for myself.

"But we went inside and had some wine instead. She told me what she knew, which was not much, and I took her downtown to to get the statement on paper. And then went back to the crime scene."

"You said she opened the door. Was it locked?"

"Nope. Closed but not locked. But there was no damage to the lock or the door."

"So several days ago, maybe even Saturday night, Sean took somebody out there with him."

"Or let somebody in, or just neglected to lock the door. If the time of death the coroner estimated works out, this is going to tie in with the riots. Or look that way, to the public and the press. The chief pointed that out."

He squeezed his eyes tight for a moment, as if to shut out the past scene or the one to come, and came back to drop wearily beside her on the couch. "Anyway, the immediate on-site stuff was done and the techs were about ready to load the body in the ambulance. And all hell broke loose."

Verity made that jump. "His father."

"You got it. I guess somebody called him, or maybe he just came into the shop the way he's been doing for days, and heard what was up. He insisted on having a look, and then he went crazy. The chief and Ray Chang were getting the worst of it until I finally got hold of the guy from behind and damn near strangled him.

"Then he fell down on the floor crying, and we cuffed him," he went on, "and I took him to Good Sam and the doctor on emergency sedated him and put him to bed. I can only hope he sleeps a long time, because he's not going to enjoy waking up."

"Johnny, is there any notion of who, or why?"

He shook his head. "We've been looking for him since Sunday. So far as I know, we haven't come up with a single lead. The thing is," he said, sliding lower against the couch back, "he didn't have any real friends here in town. He was only here sporadically, and the people he encountered casually didn't like him much. So far nobody has mentioned his connection with Andy Jorgensen, so I guess nobody had noticed."

"Daniel Soto was more or less a friend of his; I don't think they spent a *lot* of time together, because Grace Beaubien couldn't stand him. She said he was mean-spirited and always angry. But I think I told you the other night, she thought he had a crush on Danny; and Red at the pool hall said the two of them came in there together a few times."

"Not a lead that's going to do us much good, I'm afraid," he said. "I guess we'll just have to plug along, talk to all the guys we've talked to already and look for more. In a town this size,

somebody must have noticed something." He yawned, put his head back and yawned again, more widely.

"Sorry. I'm beat, Verity. You go home and get some sleep, and I'll see you tomorrow."

"Are there sheets on your bed upstairs?"

He frowned. "Uh. I put clean sheets on, I think it was yesterday. But I can sleep down here."

"Let's both sleep upstairs."

"Lady, I am so shot I'll be of absolutely no use to you. None at all."

"Come on," she said, and got to her feet to hold out a hand. "We'll just cuddle up and keep each other safe from the wolves and the bears."

VERITY had pulled her clothes on as quietly as possible and was picking up her shoes to carry them out when the blanket-covered mound on the bed groaned and rolled over.

"Verity?" He came up on one elbow and peered at her from sleep-gummed eyes. "You're up. You're *dressed!* Uh, what time is it?"

"Six-thirty, sorry 'bout that," she said after a glance at her watch. "I woke up thinking about all the things I have to do today, so I'm heading home. I'm *really* glad you weren't as tired as you thought last night," she added, and leaned over for a quick kiss. "Call me tonight."

"We need a less abrupt way to start our mornings." He sank back against the pillows and rubbed his eyes. "Could you please take five minutes to bring me a cup of the coffee I smell, and tell me what's up?"

"Your wish, et cetera," she said, and was away and back quickly, to hand him his insulated coffee mug and perch on the edge of the bed. "I think I may have a line on Daniel Soto's family. How I got there is a long story, but my mother's had a colleague in San Luis Obispo checking on construction companies on the central coast, and the woman is supposed to get back to us this morning. If she's turned up anything useful, I'll need to explore further.

"I'd like to go down there in person," she added as she got to her feet, "but just getting there from here would occupy a whole day."

His face had shifted into fully alert mode. "What you ought to do is give my uncle a call. He's retired, but only moved as far as Pismo Beach, which is practically next door."

"Your uncle, the contractor? I thought you said he was in San Diego."

"I think I said S.L.O., which is what he calls San Luis. John Lundquist, he's in the book."

"Johnny, that's wonderful. Thank you."

"That's okay. He's a good guy, a widower with his kids grown and gone. He'll really be pleased if he can help you. But listen, do figure on us getting together some way tonight, okay?" He took a sip of the coffee, and sighed. "Yesterday is coming back to me in big, loud colors, and today is going to be at least as ugly."

20

VERITY OPENED THE FRONT DOOR and hit an atmosphere of tension that felt like an invisible wall. "Whoa. What's up?"

"I won't go." Sylvie, still in her nightgown, stood in the entry to the hallway with shoulders squared and chin out.

"Sylvie, please go have your shower and get dressed," Patience told her. "Then the three of us will talk about this."

The firm chin quivered for a moment as Sylvie directed a pleading look at Verity. "Okay, but I won't go," she said, and fled.

When the bathroom door had slammed shut, Patience sighed and shoved both hands into the pockets of her robe. "An early phone call woke us both up, so she was within hearing range when I answered the second call."

"Something about school?"

"I wish. No, it was her father. He's in Santa Rosa, and he's interviewing this morning for a job at Sonoma State University. He wants to come here tonight."

"Here?"

"Well, to Port Silva. He'll call this afternoon to arrange a place to meet."

"Is he planning to take Sylvie home with him?"

"He didn't say, but Sylvie saw that as a possibility and...well, you saw her. And I think, my dear, that it's time we get our ducks in a row on this situation."

"So I suppose we'll have to...to grill her for facts. *God*, but I'm going to hate this!" said Verity through set teeth. "Let me get a cup of coffee, okay?"

"Fine." Patience followed her daughter into the kitchen and picked up her own mug from the table. "How's Johnny?"

Verity, spooning coffee into a filter, took a moment to shift mental gears. "He's good, at least this morning. I'll tell you about it all later. When are you leaving for Sacramento?"

Patience made a face, which Verity didn't see. "I'm not. The man I meant to talk to was my wake-up call this morning. He gave me as much information as he felt he decently could about the 'unsuitable boyfriend,' and I think it will be enough. I'll call my client later."

"Nice of him to save you a trip." This time Verity saw the grimace. "What?"

"It's almost two hundred miles to Sacramento, and I was planning to enjoy every mile of the drive." The pipes gave a faint rattle as the shower was shut off. "Let's conduct this discussion in the living room."

When Sylvie appeared a short time later, wrapped in her terry-cloth robe with her hair still dripping, Verity got a towel from the bathroom and applied it vigorously. "There you go, kid," she said, and stepped back for a look. "Good. Now let's go talk."

Urged into the living room by Verity's arm across her shoulders, Sylvie perched on the edge of the ladder-back rocker. "I don't see why we have to talk. I don't like him or his house or his girlfriends, and I won't go home with him. Can I have breakfast now?"

"Girlfriends?" asked Verity, but Patience broke in. "After you tell us what happened in Susanville last time to upset you so."

Sylvie shrank back in the rocking chair. "No. I *promised* I wouldn't talk about that."

"I don't think you have a choice, dear." Patience's voice was soft. "Usually it's important to keep a promise, but if it was between an adult and a child, for a bad reason, I don't believe it counts. Please tell us what he did to you."

Sylvie got up from her chair and came to sit on the couch right beside Verity, who quickly put an arm around her but looked a silent question at Patience: Should we be doing this?

"He locked me in the cellar," said Sylvie, and shivered. "There's a light, but you turn it on outside, and he didn't. And I couldn't. It was really dark."

"Why the hell…?"

"Why did he do that, Sylvie?" asked Patience.

"I was really tired of being there so long with nothing to do and nobody to play with, and I'd been saying I wanted to go home. This night he told me he and Amy, his new girl, were going

to town for dinner and a movie and I should make myself a sand-wich and watch television and go to bed. So I said I knew which way it was to Port Silva and I'd start walking and probably get a ride."

She paused for a long breath. "So he got really mad and kind of herded me around the side of the house and shoved me into the cellar. A good place for bad girls, he said. He closed the door and I heard him lock it and he went away."

"For how long?" Patience asked.

"Forever, I thought. I yelled and screamed, but there wasn't anybody around to hear. It was starting to get light out when he came back."

"And what did he say then?"

"He was kinda scared, I think." Her face eased, and she straightened up. "He said he forgot about me. He said he forgot to turn the light on. He said he was really sorry. And he said if I ever told anybody, he would be in terrible trouble and lose his job and maybe go to jail, and never be able to pay for me to go to college. He asked me to promise not to tell, and finally I did. I just wanted to come home."

"Jesus H. Christ!" said Verity, and added a less-than-sincere "Sorry."

"I didn't tell anybody until now. He'll be really mad. But I am not going to stay with him ever again. I won't. Do you think he'll go to jail?" This last sounded more hopeful than worried.

"I don't know," said Patience. "Probably not. But when he calls again, I'll arrange to meet him for a drink…" Verity made a sound, and Patience caught her glance "…or Verity will. One of us, anyway. I believe we can convince him that you prefer to stay here, and we prefer that, too."

"Go get dressed, sweetie, and I'll fix you some breakfast," said Verity. She gave Sylvie's shoulders a squeeze before dropping her encircling arm.

"When he calls, tell him I'll meet him at Paul D's," she told her mother as Sylvie departed. "The food is excellent, and Paul will be there for backup if Simonov gets troublesome."

"Are you sure you want to do this?"

"I'm sure. I'll channel my old business-world persona and be a good, calm negotiator."

"Then here's what I'd suggest. Explain to David Simonov, in as much detail as necessary, that we believe it would be in Sylvie's best interests for us—well, it would officially be you—to adopt her. Ask him to agree to yield his parental rights. Otherwise, there will be unpleasantness for all of us. The fact that he's looking for a better teaching job should weigh in our favor, I'd think."

"Oh, my. This will be an interesting evening. Maybe I should borrow your .38."

"Here," said Sylvie, who'd come back into the room from the hallway carrying her guitar in its case. "He gave me this to be quiet, and I want to give it back."

"COME on, kid, I'll walk you out to the bus," Verity said an hour later. Sylvie, her usual cheerful confidence restored, trotted down the stairs and stopped to say good-bye to Zak. "Mother?" said Verity, and put her head inside the open office door, to find Patience on the phone.

"Just a minute," said Patience to whoever was on the other end of the line, and Verity waved to her. "Sylvie's leaving, and I'm going over to the house to wait for the carpet guys, who are due any minute."

When she returned, Patience was still in the office, seated behind the desk, and the printer was whirring. "Ma, I need to tell you what had Johnny so upset last night."

"Hank just called me about Sean Flynn," said Patience. "What a sad, sorry thing. He says they have a suicide watch at the hospital for Sean's father."

"From the scene Johnny described, I'm sure that's a good idea. Do they have any suspects yet?"

"Now *that* Hank wouldn't tell me. So let's not think about it. Did the carpet-layers arrive?"

"They did, and they're working hard. Have you heard anything from your San Luis friend, Barbara Grant?"

"That's what I just printed," she said, and swiveled her chair around to pick up the papers in the printer tray and hand them across. "And if you don't mind, I'll leave you to it. The phone number is here, if you need to check further with her. Meanwhile, I have work to do at the downtown office. If it looks like I won't make it home by the time Sylvie's due, I'll call you."

"I'll be here. And you be careful downtown. The carpet guys said that there's a lot of traffic in the area of the police station." As Patience drove off, Verity went upstairs to make herself a cup of coffee. Ten minutes later she set her insulated mug on the desk and sat down to read.

Barbara Grant's brief report began by stating that three of the four companies for which Patience had requested information were old-timers in the area. The fourth company had been in business there only since 1998.

The oldest of the remaining three, Central Coast Construction in San Luis Obispo, was established by James Arkwright and William R. Lincoln in 1938. The Lincoln name vanished from the company's listing eventually, but Arkwrights continued in ownership through Andrew and Andrew Jr. By now there might well be a fourth generation Arkwright working to get his contractor's license, Verity surmised, and promptly lost interest in that family as her eyes moved to the next entry.

MacWhorter General Contracting and Construction was established in Atascadero in 1948, wholly owned by Luke MacWhorter. Bingo! she thought, and then told herself not to be silly. One tiny questionable connection, based on a vague four-year-old memory, was hardly evidence. Nevertheless...

The company became MacWhorter and Sons in 1972, although Luke MacWhorter remained sole owner. In 1980 the sons, Luke, Jr. and Douglas, came in as partners, sharing forty-nine percent of the company, the senior MacWhorter retaining fifty-one percent. Luke, Sr. and Douglas held contractor's licenses; apparently Luke, Jr. hadn't bothered or lacked the necessary skills.

Verity did a quick calculation. With Luke, Jr. and Douglas presumably the "Sons" acknowledged in 1972, there could have been another generation starting around then, in the seventies. Which could have included another Luke. Who might have become, for some reason, Daniel Soto? Quite a reach, she told herself, but not impossible.

Lewis Brothers Builders was the third long-lived company, and she'd wondered about that name as possibly significant. Now she felt it was less so, but she ran her eyes over the information anyway. Established in 1945 by three brothers, it was now owned by one Lewis and two non-Lewises, although they might of course

be in-laws. A smaller company than the other two, said Ms. Grant. Okay, more info needed. She was reaching for her cell phone when it rang.

"Verity? I'm glad I caught you."

"Today I'm right here at home, easy to catch. How are you, Johnny? Still exhausted?"

"Nope, just busy. I wanted to tell you I called my uncle. He's more than willing to help you, and here's his number," he added, and recited it.

"Thank you. That was next on my list."

"I figured it might be, so I thought I'd better warn you."

"Warn me? About what? Is he easily upset, or sick?"

His sigh was audible. "No, but he's the oldest of the three Lundquist siblings, and he takes that position seriously."

"Good to know. Johnny, something's come up that I have to deal with tonight. Let's do something tomorrow instead, okay?"

"What's…oops, gotta go. Okay, tomorrow. Talk to you then."

Verity had a few thoughtful sips of coffee before opening her phone again and tapping in the number. How bad could a relative of Johnny's be? Except, of course, his father.

"I'm Verity Mackellar, a friend of your nephew, Johnny Hebert," she said some moments later. "He told me you'd been in construction on the central coast for years and might be able to help me find some information I'm looking for."

"I've been semi-retired for a few years, but I still keep up with what's going on in the business. Have you known Johnny long?"

"Uh, yes." When silence followed, she added, "About two years. Right at the moment, I'm interested in a company called MacWhorter and Sons."

"Old-time company, used to be a pretty good one. It should probably be called just MacWhorter's these days. You're a private investigator by profession?" The voice was a good deep baritone, with a genial tone that made the questions seem less bald than they were.

"I'm presently working for my mother, who is a licensed private investigator. Previously I worked in banking. Why?"

"Why do I want to know?"

"No, why just MacWhorter's."

"Oh. Well, the old man is pretty much out of the picture. He's

not dead, so far as I know, but I believe he lives in a quote senior unquote community that's generally regarded as a nursing home with a fancier name. Do you know him, uh, well?"

"MacWhorter?" replied Verity, deliberately misunderstanding her interrogator. If real information was going to be hard to come by, she might as well enjoy the effort.

"No, my nephew. Johnny."

Another gap. "I'd say so, yes," she said. "So, are the old man's two sons now the functioning MacWhorters?"

"I'd say it's pretty much Doug MacWhorter's outfit now. His and *his* two sons, or at least the older one, Doug, Junior. How well?"

Verity took a deep breath. "Mr. Lundquist, are you asking me whether I'm sleeping with your nephew?"

"Yes, ma'am, I guess I am. Are you?"

"I am, when occasion permits. Have you any objection to that?"

"None whatsoever. I'm delighted."

"Oh," she said, and then remembered her purpose here. "So what was Doug's younger son's name and what happened to him?"

"Bart is a mean bastard, pretty much like his father and brother; but he's stupid, which they're not. I think they try to keep him out of the day-to-day business, and out of trouble."

Disappointment brushed her briefly, along with the realization that she'd put too much weight on one single lead. As she heard John Lundquist draw a long breath, probably for another rude question, she remembered the other "son," the second Luke. "What happened to Luke, Junior?"

"He's still around, and seems to live well enough, but I don't think he's active in the company. Why?"

"Does *he* have a son?"

There was a thoughtful pause. "I believe he did. Another Luke, I think. But I haven't heard anything about him for…I don't know, years. Is that who you're looking for?"

"I thought it might be. But the man whose identity I'm trying to discover called himself Daniel Soto."

Another pause, more like an in-drawn breath. "Then I'd say there's a strong possibility you've hit pay dirt. Old man Mac-Whorter's wife was named Soto, Elena Soto, from Mexico as I

recall. I think he'd spent some time there when he was younger. She's been dead for years now, but people who knew her when say she was a pistol. Story was, the money for the company came mostly from her, or with her."

"Holy shit," she said in reverent tones.

"Sounds like that made your day."

"Mr. Lundquist, I don't think I should say anything further about it for the moment, but I can't thank you enough."

"The name is John. And you can thank me by keeping my nephew happy. How tall are you, Ms. Mackellar?"

"I beg... I'm six feet tall, less a quarter to half an inch depending on how tired I am. Why?"

"Oh, just a personal prejudice, probably because of that Chihuahua-sized female he used to live with. I've noticed that little bitty women tend to have the same disposition as little bitty dogs: yappy and mean. You let me know whether there's anything else I can find out for you down here."

"I'll do that."

"And tell Johnny I'm about ready to wheel the Cessna out and fly up there for a visit."

"MY God, Gutierrez, there are three vans out there with those television antennas that look like telephone poles! There were probably fifteen murders in Oakland last weekend, so why are the television people climbing all over *us?*"

Gutierrez looked at Mayor Riley's flushed face, and wondered about Hizzoner's blood pressure. "We're a picturesque little coastal town known for eccentricity, Oakland is a grim metropolis known for a high rate of violent crime. Which would you rather cover?"

"Neither!" he snapped. "Are you going to talk to those people?"

"I am."

"And what can you possibly tell them?"

"That people in Port Silva are saddened that peaceful protest recently turned into violence, and outraged that a citizen has apparently been murdered. And that the police are working round the clock to find out who killed this young man. All of which is true."

The mayor collapsed into a chair. "Do you have any leads? Any evidence? Any idea who might be responsible?"

"The most obvious possibility is that Sean Flynn's murder ties in with the events of last weekend. I never discount the obvious. But it may also have been a purely personal conflict. We have to explore all possibilities."

"And just how are you doing that?"

Gutierrez smiled a grim smile. "For starters, we're bringing in every person we're already talked to about the march and riot, including your son, for further interviews."

"Maybe I should get Mick a lawyer." Riley looked both terrified and belligerent.

"That's your privilege, of course, or his. He's of age. I can't give you any advice about this," he said in milder tones. "But I can promise you and everyone else in town that we're not looking just to clear a case; we're looking for a murderer."

The mayor's tight jaw eased a bit. "If Mick had killed that poor Flynn boy—and I know he's basically a good, kind kid who purely wouldn't have—but if he had, he'd have come to me or his mother about it, or he'd have run like hell, been out of town and long gone by now. And he's still here, and still behaving like a normal guy."

"What you're saying makes sense," said Gutierrez.

"And there's a neutral comment," said Riley. "What about the rest of the Flynn family? I understand there's been some conflict there."

"That's true, and we'll be talking to them. However, we'd do that in any case; it's a sad fact of policing that murders are often family affairs."

"Okay, sorry. Do you want me to face the cameras with you?"

"Suit yourself. I've told them I'll speak briefly at noon, and so far, I don't know anything pertinent that you haven't been told. If I find out more, I'll be sure to talk to you before I talk to the cameras."

"Chief, isn't it possible that this was just a random thing? An attempted housebreaking that went wrong? From what I hear, there's been a rash of those recently in the outlying areas."

"There has been, and we're following up on that line, too."

"Well." He got to his feet wearily. "I'll be here at noon."

"Fine." Gutierrez rose as well. "If you don't want to take on the television cameras right now, I can let you out the back door."

"I'd appreciate that," said Riley, and Gutierrez led the way down the hall. When he'd closed the door on the mayor, he moved back past his own office to the apparently empty squad room and spotted Johnny Hebert at his desk in the far corner. "Hebert? Come down and talk to me."

"Be right there," said Johnny, and shut his computer down.

"I've been politicking instead of policing," he said when Johnny came into the office. "Are you working on the Flynn investigation along with everybody else?"

"Right. I've been doing follow-up interviews with the protest people, the ones who couldn't get in here readily. Just finished clearing up my notes on that."

"Then I've got a proposition for you."

"Chief, cameras make me nervous."

"Don't worry, Big Bad Chief is my job and I'm good at the stance. How well do you know the Flynn family?"

"Only by sight. Well, except for Dennis; last night was pretty personal."

"Forget about Dennis, for the moment. Pete Flynn and his wife, Allie, are at home at the ranch now. Their two kids, Tim and Norah, are due to arrive there sometime this afternoon."

Johnny waited.

"I've known the family for years, and so has Svoboda, which makes questioning them tricky. I'd like you to call and arrange to go out to talk to them."

"To find out where they were last weekend?"

"That and whatever else you can. Pete and Allie are generally regarded as good, hardworking people, nothing on their records except a few traffic violations. Norah hasn't had even a speeding ticket; for Tim, there's a reckless driving citation, a DUI, and what could have been a pot bust some years back if the officer had chosen to make it. That's it. And so far as I know, they're all grieving. But families…" He shrugged and spread his hands.

"I've noticed. Should I be in uniform?"

Gutierrez eyed the khaki pants and blue shirt. "I don't think so. No, just get the information in your best nonthreatening fashion."

"I'll try."

"And I just had another thought. If you have some time free before the Flynns are available, go take a look around town, feel things out. Drive your own car instead of a squad, in civvies just the way you are now. Did you get the heads-up from Svoboda this morning?"

"Yessir. Special assembly at the high school about civic responsibility and respect for different opinion, early dismissal after that, home football game this evening."

"Oh yeah. Sometime before seven P.M.," said Gutierrez with a sigh, "most of the town of Willits will be rolling in here loaded for bear. Anyway, with all that, plus the weekend, plus the heavy television coverage the Flynn murder is apparently going to get, a force as small as ours could end up in deep shit again. And not only is asking for help from the Highway Patrol expensive, it's in some ways counterproductive."

"Yes, *sir*."

21

"OH, GOOD," SAID VERITY WHEN Patience answered the downtown office phone. "Ma, have you got a minute?"

"Just about. What can I help you with?"

"I read the stuff from Barbara Grant, and then I think I maybe struck gold—he called it pay dirt—with Johnny's uncle," she said, and gave a quick run-down of what she'd learned.

"Now here's the problem. I can't get Grace on the phone, but I think the police need to know this possible—shit, *probable*—MacWhorter–Soto connection. Don't you?"

"Yes," Patience said after a moment. "Clearly Daniel Soto's real identity hasn't been of major concern to them yet, but they'll need to know eventually. If you can find Grace Beaubien, tell her first; she's paying for the information. Then go see Hank."

"I'll do it."

Verity put two copies of her report into envelopes, collected her mug of still-warm coffee—bless modern technology—and went upstairs, to spend a few minutes with the newspapers. The San Francisco *Chronicle* had the briefest mention of a "possibly riot-related" murder in Port Silva, probably because it had come in too late Thursday night for full coverage in Friday's edition.

The latest issue of the weekly Port Silva *Sentinel* had gone to press before Sean Flynn's murder was discovered, but it had wide coverage of the march, the riot, and the events of the ensuing four days. The editorial gave cautious, somewhat qualified approval of the behavior of the police and other city officials. Letters to the editor were about evenly divided between whatever-it-takes people and anti-war folk, with civility in evidence on both sides except for the man from out in the county who blamed the continuing decline of his country and its liberties on environmentalists and the ACLU.

She set the papers aside, failed once again to reach Grace

Beaubien by phone, and decided to go look for her. She locked cottage, office, and studio and trotted over to her own house, Zak beside her, to check on the carpet-layers.

"It looks fine," she said to Buddy, the crew chief, after a good look at the velvety taupe nylon now carpeting the master bedroom. "I have some errands to run. If you finish the other bedrooms before I get back, just lock up and leave the key in that planter with the lemon tree. I'll be in touch later."

"OKAY, I gave in because I could see how bored and lonesome you were," she told Zak, who could hardly believe his good luck as she opened the back door of her car to let him in. "But you had better be good or it'll never happen again."

Turning onto Gracie's street ten minutes later, she said, "Well, shit," with a vehemence that caused the dog to lay his muzzle briefly on her shoulder. "Not to worry," she told him, and pulled up to the curb. "I'll just leave this in the mailbox." But as she got out of the car, Gracie's Honda pulled up to park behind her and Gracie came running, to greet her with a hug.

"Oh, Verity, I'm sorry I've been out of touch. I should have called to thank you for rescuing me last night." Under an unzipped hooded sweatshirt, she wore her WAR IS A BAD IDEA T-shirt and jeans; add the hair tied in two pigtail-like bunches, and she looked like an alert ten-year-old.

"I haven't done anything to bother anybody today," she added."

"Good. Because if you find yourself being arrested again, I suggest you call a lawyer."

"I will, I promise. Do you want to come in?"

"For just a minute. I have a current report of my investigation, with information I think you'll be interested in."

"Bring your dog if you want," Gracie said, and led the way into the house. The mess from the weekend's burglary had been mostly cleared away, but the place had an air of dusty negligence, as if no one had spent much time here in recent days. Verity took the day's report from her bag and handed it over. "Have a look at this, while I take Zak for a quick stroll."

Zak ambled halfway down the block, eyeing the new scene with interest and visiting a tree next to the street before coming

back briskly at Verity's call. In the living room, Gracie sat on
the couch, the report on her lap and an unreadable look on
her face.

"So that's his family."

"It certainly looks like it."

"He said he had a grandfather who got too old."

"My informant said the senior Mr. MacWhorter is eighty
years old and has been in what appears to be an assisted-living
facility for some years."

"And the rest of them don't sound very appealing. I think
Danny probably had good reason for leaving."

"I'm sure he thought he did."

"Well. Thank you. I think I've learned all I need to know. I
see you included your bill; let me get my checkbook, and I'll pay
you."

"Gracie, I don't know what you intend to do about this, if
anything. But I'm going to have to give the information to the
police, as well."

"I don't see why." The round brown eyes narrowed. "I'm
paying for it, it should be mine."

"The police have an accident—"

"An assault!"

"Okay. But call it what you like, the person we all knew as
Daniel Soto went into the sea nearly a week ago and is presumed
dead. The police have an official event on record, and they'll
want to notify family members once they find out who and where
those are."

"I don't see why," Gracie said again.

"I think it's probably the law."

"And we don't know for sure that it's his family."

"Not yet, but it's clearly a strong possibility."

"I don't want to have anything to do with those people, and
obviously neither did Danny."

"Fine. Probably you won't need to."

"But you're still going to tell the police?"

"I am."

"Okay." Gracie got up, went into the hall and presumably on
to the office, returning shortly to hold out a check. "Thank you,
and Patience, for your work," she said in not-very-thankful tones.

"Thank *you*," said Verity, tucking the check into her bag. "Gracie, I'm sorry we disagree on this. If there's anything else I can do, professionally or personally, please call me."

"There's one thing. Do you know a good lawyer? Just in case," she added. "My parents' guy would be a direct pipeline to them, and I don't want them involved in...whatever."

Uh-huh, whatever. "Actually, I do. Larry—Lawrence—Klein is an attorney my mother works for occasionally. He's not a Port Silva native, but he's lived here for years with his family, and he's a good lawyer and a likeable person."

"Klein. I'll make a note of that. Thanks."

Verity throttled the impulse to give more unwelcome advice, called her dog, and went back to her car. "I promise not to be long," she told Zak ten minutes later as she pulled to the curb just around the corner from the police station. She lowered both front windows a few inches, said, "Stay and be good," to the dog, and went to look for Hank Svoboda.

"Captain Svoboda?" The clerk behind the glass shook her head. "He's out right now, and I'm not sure when he's coming back. Can someone else help you?"

"Oh, I don't think so. I'm Verity Mackellar, a personal friend..."

"Oh, sure. Patience's daughter. You want to leave him a message?"

"Thank you, I do." Verity dug into her bag for the envelope containing the second copy of the MacWhorter report, wrote "Capt. Svoboda from Verity Mackellar" on it, and handed it over.

THE younger Flynns had not yet arrived at the ranch but were expected soon, Allie Flynn told Johnny, and four P.M. would be a good time for him to arrive. Johnny agreed, and set off into the blustery air and shifting lights and shadows of a late-October day on the second mission Gutierrez had given him. Being out and about in this small town, with the always-present, ever-changing ocean in view at the end of this street or between those two buildings, reminded him of his overall purpose. This was a place worth protecting.

He drove along Main Street, with side trips onto several cross streets, and saw no gathering groups; perhaps the high school

hadn't released its hordes yet. Shops were open, and the window of a store selling athletic apparel and shoes, broken in Saturday night's melee, had been repaired. Only an experienced eye, he thought, would be aware that there were a few more cops on the street, police cars moving by more frequently, than was customary.

Silveira's big grocery, hardware, and whatever-you-need store was busy, as usual. Johnny ambled through, exchanged greetings with one of the regular clerks, and stopped to chat with Rod Silveira, the second-generation owner of the store. "Pretty quiet around here," Silveira told him. "Maybe the news of a bloody murder made people stop and think. Or maybe it scared 'em into staying home, who knows? Hey, the coffee pot's on in the back, you want a cup?"

"I think I'm over my limit already," said Johnny, and wished him a good day. Outside, people were moving about the parking lot with full or empty shopping carts, a couple of middle-aged women chatting beside a car with its hatchback open. No other cops in sight, nor any sign-carriers.

He walked a couple of blocks further north on Main, turned up Harrison Street past a book store, a fabric and upholstery store, and a print shop, turned the corner and strolled past the Dilly-Dally-Deli, where some of the town's scruffier teens tended to gather. In today's chilly wind, one lone boy sat on the outside bench with a soda and a cigarette, and the place itself was mostly empty.

And back to Main Street, to walk another two blocks, spot several small groups of kids who must have just left the high school, and spot as well Val Kuisma, in what appeared to be a pleasant exchange with three boys. Val moved on, and so did Johnny, to the spot where he'd parked his car.

Safeway's lot was crowded with cars and grocery-laden carts but the pick-up site for casual workers was vacant. He paused for a look at the memorial to Daniel Soto before moving on to the far end of the roofed area that shielded the big entry doors, empty carts, and newspaper racks, where a solidly built gray-haired woman and a much older, thinner companion sat behind a table with a sign that read PEACEFUL PETITION FOR PEACE.

"How's it going?" Johnny asked, and the frailer woman held

up a pen. "Just fine, thank you. Would you care to sign our petition to our congressman?"

"If you two represent Grannies Against War, I think I've already signed," he told her.

"I've seen you before. You're a policeman," said the younger woman, in a tone that made the words an accusation.

"Ella, don't be rude," said her companion.

"Just one of your local guardians of the peace," Johnny said. "It looks peaceful enough here. "

"We still believe in our cause," said Ella firmly, "but after all the trouble, we're just not being noisy about it. And nobody has yelled at us yet."

"Glad to hear it. Good luck to both of you," he said, and went back to his car to drive down the steep road to the wharf. There he had a cup of coffee at The Dock restaurant while listening to nonpolitical conversations around him; grabbed an order of fish and chips at a nearly empty Cap'n Jack's where a young waitress and an older cook argued amiably about military service; and finally had a foot-on-the-bench chat about fishing with several old guys sitting in front of the marine supply store.

The serious complaints there weren't about war or peace but the recent salmon season and how the damned government was regulating fishermen to death. "Hell, half the guys I know are selling their boats, and the rest are trying to survive doing whale-watching runs for *tourists*," one of them told him, and spat for emphasis. "Fed-Guv goddamn near wiped out the Klamath run this year, sending most of the river to the fuckin' farmers. Three years from now there won't be a salmon boat north of Bodega Bay."

All in all, he decided as he drove back up the narrow road to Main Street, he'd spent a big chunk of the afternoon without encountering any sense of urgent anger. If planning was going on, it was not out on the street, and if ordinary citizens were worried, they weren't letting it hamper their movements.

A CAUTION sign still hung from a wire strung between two temporary bollards across the paved path into South Bluffs Park; but the grassy areas to either side of the path gave easy access to Johnny, as they had to maybe a dozen people he saw scattered about beyond the sign. He hadn't been down here since Saturday night, or more accurately Sunday morning; but the tough grass

had sprung back from its trampling and the original wooden barriers marking the edge of the bluffs had been replaced. Maybe, he thought, the implied closing-off was intended mostly for the weekend.

At low tide or near it, the ocean was green-gray, with little whitecaps whipped up by the late-afternoon wind. He gave himself a moment to stand there and watch, taking pleasure in the cool air and the play of cloud-filtered rays of late sun on the ruffled water. He wished he were a photographer, or better yet, a painter, like the broad-hatted person who had set up an easel and a seat on a slight rise that gave a clear view over the barriers to the water.

He scanned the scene with more attentive eyes: a young mother with two just-preschool kids and a large golden retriever. A young woman sprawled on a blanket with legs and arms bared in hope of a last bit of sun color. An older couple walking hand-in-hand along the bluffs. A bundled-up man in a folding chair facing the sea, although he seemed to be concentrating on the book in his lap.

Far right, two sturdy women in running shoes and shorts came jogging in his direction on the section of old north–south lumber road that crossed the park. Off to the left, a slim, limber man did slow tai chi moves while facing the ocean, not pausing in his routine as the joggers pounded past behind him.

Johnny tossed a mental coin and headed for the painter, but was intercepted by the older couple, still hand-in-hand. Closer up, Johnny recognized the pair as owners of a B&B a mile or so north of town. "Officer—Hebert, isn't it?" said the man. "I hope we aren't in trouble for ignoring the caution sign. We wanted to snatch a few free hours before the weekend crush hits."

"Not to worry, Mr. Jones. That sign was probably put up before the barriers were replaced; the area looks safe enough now. Has anyone bothered you, panhandling or waving signs?"

"Oh no, it's been quiet. Very nice. We're hoping for an equally quiet weekend."

"So are we," said Johnny, and gave them a half salute as he moved on to the painter, who was wiping off his brush and capping a tube of paint. "Is this a particularly good time of day to try to paint the sea?" Johnny asked, glancing at the easel.

"As good, or as bad, as any," was the answer from a man of maybe fifty with a shock of thick gray-streaked hair poking through the openings of a billed cap. "But this is a good viewing spot. And peaceful today."

For a change, was the implication. "So it seems," said Johnny. "No raucous juveniles yet, nor any of the cliff-dwellers."

"That's true," said the man, frowning as he tucked his gear into a box. "Most days there's a skinny little guy in a green hat who seems to just pop out of the grass or something, but I haven't seen him this afternoon. Not that he's any real bother," he added, "so long as you stay upwind."

That sounded like E.T., the homeless guy Johnny had fallen on Saturday night. E.T. had spent the rest of that night in jail, green hat and all. "Maybe the problems last weekend scared him off."

"Maybe so. But there's been hardly anybody at all down here the last few days, so probably the garbage cans don't have as much to offer as usual."

With an inward wince at the logic of this, Johnny nodded and went on to say hello to the basking girl and then to the reading man, neither of whom was a frequent visitor to the place. He moved on, and was considering a trek south along the bluffs to see whether the trogs might have settled back into their cellar when a large man in shorts and T-shirt surged up over the lip of the bluff, tossed aside the rope he'd climbed with, and flung himself full-length on the sparse grass there.

Johnny stepped past the supine man, and past the jutting rock that had anchored his climbing rope, to peer down at the drop-off, a slightly out-sloping cliff falling probably a hundred feet to a rock-rimmed patch of sand. "Quite a climb," he said to Matty Matila, and the big, deep-chested fireman rolled over and got to his feet, grinning.

"Regular practice for local rescue work," he said. "Hey, it'd be a good workout for a cop, too. Wanna try it?"

"Sorry, I climb only walls," Johnny told him. "But I've been wondering about the guys we clashed with south of here Saturday night. Seen any of them around recently?"

He shook his head. "A couple of those guys go up and down these cliffs like rock squirrels, but I haven't seen 'em this week.

Maybe because some state park guys came in with a bulldozer and filled that old cellar-hole with brush and dirt. Worried some other careless cop might fall in and break his neck, I guess."

"I'll write them a thank-you note. Okay, Matty, see you around."

IF he occasionally wished that he had more interest in clothes, and in personal appearance beyond staying clean and reasonably well barbered, Johnny Hebert wasn't troubled by the fact that he didn't look much like a cop. Often that lack turned out to be an advantage, and he thought it was probably working that way with the Flynns, who were grimly polite and bewildered, with no new insights to offer into who or what might have brought about Sean's death.

Pete, caught somewhere between sad and worried, kept looking at his watch and wondering aloud whether he should try again to make contact with Dennis at the hospital. He himself had been at the Redwood Monastery in the Whitethorn Valley from Thursday or maybe Friday of last week, the nuns would remember. And he was still there when Allie called him on… Here he looked at his wife, and she said, "Last Tuesday. The twenty-second."

Allie was right here at home Saturday and Sunday, alone. "I don't drive much anymore, and never at night. But I had a phone call from a friend in town, Sally Calhoun, about the march. Her daughter was one of the protestors and she was worried about it, so I turned on the television and watched for a while. She called me back much later," Allie added, "to say Sally, Junior had come home safely. So I went to bed."

Norah, who taught second grade in a suburb of Sacramento, told Johnny with a faint blush that she'd spent the weekend with her boyfriend in a cabin near Grass Valley, returning to her apartment late Sunday night.

Tim, the only one of the four to bristle at being questioned, finally recalled that on Saturday he'd driven from his apartment in San Francisco down to Portola State Park in the Santa Cruz Mountains, where he'd camped for two nights. "By myself," he added. "I don't think I kept the tag—I didn't have a reservation, but there were plenty of open sites—but I paid at the gate and it might be on the park computer."

"Credit card?"

"Cash."

"How was the weather down there last weekend?"

"Better than here, but not great. I have good rainy-weather gear, but I slipped on a wet trail and got banged up some." Tim turned his head to show healing scrapes and fading bruises on the left side of his face.

"Must have been a nasty fall," said Johnny, and got to his feet. "That should do it for now, and I thank you all for your time."

Pete Flynn stood up, too, to show his guest to the door. "You'll keep us posted on any progress in the investigation?"

'Yes sir, we will."

"I'll walk out with you," said Tim, saying nothing further until they reached the car. "Look, I spent the weekend at the Portola campground, but I didn't register, because the place was mostly empty and it seemed silly to put money in the little box. So there'll be no record. What I said inside was for my parents' benefit; I don't want them to worry about my getting in trouble."

Johnny pulled his notebook from his pocket and made a note.

Flynn put his hand to his face. "However it might look, this is from a fall, not a fight. My cousin Sean was a son of a bitch, but I didn't kill him."

"Did you see anyone you knew there? Or notice anybody noticing you?"

"Unfortunately no, not that I remember."

BACK at the station, Johnny wrote his report on the Flynn interviews. Tim Flynn's facial injuries, he noted, could be the result of a bad fall on a rocky trail, but they could also have been caused by somebody's fists. In spite of his denials, and given what's known of the conflict between the two sides of the family, this possibility should be explored.

He printed that, and then typed up a short run-down on his afternoon's wanderings, with the conclusion that daytime life on the streets of Port Silva looked reassuringly ordinary and adding a note about the old fishermen and their dilemma: would it be possible to organize them and their boats into a citizens' watch-group? All that familiarity with the coastal waters might be of use

to the Coast Guard, now to be charged with watching for terror-
ists as well as poachers, smugglers, and boats in trouble.

"Hey, Johnny, good you're here," said Alma Linhares, who'd
just come into the squad room. "Have you talked to Verity this
afternoon?"

"Nope. Why?"

"She brought in this for Hank," Alma said, and handed him
the copy of Verity's report on the possible Soto/MacWhorter con-
nection. Johnny scanned it quickly, and said, "Good for her. Has
Hank done anything about it?"

Alma, perched on the next desk, shrugged. "He called the
MacWhorter outfit in Atascadero and left a message with the sec-
retary or somebody. I think what he said was that there's infor-
mation about a possible connection between a recent drowning
victim and the MacWhorter family. Nothing back yet."

"Ah. And he wants me, or you want me, to do a computer
search."

"It'd be a big help. You did the original check on Daniel Soto,
and God knows you're a lot swifter at that stuff than I am, or for
sure than Hank is. And I've got a couple of people on my list I'd
like to find before I knock off for the day. Or at least, go get some-
thing to eat and wait for the phone to ring," she added. "Care to
come along?"

"Thanks, but I had a late lunch."

"Okay. Good hunting," said Alma, and he followed her out
the door and went to look for the file on Daniel Soto, with its
minimal information. But when he fired up the computer again,
he found that Luke MacWhorter III was another matter entirely.

Luke III was born May 27, 1978, in San Luis Obispo County,
to Luke, Jr. and Margaret Wylie MacWhorter, and issued a Social
Security number. Johnny noted names, dates, and number and
went on to check death records: no listing for Luke, Jr. or Luke III,
or Luke, Sr. for that matter. Margaret MacWhorter, however, had
died in 1990.

The most recent Luke—what did they call him, Johnny won-
dered, Three? Trey? Anyway, he got a driver's license in Atasca-
dero in 1994 and renewed it in '95 and '96. And that was it.
Expired. Hmm.

Auto registration: a 1995 Chevy pickup, licensed again in '96 and that was it. Sold out of state, maybe?

Luke III had no DMV record of driving or even parking offenses. If there was a juvenile arrest record, it was just that and not available. No record at the state universities or colleges. Probably he'd gone to high school in Atascadero or maybe San Luis, but those would be city or private records, not state.

No credit cards, not unusual for someone just eighteen when records apparently stopped. The MacWhorter Company, according to the newspaper stories Verity had found, was in trouble for various reasons, among them their frequent use of off-the-books illegal aliens for whom Social Security was not withheld. Maybe young Luke had worked for the family company under a similar arrangement. Or not; not all sixteen- to eighteen-year-olds held jobs. Except that people here in the county for whom Danny/ Luke—Johnny was pretty well convinced the two were one and the same—for whom he had worked had remarked upon his unusual knowledge and skills for someone his age.

There was enough here, he decided, to be going on with, either to call MacWhorter's again or to have available when someone from there called back. He shut down the connection, put his notes into shape and printed them, and put them in the Daniel Soto folder.

Looking around, he realized that the place was nearly empty; people had come and gone unnoticed while he was working. He put this folder on Hank Svoboda's desk, and thought, now what? Verity had said she'd be busy. He could check around with Alma or Val to see if somebody needed backup or assistance. Or he could just go home and have an early night for a change, with his cell phone close by.

22

DAVID SIMONOV HAD AGREED TO meet Verity at eight o'clock at Paul D's, and when he came in at a few minutes after eight, he told her he was staying at a motel several blocks north. "I looked at a room here, but it was over my budget," he said.

Simonov, a rather pudgy five feet ten or so with a round face and graying no-color hair, looked weary but not particularly combative. Maybe he'd had a successful job interview.

He ordered a dry Absolut martini straight up; she asked for a glass of chardonnay and suggested an appetizer. "I've been on the road for days, feels like," he muttered. "And I'll be back behind the wheel tomorrow, got classes Monday and it's not easy to get somebody to cover. Good, here we are."

He seized what looked like a king-sized martini glass and tipped it to his mouth with a hand that shook slightly. "Ah, the water of life. That'll make a man... Uh, is that local wine you're drinking? Not many grapes growing where I live, but around here, every damn hillside is covered with vines. Doesn't anybody raise cattle in this county?"

"It's a big county, and not all coastal," she said, and the goat-cheese soufflé arrived, to be split for two. Either Paul had acted on her suggestions of the other night and managed to speed up his kitchen, or he was giving her special treatment; he'd come to greet her when she came in, and shown her to a secluded corner table.

They—at least she—nibbled at the soufflé, while Simonov sipped steadily from his glass and looked the menu over item by item. "Mr. Simonov, I have—"

"No crab. How's the fish here? Is it fresh? I should ask the waitress," he muttered, and turned to look over his shoulder.

"The crab season hasn't started yet. If there's fish on the menu, you can be sure it's fresh. Do you eat meat?"

"Meat? Of course I eat meat." He looked at her belligerently over the rim of his glass.

"Good. We'll have the steak *frites*," she told the by-now-hovering waitress. "Medium rare?" she said to Simonov, who said neither yea or nay. "Medium rare."

That distraction out of the way, Simonov launched on a series of stilted comments about the recent troubles in Port Silva: Did she know the people who'd been killed? Any of the people who'd been arrested? Did it worry her to live in a town so violent?

Yes, yes, no.

Did she still work as an investigator? Did she find it interesting? Did she ever think of joining the real police? He gave her time for only the briefest replies and then plunged on.

When the steaks were placed before them, he eyed his suspiciously, said, "Well, I'm happy to say, it looks like I'm finally gonna make it out of the community college grind to a real university," and downed the last of his martini. She had one bite and then another of her very good steak, put down her knife and fork, and said, "Mr. Simonov—"

"So, down to business. How is Sylvie doing? Still a good student?"

At last! "She's a good student. She has friends. She enjoys life with us."

Without having tasted his steak, he turned to signal the waitress for another drink. Verity, chardonnay long gone, added a much-needed glass of pinot noir to the order, and then geared up once again.

"Mr. Simonov, when you called this morning, Sylvie thought you were going to insist on taking her home with you, and she was deeply upset."

"I understand, I understand. We had a bad time on her last visit, and I know she—"

"Mr. Simonov—"

"David, please."

"David, she was clearly troubled when she came home from that visit, and we—"

"Sylvie's high-strung," he said quickly, "always has been. And stubborn, much as I hate to say it. I don't think you should give too much credence to her little complaints."

Maybe if she picked up her chair and hit him with it. "As I was trying to tell you, we've been worried by the fact that she's insisted on sleeping with a night-light ever since she came back. It took until yesterday to get her to tell us what you'd done to cause that."

The man sitting across from her grew smaller, deflating like a leaky balloon. "I didn't mean that to happen. I truly didn't."

And how do you lock someone in a cellar without meaning to? Verity took a firm grip on her temper and decided that this drama needed props. She pulled out the adjoining, apparently empty chair, lifted the guitar case, and set it upright there.

"But she's an honorable little girl, and she felt so bad about breaking her promise to not tell that she asked me to return this to you."

He looked at the case, looked up at her, and she was astonished to find his eyes full of tears. "She's…I don't know how to be her father," he said, blinking hard. "I do love her, anyway I try to love her, but she's just not… She doesn't even *like* me."

And how to respond to that? "I'm afraid that's true."

The drinks arrived, and he picked his glass up, looked at it for a moment, and set it back down. "I couldn't believe I did that, you know? The cellar. I've thought about it every day since, trying to convince myself it didn't really happen. I'm not that kind of man, to lock a kid up in the dark. I have never, ever hit her, I swear, not even a smack on the butt when she was a *little* kid."

Now he did have a sip, a small one. "There's something about my daughter that makes me behave like a monster. I'm not a monster, I'm just an ordinary man. Sylvie's like her mother, and not like her, and I just can't deal with it."

Verity sat in breath-held silence as he took another mouthful of vodka.

"But you and your mother, even I can tell Sylvie's been happy with you. She's growing, she's bright-eyed and strong and smart, she's… Anyway, if you want to adopt her, I'll give up any claim."

It took Verity a moment to fully absorb what the man had just said, and then she had to clear her throat before speaking. "Mr. Simonov, David, that would make us all very, very happy. Thank you."

"And maybe, when that's all arranged and she's older and sure

of her life, she'll be willing to see me now and then? To find out I'm not a monster?"

"I believe she will. She's not a monster, either. I'll talk to our lawyer, Lawrence Klein, to find out just what the process is and get it started." Suddenly ravenous, she picked up her fork. "David, you'd better eat, too. This is very good, and with two martinis on an empty stomach, you're going to be catnip to the local DUI cops."

VERITY got out of her car, took a deep breath of the misty night air, and surveyed the scene. No lights were on in the studio, none in the basement office. None in the bedrooms. Only the living room was lighted, by the big floor lamp in the corner by the couch.

She tiptoed up the front steps, opened the door quietly and stepped inside, reaching down to put a quelling hand on Zak, who'd heard her steps and come to check. "Mother?"

Patience looked up from her book. "Oh my, I was beginning to think about calling the restaurant," she said, and lowered her voice as she noted the finger Verity held to her lips. "Whatever kept you so long? And don't worry, Sylvie's been asleep for ages."

"I had to go for a drive after I left the restaurant, to get my head in gear." Verity took off her jacket, looked down at it blankly for a moment, then simply let it and her bag fall to the floor.

"Why? Verity, *what happened?*"

Verity considered playing her mother's game, making a point-by-point story of the evening. But she couldn't stop the huge grin she knew was spreading across her face. "David Simonov says he'll agree to our adopting Sylvie."

"Good heavens." The book fell to the floor as Patience bounced up from the couch to fling both arms around her daughter. "Oh my, oh my, miracles do happen!" She stepped back, shaking her head. "What on earth did you do to the man?"

"I don't know. Nothing really. Maybe it was the guitar."

"Well, sit down and tell me," said Patience.

Patience returned to her spot on the couch and Verity dropped into the rocker, and put it in motion as she described the meeting. "And finally he just came unglued."

"He didn't deny locking her in the cellar?"

"Nope. He says it's haunted him ever since. He says he couldn't believe he did it. He says he's not a monster." Verity stilled her chair, and the two of them stared at each other for a moment.

"And you know," Verity said softly, "he's really not. He's inadequate as a father and probably in lots of other ways, but he's no monster. When she's older, and chooses to think about it, Sylvie will be able to know that her father was not a really rotten person. I think that's important."

"Indeed."

"So I'll call Larry Klein and ask him how to proceed."

"Do it first thing tomorrow. From what you've said, it appears that David Simonov is seriously regretful and means to do the right thing. We should make sure he gets that chance as soon as possible."

"Yes, ma'am, we should. Should we fill Sylvie in on what's happening?"

"I think it might be well to wait on that."

"Okay," said Verity, and raised her arms over her head in a long, happy stretch. "My God. All of a sudden I'm about to become an actual grown-up with my own house and kid. Can you believe it?"

"Just about. Can you?"

"Huh. I'm not sure, ask me tomorrow. But here's another thing, you'll get *your* house back, all yours." Verity got up and stretched again. "Would you like to have a look at the ten o'clock news?"

"What? Oh, I suppose so, since we didn't turn it on at five."

Verity sat down on the couch and remote-flipped from channel to channel picking up bits of news and weather-chatter until she flipped past and quickly returned to a familiar scene. "Hey!"

They were looking at Port Silva: first the river harbor, then the entrance to South Bluffs Park, then the police station. Police of Chief Vincent Gutierrez faced the cameras resolutely and responded without any visible emotion to questions about civil unrest and murder, although Patience, who knew him fairly well, caught a brief, characteristic twist of lip; Vince Gutierrez didn't think much of reporters.

A different camera, with a long view coming in over the

bluffs from plane or 'copter, and then a shot from the park entrance at night. "Scene of the fatal riots," said the voice-over, "which appear to have claimed a third victim." On to a head-and-shoulders portrait of Sean Flynn, followed by a candid shot of him in a stream with a fishing rod, and then a view of a tall white farmhouse. "Youthful anti-war protestor Sean Flynn," said the speaker, "whose bullet-riddled body was discovered only last night. Two other victims fell or were thrown into the sea during the riot. One was Rudy Diaz, whose body was pulled from the ocean two days later. So far, nothing is known of Diaz's background. The other was almost as mysterious, a young man named Daniel Soto who came from nowhere and had made a place for himself in this small coastal town. Soto's body has not yet been recovered."

"Mother!" Verity shot bolt upright from her slouch. "Where did *that* come from?"

The camera lingered on an almost full-face video shot of Danny, head tipped slightly and pale eyes intent as he reached forward to something out of the frame. Then the frame widened, the camera pulled back, and Danny was crouching to adjust some kind of gear while four young women in loose tunic tops and white trousers stood nearby.

"That's from the memorial service for September eleventh," Patience said after a moment. "He's arranging the sound equipment for Old Music, New Voices. See, there's Grace, at the left. CBS used that bit from the local station in the small-towns piece they did later, and now they've pulled it out again."

They watched the rest of the brief report in silence, learning nothing they didn't know, and Verity flipped the set off. "Well, with that the MacWhorters will now know for sure, yes or no, whether he's their boy Luke."

"If they happened to catch it," said Patience. "I'd better call Hank, who rarely watches the late news." She headed for the kitchen, and the phone, and was back in a very short time.

"He didn't see it. But he'll check with CBS for a copy, and call the MacWhorters in the morning." She looked at her watch, and went to the front door, giving a whistle to Zak. "Come on, boy. Just a quick trip, and then bedtime. For me, at least," she said to Verity as the dog bounded outside.

"Me, too," said Verity. "You go on. I'll get him back in, and lock up as I go out. But first I'm going to call Gracie."

Wherever she was, Grace answered her cell phone on the second ring.

"Gracie, this is Verity. Did you catch the evening news tonight?"

"No. Why?"

"On a piece about the Port Silva riots and related deaths, there were two very clear shots on film of Danny, from the September eleventh memorial. He was identified as 'Daniel Soto, a young man who came from out of nowhere.'"

"I think…yes. Right after our stint that night, the television people got hold of Lisbeth, she's one of the group, and asked for our names, and of course she gave them. I mean, we were thrilled about the publicity. She must have given them Danny's, too."

"Well, if you want a really good picture of him, you can probably get a print from CBS."

"Verity, that's a wonderful idea. Thank you for calling me."

23

"HEY, VINCE," HANK SVOBODA CALLED out as the chief of police strode past his office Saturday morning. "I hear you did good work last night."

Gutierrez did a quick about-face and stepped inside. "By God, we did. With any luck it'll keep two local hoods and two apprentice hoods out of circulation for a while. And if I hear one more 'police brutality' scream from Markovich, Senior, he'll wind up right there in the cell with his two worthless sons."

"And that would make the city and county a better place. Looks like you had a real good time, too?" Hank Svoboda added, pointedly eyeing a bruise high on his boss's left cheekbone.

Gutierrez grinned. "The rest of the crew enjoyed seeing the chief get down and dirty. And if God didn't approve of old guys getting their aging rocks off by kicking the shit out of twenty-year-old assholes, He wouldn't let it happen."

"I'll try to remember that."

"From a tactical point of view," Gutierrez said, "I do believe we'll have a more peaceful Saturday night tonight because the younger Markoviches won't be out there stirring up public unrest."

"Probably. I guess they thought the potential for trouble at the football game would keep us busy last night. Anybody know who the tip came from?" An anonymous tipster had called the station late Friday afternoon with the location of a proposed burglary, and Gutierrez, Lieutenant Hansen, and four officers had successfully staked out the elegant, empty home and collared Billy Markovich, his older brother, and two other locals in the act of breaking and entering.

"Nope. Probably some buddy they'd pissed off. Or maybe just a concerned citizen who sensibly enough wanted them off the street but preferred to avoid the family's shit list."

"And what's happening with Dennis Flynn?" asked Hank.

"That's a bad one." Gutierrez, who'd been pacing about the room, pulled up a chair and sat down. "He threatened Mick Riley, actually took a swing at Chris Matila."

"Proving he was out of his mind."

"True. But when he got nasty with Rafaela Flores, her boyfriend took him out, and Rafaela called us. Now he's in a cell, under watch, with the caution that the next step is another hospital room with restraints. He's still screaming, accusing everyone from his own nephew, Tim, to Danny Soto of murdering his son." Gutierrez shook his head. "Pete and Allie are coming in later today to try to talk sense into the poor bastard, but I don't hold out much hope."

"Hebert seemed to think the nephew was a possibility."

Gutierrez got to his feet again, to move around restlessly. "We'll bring him in for further questioning. We can ask the state park people for a list of registrations at the Portola campground that night, see if somebody on the list remembers him. But Tim Flynn has no record of violent behavior, and it feels to me like whoever killed Sean Flynn went out there to do just that.

"Incidentally, what are you doing here on a Saturday? The streets are quiet, the people at the vigil site aren't attracting trouble, and you've put in far too many hours over the last week."

"I'm waiting for a call from Doug MacWhorter," Hank told him.

"Ah. The guy who may be a relative of Daniel Soto's."

"Yup. His uncle, if it turns out Soto is really Luke MacWhorter. The guy wasn't real receptive to the possibility when I finally talked to him yesterday, but the new information makes it looks like a serious possibility."

"Katy told me there was a good, clear shot of Daniel Soto on the news last night," Gutierrez said, and added, with a grimace, "at the end of a nifty piece about our sudden rash of unsolved murders."

"I didn't see it myself, but Patience did, and called me. I've asked the CBS station in San Francisco to FedEx a copy of the tape. And I called Harris, the police chief in San Luis Obispo, to ask him to do the same thing."

The phone on Hank's desk rang, and he picked it up. After a "Svoboda here," and a moment's silence, he hit the speaker-

phone button and Gutierrez propped his rear on the desk edge to listen.

"Mr. MacWhorter, did Chief Harris get in touch with you?" Hank asked.

"He did, and I'm expecting a copy of that tape any minute. But I was going to call you back anyway."

"Oh?"

There was a heavy sigh from the other end, maybe weary, maybe just exasperated. "My father saw that show last night."

"Ah."

"My father is eighty years old, and not always—alert. But when he's having trouble sleeping, he keeps his TV on twenty-four/seven. Now he's absolutely convinced the man he saw, this Daniel Soto, is his grandson, Luke MacWhorter."

"And you're not?"

"I didn't see the piece, and of course I haven't seen the tape yet. But even if I don't agree with him after I do get a look at it, he's going to continue to insist that I take time off from work to make a trip up there."

"Mr. MacWhorter, Danny Soto had been living and working in this area for more than two years. If he was your nephew, Luke MacWhorter—"

"Look, Captain Svoboda, Luke was a whiny little mama's boy until his mother died when he was about twelve, and from then on he was just a total screw-up. His father couldn't handle him, nobody could get along with him. My boys couldn't stand him."

"So?"

"So when he was eighteen and about to graduate from high school, he disappeared. Just took off without a word."

"And that was when?"

"Uh, must have been 1996."

"And you say nobody's heard from him since then?"

"Nope, not a word."

"What steps did you or his father take to find him?"

"None."

"None," Hank repeated, without inflection.

"Nobody was exactly unhappy he was gone except my father, and he was sick at the time and didn't really have a handle on what was happening. When he got a little better and understood

Luke wasn't around, he decided he'd gone off to see the world on his own—the way he himself had when he was about that age."

"And that was six years ago."

"We had a business to run here. Look," he said again in milder tones, "I appreciate your calling us about this. It wasn't very clear to me, yesterday, what it was that suggested to your department that this Soto boy might be Luke MacWhorter."

"The Soto name was part of it," said Hank, "since that was your mother's maiden name. And then there were similarities in dates and apparent background. Mr. MacWhorter, why don't you get a good look at the tape, maybe show it to others who'd recognize your nephew. We'd really like to get this settled. For one thing, any day now we expect to have a body, and if it's not yours, we need to find who it does belong to. Danny Soto was a well liked young man here and we want to do right by him."

"I'll do that. And if I think there's a good possibility that it's Luke, I'll call back. What my father wants me to do is talk to people who've known him. And collect impressions, I guess, to help an old man accept the fact of his grandson's death."

"Fine. If I'm not here at the police station, they'll know where to get in touch with me."

"Pretty weird family," muttered Hank as he hung up the phone.

"Maybe not as weird as we'd like to think," said Gutierrez, and got to his feet. "Meanwhile, I'm going to make some calls to set up an after-lunch conference on Sean Flynn. I want to get the troops who've been on this murder to come in for an hour or so, see if I can get some perspective."

"If it's okay with you, I'll pass on that. I'm heading down to Point Arena and Gualala this afternoon, to have a look at a couple houses there."

"I thought it was Petaluma you were thinking about."

"It's one possibility, because my grandkids are there. But the big six-oh is less than a year away, and I always figured that's when I'd retire. Gotta have just the right place to do that."

"What does Patience think about this?"

"Not much," he admitted. "But I think she'll come around."

⌁

AS Sylvie came bounding across the wooden floor of the exercise room, Patience stood up and clapped. "Sylvie, that was exciting. I wish I'd had aikido lessons when I was your age.

"Why didn't you?"

"I don't think such classes were available then, dear. At least not for little girls."

"Really? That was so totally not fair!"

"True. Things are better these days."

"Some things, anyway," said Verity, who'd been talking with Ronnie while Jess changed her shoes. "Ma, we're going to have fish and chips at Cap'n Jack's. Care to join us?"

"Thanks, but I have some work to catch up on. I'll see you both at home later." She gave Sylvie a quick hug, waved to Jess and Ronnie, and headed for her car. One day not too far in the future, she'd reach out to hug Sylvie and find the two of them standing eye-to-eye.

On a chilly but dry Saturday near noon, downtown traffic was light and Patience parked on the street in front of her office rather than in the rear lot. She slung her bag over her shoulder, picked up the case containing her laptop, hit the lock button on her key chain, and headed up the walkway to her office. If she didn't have any interruptions, she should finish here in about an hour and go find lunch somewhere close. Fish and chips midday always made her feel like taking an after-lunch nap.

She was running over a mental list of nearby cafés and delis that might be open on a Saturday as she unlocked her office door, and had only the briefest sense of movement behind her before someone pushed her hard and sent her crashing against the door and into a staggering, stumbling lurch forward. As the door hit the wall, she struggled to stay on her feet and hold on to her computer case.

"So, you old bitch..." The next push would have slammed Patience into her desk, but she'd managed to swing around and step to one side, so the young woman plunged into empty space and nearly fell herself.

"Debra Hogan," said Patience, and planted her feet and got a two-handed grip on the handle of the leather case containing the laptop, a solid older model weighing close to seven pounds.

"Damn right, and you're gonna be sorry you ever heard the

name." As she lunged, right fist cocked, Patience dodged left and put her shoulders into a solid, backhanded swing of the case, its lightly padded flat side striking the girl between hip and elbow and knocking her asprawl.

"Yow!" After a stunned moment, she came up on her left elbow, reached across with her right hand to push herself upright, and shrieked again, cradling the right arm close. "Goddamn you, you broke my elbow!"

"I doubt that. But better yours than mine," Patience said. She set the computer down and hitched her shoulder bag back into place, to reach into it for her cell phone.

Debra pulled her knees close, ready to rise. "You dried-up old cunt, I'll knock your head off!"

Not until you get your breath back. "Debra, don't be silly, I can speed-dial the police station before you even stand up."

"Well, shit." She slumped, and let her legs sprawl. "So go ahead, you already ruined my life. My boyfriend is really mad and now I'll never see him again."

"Your boyfriend is thirty years old, he's been married and divorced, and he's about to lose that sports bar in Sacramento to his partner."

"He just had some bad luck. My father could have helped him."

"His 'bad luck' is a huge drug debt, and when the liquor control people discover that, as they're about to, his days in the bar business will be over. He'll be lucky if his drug supplier doesn't send some goons to help him work out a nice payment plan."

"I can't...I didn't know..."

"Now you do. Your father has the information I found for him, and I'm sure he'll show it to you if you ask." Or even if you don't, she added silently. "He was just trying to protect his daughter."

Debra sniffed loudly and reached out a hand to be helped to her feet, but Patience stepped well back and shook her head. "The aikido instructor would consider that a risky move."

"You take aikido? Shit." She got carefully to her feet, holding her right arm close against her body. Nineteen years old with a tennis-player's build, wide blue eyes, and a well-cut mop of short blond curls, she had a pouty little face that was years behind the

body. Patience thought Daddy was going to have to pay attention here for a while yet.

"I'm...sorry," Debra said, without meeting Patience's gaze.

"And I'm sorry I had to defend myself," Patience told her, and led the way to the gaping door.

As Debra scuttled out without another word, someone said, "Well done!" and Patience turned to see that the upper half of the door into the adjoining office was open.

"Hello, Marilyn. Please don't let the landlord know I'm beating people up on his property."

"Shoot, he'd be delighted. He'd hire you for security," said Marilyn Ritter, her anti-war march companion of a week earlier. "I heard the ruckus and thought about trying to help, but I could see that you were doing just fine on your own," she added. "That girl seemed very upset."

"She was that and more. And I really had no choice but to defend myself by whatever means possible, but *my*, it felt good to give that little wretch a solid whack. I should be ashamed of myself." But if she hadn't adjusted the angle of her swing at the last split second, Debra would have taken the edge rather than the broad flat of Patience's improvised weapon and probably suffered a couple of broken ribs.

"Don't be silly. Come on through and I'll give you a cup of coffee and a doughnut. You can tell me all about aikido."

"Thanks, Marilyn, but I'll wait for another time. I need to make a phone call, and then I'd like to head for home." Or somewhere other than here.

"Okay, rain check. Feel free to tell whoever you're calling that you have a witness who would happily testify in your behalf."

"I don't think it will come to that. He's a nice enough man who simply has no clue about dealing with a teenager in heat."

"Let's hope he figures it out in time." She closed the upper door and Patience heard her footsteps fade away.

Mr. Hogan, reached at his office, listened without interruption as Patience told him about his daughter's visit. And then, "You hit her?"

"To prevent her from hitting me again."

"But couldn't you have talked to her or something?"

"Mr. Hogan, your daughter is nineteen years old, about five

feet ten, and appears to be in very good shape. I, on the other hand, am five feet two and in my fifties. I was in my own office and I certainly had not invited her in."

He was silent for a moment, perhaps visualizing the scene. "Yes, I see. I apologize for Debra, and I hope you won't need to take this further."

"I hope not, too, although that's probably up to Debra."

"I don't think so. Anyway, thanks again for the information you uncovered. It'll give me a chance to make her see the light."

"Good luck, Mr. Hogan," she said, and turned off the phone.

24

"OKAY, TROOPS. WHAT WE'RE LOOKING for here is an overview of Sean Flynn's murder." A brief grimace pulled Gutierrez's lips tight against his teeth. The word "murder" wasn't one he'd had to use often in his small town, and he was sick of it already. "So tell me what we've got," he said, and waved them to the row of chairs before his desk.

"Chief, we got nothing," said Dave Figueiredo. Seated next to him, Alma Linhares nodded agreement. "The two of us, and Johnny, talked again to every damned person we'd interviewed right after the riots, and like they all said last time, nobody saw Flynn later Saturday night. A couple people knew he drove a Ford pickup, but those one-fifties are ten to a block around here, and the fact that it was old and had a shell on the back didn't exactly make it stand out."

"It was parked out behind the Jorgensen house," said Ray Chang. "Keys in it, usual mess of fast-food boxes and bags and empty beer cans inside. Snuffed-out joint in the ashtray, one little baggie in the glovebox.

"Yesterday and this morning Kuisma and I visited every house in a half-mile radius of the Jorgensen place," he went on. "With one exception, nobody we talked to had noticed anything out of the ordinary Saturday night or Sunday morning, which is when the coroner figures he was killed. Or in the days after, for that matter. Andrea Jorgensen had friends around frequently, but no rowdy parties, nothing that would have kept the neighbors on alert. And the way the houses out there are set, on big lots with pastures or vegetable gardens, you wouldn't see or hear what your neighbors were doing unless you made an effort."

"The exception?"

"A high school kid who was up late Saturday night watching a DVD of *Pulp Fiction*; his parents were out of town. He said some kind of sound outside that *might* have been shots caught his atten-

tion around midnight, and he went to look out the window. Saw nothing, isn't even sure he really heard anything. So he went back to his movie, which as I recall has plenty of loud noise."

"How close was he to the murder house?"

"Just two doors away, to the east."

"How many shots?"

"Three, four, he wasn't sure. It was all very iffy, Chief. I don't think the kid was lying intentionally, but he might have been carried away by being on stage."

"Flynn took two nine-millimeter bullets in the chest," Val offered. "And the crew found a third one that went through the back of a couch and into the plaster wall."

"I haven't looked over the reports of recent burglaries," said Gutierrez. "Were any of them out in that area?"

"Nope," said Chang. "In spite of the big lots, the houses are ordinary, nothing built later than maybe 1950, and the take wouldn't be much more than your ordinary TV or laptop. Of course," he added with a shrug, "the kind of guys out looking for booty aren't above making a mistake."

"As far as personal enemies go," offered Figueiredo, "the general view of Sean Flynn, when there was one, was that he was a jerk but nobody had an actual beef with him. He hadn't messed with anybody's girl or swiped anybody's stash, hadn't used his fists in any of the arguments among the protestors themselves. The two people who swore out complaints against him after the riots didn't know him by name, but that white-blond hair made him noticeable."

Gutierrez caught a movement from Alma. "Something?"

"Maybe." She tugged at a handful of the blue-black mane that invariably escaped from whatever was restraining it. "This time, Rafaela Flores remembered that when she caught a quick glimpse of Flynn as they were all running away, he looked like he'd been crying, and she wondered later whether it might have been because he'd seen Daniel Soto go over. Everybody says Soto was the only person Sean Flynn seemed to like, or maybe the only one who'd tolerate him.

"The point is," she said in response to Gutierrez's continued silence, "if he was close enough to see Soto go over, he may have seen…well, some of us looking at the tapes thought there was

maybe a third person involved there. Somebody besides this Rudy Diaz."

Chang sat forward. "Chief, has anything more come up on Diaz?"

"Nothing." Gutierrez pointed to a folder on his desk. "As you know, his papers were fake and not traceable. We've had no response from other agencies on his prints or description, and we're thinking that he's an illegal. And we haven't turned up anybody else who saw his friend with the Toyota."

Gutierrez looked at Val Kuisma. "What else have we got from the crime scene itself?"

"The fingerprints at the murder house were too many, too smeary. They're running the few good ones they picked up, but haven't turned up any connections. Like Chang says, Andrea had lots of friends, and nobody had really cleaned that place for about a year."

"No surprise. Anything else?"

"Yessir, maybe something useful. The tech people figured from the start that there was a fight, not only from the way the room was messed up, but because the wounds were from real close, like the two of them were in fighting contact when the shooter pulled the trigger."

Gutierrez thought he could see where this was going. "Blood?"

"Right. Flynn bled mostly from the exit wound in his back, bled out. But there was a lot of blood on his right hand and shirtsleeve, too much to have come from his own banged-up knuckles."

"The guy was in at least two fights out on the bluffs earlier," Gutierrez reminded him.

"Right, but the techs decided to take scrapes anyway, from his sleeve and from a couple of big smears they found on the floor some distance from the body, like somebody'd tried to wipe 'em up. Both turned out to be O-negative, Flynn was A-positive. They figure he'd maybe bloodied his attacker's nose. We ordered DNA tests, but they take a while."

"A long while," said Gutierrez. "Alma?"

"If we've missed anybody who was at the march and knew Sean Flynn, he or she must have come to town just for the event and left immediately afterwards. And didn't know anybody here

but Flynn. Among those who did know him, we found two guys who admitted they'd heard he was staying at Andy Jorgensen's place," she added. "Neither of them could prove where they were after everybody scattered, but like Dave said, according to them and to their acquaintances, neither of them had had any beef with Flynn." She shrugged and spread her hands.

"Goddamn," muttered Gutierrez. "So we'll wait for the DNA result, which won't be much good unless we can find somebody it's reasonable to test for a match. Ray, did you get anything useful from Arcata?"

Ray Chang shook his head. "That Sean Flynn must have been a very lonely guy," he said. "Or maybe he just didn't like people. Last week, when Flynn was only missing, I had my buddy on the Arcata force check out the two addresses Flynn's father gave us, boarding houses. He got nothing either place. He went back for follow-up yesterday, with a picture, and this trip, two girls and one guy recognized his face, but said they never had any contact with him."

"The school?"

"He talked to people there last week, too. They won't give out grades, but said Mr. Flynn took a light load with low average grades first semester last year and incompletes for the second since he stopped attending classes in late April. I could ask him to go back and talk to the professors, but it doesn't sound like he was any more memorable in class than in his boarding house."

"What about contacts with anti-war groups in Arcata? There's a liberal-to-loony contingent up there, and I'd bet they've been active."

"My buddy says there's been a movement building, but it didn't really start getting noticed until summer, and Flynn had left the area, or at least the college and his lodgings, by then."

"Okay," Gutierrez said with a sigh. "Do phone follow-up with the neighbors tomorrow; maybe somebody will have remembered something."

"Chief, what about the rest of the Flynns?"

"We're checking their reported locations during that time. Tim is the only person who might be a possible, and we're asking him to come in for another little talk." He got to his feet. "Okay, that'll do for now."

⏦

PATIENCE turned off her laptop cum weapon, pushed her chair away from the desk, and rotated her shoulders. So far, no twinges from that vigorous backhand swing, but tomorrow, who knew? She reflected on the fact that she'd come very close to being knocked down and even worse. Maybe she should seriously consider taking aikido lessons, or at least getting in some gym time.

The office was very quiet, and warm. Stuffy, she thought, maybe still smelling of anger and physical exertion. What she needed right now was fresh air and some mild, noncombative exercise. She collected her gripper-soled walking shoes from a bottom drawer, pulled on her jacket, and headed for her car.

The Saturday streets looked near-normal for a chilly day in late October. Shoppers were moving in and out of stores, downtown curbs were lined with cars; the big wooden announcements board at the high school showed that the Port Silva Orcas had defeated Willits the night before, 27 to 13. She saw a patrol car moving slowly along, noted another at an intersection where the traffic lights were apparently not working.

She passed up Armino's in favor of a quick stop at a new deli on south Main, then drove on to claim one of the head-in slots at the edge of South Bluffs Park. Car locked, bag slung across her chest instead of over her shoulder, she set out for the trail that skirted the edges of the bluffs. Before this chunk of land was smoothed into a park, it had been just an expanse of rocky, uneven ground dotted with rough grass, the occasional volunteer shrubby tree of some kind, and wildflowers in the spring, growing low and tight to the ground in defense against the hard wind off the ocean.

"I think I liked it better before," she said aloud, drawing a startled look from a woman who was using a plastic bag to pick up after her elderly retriever. Patience nodded approvingly and quickened her pace. She'd come here often in the past, in the middle of the day after she'd sat too long in her office and needed to move and breathe. At least, she told herself, the footing on the rehabbed trail was better than before. Verity loved to run on the beach, right down there where the surf reached for the feet of the inattentive; Patience preferred the bluffs, the view and the

sense of being way up high. Did these preferences reveal something about character?

The ocean was rough today, whitecapped and splashing against the cliff walls, foaming with a hearty roar through gaps in the sea stacks. She marched along, feeling her muscles stretch and her breathing get deeper and stronger with each intake of clean, cold air, meeting a few other walkers, passed by a few runners; but the new trail was wide enough not to feel crowded.

At the north end of the trail she paused for breath and a look at the view from a different vantage point. What a very fine place this was, her town and her ocean. She turned and headed back, got a broad smile from a young woman jogging north, and realized it must be in response to a silly grin of her own, one she hadn't realized she was wearing.

Instead of eating in the car, she brought her lunch back into the park and settled on one of the comfortable new benches to enjoy it. She'd finished half of her turkey-and-provolone sandwich when a familiar figure appeared from behind a row of bushes to her right, a paper bag clutched in his right hand. The wizened little man called E.T. was part of the local homeless population, and he'd often tucked himself up to sleep in the alleyway between her office building and its neighbor. That broad-brimmed green felt hat, his signature, was not really sufficient in this weather, she thought. He needed a watch cap.

As she had a sip of coffee, she realized that she hadn't seen him recently. In fact, there'd been fewer of his—group? tribe?—on the streets over the last few days. People she'd become accustomed to seeing, at the library or here at the park or further down the bluffs; had they been washed out to sea in the storm?

Don't be silly. They've moved on to other places, or more probably, the turmoil in town had sent them underground. Too many police on the streets, ordinary citizens less than friendly in troubled circumstances.

Turning as he raised the paper bag to his mouth, he caught her glance, and changed his mind. "Hey, Missus. Nice day?"

"Hi, E.T. Yes, it is."

He came a little closer, and recognized her. "Haven't seen you for a while. You been away?"

She shook her head. "Sit down if you like. And I'm not a policeman, I don't care what you're drinking."

He perched on the far end of her bench, his small frame swallowed up in what looked like two or three pairs of old wool trousers and probably several sweaters or sweatshirts under a once-red windbreaker. "I see cops around your place a lot, though."

"I have friends who are policeman, that's true. E.T., I haven't seen you for days, either. Where have *you* been?"

"That night everybody went crazy? A cop fell on me and I, um, hit him. It was the surprise, see, I don't generally hit people, specially cops. So I spent a little time in jail."

E.T. as Johnny's assailant? "So you were involved in the riot?"

"Oh no, ma'am." He opened his bag to expose a wide-necked brown bottle, and had a drink. "Couple other guys had went down to have a look at it, but not me or Chaz or Buck. All them loonies raising hell down at the park would just have ate us little guys up. So I was just sleepin' in the cave. Uh, that looks like a good sandwich."

"It is. I got it from the new deli two blocks from here. If you like, I could go get you one."

"Maybe you could give me the money, and I could go get it myself?"

E.T. hadn't had a bath in days, maybe weeks. Years? And even swaddled in all those clothes, his aroma was…distinctive. Patience knew, as he surely did, that he wouldn't get in the door at the nice clean deli; any money she gave him would go for another forty-ounce Mickey's malt liquor. Which was his business and not hers, but first she'd like to hear more about those "other guys."

"I might do that, when I'm finished here," she said, and had a thoughtful bite of her sandwich. "What did the other guys do? Saturday night?"

"I dunno. Doc and Arlie, they're big guys nobody'd mess with, they go where they want. Maybe they was *lookin'* for a good fight."

"What did they say when they came back?"

"They never *came* back. Could be they got drowned. They ain't afraid of the cliffs and the water like me, they go right down after stuff if they see something they want."

"I don't think they drowned, E.T. Everyone's pretty sure that only two people went off into the sea."

"And died. I heard about that." After a quick glance around in case of official observers, he had another drink. Or maybe he was just looking for another handout possibility, since this one hadn't yet produced anything but questions.

She unzipped her bag, but didn't reach inside. Chaz and Buck she drew a blank on, but Arlie was the red-haired beanpole who played a harmonica on street corners, his orange tabby cat curled on a blanket beside him. Arlie, she thought, might well have taken his act and his pet south for better weather.

"I've dropped an occasional dollar in Arlie's donations can," she said. "But I don't think I know anybody called Doc."

"He's a guy used to be a medic in 'Nam, that's why the name. Pretty old, got this long, gray hair," E.T. said, pressing one hand against the back of his own neck under the green hat, "but he's big and ugly and can take care of himself." He drained his jug and stood up.

"Good for him," she said, and took a five from her wallet, reconsidered, and replaced it with a ten. That should be enough to buy him something to eat as well as more malt liquor. "It was nice talking with you, E.T."

He set his empty bottle down on the bench and reached out a shaky hand to grip the bill. He inspected it briefly, grinned, said, "Thanks, Missus. Bless you," and tucked his treasure away somewhere in all that clothing.

As he went up the path toward the road, a woman who'd observed the exchange said something that sounded like "Hmmph!"

"I beg your pardon?"

"You shouldn't have given him money. He'll simply go off and buy more of *that*." She pointed an accusing finger at the now-naked Mickey's bottle on the remains of its paper bag.

"Oh dear, really? And he didn't even pick up his trash. I'll take care of it," Patience said, and did, depositing it with her lunch debris in the nearby garbage can.

Can't resist being a smart-ass, can you, she said silently to herself as she headed for her car. Can't resist being snoopy, either, even when you should be enjoying fresh air and the beauties of nature. "It's a curse, I guess," she said aloud, startling a passerby for the second time that afternoon.

25

"WHEW," SAID VERITY, NOT FROM weariness but because she'd worried that the patterned fabric of the drapes she'd just finished hanging, vaguely botanical figures in dark red, blues, greens, and dark gold, would overwhelm the big bedroom. Not so. Just lovely, as Sylvie would say.

"Hello?" called a familiar voice from downstairs, and Verity called back, "Up here."

Johnny came in moments later, put up a hand as if against glare and said, "Wow!"

"Stop that! They're not too bright!"

"I was kidding, they're just fine." He cocked his head for a good look at her. "What's blinding in here is you. Did you just win the lottery?"

She grinned, took a deep breath. "Better than that. We haven't told her yet, but David Simonov is going to let me adopt Sylvie!"

"Well, hallelujah!" He swept her up and swung her around. "We should celebrate," he said as he set her down, "and I have just the plan."

"I bet," she said, but didn't pull away.

"That's only part of it, lady. Let's go where there's something to sit on, and I'll tell you the rest."

Downstairs, he followed Verity into the living room. "The furniture I had in storage in San Francisco will be delivered next week," she said, a gesture taking in the big space presently furnished only with a somewhat worn tuxedo sofa, a nicely aged leather Barcelona chair, and an antique oak rocker. "Have a seat and tell me your plan."

He sat down in the rocker and set it in motion. "How would you like to go to the symphony tonight?"

"There's a symphony in town?" She perched on the edge of the sofa.

"San Francisco Symphony," said Johnny. "When I lived in

the City I always had tickets to a series—not the whole season, just five or six particular concerts. For the first year or two after I moved here I went down regularly, but after that I just stopped making the effort.

"Anyway, a friend who also was a regular called me this morning to say he has two really good seats for tonight and has been called out of town. He knew I liked Mahler, so he's going to leave the tickets at the box office for me."

"Mahler?"

"Michael Tilson Thomas is conducting, and he's regarded as a fine interpreter of Mahler's symphonies."

"I know that. I lived in the City, too, even went to the symphony now and then. But my inclinations run more in the Haydn-Mozart-Beethoven-Schubert vein. I don't know that I'm up to Mahler."

"Hey, if you don't like it, we can always leave."

"Right, I can see that. Your mother would come back from the grave to haunt you, or me."

"True. But Mark also has before-symphony dinner reservations at Jardinière, and I told him I'd take them, too."

"Jardinière? John, you've come into money."

"Too good to pass up?"

"You bet, if I can get hold of Patience to see whether she can stay with Sylvie. How long before we'd have to leave?"

"If we put on respectable clothing here, an hour absolute max. And here's the bonus: Mark has a nice little house in Bernal Heights, and we're welcome to stay there. He's leaving a key for me with his neighbor."

PATIENCE turned into her driveway to find Verity's car at the cottage and beside it, Johnny Hebert's Volvo.

"Hey, Ma," said Verity when Patience opened the front door. "I missed you at your office and was about to try your cell. Did you have lunch somewhere?"

"I did. Hello, Johnny." Patience went to hang her jacket in the hall closet. "Where's Sylvie?"

"She went to the studio to practice, but I think she's probably having a nap. All that exercise, and then all that fried fish and potatoes."

"Good for her, I may do the same. Now tell me what you two are cooking up, and it's clearly not food."

"If you'd be willing to baby-sit—"

"Johnny, if Sylvie hears you use that term, she'll set fire to your beard," Verity told him. "Mother, Johnny has tickets to the symphony for tonight, and if you'd be willing to stay with Sylvie, I'd love to go."

"We have a symphony?"

"In San Francisco," Johnny told her. "And dinner before at Jardinière."

"Go and enjoy yourselves, children; I have nothing on for the weekend. I trust you're planning to spend the night?"

"Yes, ma'am. Mark, the friend who got the tickets and then had to leave town, has offered us his house in Bernal Heights as well. Here's the address," he said, reaching into his shirt pocket for a three-by-five card.

"We should be back tomorrow by midafternoon," said Verity. "Ma, are you sure you don't mind?"

"I truly don't, but Sylvie might."

Verity made a face. "She will, when she hears it's about music. I'll break the news to her."

"Excellent."

"You stay here," Verity told Johnny as she got to her feet. "It will take me about ten minutes to change and pack."

"Then we'll stop by my place on the way out of town. Is there anything we can bring you from the City?" he asked Patience.

"No, thanks." She sat down on the couch, kicking her shoes off and tucking her feet up. "Are things looking so peaceful in town that Vince Gutierrez is giving people permission to leave?"

"They're not bad. For one thing, the Flynn murder investigation has settled into saturation doorbell-ringing and phone follow-up." Except maybe for Tim Flynn, not something to be talked about yet. "For another, the most serious of the anti-war people are on their way to Berkeley, where there's a big protest planned for late this afternoon. I understand Grace Beaubien is going."

"Oh, dear. Well, the Berkeley jail has quite a good reputation."

"Maybe the size of the crowd will intimidate her."

"I wouldn't count on it."

"And on Soto, the people who appear to be Danny's family are coming to town Monday."

Patience sat up straighter. "So you made contact and they responded?"

"Hank did, last night and this morning," said Johnny. "Turns out most of the MacWhorter family said good riddance when the youngest Luke disappeared six years ago, but the eighty-year-old grandfather—he's the first Luke—caught the recent TV bit and is demanding action."

"Interesting."

"Yeah. I really wish…"

"What?"

"I wish Soto's trailer hadn't gone missing at such a convenient time. It bothered me so much that I asked sheriff's guys and state park people in both Mendo and Humboldt counties to have a look in campgrounds. But nobody came across it."

"That was a good idea."

"And like many good ideas, it didn't pay off. Same with my notion about checking out the homeless guys Soto was said to be friendly with, like the big old guy with the long gray ponytail. Turns out many of our homeless folks have hit the road. Hey, Verity, that was only eight minutes."

"I can be speedy when there's good reason. Sylvie is not happy, Ma," she said to her mother, "but she's promised not to sulk about it."

"I'll keep her amused and occupied," Patience promised. "You two have a good time." Thinking: *Ponytail* is what E.T. meant by that gesture.

"IT was complicated."

"It was," Patience agreed.

"And I didn't understand all of it. But I liked it."

"Good." They were on their way home from the movie theater where they'd seen *The Fellowship of the Ring*, Part One of Tolkien's *Lord of the Rings* trilogy. Patience had chosen it because she herself wanted to see it and because she was fairly sure it would entrance Sylvie.

"Is there more?"

"There will be. There are actually three books—no, four, if you count *The Hobbit*. But they're also complicated."

"That's okay."

"I thought it might be. We'll look for them next week."

At their driveway, Sylvie got out to open the gate and Patience drove through, leaving the little girl to close it and deal with an excited Zak. Maybe, she thought as she parked, it would be a good thing to lock the gate tonight.

"Thank you for the movie, Patience," Sylvie said as she joined Patience at the front door.

"You're welcome." Patience went to hang up her jacket, glancing at the message machine as she passed. Nothing there.

"Can I have a piece of Verity's cake?"

"You *may*, and then brush your teeth; it's past bedtime."

As Sylvie headed for the cake plate on the counter, the phone rang. Noting the incoming number, Patience picked up the receiver and said, "Hello, Hank."

"Patience, sorry to bother you this late."

From his tone, more than a report on house-hunting was on his mind. "It's okay, Sylvie and I just got in."

"Would you mind coming out again? I'm at Good Sam—"

Verity! An accident! blanked her mind for a moment before she caught the end of his sentence.

"...Allie Flynn. She's been hurt and for some reason she asked me to call you."

She sat down in the small chair beside the hall table. "What happened?"

"It's not real clear. Pete Flynn got a lawyer for Dennis late this afternoon, and he was released from jail, then sometime later turned up out at the ranch. From what I can pry out of the two men, they got into a real punch-up and somehow Allie got in the middle, most likely trying to stop the fight."

"Damn."

"You got that right. Pete says Dennis hit her, Dennis says it was Pete, my guess would be both, two middle-aged, out-of-shape guys punching blind. Anyway, she's pretty battered, the two of them are locked up, and she wouldn't give me her kids' phone numbers. Asked me to call you. I guess you're good friends or something?"

Not really, but she'd sent the poor woman a sympathetic message right after learning of Sean's murder. "Good enough. Hank, how bad is she?" Because she was going to have to bring Sylvie with her.

"Nothing life-threatening according to the doctor, but kinda ugly. She has a big knot on her jaw, a split lip, a body bruise or two, and a wrenched shoulder. Best thing would be if you could talk her into staying here for the night. So far, she just says she wants to go home."

Patience looked at the kitchen clock. "Tell her I'll be there in fifteen minutes."

"She'll be real happy to hear that."

"Patience, who got hurt?" Sylvie, wide-eyed, had listened to most of the conversation.

"Not Verity. It's a friend of mine, Allie Flynn. She got…hit a few times, and I'm going to go get her."

"Was it her husband?"

A deep breath. "Do not lie to children" was a principle of particular importance in dealing with this child. "Apparently it was her husband and his brother, by accident; they were fighting each other. But she's bruised and battered. Maybe you should stay here with Zak, and I'll lock the door and the gate."

"I know what women look like that've been hurt." Sylvie's voice was flat. "The Devil liked to hit Lily sometimes."

Devlin Costello, Lily's second husband. "Did he ever hit you?" A question neither Verity nor Patience had ever asked.

"One day he started to, and Lily made him stop. We ran away the next day."

"Good for both of you. If you don't think it will upset you too much, I'll feel better if you come along."

"Me, too."

HANK met them at the entrance to the Emergency Room. "Hello, ladies. Sylvie, why don't you wait out here with me? Patience, Mrs. Flynn is in the first cubicle—in a chair, not on the cot. But she wasn't quite ready to come out."

Patience lifted one hand in a gesture of understanding. "I'll see both of you in a few minutes." She walked past the central area into the corridor behind it, and pulled back the curtain on the first booth. "Allie? It's Patience."

Allie Flynn was huddled on a chair, as if trying to disappear. "Patience, I'm so sorry to bother you, but you were the one person I could think of who might not be shocked or judgmental."

Patience pulled up the other chair and sat down. "Not a problem, I was at home and not doing anything special. You didn't want to call your daughter?"

"Oh, no. I don't want Norah or Tim, particularly Tim, to come here and see me like this and blame their father. Or even Dennis, I suppose.

"I'm just so ashamed," she went on, so softly Patience could barely hear her. "I shouldn't have let this happen."

"Right. At all of about ninety-five pounds, you should have been able to stop two large, angry men right in their tracks."

Allie sat up straight, startled.

"Look, Allie, I wouldn't quarrel with your decision about your kids. I think they'll need to know, but later would probably be better. Beyond that, blame yourself only for a well-meaning error in judgment. End of sermon," she added.

"You told me your mother was a preacher." Allie's voice was stronger.

"Right, and I said I wasn't. See how wrong we can all be?"

The two women looked at each other and exchanged grins, one of them very tentative, as Patience reached out a hand to help Allie to her feet.

"I can take you home, or you can stay with Sylvie and me tonight; Verity is out of town and that leaves a bed free. It's entirely up to you."

"Patience, I'd love to stay with you. My house is a mess I don't even want to look at tonight."

"Come along, then, we'll be glad to have you."

"Oh, but your granddaughter? I don't think she should see this." She put a hand to her face.

"Sylvie knows quite a bit about the unhappy things people can do to each other, Allie. Don't worry about her."

AT the cottage, it was decided that Allie Flynn would have Sylvie's bed and Sylvie would sleep in the studio. "I really like to sleep out there, but I don't get to very often," Sylvie told her.

"Thank you, Sylvie. Sleep well."

"And it's time to do that now," said Patience. "Here, take the key and lock the gate. And take Zak."

"Okay. G'night, Allie, g'night, Patience. Come on, Zak."

Janet LaPierre

"That's a wonderful child," said Allie when Sylvie had disappeared. "You and your daughter are very lucky."

"We think so, most of the time. Come on, I think I can find you some clean pajamas. Then you should take one of those pain pills the doctor gave you and try to get some sleep. If you find sleeping in a strange place difficult, you can turn on Sylvie's night-light, down by the dresser."

"I don't like pain pills. Could we have a glass of wine, and talk a bit?"

"Of course. White or red?"

"White, please."

Allie put on the pajamas and came out to tuck herself into the corner of the couch. Patience put on an album of Bach sonatas and partitas played on a lute, and brought two glasses of wine.

"I really appreciated your note, Patience."

"E-mail is probably not socially correct, but it's immediate."

"Immediate is good, especially when the rest of the family is out of its mind. Tonight Dennis actually accused poor Pete of killing Sean."

"His own nephew."

"Yes. Dennis Flynn is the most mean-spirited... Then he said it was probably Tim, and that was when the fists started to fly. When I managed to get clear, I just locked myself in the bedroom and called the police. Not a very loving thing to do, I guess." She shrugged, winced, and had a sip of wine.

"It beats going for a gun, which might have been my inclination."

"Oh, my, a gun. I'd have... Never mind. Dennis was a wild-eyed anti-government nut in his twenties and eventually turned into a wilder-eyed conservative Catholic nut. Before this particular meltdown, he was blaming Sean's death on that young man who was killed in the riot."

"Danny Soto?"

"That's the name. Dennis said Sean had been led astray by Soto." She tipped her head to listen to the music for a moment. "That's lovely."

"It's a two-disc set of Verity's. She has a knack for finding wonderful music."

"Sean wasn't a very nice young man," Allie said. "You saw

that yourself. At the start he was a sweet, loving little boy in spite of having two crazy parents who were utterly unsuited to each other or to dealing with a child. But after they divorced, the two of them tossed him back and forth between them as if his only value was as a weapon in their battles. Pete and I wanted to take him in, but it didn't work out."

"Was he fairly close in age with your two?"

"Yes, and they'd have been fine with it. The problem was that Dennis had a grudge against me, because of a...a personal conflict a long time ago." She shook her head, lifted her glass to finish her wine, and stood up.

"Patience, forgive me for unloading my troubles on you. I think I should go to bed now."

With Allie apparently settled comfortably in Sylvie's room, Patience let the lutenist finish his program while she washed the wineglasses. Should she go down to check on Sylvie, make sure she'd locked her door? Realizing that would surely set the dog off, she contented herself with stepping out on the front porch to observe the dark studio, the closed gate. Unlike Sean Flynn and Danny Soto, Sylvie, bless her, was going to have a chance to grow up with people who wanted and loved her.

"PATIENCE, what were you and those other people talking about, in the yard after church?"

"Oh, this and that." They'd had lunch and were clearing kitchen surfaces and loading the dishwasher, and Patience was wondering whether the abysmally repentant Pete Flynn and his refreshed and irritated wife were talking to each other yet.

"Was it about what Reverend Noble said in his sermon? Because I thought about it afterward, and I think he was maybe saying we should go to war in Iraq. Is he allowed to do that, in church?"

I am not up to this today, thought Patience. "I don't believe there's a general rule against a minister's expressing an opinion in church. Some choose to do that, some don't."

"Don't you think there should be? I thought church was supposed to be about Jesus and how to be a good person, and about helping people."

"Sylvie..."

"So do we have to be quiet and act like we agree with him? Or can we say something?"

"Let's not say anything just yet. And in any case, we wouldn't say it right in church."

"So maybe we should go to another church. There're lots of churches."

"That's true. Now we'd better change the sheets on your bed, and you should pick up Zak's bed and anything else you left in the studio before Verity gets home."

Sylvie sighed. "So I guess you don't want to talk about this."

"Not at the moment." She turned on the dishwasher, picked up two damp dishtowels, and took them out onto the deck to drape them over the railing. Early morning overcast had been shredded by a brisk breeze, and the day was now calm, chilly, and intermittently sunny. From this height, she could see over the fence and hedge into the yard of Verity's house.

Work nearly complete there, probably be ready for Verity and Sylvie within the week. The moving-in would take a while, and new patterns would settle in gradually, but as Verity had re-marked, Patience would soon have her own house back. She should be thinking about that, but was caught up in something far different: connections and conclusions that had somehow be-come apparent, or at least possible, to her while she slept. And what she should do about them.

Sylvie came trotting out with Zak's bed. "I got my stuff out of the studio, and I thought I'd put this out in the sun for a while."

"Fine."

"Patience, what are you doing just standing there? Aren't you cold out here?"

"I'm just looking at your new house. And thinking about Daniel Soto."

"I think about him, too, about him and poor Gracie. It's as sad as a story in a book."

"I guess it is. Sylvie, didn't Daniel come here on a bike some-times?"

"Oh, yeah, a big, black bike with funny tires and I think gears. Sometimes he rode it here, sometimes it was just in his van. He had a lot of stuff in his van."

Click! went the image-shaper in Patience's brain.

Gravel crunched and rattled, and both of them moved to the railing to see Johnny's car come through the gate. "Oh, they're back. I wish I could have gone with them."

"Maybe next time," said Patience.

26

IN A KITCHEN LIGHTED ONLY BY a small under-counter fluorescent fixture, Patience scooped ice into a cooler chest and added two cans of Coke, two bottles of water, a big chunk of sharp cheddar cheese. After another glance into the fridge, she picked up two brown bottles of ale. And from the pantry, a box of saltines. It was surely a good idea to be well prepared when venturing out to follow a...hunch? Feeling? Some kind of pull, anyway, not her usual motivation, so more probably just the misfiring of an aging brain.

She carried the lot out in damp predawn darkness to the pickup truck parked behind the house. Back inside quickly, to grab her shoulder bag and turn out the light and pause for a moment, listening for sounds from Sylvie's room, hearing none. She went out into the dark again, pulling the front door quietly shut, deciding not to lock it.

At the studio, she rapped on the door before opening it. "Verity?"

There was a mumble from the bed, and the sound of movement. "Um. Ma?" Verity came up on one elbow and reached to turn on the bedside lamp, and squint at her clock. "What's happening?"

Nothing she wanted to talk about, even to Verity. "There are a few loose ends I'd like to tie up today, and I thought an early start would be a good idea."

"Well, six is sure early enough. Anything I can help with?"

"Sylvie's still asleep. If you could get her up in time for school, and fix her breakfast?"

"Yes, ma'am," said Verity, and yawned.

"And can you arrange to be here for her this afternoon? Just in case I'm not back in time."

"No problem. In fact," she added, "I thought you looked tired when Johnny and I got back from the City yesterday, so please, go your merry way."

"Thank you, dear, I'll do just that. Incidentally, I'm taking the truck today. The poor thing hasn't put tire to road in months." And before Verity could frame question or reply, Patience gave her a wave and was out the door.

In town, she filled her gas tank and headed north through thick, gray overcast that she hoped wouldn't develop into rain. An hour and a half later, she pulled into Garberville, where she stopped for a quick breakfast, restricting herself reluctantly to a single cup of coffee. Peeing behind a bush along an unfamiliar rural road was not an activity she enjoyed.

Back in the truck, she drove very briefly north, then west onto the southernmost of the two good roads into the Lost Coast. From a branch of this road she could reach a couple of the small, remote, and relatively unsupervised campgrounds overseen, more or less, by the Bureau of Land Management.

Her initial response to the news of Daniel's missing trailer had been sarcastic incredulity: So he'd leapt from the stormy sea, jumped into his van, collected his trailer and fled? The oddity of the circumstance—lost man, stolen van, stolen trailer—had hummed very quietly in the back of her mind until jolted to life by E.T's and Johnny's descriptions of a homeless man who was Daniel's friend. A man she'd seen a time or two on the bluffs, and once more recently. *What if Daniel had had help?*

She turned her radio on, found only static, and slipped in the first CD that came to hand, which turned out to be The Anonymous Four singing American hymns. See, she told herself, miracles do happen

This was reasonably good road full of little kinks and curves that made for cautious driving, so it took a while to reach the Y where the road divided. It was a while longer before she lurched into a small campground, empty, that clearly had room only for tents. Small tents.

A short distance further on she came to the second, slightly larger campground, where a man who reminded her of a great blue heron, only gray, strode over from his pop-up trailer to tell her that he'd been here for two weeks and no one else had so much as driven by. She was, he assured her, entirely welcome to stay, but he hoped she didn't play loud music.

She left him to his solitude and headed on to Shelter Cove,

on the coast, where the manager of a large, expensive, not particularly attractive campground assured her that no old trailer–blue van combination was there, nor had been. Neither of the people she described had shopped in the store recently, either.

So it was back into the truck, and soon onto the ridge road leading to Honeydew. It was while driving this road last week in the opposite direction, on her way to the monastery, that she'd passed the man stopped astride his bike to drink from a bottle of water. Creeping past cautiously to avoid throwing gravel, she'd had plenty of time for a good look at him: his size, his scarred face, his gray ponytail. Now she thought, as she had yesterday, that he was—might have been? could have been?—the man called Doc.

In the tiny town of Honeydew, which hadn't changed much in the week since she'd visited it, she stopped in the store's parking lot to look again at the map. There was a likely-looking rivermouth BLM spot fifteen or twenty miles northwest of here. But first, a stop for coffee and information. And a rest room.

The woman behind the counter was the same person she'd spoken with last week. "Hello, Patience Smith, lady detective. Who are you looking for this time?"

"Hello, Jean. Something about this area just pulls me back, I guess. Anyway, I'm wondering whether a different man I've been hired to find might have been camping somewhere around here over the past week. He's just a youngster, about twenty-four, brown hair and gray eyes, over six feet tall and broad-shouldered. He might be a little battered-looking, from an accident. He drives a light blue Dodge van and is probably pulling an old trailer."

Jean shook her head. "I've been here in the store every day since last Sunday, and I haven't seen anybody like that. Joe's handled the pumps and outdoor stuff most of the time, but he's not here right now. If you want to wait…"

"Let me ask about one other person. This one's older, a big man with a scarred face and a gray ponytail. He's not very sociable, and probably wouldn't have had much to say if he did come in. He could have been alone, or with the younger guy."

Jean's expression had brightened halfway through this description. "Now that guy I did see. And you're right, he was not exactly charming. In fact, he made me a little nervous, which is probably why I remember him. He bought some deli stuff and

canned soups, chips and such, and beer. Oh, and several big jugs of bottled water and a bag of ice."

Miracles. "Jean, what day was this?"

She shrugged. "Thursday? Or maybe Friday? He paid cash, so I don't have any record."

"Did you see what he was driving?"

"Sorry," she said, shaking her head. "Is this guy some kind of crook? Either of the guys?"

"Not so far as I know. Anyway, thanks for the information. It may be helpful."

"Any time."

It was early for lunch, but the deli counter was open and on the principle that you never know, Patience bought a decent-looking ham sandwich on a bun, picked up a bag of salt-and-vinegar potato chips, and headed back to her truck. The thermometer on the storefront read only fifty-five degrees, but the overcast was higher and lighter, no longer threatening immediate rain. She hadn't really needed the height and power of the truck so far, but it felt less vulnerable than her little Toyota.

THE campground at the mouth of the Mattole River offered a spectacular view of the Pacific, and apparently fishing as well; one lonely figure was out there in the surf with a pole. Closer, Patience saw maybe a dozen sites with weary-looking picnic tables, rock fire rings, and a pair of pit toilets nearby. The whole place had a battered, bedraggled look, and the beach was strewn with kelp and other debris. Apparently the storm that hit Port Silva a week earlier had struck here, too, and raked the place hard.

But the result hadn't discouraged the driver of a light blue Dodge van parked at the south edge of the camping area, beside a small tan-and-white trailer. Patience had never seen Daniel Soto's trailer, and one Dodge van looked like any other, but the combination, in this circumstance, was promising. Next questions: who was here with it, Daniel? Doc? Both of them?

Her truck was one of two vehicles in the parking area that faced the camping spaces; the other, also a pickup truck, had fishing gear in its bed. As for camping persons, there were no other sites presently occupied, although a puff of wind coaxed wisps of smoke from one of the fire rings.

What she should do, Patience knew, was drive right back to Honeydew and phone Hank or Johnny. What she did was put her shoulder bag on the floor out of sight and slide from the truck, locking it and tucking the keys in the pocket of her jeans. As she was considering her next step, a starter ground and ground again, and the van vibrated as its engine stuttered to life. The driver gave it gas, a cloud of dark exhaust flared from the tailpipe, and boards laid behind the deep-in-sand back wheels simply tilted up as the wheels dug in deeper. Oops.

The engine died, the driver's door swung open, and someone Daniel Soto's size and shape got out and trudged around the vehicle to look down at his failed fix. Shoulders slumped, hands stuffed in his jacket pockets, he was the picture of dejection.

"I don't think you're going anywhere very soon," she said, and he swung around, straightened to look at her, frowned.

"Mrs....Mackellar?"

When she made no reply, he snapped, "What the fuck are you doing here?" Although his face was smeared with old bruises, the gray eyes were clear and undamaged, and so were the very white teeth.

"Looking for you, Daniel. Or is it Luke?"

He ignored that. "I didn't think Doc would... But hell, he didn't owe me anything. In fact, the debt is all mine."

"I haven't talked to Doc, and I don't think he's said anything to anyone about you. Was it Doc who pulled you out of the water?"

A twist of that battered face. "Sort of. Best I can remember, I surfaced and was trying to swim south along the shore and not get dragged further out when a monster wave caught me and slammed me way up against this big rock. I must have yelled and Doc heard; anyway, he came down on a rope. He's a crazy man.

"So if it wasn't him," he went on quickly, "how did you find me? And why were you looking? I haven't done anybody any harm."

"What about Grace Beaubien?"

He flinched, and she regretted her tone. "Grace couldn't bring herself to believe you were dead, although everyone else did, so she hired my agency to try to find you, or to find out what we could about you."

"Grace will be better off forgetting about me. Is she okay?" The question was quick, and he looked surprised that he'd asked it.

"She's taken up your banner. She left her quartet, formed something like a folk-singing trio with two old friends, and is taking part in anti-war protests. She almost landed in jail the other day for hitting a cop with her guitar."

A quick flash of grin reminded her of the nice boy who'd worked so well and patiently under Val Kuisma's direction. "Yeah, she's a whole lot tougher than she looks. But not as tough as she thinks she is," he added in grimmer tones. "Mrs. Mackellar, how did you find me?"

"Verity found out about the MacWhorter family," she said.

He shook his head. "She's a smart woman, I could tell that. But how did *you* find me? And now that you have, what do you plan to do about it?"

She wasn't sure about that, either, not without more information, but he gave her no time to decide what question to ask next. "Mrs. Mackellar, you can call yourself a detective, but to me you're just a little gray-haired woman. Close to being an old lady, even. And here you are out in the woods all by yourself, no cops around, no big redheaded daughter to back you up. I'm half your age, twice your weight, and believe me, not in any mood to be pushed around."

"Luke—"

A flush of anger made his damaged face uglier as he straightened and took a step forward, to loom over her. "I am Daniel Soto, got that? I haven't committed any crimes, I haven't hurt Gracie in any permanent way, and what I do and where I go is nobody's business."

Patience resisted the urge to step back, even turn tail and flee toward her too-distant truck. "Grace will recover, that's true. But if the news of your death was a blow to her, the fact that your escape and survival are none of her business will be another."

He stared at her for a long moment, then backed up against the bench of the battered picnic table and sat abruptly, to bend over, elbows on knees, and drop his head into his hands. "I didn't think of it that way. I just thought she'd probably be better off with me gone."

Now there was an Everyman's excuse for abandoning a relationship. Where did boys learn these classic cop-outs, in Little League? Except Patience was fairly sure this miserable, shivering man had not had a Little-League kind of home. "As for what brought me here, it was the missing trailer, added to the missing van, along with the feeling that if you'd been hurt, and were on the run, you'd need a reasonably close, out-of-the-way place to hide."

He didn't lift his head. "Oh, you got it, all right. Run and hide, that's me."

"From whom?"

Eyes still closed, he sat up, opened his mouth and then closed it tight. After a long moment, he said, "Whoever the bastards were who tried to kill me. Probably thought they did kill me."

Whoever? "The man who apparently pushed you in fell in, too. A body was recovered, anyway, and the police learned he'd been looking for you earlier."

"Stubby little bastard didn't fall, I took him with me. Must've surprised the hell out of him. I may not have guts, but I've got reflexes." His grin was brief, and bitter. "Uh, Mrs. Mackellar?"

"Yes?"

"What I wonder, would you happen to have anything to eat in that truck? The stuff Doc brought in before he left ran out yesterday."

WHILE Patience went to get the cooler from the truck, Daniel built a fire in the fire ring and brought out two folding chairs from the trailer. Then, in a surreal version of campground sociability, they used the lidded cooler chest as table while Luke devoured the ham sandwich, followed by cheese and crackers, washing everything down with gulps of beer. Patience sat and watched, sipping at a Coke and nibbling potato chips as she considered the gap in his earlier responses. Clearly he knew who they were, the people who'd meant to kill him.

She pulled herself back from contemplation to find that Luke/Danny had finally stopped eating. He noticed her attention, tipped his bottle up to drain it, and looked directly at her. "So?"

Try a different tack. "Tell me about the original Daniel Soto."

He turned his gaze from her to the fire. "Danny was Hector

Soto's son, a couple years older than me. Hector was a relative of mine, sort of like an uncle. He worked for MacWhorter's as a project crew-chief."

"What happened to Danny?"

"His mother took him home to Mexico when he was thirteen. She was born there, had family there, and she didn't think the U.S. was a good place for a Mexican boy to grow up. Danny got killed in an accident down there."

"And Hector?"

"He…grieved. And sort of adopted me when my mother died a year later."

"And your real father?"

"Luke MacWhorter, Junior, son of the original one and only Luke MacWhorter. He was… Shit, I guess he was a nice enough guy, but like me, he'd missed out on the old MacWhorter guts and drive. He was lost after my mother died, and pretty soon he met another woman, rich widow with a vineyard, and married her. He enjoyed being a vintner a whole lot more than he enjoyed being a contractor. Or a father.

"Anyway." He set the empty bottle aside. "I sort of camped at my grandfather's; he had a housekeeper, and I spent my time going to school, or working around the construction office and yard, or being beat on by Doug, Junior and Bart, my cousins. They were a lot older then me, and big; I was a scrawny runt till I was almost seventeen."

"Was Hector at the yard a lot?"

"Yeah, and nobody messed with me when Hector was around. Sometimes I stayed out at this little place he had, or in his trailer if he wasn't living in it on a work site." He nodded toward the little trailer. "Meanwhile, I grew about two feet taller and those two Orcs had to team up to give me any trouble and couldn't always manage it even then.

"So there I was, about to graduate from high school, and I'd been accepted at UCLA and Santa Cruz. And Humboldt State, I thought I might like that one best." Silence for a long moment, while he stared out toward the ocean where the lone fisherman, Patience noted, had disappeared. Further up or down the beach, she hoped.

"And then …" he said, and paused, to take the top off the

cooler and fish out not another beer but a bottle of water. "And then one of the jobs went bad, no surprise, but this time a guy died on the site. See, with my granddad sick, my uncle and cousins had been running the business their own way, ignoring codes and regulations, bribing inspectors. Doing substandard work with inadequate gear, just the kind of stuff the company is under investigation for now," he added.

"Hector knew about most of this, of course. Shit, even I knew some of it. But when the guy died, Hector blew up and said enough, no more, or he'd go to the county or the state. So the next night, late, I was working there in the office and I heard a ruckus in the yard and went out to see."

He took a deep breath, and then another gulp of water. "Bart, and I think Doug and three or four other guys had Hector down and they were all over him. I went out there and jumped in and tried... Well, they knocked me out in no time. I came to in one of the sheds, hands and feet tied and the door padlocked."

Almost holding her own breath, Patience kept her eyes on him and her mouth shut.

"I was lying there wondering what the hell I was gonna do and all of a sudden the door opened, and it was one of the workers, a guy I knew. He cut me loose and said they'd gone off to get rid of Hector's body and would be coming back for me, and if I was going to run, would I please drop him off on the highway."

Another long pull at the water bottle. "So I got in my truck and went out to Hector's place and hooked up his trailer. Then I dropped the guy off like he'd asked and ran and ran and kept running. Just like I did a week ago."

Bart and Doug, he'd said. Was one of them the person "from another time" he told Grace he'd seen in town? And had he actually seen that person, whoever it was, or imagined it?

"Except this time it's gonna be different."

The hard edge to his voice startled Patience, and so did the look he gave her as he got to his feet.

"Now what am I going to do about you?"

"You have no reason to do anything about me," she said, her own voice calm.

"Yeah, I do. I've said a lot more than I should have. How'd you get me to do that?" he added, a question meant for himself

rather than her. "So your daughter found the MacWhorters, and told you. Who did *you* tell, that cop friend of yours?"

"The police were looking for someone to notify about your presumed death, so when we found out who you really were, we told them." She sat tight, literally, in her folding chair.

Daniel moved uneasily, sidling a step or two to his right, then back and to his left, keeping his eyes on her the whole time. "Did they talk to one of them? To Uncle Doug, maybe?"

"I don't know."

"I bet. Anyway, they would have, if they were doing their job. Did any of the cops go down there, to Atascadero?"

"I…not that I know of."

"Uh-huh. But probably they wouldn't have, they're a small force and this wasn't exactly an emergency, nobody at risk. So far as they knew." More pacing, then a shake of his head. "I bet they, or that chief with the *Indio* face, he'd have asked Uncle Doug to come up to Port Silva, get this all straightened out. And good ol' Uncle Doug, he'd have been real sad about it but basically too fuckin' lazy to want to get off his butt to come up to sign the papers or whatever.

"But he'd have to come eventually, Grandpa would make him. Is he there now?"

The sudden question startled Patience, and she took a second to regroup. "I don't know."

"This is what, Monday. Was he there Saturday? Sunday?"

"Not so far as I know. But I wouldn't necessarily have—"

"Yes, you would. Captain Svoboda would have known, so you'd know. Stay where you are," he snapped as she pulled her feet under her and gripped the chair arms.

"That's better," he said as she settled back into the chair. "You probably won't believe this, but I've been thinking seriously about heading back 'home' to finally deal with family business. Now it looks like I can take care of that right in Port Silva." He glanced around him, at his trailer, his van. "My van's pretty well buried, and not in good shape anyway. So I could leave you here, in the trailer, and take your truck."

"I don't think so."

He wasn't listening. "But even if you promised to stay here and be quiet, or if I took your cell phone—you've got one of

those? But it won't work here anyway, I don't think. Even then, you might walk into Honeydew, could you walk that far? Sure you could.

"No, best thing would be to leave you in the trailer but tied up, and tell your daughter where to find you. After I've found out who's where and done what I need to do. Then somebody could come and get you, in the morning."

"And in the meantime, I'd freeze or get washed out to sea?" Patience took a deep breath and got to her feet. "Danny, I have a much better plan."

27

"HEY, BIG JOHN?"

Johnny looked up from his computer to meet the bland, blue gaze of Brad Coates. "Yeah, Bradley?"

"The chief wants to see you. Hope you're not in trouble."

"Sure you do," Johnny said, and logged off. He stood up and made a point of straightening to his full height, shoulders squared and chest out, before striding past the much smaller Coates, and was almost ashamed of himself.

At Gutierrez's closed office door, he rapped briefly and waited for the chief's "Come!" before entering. Gutierrez, in uniform today, rose from behind his desk, and a tall man in pressed gray trousers, white shirt, red tie, and tweed sports coat got up from the visitor's chair. As he returned the enquiring gaze, Johnny saw Danny Soto's distinctive bone structure, blurred by added flesh in a middle-aged face.

"Mr. MacWhorter, this is Detective John Hebert. Johnny, Douglas MacWhorter has come up from Atascadero for information about his nephew, Luke MacWhorter. Apparently that's the real name of the person we knew as Daniel Soto. Let's sit over here," he said, leading the way across the room to the couch and two chairs set around a low table. "Coffee's on the table against the wall, for anybody who wants it."

Johnny played waiter, and when everyone had a mug to his liking, sat down on the chair across from MacWhorter's position on the couch. "It's a long drive from your area," he said. "My uncle from San Luis Obispo is flying up tomorrow for a visit, in his Cessna. You might know him: John Lundquist."

"Hell yes, I know him. Good builder. If I'd known he was coming I'd have hit him up for a ride," MacWhorter said. "What I did, I flew to Oakland and picked up a rental car. I wanted to send my older son to take care of this, but my father—young Luke's

grandfather—insisted I make the trip. I guess the body hasn't been recovered yet?"

"That's true, but as you probably know, not unusual," said Gutierrez. "However, Danny's, or Luke's, fall from the bluffs was witnessed by a number of people, including the local television crew, and the body of the man who fell with him was recovered two days later. Rudy Diaz, is the name familiar to you?"

MacWhorter shook his head. "I don't have much direct contact with the Hispanic laborers, but when Captain Svoboda mentioned that name, I had a look at our payroll records, and he's not there. I should say that one of young Luke's problems was that he insisted on making friends with those people instead of remembering his family's position. I and my boys can *hablar* a little *Español* when it's necessary, but Luke had to go whole hog."

And here was a man with a tin ear as well as a blind eye, noted Johnny, watching his boss control his irritation. The phone buzzed, Gutierrez got up to answer it, and turned a minute later with a gesture meant to be apologetic. "Mr. MacWhorter, I'm sorry, but the mayor's called a special meeting in his office. I'll have to leave you in Detective Hebert's capable hands. Johnny, you'll see that Mr. MacWhorter gets whatever he needs."

"Yessir," Johnny said, and turned his attention back to MacWhorter as Gutierrez left the room. "Mr. MacWhorter, what kind of information does your father want about—? I'm going to have to learn to call him Luke, we knew him as Danny."

"Well, uh, how long had he been here in Port Silva? And what did he do here, did he work?"

"He'd been in town about two years, working in construction," Johnny said, and gave MacWhorter a run-down on his nephew's various employers. "He was well thought of. Good, skillful worker, and his Spanish came in handy because many of the laborers here are Hispanic, too."

"Probably illegals," said the other man with a shrug. "My company uses them, couldn't get along in the business otherwise, and some of them are real good workers. But I feel bad about the burden they and their families put on the taxpayers."

And your company of course provides medical benefits and insurance? "Right. Anyway, he was a reader, spent a lot of time at the local library. The librarian liked him. For the past six months

he'd been living here in town with his girlfriend, a professional musician from a nice family out in the county. Grace Beaubien is really broken up over his death."

"I hear he turned into one of those anti-U.S. people, a peacenik. It was an anti-war riot that got him killed, wasn't it? He hasn't said so, but that's gotta be the hardest part for my father to take. He was real proud of his service in World War Two."

"There was a peace march and rally that some other people turned into a riot. Luke's death seems to have been an accident."

"And he didn't have any police record here? As a teenager, Luke was basically a troublemaker with a vicious streak. My two sons—they're six and eight years older—he always gave them a hard time."

"No record, not in his time here nor anywhere else that we were able to turn up. Of course, if he had arrests in your area as a juvenile, the records might have been sealed for one reason or another?"

MacWhorter shook his head. "My father, his grandfather, was semi-retired but still active in those days, and had a lot of local clout. Been a brave cop who arrested Luke MacWhorter's favorite grandson. For instance, Luke beat my younger boy, Bart, to a pulp one time, for no reason. Put him in the hospital, damn near killed him. But the old man wouldn't let Bart press charges."

"I'm sorry to hear that," Johnny said, remembering Danny Soto's reported explosions of temper here. "How long ago was it that Luke disappeared from home?"

"Uh, six years. And he didn't disappear, he left. Just took off out of the blue."

"No signals? No note to his grandfather, for instance?"

"None. It practically broke the old man's heart, I can tell you."

"What about Luke's father? We thought maybe he'd be the one to come here for information."

"Oh, he gave up on Luke long ago. Everybody did, except the old man. So when he left, I'd have to say we all more or less heaved a sigh of relief. Except about Hector; we were sorry to see him go."

"Hector?"

"Hector Soto, some kind of shirttail Mexican relative of my

mother's. For years, he was our best crew manager, and Luke thought the sun shined out of Hector's ass. What we finally figured was, Hector'd headed back to Mexico, which he did every now and then, and Luke went with him. And neither of 'em came back."

"That must have made your father feel a little better."

"You know, it did. But he still missed the boy. Luke was his favorite grandson, for no reason anybody ever could see. My two boys felt kind of hurt by that, not that they really thought about it a lot."

"Understandable. Mr. MacWhorter," Johnny said, getting to his feet, "the chief thought you might like to meet a few people who knew Luke. Grace Beaubien, for example? And maybe Joe Linhares; Joe and his brother own a well-regarded construction company here in town, and Luke worked for them. If you're interested, I'll call to see when they're likely to be available."

"I think my father would expect me to do that." MacWhorter looked at his watch. "Tell you what. It's gonna be too late to drive back to Oakland today. I need to go find me a good motel, preferably with a decent restaurant nearby. And then make a couple calls home, see how things are going there. How 'bout I go take care of that stuff, and meet you back here in an hour?"

"HARLEY, thank you." Verity looked at the results of her day's labor, hers and Harley's. The four straight chairs, round pine table, and low ash coffee table had come in boxes, to be assembled. The brass floor lamp Harley had spotted in a used-furniture store and brought to her on spec, so to speak. And *mirabile dictu*, her grandfather's antique rolltop desk now stood proudly against the wall.

"How on earth did we manage to carry this in?" she asked, rolling its front up and then down again.

"With great effort," said Harley, making a show of wiping his brow.

"True. Can I get you a beer?"

"I better not, thanks. I've got a late class. When's your other stuff coming?" he asked, with a look around the room.

"Wednesday or Thursday, I think. But the guys who drive it up from the City will also carry it in, so you're off the hook there. Bless you, my son," she said, patting his shoulder. "Now go and study well."

"Let's put that table in the dining room first."

When Harley had departed, she washed her grubby hands and went upstairs, to finish hanging curtains in Sylvie's room. Sylvie's personal choice like the rosy wall-paint, the fabric was a soft grayed beige printed with long, narrow leaf-blades and fronds of fern in a muted green. The curtains were, as requested, unlined, to let light through.

"That takes care of both bedrooms," Verity said aloud. "And downstairs, we'll just have to keep our clothes on." Probably they could make do with sheets until she had more money or time available.

"Time," she repeated, and went to find her watch. Wasn't the school bus about due?

Oops, the bus should have come a good forty-five minutes ago, she realized as she picked up the watch from the kitchen counter. But there'd been no sound from Zak, so presumably the bus hadn't delivered Sylvie. She patted her pockets, and then looked around at various flat, bare surfaces: no cell phone.

"Shit," she muttered, and hurried from the house. "Hey, Zak?" she called, and he came through the gate she'd left open. Looking worried, she thought, if a dog's face can do that. "Okay, where's our kid?"

Her bag was in the studio, and her cell was in it. As she flipped it open, its ring startled her into nearly dropping it.

"Sylvie?" she said, recognizing the number of Sylvie's cell phone. "Where the hell *are* you?"

"I tried to call, to tell you I was going to go to see Gracie and catch the five o'clock bus home. But—"

"Since you didn't reach me, you should have come on home," Verity snapped.

"But you weren't there," said Sylvie's ultra-reasonable voice.

"Sylvie—"

"But listen, Verity, I think you need to come here. If I didn't get you this time, I was going to call Johnny."

"Johnny? Sylvie, where are you?"

"I'm at Gracie's, in her backyard. See, this guy came to the front door a little while ago who says he's related to Danny. Only he said Luke."

"And you let him in?"

"Not me, Gracie. And he started right in asking her about Danny, about his stuff that he might have left there. Pretty soon she started to cry, and I told him to leave her alone, and he told me to butt out, little girl, and gave me a shove. So I came outside and called you. I don't like him, and I don't think he should be here, whoever he is."

"Sylvie, you go through the backyard next door and then up to the corner, in the direction of the school." She couldn't remember the name of that cross street. "Wait at the bus stop there. I'll see you in about five minutes."

She dropped the phone into her bag, fished out her keys, and set off for her car. "Oh, Zak, forgot about you. Come on."

Once she was out the driveway and on her way, she fished around for her cell again and took her eyes off the road long enough to speed-dial Johnny. Instead of a ring, she got his voice asking her to leave a message.

"Shit!" She sped toward town; if some cop wanted to stop her, let him catch her. Here was the cross street: Mariposa. She swung left, drove three blocks, turned left and stopped in front of the bus shelter, to open the door for Sylvie to jump in.

"I've been watching, and he didn't come out. His car's still there, right in front of Gracie's. Hey, Zak," she said to the dog, who'd thrust his head over the seat-back to lick her ear.

"I see it." Black, with tinted windows, it was a medium-sized SUV, she thought one of the Toyota line. Verity pulled up behind Grace's little Honda. "You stay here," she instructed as she got out, but Sylvie and Zak were on the sidewalk before she'd come around the car.

"Sylvie—"

"I'll bring Zak."

"Just stay behind me then, both of you. And Sylvie, get your cell out. If there's trouble, call Hank." Verity trotted up the steps, touched the doorbell, and opened the door. "Grace? Where are you?"

"Oh, Verity!" She came running from the back of the house, the bedroom or the study. "This...he wouldn't tell me his name, but he says he's here to get Danny's stuff. He won't believe me when I tell him Danny didn't leave anything here but some old clothes."

Right behind her, looming over her, was a big guy with long-ish brown hair and wrap-around dark glasses. Maybe early thirties, thought Verity, with sloping, meaty shoulders and a prominent belly-bulge. If he was related to Danny—Luke—nothing but his size gave any indication of the fact.

"Who the fuck are you?" he demanded.

"I'm the person whose daughter you assaulted a few minutes ago, and I'm telling you to get out of here right now."

"Hey, I never assaulted her, I just gave her a little push. Besides, poor ol' Luke MacWhorter was my cousin and I got a family right to anything of his I can find. Which he probably stole from us anyhow. In fact," he added to Gracie, "I think that's my grandmother's ring you got around your neck."

As he pushed Verity aside and reached for the ring on its silver chain, Zak gave a single high whine and half crouched to burst into a thunder of teeth-baring barks.

"Jesus!" the man yelped, and stumbled backwards. "Hold onto that dog! Keep him off me or I'll shoot the bastard!"

"Sylvie, call the police," Verity called over her shoulder.

"Never mind! Never mind, I'm going. You just keep hold of that dog."

Verity hooked her fingers under Zak's collar, said, "Wait, Zak," and stepped aside to allow Whoever-he-was MacWhorter to edge past and out the door. Zak whined and the two women and Sylvie stared at one another and then at the open door in silence until they heard an engine fire and roar away.

"Should I still call the police?" Sylvie asked.

Verity looked at Grace, who shook her head. "He didn't hit me, or even really threaten me, and I'd rather not deal with the police again unless I have to. I'm going to the library for a while, anyway. I'll just lock my doors, and call for help if he comes back."

It occurred to Verity that the man who'd just left might very well be the MacWhorter family member who'd come to town to talk with the police about Danny/Luke's death. If so, she'd find out about it later from Johnny. And tell him friend-to-friend and unofficially what had gone on here.

28

"SHIT, I PROBABLY WOULDN'T HAVE the guts to tie you up and drive off anyway." Daniel ran his right hand through shaggy hair that after a lengthy argument—discussion?—was standing up in spikes. "So okay, you give me your solemn word that you won't make some kind of cop's secret signal at a passing highway patrol car, or hang a towel out the window with 'Help!' printed on it in lipstick."

She raised her right hand. "You have my word. I don't think I have any lipstick with me."

"And there's this problem. I've got no personal attachment to that old van, it's on its last legs anyway, but I can't leave the trailer. Not yet, not after all the years and miles I've been hauling it around."

Patience had laid claim to the second, and last, bottle of ale as she presented and then defended her plan. Now she had another sip and eyed van and trailer. The van's rear wheels, as she'd observed earlier, were buried hubcap-deep in loose, sandy soil. But the little trailer, probably parked when Danny and Doc first got here and never moved, seemed to be sitting fairly lightly on its patch.

"I believe we can deal with that. My truck has a trailer hitch and four-wheel drive, so it will probably pull your trailer out of the sand without much difficulty. Shall we try?"

"Might as well, I guess. Want me to back your truck around?"

She had no intention of turning her keys, or her truck, over to him. Not yet, anyway. "I'll do that, when we're ready. You can deal with the hitch."

She sat nursing the last of the ale while Daniel shifted tools and whatever else he thought important from the van to the trailer and snugged everything down for travel. He locked the trailer door, cast a final glance around the site, and shrugged, empty hands spread wide. "Done. You all set?"

Patience got to her feet, dropped the empty bottle into a nearby trash can, and headed for the parking area. The gray Ford half-ton had been her sole transportion for several years, and she got it into place neatly. Daniel managed the hitching without difficulty, and she put the truck into four-wheel mode and slowly pulled the trailer from sand onto gravel. When all wheels were clear, she drove a short distance up into the parking lot before stopping, to set the brake and climb quickly out. By the time Daniel caught up, she was ensconced in the passenger seat.

"Hey, don't you want to drive?"

What she wanted now was to keep her hands free and her attention on more than the road ahead. "Thanks, but here's where I turn the wheel over to you. I never drive after drinking alcohol."

"One bottle of beer?"

"Any alcohol at all. The seat will be too high for you," she added, "and the mirrors will be wrong. The controls are—"

"I can find them." He made adjustments, checked them, adjusted again. Pulled his seat belt down and snapped it into place. "Okay, here we go. You've got the deer and wild turkey watch."

He drove cautiously, with attention to both the rough road and the trailer behind. Once they were on the better surface of the Mattole Road, he was relaxed, but still attentive. A good, careful driver, she decided, no doubt the result of the years and miles he'd mentioned, most of them over curvy, hilly roads like this one.

Relaxing a bit herself, she bent forward to pull her heavy bag from under the seat. She opened it, found her cell phone, closed the bag, and pushed it back into its place.

"Hey!" he said when he saw the phone in her hand. "We had an agreement, remember? No advance notice."

"I remember. I'm just checking a number. When we get to Honeydew, if you have no objection, I'd like to call Larry Klein to see whether he's in and has time to see us."

He looked at her, then turned his eyes forward again, gripping the wheel harder. "I...I'm not sure that's a good idea."

"It's what we agreed on. And it's for your benefit, not mine."

He made no answer in word or glance but simply blew out a long breath.

"And we can stop at the Honeydew store if you like. They have a nice deli section."

"I don't think I'll be hungry."

"BART old boy, you have really fucked up big-time." Bart MacWhorter spoke softly but with feeling the truth that he'd been trying to dodge for more than an hour and most of a six-pack. Down the block and across the street from where he was parked, the house where Luke had lived with his skanky little bitch was showing no lights and no car, no sign of life. As he'd just found out, it was also locked up tight, with new locks.

He could have gotten in. Heavy cloud cover was making for early darkness, and breaking a window in the rear would have been easy enough. No point to it, though; he'd taken that house apart once already, and had to figure Luke had hidden his real stuff someplace else. What he should've done today was make nice with that little cunt, convince her that he, that the MacWhorters, deserved to have back what Luke stole and she should do the decent thing and tell him where to find it.

He'd started out that way, or meant to. Talking nice, being polite. But something…that interfering brat of a kid, that's what got things turned around wrong. He should have…

God*damn*, but he had to pee. He made sure the overhead light was turned off before climbing out. Smart of him to park next to a vacant lot, wouldn't want to offend the neighbors. He unzipped and spent the best time he'd had in a while watering a stand of raggedy bushes.

"Fucked up," he said again, but more softly, as he got back into his car. So what the hell did he have to lose, then? He leaned his head back and closed his eyes, and let his mind wander over various approaches he might make to Gracie, that was her name, when she finally came home. Should it be softly, softly? Or more forcefully?

AT the police station, Gutierrez let himself in the back door, strode down the hall and into the squad room. "Alma, shouldn't you be off duty by now?"

"Yessir," she said, and swung her chair around from the computer. "Just finishing some notes."

"Hebert and Mr. MacWhorter not back yet?"

"Johnny called in just after five. I left a note on your desk."

Gutierrez cocked an eyebrow at her.

"They met with Joe Linhares, and then talked to a couple of his workers. They drove up to Westport to talk to Matt Evers, the architect Danny, that is Luke, had worked for. They stopped by the library to talk with Mrs. Jenkins. They'd been to see Chris Matila; I'd suggested him as a friend of Luke's near his own age."

"All peaceful so far?"

Alma shrugged. "Mr. MacWhorter and the architect—he's gay—didn't exactly hit it off, Johnny said, but nobody punched anybody out. Anyway, MacWhorter wanted to stop someplace for a drink, and by now they should be getting on their way to talk with Grace Beaubien. She wasn't at home earlier, but they got her by phone and she agreed to meet them at her house after six. Johnny said she wasn't happy about the whole business, but he talked her into it."

"Good for him," Gutierrez said. "I was going to head home for a drink myself, but I think I'll go meet them at Ms. Beaubien's place first. She's had a bad time over this, and seeing MacWhorter is likely to be hard for her."

"Johnny will be supportive," Alma told him.

"I know, but MacWhorter's less likely to get pissy if the biggest cop—scratch that, highest rank—is on the scene. He's not exactly a warm, kindly personality."

DENNIS Flynn sat alone at a window table in the bar at The Dock, a notebook in front of him along with a wine bottle, glass, and empty sandwich plate; his cane hung from the back of his chair. A number of the stools at the bar itself were in use, and people having predinner drinks were chatting and eating appetizers at several of the other small tables, but Dennis ignored them all. Didn't hear them. Sat with one hand on his notebook, the other lifting his glass at intervals.

With daylight fading to a low gray line in the darkening western sky, he watched the lighted boats come past the breakwater that shielded the river-mouth and proceed slowly along the marked channel on their way to a dock for unloading a catch, or upriver to the marina. Saw the sleek, dark heads of several seals

break the surface and then disappear again. Wondered whether the tide was coming in or going out. Sean would have known, kept information like that in his head, although he, Dennis, was long away from the coast and had lost the connections with the ocean-edged world that had once been automatic to him.

A couple years ago, Sean fell in love with an old fishing boat and asked his father to help him buy it, saying he could fix it up to live aboard, maybe eventually use it to take tourists fishing. Dennis had seen the boat as a bad investment, a waste of money, and told his son to get a real job instead. Maybe, if he'd given the idea more thought…

He changed his focus to look at the level of chard, he thought it was, in the bottle, and leaned forward to peer more closely at the label. Right, a Mendocino chardonnay with a name he didn't recognize. Enough for one more glass, and with the sandwich in his belly, he should be able to handle that and still safely escape the notice of the ever-vigilant Port Silva traffic cops.

Hell, it was only wine and should barely make a dent in his brain after the amount of Jack Daniels he'd been absorbing over the last several days. Besides, it was what he had at the moment, and he needed it.

He poured the wine into his glass, set the empty bottle aside, took a still-chilly mouthful. Probably enough in the glass for fifteen minutes? Half an hour? Drink slow, old man, you're running real low on cash. And friends, and family, and pretty much everything else. Life.

Without what he recognized as intention, he flipped open the cover of the notebook and found himself looking at the list of names there in his bad handwriting. People he knew Sean knew, people he'd heard Sean knew. People he knew that he thought might have known Sean. Fourteen names, a sadly brief list, twelve of them checked and double-checked. From those he'd gotten platitudes, expressions of conventional sorrow, twice a hint of warmth. Once a spate of meanness for which the speaker quickly offered apology without convincing him that she meant it. Two people who had told him that Danny Soto appeared to be Sean's closest friend.

The Jorgensen girl, who'd been close enough to Sean to lend him her house, had left town after finding his body and had not

yet returned, so far as he'd been able to learn. Her name was checked but not double-checked. And the last name, also marked with a single check, was Grace Beaubien, the girl Danny Soto had been living with until he died, apparently on the same night Sean was killed. Grace had not replied to the phone message he'd left her, nor answered his knock on her door the two times he'd tried to see her at home.

He closed the notebook, picked up his wineglass and stared out the big cold window toward the ending of day, the black river with its lighted channel-markers, the barely visible but restless, relentless ocean beyond. He thought he might be almost invisible himself, and weary beyond any weariness he could remember. He should finish this wine that had no taste at all in his mouth, and try one more time to talk to Grace Beaubien, who had known his son.

29

"LARRY, THIS IS LUKE MACWHORTER, who was known during his two years here in Port Silva as Daniel Soto. He prefers to be called Danny."

"I've heard about you, Danny, but didn't expect to get the chance to meet you." Larry Klein was about five and a half feet tall, with curly, fair hair thinning on top, sharp green eyes, and a wiry body that seemed to vibrate with suppressed energy. "Patience tells me you may need some legal advice."

Danny looked at Patience, who shook her head. "If Larry can help you, if he chooses to help you, it will have nothing to do with me. Think of me as your chauffeur."

"In fact, Patience my dear," Larry said, "it might be as well if you were to wait in my outer office while Danny and I talk."

Larry Klein's outer office lacked receptionist, luxury, or in Patience's opinion, even comfort. "Thanks, but I'll just go for a walk. There's a nice book store about three blocks from here."

"Patience…?"

The last few hours had left Patience with a fair grasp of his basic apprehensions, even when he couldn't or wouldn't voice them. "I'll be back, Danny. Oh, have you a dollar in your pocket, in case Larry decides to act as your legal representative?"

"Yes, ma'am."

"So have a good time, boys, and I'll see you both in a while," she said, and closed that door and the second door behind her, to walk down a dusty flight of stairs and along a dim, narrow hall and out into the twilight of an almost-November early evening. Larry Klein's office had even less gloss than the man himself, which probably encouraged people to underestimate the skill and determination of Lawrence Klein, Esquire. Maybe, *maybe*, Danny Soto could after all come out of this mess in one piece. She resisted the impulse to cross her fingers.

⤿

GRACE Beaubien opened the door to Johnny's knock and surveyed the two men standing there for a long moment before stepping back to admit them. Gracie was not an eager hostess.

"Ms. Beaubien, this is Douglas MacWhorter, from Atascadero in San Luis Obispo County. He's Danny Soto's, that is, Luke MacWhorter's, uncle. Mr. MacWhorter, this is Grace Beaubien, your nephew's good friend."

"Miss Beaubien, I thank you for agreeing to meet with me. I understand you and my nephew, Luke, were close." This was said stiffly, with a question-lift on the last words.

"I know him as Danny. Danny and I lived together here in my house until he was pushed off the cliff." She crossed the room to sit in the rocking chair, leaving the couch or their own feet to her visitors. Johnny led the way to the couch and sat, and MacWhorter followed.

"I'm sorry about what happened to…to my nephew, and I'm sorry for your loss," MacWhorter said. "My father asked me to come here to see what I could learn about the grandson he hadn't seen in six years."

"Danny wouldn't talk about his family, and I gathered he didn't care much for them. He did say he'd had a grandfather who got too old."

"Luke wasn't much of a family member himself," said MacWhorter sharply. "Always hard to get along with, never co-operative. Resented his cousins."

"So I don't suppose any of you minded when he left."

"Miss Beaubien…"

Gracie folded her hands in her lap. "Danny was a good man. My family liked him a lot, and they were happy to see me with him. I don't see that there's anything else I can tell you."

"What about his unpatriotic anti-war activities? My father will certainly be interested in that; he's a World War Two veteran."

"Danny was acting on his convictions, which I share. I'm continuing to take part in protests against going to war in Iraq, and I'm doing it in Danny Soto's name as well as my own. You can tell your father *that*. But you can assure him the name I use will be Danny Soto," she added, "not Luke MacWhorter. That should relieve his veteran's mind."

MacWhorter took a deep breath, in an obvious effort at self-control. Johnny, watching, thought it might fall to him to haul the guy out of here before Grace planted a fist in his face or a foot in his balls.

"Miss Beaubien, I guess we'll have to agree to disagree. Here's two—no, three—more things I'd like to ask, and then I'll get out of your life. First, have you got any pictures of Luke from the time you were together? Something for his grandfather to see?"

"No."

"Okay. Here's something I know my father would want me to offer. If Luke owes you any money, if he left any debts that you share, like rent, we'd be happy to pay them off."

"No."

"Okay." MacWhorter got to his feet, but Grace did not. "Whatever belongings my nephew may have left here, I'd like to take them back to my father. If I may."

"All I have left are some old clothes; you're welcome to those."

"He owned nothing more? After living in this town for two years?"

"He had quite a few tools, but they were in his van, and that got stolen the same night he was killed." Johnny's slight movement caught her attention, and she gave him a brief glance. "And someone broke in here two nights later and took pretty much everything else. I suppose there might have been some personal things in his trailer," she added, "but nothing that I ever—"

"Trailer? What trailer?" MacWhorter broke in, suddenly on-point like a bird dog.

"It was just a little old travel trailer, maybe fourteen feet long. He had it when he came to town, and was living in it when he went to work for my family."

"Miss Beaubien, I'd surely like to see that trailer. It may be MacWhorter company property."

"Too bad. It's gone. Somebody stole it, too." She got to her feet and walked to the door, to open it and hold it wide. "I've seen all I care to of MacWhorters, and I'd like you to leave. And you can tell the other one, that jerk who said he was a cousin of Danny's, that he'd better not come back here, either. If he does, I'll call the police."

"Looks like we're here already," said Vince Gutierrez, who'd just come up the front steps. "What's the problem?"

"Miss Beaubien needs to learn better manners," snapped MacWhorter. "And I need to learn more about what's been going on here."

"Mr. MacWhorter, you seem to have forgotten that this is Ms. Beaubien's home." Gutierrez was inside now, and Johnny was on his feet. "If she wants you to leave, you'll just have to do that."

MacWhorter's shoulders slumped, and he shook his head. "Sorry. I'm better on a jackhammer or a bulldozer than in a living room. Miss Beaubien, I respect your feelings, I know this is a difficult time for you."

She waited.

"If another member of my family has been to see you, has bothered you, I swear to you I knew nothing about it. Will you please tell me who it was? When it was?"

DANNY had parked her truck, and his trailer, at the curb in front of Larry Klein's office building. Now, returning from the nearby book store with a bag containing several novels she'd been lusting after for months, Patience saw that the door to the trailer was open and the trailer itself was bouncing slightly from movement inside. She stepped from curb to metal step and put her head in. "What's up?"

"This is a nice little rig," said Larry. "I've always wanted a trailer. Come on in."

"Nice" would not have been Patience's word. Spartan, perhaps. Old, certainly. But with a couch-bed, a pull-down table, and a few shelves, as well as sink, stove, and ice-box, someone could probably live in it. But someone Danny's size?

At the moment, he was taking items from a closet or cupboard in the rear of the trailer to put them in a cardboard box on the floor beside him. As he straightened, head brushing the ceiling, he caught sight of her.

"Hi, Patience. Here, I want you to see this." He peeled something away from the inside of the closet door, and came to show her a small photo of a boy maybe twelve years old with thick, rough black hair and round black eyes and a wide grin.

"The original Daniel Soto?" she asked.

"Yup." He took it from her hand, looked at it for a moment, and slipped it gently into his shirt pocket.

"Danny's asked me to take charge of some important items for him," Larry told her as Danny closed the closet door and picked up the box. "You don't need to know what they are."

"Good."

"I'll just take them up to your office?"

"Never mind, Danny, I'll do it. I'll put them in my safe." He looked at his watch. "Then I gotta get home. Marian's on her way back from San Francisco and she'll expect a meal when she gets here, not to mention a martini. But we'll go over the stuff tomorrow morning," he said to Danny. "Nine o'clock okay?"

"Sure."

"Good. See you then," he said, and picked up the box and went on his way.

"And I need to get home, too." About to head for her truck, Patience realized belatedly that she and Danny had a transportation problem. "You're welcome to come home with me, if you like," she told him, hoping her reluctance didn't show in her voice. Bringing trouble home was something she tried hard to avoid, and Danny Soto trailed trouble after him like an extra shadow.

"Or I can take you downtown to meet Chief Gutierrez, who's going to be very much interested in your situation."

"Could you just take me home, to Gracie's house? Or maybe that's not a good idea," he added in subdued tones. "Having a ghost turn up on her porch might freak her out."

"You'll certainly have some explaining to do." She looked at her truck, and at the trailer, and he caught her thought.

"Patience, I'm going to ask you for one more big favor, and please feel free to say no if it would make you uncomfortable. Could you maybe drop me off at Gracie's, and then take the trailer back to your place? And I'd come to get it tomorrow."

With what? "I think that should work out," she said slowly. "There's certainly plenty of space. Okay, I'll do it. Let's hope Grace is home."

BART MacWhorter woke from a brief, heavy sleep and realized that his face hurt from where it had been pressed against the side-

piece of his dark glasses, that he must have drooled—he hoped it was just drool—on his jacket. That his gut was both empty and uneasy; he belched, loudly.

There were lights in some houses now, including Luke's pee-wee girlfriend's place. Nobody standing around outside in the cold-as-dammit evening. No traffic at the moment. He straightened and stretched, found a comb in his shirt pocket and ran it through his hair. Picked up the half-full bottle of water from the cup holder, took a mouthful, put his window down and spat it out. And repeated the action.

He was about to put the window back up and get out when he took a longer look toward the girl's house, and paid attention this time to two cars parked in front. Right behind a little black number he thought belonged to the girl was one of those plain white sedans cops always seemed to think you wouldn't spot for what they really were.

Bart settled back behind the wheel and cranked up his weary brain. The only people left in this town who'd seen him up close were the girlfriend and her lesbo friend, and he was pretty sure he hadn't given them his name. But he thought...shit, yes, he'd said he was Luke's relative, maybe even cousin.

Probably didn't matter; he hadn't hurt either of them or even threatened them, not in any major way. But it kind of limited his options, now she'd called the cops in. Best thing would be to wait a while, until the cops left at least. Maybe something would occur to him, like wrapping her up in a rug and taking her someplace quiet for a nice talk.

Bart had a brief flicker of regret for the loss of Rudy, who'd turned out to be a very handy guy. For the moment he'd just try to relax, watch the occasional car roll by. If the cops didn't move pretty soon, he'd drive off, find a bar, have a drink and come back later.

As he was working this out, he watched a light-colored Ford truck move slowly past on the other side of the street. Looked like the driver was trying to find a place big enough to park that... He sat up straight and got a good look at what the truck was pulling.

"Holy shit!" he whispered. "Where in hell did *that* come from?"

⌐

"THERE'S space there," said Danny, pointing ahead on the street. "You can probably get out of the way of traffic there long enough to let me out."

There was indeed a long stretch of curb unoccupied, with a broad driveway on this side of it. "I think I can manage it," said Patience, and did. "Is Grace's house close?"

"Five houses back. Her car's there, and the lights are on." He got out, closed the door, and came around to the driver's side, where Patience sat with her window open. "Mrs. Mackellar—Patience—thank you. Many times." He leaned in and planted a kiss on her cheek. "If I survive Gracie, I'll see you tomorrow."

"Be well, Danny. Say hello to her for me."

He waved, and set off down the sidewalk. Watching him in the side mirror, she saw someone get out of an SUV on the opposite side of the street and cross quickly. A furtive quality in the movement of that tall, bulky figure set off alarm bells, and she turned the engine off and got out.

The follower was closing in on Danny, to pass him or—or what? "Danny? Danny, look out!" she called, and set off at a trot.

Under a streetlight now, Danny spun around, caught sight of his pursuer, and yelled something unintelligible.

"Danny! Gun!" screamed Patience as the other man yanked his right hand free of a jacket pocket to brandish something large that glinted silver. Danny dropped into a crouch and charged, head and shoulder smashing his attacker amidships and knocking him flat. The pistol flew free, Danny swarmed up the other man's prostrate body, and Patience ran to kick the gun out of the way and follow it herself, to stay clear of two large men trying to kill each other in a weird silence punctuated only by thuds and grunts and gasping breath.

Had she screamed again? She didn't remember, but porch lights were coming on up and down the street, and before she could draw breath for another try, two uniformed men—Johnny Hebert and Vince Gutierrez—were between her and the struggling bodies. She nudged the errant pistol further under a low hedge and stayed where she was, standing guard.

"Knock it off! Let go of him!" The fighter now on top was still hammering the one underneath as Johnny grabbed both shoulders, wrenched him—Danny, Patience saw with relief—to his

feet, and pinned his arms behind him. "Cool it! Cool it," Johnny added in lower tones, "or you'll have a broken elbow. Grace," he said to the girl hovering close, "talk to him."

"Stay right where you are!" said Gutierrez, his own pistol in his hand as he planted a foot on the outflung arm of the follower, attacker, gunman, Patience couldn't settle on a term.

"Let him up!" snapped another man, a stranger, who'd appeared beside Gutierrez. "That's my son, Bart MacWhorter, and it appears to me that he needs medical attention.

"And *that* one," he snapped, turning to point an accusing finger at Danny, still in Johnny's grasp. "*That* one is my nephew, Luke MacWhorter, whatever he's calling himself now. I demand that you arrest him for assault."

"The man on the ground was the assailant," said Patience. "I saw him come up behind Danny with a pistol."

"Bullshit!" said the senior MacWhorter.

"Patience?" Gutierrez spared a glance in her direction as he stepped back to give Bart room to roll over and push himself to his knees.

"It's under the bushes. Looks like a nine-millimeter automatic."

The older MacWhorter swung around in her direction. "If there's a gun, it isn't Bart's, he's never owned a gun. It must be Luke's. Or yours."

"Stop right there!" said Patience, and dropped her hand deep into the shoulder bag she'd brought along without even realizing it.

"Patience, you stay where you are," Gutierrez ordered, and holstered his weapon. "MacWhorter, I'll ask you to take charge of your son. Whether we'll be pressing charges is still open."

As the older MacWhorter moved to help his son to his feet, Gutierrez turned his attention to the third member of the family. "Luke, I'll ask *you* to—"

"My name is Danny. Daniel Soto." Johnny had stepped away from him and he stood straight, still breathing hard, an arm around a confused-looking Grace Beaubien.

In the moment's shift of attention, Bart seized his father by the shoulders and flung him at Gutierrez, sending both of them sprawling as he himself set off at a dead run down the street.

"He has a car down there!" Patience called as Johnny took off after the fleeing man, Danny close behind him. And then, to Grace, "Gracie, please, stay here. You'll only be in the way if they catch him."

"Don't shoot him! Don't shoot my son!" MacWhorter hauled himself to his feet and started in the direction of the chase, but Gutierrez moved quickly to block him.

"MacWhorter, we don't shoot unarmed fleeing suspects. Detective Hebert is more than capable of handling your son," he added in lower tones to the unhappy man still trying to edge past him. "So you stay right here with us. If you try to go down there and interfere, I will personally take you down and handcuff you."

"I don't think you can do it," snapped MacWhorter, pulling himself up to his hefty height.

"Try me," said Gutierrez, with a glint in his dark eyes that Patience, watching, thought would bode ill for MacWhorter. Apparently he thought so, too, because he stepped back and shook his head.

"Bart shouldn't have run. But this town will face a lawsuit to wipe the whole place off the map if my son gets hurt."

"Ah yes, lawyers. The best thing you can do for your son right now is find a phone and call one."

"I…yes. Yes, I'll do that." MacWhorter tugged a cell phone loose from a clip on his belt. As he turned and walked away from the crowd, Gutierrez unlimbered his own cell phone. "Patience, where's that gun?"

She stepped aside and pointed toward the hedge behind her.

"Good. Keep an eye on it while I call in some help."

30

BY THE TIME GUTIERREZ HAD FINISHED his call, and Patience had made a surreptitious call of her own, what looked like the entire neighborhood had gathered on the street in front of Grace's house. "For those of you who don't know me, I'm Vincent Gutierrez, Chief of Police," Gutierrez called out. "And I can tell you that everything is under control, no one has been seriously hurt. But there are more officers on the way so I'll ask you, please, don't block the street."

Patience stayed right where she was, like a Labrador retriever guarding a tennis ball from other eager jaws. Grace stood still, too, simply shaking her head as one or another neighbor approached her. In the light of the street lamp Patience had watched that mobile little face display blank disbelief, and then joy, and now home in on offense. What you get, Danny, and good luck to you.

Sirens caught everyone's attention and stilled conversation as a squad car and a police van rolled up and pulled to a stop. The sirens cut off abruptly, but the bar lights continued to flash.

"Good!" said Gutierrez, and went to meet the four officers who spilled out of the vehicles. "Figueiredo, you and Jackson down there," he ordered with a wave of his arm, and turned to the other two.

"Coates, there's a piece of evidence under the hedge right there. Collect it very carefully and tag it and put it in the van. Linhares...you're pulling aother shift? Good. When we get everything sorted out here, there'll be an extra vehicle and you can bring it in. Belongs to Bart MacWhorter, or at least he's the one been driving it. But first, get a statement from Mrs. Mackellar."

"My son's Highlander?" said MacWhorter. "You can't take that."

"Toyota Highlander? Black?" asked Alma.

Gutierrez gave her a quelling look and spoke to MacWhorter.

"You, or he, will get it back, unless there's good reason for us to keep it. Ah, here we go. Good work," he said as three people came under the glow of the nearby streetlight. A handcuffed Bart MacWhorter, being hustled along between Johnny and Bo Jackson, had clearly put up a fight, or at least been tackled hard; one side of his face was bloody, there was a rip in the knee of his jeans, and the finish of his black leather jacket bore ugly scraped spots. Jackson looked fine, but Patience, who had stepped aside to let Coates scoop up the pistol, got a good look at Johnny and thought he was limping a bit.

"I demand medical attention for my son!"

"He'll get it," Gutierrez told him.

Behind the trio, Danny Soto walked close beside Dave Figueiredo but wasn't cuffed. So far as Patience could tell from here, his bruised face hadn't suffered any new damage, and he managed a smile for Grace as she darted out from the still-silent crowd to join him.

His captors hauled Bart MacWhorter to the squad car and half pushed, half lifted the struggling man into the backseat. Figueiredo and Danny approached Gutierrez, Grace falling back, and the crowd opened up as people began to talk, started to move away. A car approaching slowly from the direction of downtown paused, edged to the curb nearby, and stopped. Larry Klein, already?

"Patience?" Alma Linhares touched her arm to get her attention, and gestured with a notebook. "Do you want to talk to me here, or meet me downtown?"

"Probably downtown, if that suits you," said Patience. "But if you'll excuse me, I think I need to talk to someone else first." The driver, whom no else seemed to have noticed, opened his door and climbed out, without turning off his headlights. Outside the circle of the streetlight, his features weren't clear, but he was too tall to be Klein, and his movements were stiff. He stood still for several seconds, looking toward…Gutierrez? When he began to move forward again, she saw that he was walking with a cane, which didn't seem be slowing him down much.

"Oh, damn!" she said, and Alma turned to follow her gaze.

"Shit, that's Dennis Flynn! Chief?" she called out, and thrust her notebook at Patience as she set off at a run. Meanwhile,

people between Flynn and the chief were moving out of his way, dodging his cane.

"Flynn!" Alma called out, and Gutierrez said, "Flynn? What are you doing here?"

Flynn stopped and stood straight to stare at the scene before him. Patience, holding her breath, found herself looking at a silent freeze-frame: white faces of neighborhood people turned cowlike to watch; cops seemingly suspended in mid-gesture, mid-stride; the whole scene lit by flashes of red and blue light.

Click! Action now with the flailing of Flynn's cane, sound with the roar of his hoarse voice: "Soto! You killed my son!" He flew past Gutierrez and was on Danny, slashing back and forth with that cane, screaming wordlessly.

Danny fell to his knees, hands up to shield his head, as the closest uniforms, Alma and Figueiredo and Gutierrez, surrounded Flynn and forced him to the ground, seizing his cane.

"You killed my son," he sobbed, not struggling now.

"Mr. Flynn." Danny stood up, blood streaming from a cut on his forehead. "I didn't, I didn't. I wouldn't hurt Sean."

As Alma and Figueiredo lifted the sobbing man to his feet, Danny turned to Gutierrez, hands spread in question. "What? What happened to Sean?"

"Someone shot and killed him."

"At the riot?"

Gutierrez gave Danny a long look before answering. "No. Later that night, at the house where he'd been staying."

Danny's shoulders slumped, and the hand he put to his face came away bloody. "If you can find a guy named Doc, he'll be able to make real clear why the shooter couldn't have been me. But I sure as bloody hell know who he was," he added, the words low and harsh. "And why."

Patience sensed movement behind her and turned to see Doug MacWhorter reaching for the door of the squad car. "Get away from there! Johnny?"

Johnny Hebert and Bo Jackson materialized to either side of the suddenly rather small Doug MacWhorter and walked him back from the squad. "No sir, not a good idea," said Bo. Inside the car, Bart MacWhorter gave a teeth-baring yowl and began banging his head against the window glass.

"Might do himself some harm there, he keeps that up," observed Jackson, and put a huge hand on the older man's shoulder to push him further away. "Chief? Maybe we better take that guy downtown before he gets blood all over the upholstery."

The neighbors had pulled back into groups of two or three people, some of them still watching, others beginning to drift away. As Patience reached into her bag for her phone, for a belated call to Verity, she saw another car approach. and so did Gutierrez. "Now what?" he snapped.

"I think…" Patience watched as the car parked a respectable distance back and a short man got out, to come briskly in their direction. "Ah! It's my salvation," she said. "Or Danny's. Danny, here comes your lawyer."

As Klein spoke to Gutierrez and then approached Danny, she flipped her phone open and walked a few feet away from the scene. "Sylvie, it's Patience. Give me Verity, please.

"I'm at Grace Beaubien's house," she told her daughter. "I found Danny Soto and brought him home and it's been very busy since then. I'll tell you all about this when I get there."

She put the phone away and was heading for her truck when she heard, "Patrience, wait!"

Danny Soto had broken away from lawyer and cops and was coming toward her at a trot. "Patience? I like to think I'd have come back anyway, but maybe not. Beyond the call of duty, for you to come all that way. I really owe you."

Would "Most satisfying day I've spent in ages" be an appropriate response? Probably not. "It was a pleasure, Danny."

He shook his head, and lifted her up in both arms for a giant hug. "Thank you, lady." Her bag slid off her shoulder as he set her down, and he caught the strap and pulled it back into place. "Hey. What the hell have you got in there, a machine gun?"

She tucked the purse strap tighter. "A nice little S and W .38 revolver, for which I'm fully licensed."

"You mean you had a gun all along? All day?"

She stepped back, to avoid craning her neck to look up at him. "Fortunately, I didn't need it. You'd better go talk to Grace. Carefully."

"Right." He stood looking at her a moment longer, his face expressionless. "Right. I'll see you tomorrow."

I hope so, she said silently, and wished him well. She believed all, or most, of what he'd told her; but she had a feeling the MacWhorters would be resourceful adversaries.

"MY attorney can't get here until tomorrow, but he's advised Bart not to talk to anyone until then. So if you'll just release him to my custody?"

"Sorry, but I can't do that. He's charged with assault, fleeing to avoid arrest, resisting an officer. Possibly with possession of an unlicensed firearm; we're checking on that. He'll spend at least tonight in jail," Gutierrez added.

"That's unreasonable. He's not a criminal."

"Mr. MacWhorter, in San Luis Obispo County he's been charged with assault twice and convicted once. There was a rape charge, dropped; rumor in the D.A.'s office was that somebody bought the girl's family off. And he lost his license for a year for a road-rage incident along with DUI."

"He... When he was younger, Bart had problems with what the therapist called 'impulse control,' whatever the hell that means. But he's matured. I'm a reputable citizen and businessman, and I'll see that he shows up tomorrow."

"Sir, I'd suggest you go get some rest, talk to your lawyer again, and arrange to be here with him tomorrow morning. Now if you'll excuse me." Gutierrez got to his feet, walked to the door of his office, and opened it. Doug MacWhorter, face reddening, strode out, snarling a word or two the policeman chose to ignore.

"Hebert?" he called, and a moment later Johnny Hebert poked his head in the door.

"Yessir?"

"Would you bring Daniel Soto and Larry Klein in here, please? Along with the tape recorder and your notebook. Maybe we can all get home before midnight after all."

JOHNNY set a tape recorder on the table and turned it on, and Gutierrez sat back in his chair. "Luke MacWhorter, also known as Daniel Soto: are you sure you want to make a statement?"

"Yes sir, I do. Mr. Klein and I talked over what I have to tell," he said, with a nod at the silent man seated beside him on the couch. "He gave me the go-ahead but said he'll speak up here if I

get myself into trouble. More than I am already, anyhow." He squared his shoulders and took a deep breath.

"Okay, the immediate stuff. Bad feeling between me and most of my family goes back a long way, and I can tell you about that later. But I hadn't seen any of them in six years until the Thursday before the protest march. That day, I saw Bart MacWhorter downtown. He caught me looking at him, and took off."

"You're sure it was Bart MacWhorter you saw?"

"What I told Sean Flynn—he was with me and saw how upset I was—I just told him that the guy was somebody I'd known a long time ago. Same thing I said to Gracie Beaubien later. But I was sure."

Gutierrez waited.

"I didn't do anything more about it, and I didn't see him again until that Saturday night, when Bart and some guy who was with him threw me off the bluffs. I'm absolutely sure it was him, I'll swear to it. Sean was right there, he had to have seen him, too. That's why I believe Bart found Sean later and killed him. I wasn't there, I didn't see it, but it's exactly the kind of thing Bart would do."

"Danny," said Larry Klein softly.

"Right, sorry. Bart and his buddy pushed me off, and Sean was close enough to see that. I managed to grab hold of the other guy, whoever he was, and take him along. I got rescued, I understand he didn't."

"That's true. We found his body last Monday," Gutierrez said. "And today?"

"Today Mrs. Mackellar found me up on the coast, at a BLM campground. I decided to come back to Port Silva, and she brought me, and my trailer. It was just getting dark when she drove me to Grace Beaubien's house, where I'd been living before. When I got out of her truck, Bart saw me and tried to jump me, with a gun. That's the fight we were having when you came and found us."

Gutierrez nodded at Johnny, who turned the recorder off. "We'll get that transcribed, and have you sign it. I don't believe we have any reason to hold you here, but I'd appreciate it if you'd stay in town for a few days."

"Do you believe me?"

"Mrs. Mackellar corroborates the events of today. As to what went before, we'll check it. We've been investigating the original assault on you for the past week."

Danny nodded. "I hope you won't ask me to stay here too long, because I want to go to Atascadero to make a statement about Hector Soto's death six years ago."

"Ah," said Gutierrez. "Would you like to try that out here first?"

Danny looked at Klein, who said, "If it can be off the record."

"If we're told of a crime, we have to report it," said Gutierrez.

"That's fine," said Danny. "That's just what I plan to do." He sat straighter, took a deep breath, and repeated the story he'd told Patience earlier.

"Danny, do you have proof of any of this?" asked Gutierrez.

"I have—Mr. Klein now has—all of Hector's work journals, dated and signed, and the notes he made, with the names of the inspectors and county officials the company was dealing with. I've had them in the trailer with me since the day my cousins killed him and I ran away. Mr. Klein has them now.

"And I can tell you where to find Hector's body."

31

"AHA! BACK FROM UKIAH," said Gutierrez on Thursday morning as Hank Svoboda stepped into his office. "Did it work out the way you expected?"

"Yup, everything's pretty much on track at the county seat. The D.A.'s happy, and so far, on the basis of the evidence, the judge will probably go with a no-bail call. I came home late last night, but Hebert's staying around today until that's for sure. I gotta say," he added as he pulled up a chair and sat down, "we should respectfully ask God to make all shooters as dumb as Bart MacWhorter."

"'Poor impulse control' is a phrase I heard recently," said Gutierrez. "If MacWhorter had just left town and stayed away, or if he'd had sense enough to get rid of that pistol. Or to resist pulling it out again when he spotted his cousin," he added. "Incidentally, two of our own—Jackson and Linhares—will swear that they saw MacWhorter on the bluffs Saturday night, and if we were to arrange a lineup, I'd bet we could find one or two march monitors who'd recognize him."

"Add to that the motel maid and the guy from the liquor store, probably," said Svoboda. "We'll be talking to them again, because MacWhorter says he absolutely didn't have anything to do with some guy named Rudy Diaz."

"Surprise," said Gutierrez. "Did you bring Soto back with you?"

Svoboda shook his head. "He's coming with Hebert. I understand he plans to leave right away for Atascadero, with Larry Klein."

"Good luck to both of them, and I'm glad that situation isn't our problem." Gutierrez pushed aside the reports he'd been reading and rolled his chair back. "What we need to gear up for now is Halloween. Tonight."

"Jesus. I forgot."

"I think we'll be okay except for the usual foolishness," said Gutierrez. "Both the anti- and the pro-war folks have been quiet for two days; my guess is, they've worn themselves out for the time being. So you have your evening to yourself, so long as you keep your cell phone handy."

"HEY, Ma, looks like you had a good time last night," Verity said as she came in the back door.

"Verity, I've been up since nine." When Verity merely cocked an eyebrow on her way across the kitchen, Patience shook her head. "It wasn't particularly late when I got in, but I did have a nice evening. John Lundquist is an interesting man."

"Sylvie and I would agree with that." Johnny Hebert's uncle, who had arrived in Port Silva Tuesday about the time his nephew was leaving for Ukiah, had quickly adjusted by arranging to take all three of them to dinner that night, and had somehow managed to coax Patience out on her own last night.

"Good. Verity, I want to go downtown to the office right after lunch. Can you be here for Sylvie this afternoon?"

"I'll make you a deal," said Verity. "Right now I'm going to smear orange frosting on all those chocolate cupcakes I made last night for Sylvie's class party. If you can drop them by the school on your way into town, I can stay around to wait for my furniture to arrive, and for Sylvie. And if you get tied up by someone or something, I'll get her to Ronnie's later for the trick-or-treat stuff and *that* party."

"Done," said Patience, and set aside the newspaper and her empty coffee mug as she got to her feet. "I must say, that costume your friend at the fabric store concocted for Sylvie was... terrifying."

"I know just what you mean. Fortunately, she has no idea."

VERITY was at the table dripping orange food coloring sparingly into a bowl of powdered-sugar frosting when Zak announced the arrival of a car. She went to the window for a look, and called to Patience. "Company, Mother. Gracie."

Grace Beaubien knocked on the door moments later, and Verity opened it. "Come in, Gracie. How are you?"

"I'm fine, thank you." And she looked it, Verity noted. Her

hair was restrained, her eyes were bright, and she stood as tall and straight as her five feet plus maybe an inch would pemit.

"Can I give you coffee? Or a Halloween cupcake?"

"Thank you, no," said Grace, and turned as Patience came into the room. "Oh, Patience, I want to thank you for bringing Danny home. I'm sorry and embarrassed that I was so, um, *ungracious* Monday night."

"Grace, I understood and wasn't at all offended. Sit down, please, and tell us what's happening. Has Danny come back from Ukiah?" she asked as she took a seat at the kitchen table and Grace followed suit.

"He'll be back later today. I'm going to drive him to Atascadero, to his grandfather's house and...wherever after that. Mr. Klein is down there now, I think."

"Do you plan to stay there?" asked Verity.

"As long as I can be of help, probably quite a while. He's been talking to the police there about digging up the section of the mall parking lot where he believes Hector Soto is buried, the place the plans indicate the crew was working at the time. He thinks they're going to agree. But..."

"If he's there, how to prove who put him there," said Patience.

"Right. The MacWhorters says if he is, 'Luke' is the one responsible," Grace said, her voice rising with indignation. "But the county people are really interested in those work plans and Hector's notes, as a boost for their present investigation."

"So I'd better go and finish packing," she said, reaching into her bag as she got to her feet. "But I wanted to give you a bonus for your professional help," she added, and held out a check.

"Grace, this is not necessary."

"I think it is, and so do Danny and my folks. And thank you."

Verity went to the door with her, and watched until she'd reached her car. "Well, now she has a new cause for all that energy. I hope he's worth it."

"I'd imagine that Daniel Soto will have a way to go to... become an ordinary person in an ordinary world," said her mother. "We can only wish them well."

⌒

"VERITY?"

She gave the rug she was trying to shift another jerk, and dropped it. "Johnny?" She went to meet him at the door and turned her face up for his kiss. "How nice! I didn't expect you until tomorrow."

"Danny Soto needed a ride back to town, and I had some things I wanted to do here. Then I stopped at the cottage, and Sylvie told me your furniture had arrived. Can I help?"

"You bet."

"Just let me put this in the fridge," he said, and took the paper bag he'd brought with him to the kitchen. "Wow! A real living room," he observed on his return.

"Right, with all the furniture piled in the middle. I need to clear enough space to get the rugs down, and then move it all to where it belongs."

After a lengthy time of deciding, lifting, shifting, and carrying, some pieces more than once, Verity said, "Okay, that'll do it, for now anyway," and brushed her hair back from her sweaty forehead. "Can I get you a beer?"

He lifted his head to listen. "Wait just a minute."

"What?" She followed him to the door and saw a truck pulling in from the road to park right in front of the house. "Johnny?"

"That's what I came home to see to. It's a housewarming present."

"Johnny…"

"All you need to do is stand out of the way." He went outside to meet the driver and another large man, and follow them to the rear of the truck. The doors there opened, she heard some grunting and mumbling, and then the driver and his helper moved past her carrying an enormous paper-wrapped rectangle that had to be a mattress .

"Johnny, who do you think—?"

"Just a minute. Up the stairs there," he said to the men.

"Johnny, this is my house!"

"Right. And that's your new bed. Don't worry, it's paid for and carries no restrictions as to who you share it with."

"Whom," she snapped.

Half an hour later the bed was in place, two box springs on a

low frame supporting a mattress probably six feet wide by seven feet long. "Thanks, guys," said Johnny, and handed the driver some bills as they left.

"If you don't like the headboard, you can exchange it," he said, turning to find her staring at the huge piece of furniture now occupying her bedroom. "In fact, you can exchange the whole thing."

"Oh, no. It's fine."

"I bought sheets and pillows and a comforter, too, they're in my car. Want to dress it up and try it out?"

"Not just yet, thank you."

"Verity, don't be mad. I checked with your mother last week, she told me you were planning to move the double bed from the studio in here, and that gave me the perfect choice for your housewarming gift. It's a nice big room, a nice big bed, and it's yours, only yours. I brought champagne, too; let's go open it."

She followed him downstairs and into the kitchen. "It's not even six o'clock."

"Champagne suits any time of day, or night." He popped the cork without spilling, waited a moment, poured. "Cheers," he said, and handed her a full flute in which tiny bubbles rose prettily. "Let's go sit in your new living room."

"Thank you. Good champagne," she said after a taste.

He waited until she'd settled into the rocker before stretching out in the Barcelona chair with its matching footstool. "Just to get this out of the way. If you haven't heard yet, you'll be pleased to know that Bart MacWhorter has been charged with the murder of Sean Flynn, remains in jail in Ukiah, and is unlikely to be bailed. His gun, with his prints all over it, did the job. There's other evidence, too, but the gun is pretty much a clincher."

Verity felt her tight shoulders relax at this turn to what passed in her life for the ordinary. "Will he be charged in any way for the death of Diaz? And with trying to murder Danny?"

"Not clear yet. People here are working on that."

"Grace came this morning to tell us she was going to drive Danny to Atascadero and stay with him there for a while, at least."

He caught her worry, as she might have expected. "Verity, I don't think Danny Soto is any more of a risk than the next guy

she might meet. Probably less. Just a minute," he said, and got up to head for the kitchen, to return with the champagne bottle.

"Here's something I myself am wondering about," he said as he topped off their glasses. "I stopped by my house long enough to check in with my Uncle John, who was getting ready to leave for Trinity County to visit his brother. He told me he'd had a fine couple of days in Port Silva and planned to stop here again on his way back."

Verity watched the bubbles floating up in the narrow glass.

"Uncle John thinks you're probably too good for me, but wishes me luck. A judgment I agree with completely. But the person he really wanted to talk about was Patience."

He paused for a thoughtful sip of wine, waiting for a reply that didn't come. "What I couldn't tell him was whether there was a chance she might be interested in him. Or in any new guy."

Verity drained her glass and set it down. "Okay, strictly between you and me. Strictly!"

"Got it."

"Hank Svoboda, dear man, wants to retire next year. And he's looking for a new house, further down the coast or even in Petaluma; he has grandchildren there. Change of scene, new life."

"Ah."

"Right. My mother does not want to retire. She does not want to move from here; she's been waiting eagerly to get her own little house back." She paused for a deep breath. "And she doesn't want to get married."

"Oops."

"So I honestly don't know what she'll do, about Hank or anybody else. I only hope that nobody pushes her too hard."

"Well. I do, too. Well," he said again. "If you're going to be baby-sitting—or whatever you call it—tonight, maybe I should go get us something to eat? Or maybe you'd rather—?"

"Lover, my mother's life is different from mine. Actually, a few days ago she suggested I rent you a room here instead of running back and forth."

"I...don't think that's quite what I had in mind."

"Nor me, and she was kidding, sort of. But how would you feel about *thinking* about moving in here, as in living together? To see how it works out."

He stared at her. "I don't *need* to think about it. How about tomorrow?"

"Why not? There's that nice new bed."

"Verity—"

"I'm just being flippant because I'm scared."

"I'm not, I'm ecstatic. I need to take half a dozen deep breaths before I say anything more."

"Verity?" Sylvie's voice brought them both to their feet.

"Hi, you guys. Verity, could you come and draw my whiskers on? And I wanted Johnny to see my costume." Sylvie had on furry black slipper feet with nails painted in the fur, slim black leggings, and a close-fitting black turtleneck top; a black furry hat with up-standing pointed ears fit snugly over her shoulder-length black hair, and a long, black, furry tail trailed behind her.

She spun in a circle and then half crouched, lifting clawed hands with long, red nails.

"Sylvie, you're the best-looking black cat I've ever seen."

She grinned at him, and hissed.

"Sylvie, there's at least half an hour before we need to leave for Jess's," Verity told her. "Go on back to the cottage and have a glass of milk or something. I'll be in to do your whiskers in a few minutes."

"Meow!" she said over her shoulder as she leapt for the door.

"My God," said Johnny when she was safely out of hearing.

"I know. Isn't it scary?"

"I'd say that new fence going up out there will be obsolete almost as soon as it's finished. Give her another year or two, we're gonna need a moat."

"What fun."

"Yeah. Uh, Verity, I wonder… Do you suppose we should ask Sylvie how she feels about my moving in?"

"Oh, Johnny," she said, and reached up to pat his cheek. "Even *I* know that asking your kid's permission for something you've already decided to do is a very bad idea."

"Lady, I yield to your judgment—probably not for the last time."

෴

Jerry Bauer

ABOUT THE AUTHOR

Janet LaPierre came to northern California from the Midwest via Arizona, and knew that she was home. After raising two daughters in Berkeley, she and her husband began to explore the quiet places north of the Bay Area: the Mendocino region, the Lost Coast, Trinity County. Often working on a laptop computer in a travel trailer in the company of her dog, LaPierre has tried to give her books a strong sense of these far-from-the-city places.

LaPierre's mystery novels and short stories have been nominated for the Anthony, Macavity, and Shamus awards. She welcomes visitors and e-mail at www.janetlapierre.com.

MORE MYSTERIES
FROM PERSEVERANCE PRESS
🕲 *For the New Golden Age* 🕲

JON L. BREEN
Eye of God
ISBN 1-880284-89-8

TAFFY CANNON
ROXANNE PRESCOTT SERIES
Guns and Roses
*Agatha and Macavity Award
nominee, Best Novel*
ISBN 1-880284-34-0

Blood Matters
(forthcoming)

Open Season on Lawyers
ISBN 1-880284-51-0

Paradise Lost
ISBN 1-880284-80-4

LAURA CRUM
GAIL MCCARTHY SERIES
Moonblind
ISBN 1-880284-90-1

JEANNE M. DAMS
HILDA JOHANSSON SERIES
Crimson Snow
ISBN 1-880284-79-0

KATHY LYNN EMERSON
LADY APPLETON SERIES
Face Down Below the
Banqueting House
ISBN 1-880284-71-5

Face Down Beside St. Anne's
Well
ISBN 1-880284-82-0

ELAINE FLINN
MOLLY DOYLE SERIES
Deadly Vintage
(forthcoming)

HAL GLATZER
KATY GREEN SERIES
Too Dead To Swing
ISBN 1-880284-53-7

A Fugue in Hell's Kitchen
ISBN 1-880284-70-7

The Last Full Measure
ISBN 1-880284-84-7

PATRICIA GUIVER
DELILAH DOOLITTLE PET
DETECTIVE SERIES
The Beastly Bloodline
ISBN 1-880284-69-3

The Scarpered Sea Lion
(forthcoming)

NANCY BAKER JACOBS
Flash Point
ISBN 1-880284-56-1

JANET LAPIERRE
PORT SILVA SERIES
Baby Mine
ISBN 1-880284-32-4

Keepers
*Shamus Award nominee,
Best Paperback Original*
ISBN 1-880284-44-8

Death Duties
ISBN 1-880284-74-X

Family Business
ISBN 1-880284-85-5

VALERIE S. MALMONT
TORI MIRACLE SERIES
Death, Bones, and Stately
Homes
ISBN 1-880284-65-0

DENISE OSBORNE
FENG SHUI SERIES
Evil Intentions
ISBN 1-880284-77-4

LEV RAPHAEL
NICK HOFFMAN SERIES
Tropic of Murder
ISBN 1-880284-68-5

Hot Rocks
(forthcoming)

LORA ROBERTS
BRIDGET MONTROSE SERIES
Another Fine Mess
ISBN 1-880284-54-5

SHERLOCK HOLMES SERIES
The Affair of the Incognito Tenant
ISBN 1-880284-67-7

REBECCA ROTHENBERG
BOTANICAL SERIES
The Tumbleweed Murders
(completed by Taffy Cannon)
ISBN 1-880284-43-X

SHELLEY SINGER
JAKE SAMSON & ROSIE VICENTE SERIES
Royal Flush
ISBN 1-880284-33-2

NANCY TESLER
BIOFEEDBACK SERIES
Slippery Slopes and Other Deadly Things
ISBN 1-880284-58-8

PENNY WARNER
CONNOR WESTPHAL SERIES
Blind Side
ISBN 1-880284-42-1

Silence Is Golden
ISBN 1-880284-66-9

ERIC WRIGHT
JOE BARLEY SERIES
The Kidnapping of Rosie Dawn
Barry Award, Best Paperback Original. Edgar, Ellis, and Anthony Award nominee
ISBN 1-880284-40-5

REFERENCE/ MYSTERY WRITING

CAROLYN WHEAT
How To Write Killer Fiction: The Funhouse of Mystery & the Roller Coaster of Suspense
ISBN 1-880284-62-6

Available from your local bookstore or from Perseverance Press/John Daniel & Co. at (800) 662-8351 or www.danielpublishing.com/perseverance.